SUPER MARIO BROS. ENCYCLOPEDIA

THE FIRST 30 YEARS

THE OFFICIAL GUIDE TO THE FIRST 30 YEARS
1985–2015

DARK HORSE BOOKS

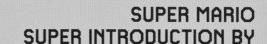

GENERAL MANAGER OF NINTENDO CO., LTD.
ANALYSIS AND DEVELOPMENT, GAME PRODUCER

TAKASHI TEZUKA

It's been over thirty years since *Super Mario Bros.* first went on sale, and for all those years, Takashi Tezuka has been working on the development of the series. Now he has a message for all of Mario's fans!

MY FRIEND MARIO!

THIS MIGHT TURN OUT TO BE SOMETHING REALLY INCREDIBLE . . .

Now, over thirty years on, it's safe to say that the *Super Mario* series has been an unqualified hit, selling more than three hundred million copies of the various games over that time. I could never have imagined that so many people would have played it. There are many things that I still remember about the creation of *Super Mario* like it was yesterday. Just before it went on sale, I was walking down the hallway outside of a meeting room with Miyamoto [Shigeru Miyamoto, Creative Fellow at Nintendo Co., Ltd.], when he said, "Tezuka, *Super Mario* might turn out to be something really incredible." It seemed to him that this felt a lot like when *Donkey Kong* was about to come out. But even after I heard his words, they didn't strike me as reality. Having worked there for only two years, I was still relatively new, and at the time I had never experienced a hit game.

HIRING CATS?!

When the Famicom [the Japanese release of the Nintendo Entertainment System] went on sale in 1983, I was job-hunting, and a chance word from a friend changed my life forever: "Hey, there's a company that looks interesting." That company turned out to be Nintendo.

The Famicom had only just gone on sale, and I hadn't even touched one. I had seen the Game & Watch and was drawn to it because it looked fun and had a simple design. I thought that a company that could design the Game & Watch might be a good place to work, so I applied to Nintendo and got a job.

Normally I'd have had to wait for April 1st to start work at a company like that, as is the norm in Japan. But before I was officially hired, they called me up and asked if I'd work part-time on an arcade game called *Punch-Out!!* . . .

I was drawing pixel art. At the time, Nintendo was so understaffed, they would have hired cats if they thought it would help.

LARGE, FAST CHARACTERS

When I officially joined the company, it wasn't to be on the team building the Game & Watch, but rather in the Creative division [eventually called Nintendo Entertainment Analysis and Development] —a small department with only about six people. We'd design playing cards and user manuals, and every now and then we'd get together with someone from a different division to help work on games. As I remember, it was pretty fun to go to work every day.

One of these people was Shigeru Miyamoto, and that began a game-making partnership that's lasted for thirty-plus years. The first one we worked on together was *Devil World* for the Famicom.

⊙ A handwritten note on *Super Mario Bros.* during the time of its development. It calls for "large, fast characters."

I was in charge of pixel art, but I never heard one word about the new game that Miyamoto was planning until after *Devil World* had already gone on sale.

He said, "For the next one, let's make a fast-paced game that has levels on the land, in the sea, and in the air, and let's do it with large characters!" "Large characters" actually meant a character just sixteen by thirty-two pixels. At the time, "small characters" were half that size, at sixteen by sixteen pixels. Those were more commonplace.

So we started testing large characters on the screen and seeing how they moved, and the feedback we got was extremely positive. That's when we started calling this large character "Super Mario," and that was the official start to the project.

At the time, Nintendo's building was very close to a temple called Toufukuji, which is famous for the color of the leaves in autumn. We entrusted the programming of *Super Mario Bros.* to a company called SRD, and Nintendo set up a room for them. Unfortunately the room was just some extra space between floors, and the place felt more like a low-ceilinged storeroom.

There were seven members in the core group. The director was Miyamoto, I was his assistant, and the guy in charge of sound was Koji Kondo, who joined the company at the same time I did. By the way, one person who worked for SRD, Toshihiko Nakago, went on to develop both the *Mario* and *Zelda* series.

When we started to develop the game, first Miyamoto and I would design the levels together. We'd draw them on huge sheets of graph paper, and the next morning, we'd deliver them to SRD. By that evening, they'd be finished programming it. At that point Miyamoto and I would play the heck out of it, make changes, put all of our notes and instructions in writing, and hand it all to them the next morning. Every single day was a repeat of that. We'd be there pretty much every day until the lights went off and we had to go home. Miyamoto would always be in the office even later than I was.

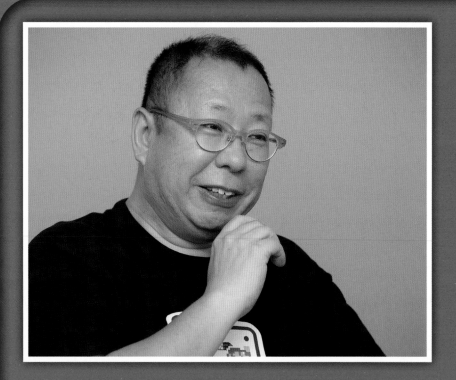

THE VINE THAT LEADS TO THE SKY!

The aspect of the *Super Mario Bros.* development that really excited me was the "air" part of the "land, sea, air" concept. I couldn't help but think that it would be so fun to play in the sky! It was then that we considered having Mario board a cloud and do battle in the air.

This may sound obvious, but it meant we needed enemies who were also flying through the air. But because of the very small capacity of the Famicom game cartridges at the time, we had almost no room to add new characters. So we decided to simply add wings to a character that already existed. That's how Koopa Paratroopa was born—by giving wings to the Koopa Troopa.

We came up with a trial product, but unfortunately, it wasn't any fun at all. It was too much like a shooting game, and it didn't have the feel we wanted from our Mario game. And so we did away with the sky aspect, but the desire to do adventures in the sky remained with me.

At one point I said to Miyamoto, "What if we did a Jack and the Beanstalk kind of thing, where Mario can climb a beanstalk up into the sky? I'd love that!" I was just tossing out ideas, but Miyamoto made a level where Mario could climb a vine into the sky. He reused some elements he'd already created and constructed a level with them. I thought that no one else in the world but he could do that.

It's easy to throw out ideas, but to be able to build a game you can actually play from those ideas is crucial. I had joined the company two years prior, but I think it was at that moment that I learned just what was important in game design.

SHIITAKE MUSHROOMS

One more thing I wanted to talk about was when I was doing pixel art for the Goombas. When we first started working on the game, the original enemy that you're supposed to meet is the Koopa Troopa. From our standpoint, the Koopa Troopas were pretty easy to defeat. You jump on them and they vanish into their shells. But for people who were just starting, this was extremely hard. So we thought we would need an easier enemy, one you could just jump on to destroy, so that people just starting the game could easily defeat them. We were nearing the completion of the game when Goombas showed up for the first time. By the way, their Japanese name is Kuribo because they look a little like chestnuts [*kuri* in Japanese], but in actuality, they're shiitake mushrooms.

It was really a lot of things coming together that led to the development of the original *Super Mario*, and we had plenty of rough patches after that, but we've always given it our creative all when we are making the games. I honestly feel that I've been just concentrating on these games, and before I knew it, thirty years had passed. At the same time, it feels like a long time, and I've been fortunate to play in a world that defies age demographics. It's made me a very happy man.

MARIO'S ADVENTURES ARE FAR FROM OVER!

The latest game in the series is *Super Mario Maker*, which went on sale in 2015. This game could only come about because of the Wii U GamePad. Now that I've seen what the Wii U can do, I really want to do a new version of *Mario Paint* like we had for the Super Famicom [SNES]. I was thinking how fun it would be to draw some cool pictures using the stylus that comes with the Wii U GamePad. There were a lot of special circumstances that prevented *Mario Paint* from being fully realized on the Super Famicom; *Super Mario Maker* was programmed with a lot of the ideas from *Mario Paint* in mind.

For example, the cursor has become a cat's paw. As I said before, when I first got some part-time work from Nintendo, they probably would have hired cats if they thought it would help. Well, this time we really have a "cat" working for us. Actually, I have ten cats at home, and I brought two of them to work and had them photographed. Of course, there are a lot of other interesting ideas in the game aside from cats' paws. I think you'll find a lot of things in *Super Mario Maker* that you will not find in any other *Super Mario* game!

After thirty years of making *Mario* games, Mario has come to be something of a friend to me. I've gone through a lot of games with the purpose of making Mario a more likable character, but there were so many times when it was Mario who made me more courageous. So it's my intention to keep on hanging out with Mario. Thirty years is just a checkpoint along the way.

Finally, I want to show my appreciation to all of you who have spent your time playing with Mario. Truly—thank you! His adventures are just starting, and we hope you and Mario will be adventuring together for a long time to come.

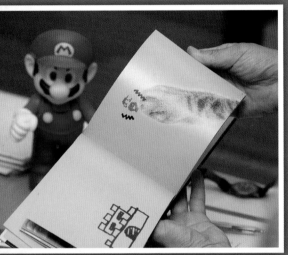

← The booklet packaged with the game *Super Mario Maker* features the paw of one of Tezuka's cats.

Interviewer and writer: Akinori Sao / Photographer: Shoji Nakamichi

てづかたかし

↑ Tezuka says that more Mario adventures are coming! Here he is outside Nintendo's Analysis and Development building in Kyoto. Above: Tezuka's signature.

Date of Birth	November 17, 1960
Birthplace	Osaka, Japan
Blood Type	B
Alma Mater	Osaka University of Arts, Department of Design
Work History	I started working at Nintendo in April 1984 and have worked as a designer and producer for both the *Super Mario Bros.* and *Legend of Zelda* series.
Nickname	Tenten
Childhood Dream	To be an artist
Childhood Obsessions	Experimenting with all sorts of things. For example, I once took apart a tape recorder and put Calpis soda in the steam iron, among other experiments.
Favorite School Subject	Math
Least Favorite School Subject	Japanese writing and literature
Schoolboy Obsessions	Making up stories, and going places with friends
Favorite Foods	Watermelon and Garigari-kun popsicles
Least Favorite Food	Snapping turtle
Favorite Music	I listen to a wide range of music (most recently, I've been listening to a bossa nova album).
Person You Most Respect	Shigeru Miyamoto (better get that on record)
Breakfast	Toast or rice
Nightly Hours of Sleep	5–6 hours
Hobby	Working on cars (recently I've been playing with their electrical systems)
Activities for Days Off	Family outings
Favorite Place in Kyoto	Arashiyama (good even when crowded with tourists)
Favorite Character	Lakitu (I like the Japanese name, Jugemu, and the fact that you can board the cloud when you take him out)
Least Favorite Character	Don't have one

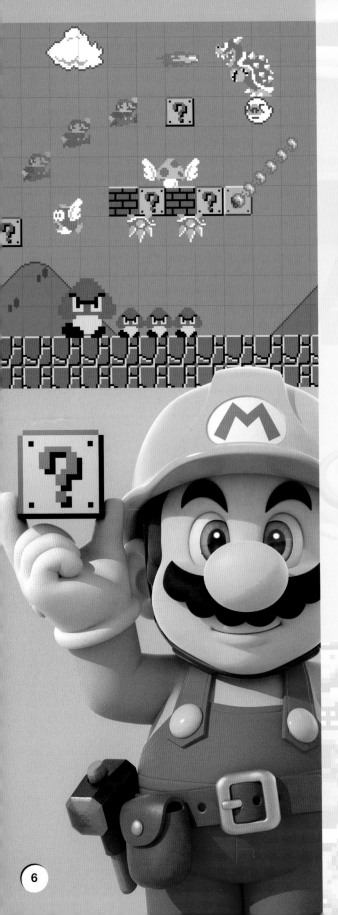

SUPER MARIO MAKER™

MAKE IT! PLAY IT! SUPER MARIO MAKER!

Super Mario Maker is the software you've been dreaming of! A 2D side-scrolling action game where you can play *Super Mario Bros.* courses and, using the Wii U GamePad, build your own courses with ease! Once you've finished a course, you can upload it and submit it online. You can also download and play courses other people have created!

To celebrate the series' thirtieth anniversary, we wanted to give creators the world over a chance to have a completely different kind of gaming experience!

RELEASE DATE	SEPTEMBER 2015
PRICE	$59.99 US

The package includes a booklet fully packed with ideas for creating your own course. You can also get the contents of the booklet on the Nintendo site for free!

⊘ Wii U BUNDLES

LIMITED SUPPLY — **Wii U SUPER MARIO MAKER—SUPER MARIO BROS. 30TH SET (JAPAN ONLY)**
Includes Wii U (white/32GB), digital download of the game, hardcover idea booklet, and 30th Anniversary Mario—Classic Color amiibo.

MSRP $299.99 — **NINTENDO Wii U SUPER MARIO MAKER DELUXE SET**
Includes Wii U (black/32GB), digital download of the game, idea booklet, and 30th Anniversary Mario—Modern Color amiibo.

SUPER MARIO BROS. 30TH ANNIVERSARY—MARIO SERIES

Two amiibo figures were made for *Super Mario Maker*: 8-bit Mario in two unique color schemes!

Available in either Classic or Modern Colors, they celebrate the 30th Anniversary and feature exciting effects when used during a game!

⬆ If you use these amiibo figures while playing a course, you can obtain a Big Mushroom. With it you can break apart even the tough blocks with Big Mario!

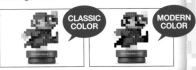

CLASSIC COLOR MODERN COLOR

EASILY MAKE AND SHARE 2D MARIO COURSES!

Build highly unusual courses or near-impossible ones with hordes of enemies. With *Super Mario Maker*, create courses freely!

Here is how you can create and play!

MAKE A COURSE
Create a 2D Mario course on the GamePad. You can adjust it whenever you feel like it.

PLAY YOUR COURSE
Now you can play the course you just created! There are also pre-made courses you can play!

SUBMIT YOUR COURSE
Submit the course you made and play courses that others have submitted!

CREATE

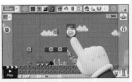

COMBINE SIXTY DIFFERENT PARTS TO MAKE A COURSE ALL YOUR OWN!

There are all sorts of parts like blocks, characters, and items you can use to build your course. Set your own time limits and auto-scrolls, and set the goal wherever you feel like putting it. On top of that, you can use game styles from different eras such as the original *Super Mario Bros.* or *New Super Mario Bros. U*, and even switch between styles. Once you've cleared the course you've created, you can submit it for others to play!

CREATE NEW CHARACTERS AND TRAPS!

By putting together different parts in interesting ways you can create tricks, traps, and mechanisms that wouldn't be possible in the original series. How they work depends entirely on you!

> There are sixty different parts you can use! Additionally, parts can be changed just by shaking them with the stylus (for example, a Green Koopa Troopa can change to a Red Koopa Troopa.)

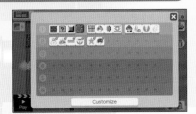

·········· EXAMPLES OF COMBINATIONS ··········

MARIO + SPINY SHELL
Break hard blocks and eliminate enemies you usually can't attack from below.

BILL BLASTER + COINS
Make a shower of coins spray from a Bill Blaster.

BOWSER + BOWSER JR.
Bowser Jr. can ride on Bowser's back, and of course they're both on the attack!

> Building a course is easy. Just place the parts using the GamePad.

Use new characters that weren't in the original!

MARIO + BUZZY BEETLE SHELL
Heavy things can fall on Mario, and yet not damage him.

MARIO + KOOPA CLOWN CAR
Mario can take flight in the iconic Koopa ride!

> Boos and other enemies that were never seen in the original game make appearances here. The characters change to match the game styles, so you can get a taste of what later characters might look like in earlier games in the series.

PLAY

HAVE FUN EVERY DAY ON COURSES MADE ALL OVER THE WORLD!

Players all over the world can submit their courses, and you can play as many as you like! You can also play any of the sixty-eight courses that come pre-made with your software. Play the Ten Mario Challenge and see how far you can get through eight levels with only ten lives.

> Challenge yourself with a series of eight submitted sample courses with the Ten Mario Challenge!

100 MARIO CHALLENGE

Take up a challenge of randomly chosen courses with a limit of 100 lives. You can choose a difficulty level from "Easy," "Normal," "Expert," and "Super Expert." Just like in the Ten Mario Challenge, your goal is to rescue Princess Peach.

SEARCH FOR COURSES

You can search for the latest courses, those with high star ratings, or any one of a number of different search options. Find courses that match your personal play style!

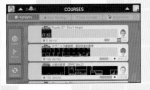

SEARCH FOR A CERTAIN MAKER

If you find a submitted course you particularly like, you can follow the "Maker" of that course! Once you've followed them, you can easily check in to see if they've made any new courses.

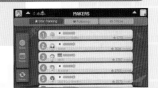

MARIO IN ACTION: A STYLE FOR EVERY ERA

Choose from four different games and six different scenes to create a unique aesthetic for your course! The basic movement of Mario is similar to *New Super Mario Bros. U*, but the individual styles will give you different kinds of action.

CHANGE THE DESIGN
GAME STYLES

You can change between the designs of the four series whenever you want. The music for each is recreated too!

CHANGE THE BACKGROUND
COURSE THEMES

You can play Mario aboveground, underground, in the very first Ghost House, and many others! There are even new scenes that aren't in the original!

SUPER MARIO BROS.

P. 16

The original game in the series where you control Mario in the way you know and love! You can power up to Fire Mario, just like in the original. Sometimes a strange, thin mushroom comes from the ? Blocks. When Mario grabs it, he becomes tall, super slender, and can jump much higher!

············ ACTION THAT REPRESENTS THE WHOLE SERIES ············

DASH
Since you can run very fast while holding the B Button down, it was called the B Dash.

JUMP
Use it to defeat enemies and avoid traps. This is what Mario does best!

Transformations that match the style!
MARIO CHARACTERS

| LINK | PEACH | Wii FIT TRAINER |

When you get a mushroom with a question mark on it, you can transform Mario into all kinds of characters. You can even expand your range of characters if you use amiibo or accomplish things, like winning the 100 Mario Challenge!

⬆ You can choose to make the transformation set or random.

COURSE THEMES We've added Ghost House and Airship themes that weren't in the original!

GROUND

UNDERGROUND

UNDERWATER

GHOST HOUSE

AIRSHIP

CASTLE

SUPER MARIO BROS. 3

P. 46

Create and play in the style of the game that introduced the world map! Though it was also for the NES, the graphics appear more detailed than those of the original *Super Mario Bros.* Since Yoshi doesn't appear in *Super Mario Bros.* or *Super Mario Bros. 3*, he appears as Goomba's Shoe in these two styles.

············ NEWLY ADDED ACTIONS ············

HOLDING/THROWING/PLACING
It seems as if you could always do this, but *Super Mario Bros. 3* was the first game that allowed you to hold and throw Koopa Shells!

Transformations that match the style!
RACCOON MARIO

When Mario gets a Super Leaf, he turns into Raccoon Mario. If you dash to fill the gauge in the upper left to full, Mario spreads his arms and can fly through the air!

⬆ You can fly when the gauge fills up. You can also attack with his tail.

COURSE THEMES We've added a Ghost House theme that wasn't in the original!

GROUND

UNDERGROUND

UNDERWATER

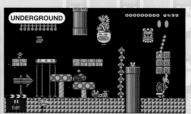
GHOST HOUSE

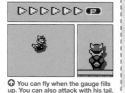
AIRSHIP

CASTLE

SUPER MARIO WORLD

P. 58

Super Mario World went on sale at the same time as the SNES! It was the first game that included Yoshi and Ghost Houses. You'll encounter a lot of new enemies, so we've redone Yoshi's interactions with them. See Yoshi eat a Dry Bones, then spit out the bones for the first time!

········· NEWLY ADDED ACTIONS ·········

SPIN JUMP

This game is where Mario's Spin Jump debuted, allowing you to defeat certain enemies and get over traps.

THROWING UPWARD

You can pick up an object and throw it upward. The *Super Mario World* skin is the only one where you can perform this action.

Transformations that match the style!
CAPE MARIO

When you get a Cape Feather, you transform into Cape Mario. You can attack with the cape and fly through the air. By doing a quick descent, you can attack enemies by bouncing off of them.

We've added an Airship the

COURSE THEMES

 GROUND

 UNDERGROUND

 UNDERWATER

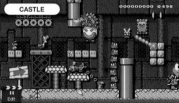 GHOST HOUSE

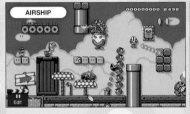 AIRSHIP

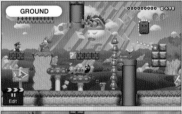 CASTLE

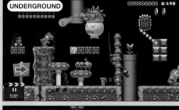

NEW SUPER MARIO BROS. U

P. 204

If you put in the original software and use the GamePad, you can have a five-person multiplayer game. With *Super Mario Maker*, this is the only style where the characters are rendered in 3D! Yoshi also appears here!

········· ACTIONS UNIQUE TO THIS STYLE ·········

TRIPLE JUMP

If you dash and jump, then use good timing to jump again each time you land, you can do a triple jump.

GROUND POUND

You can ground-pound when you press down on the +Control Pad while in the air. Use it to attack or activate machinery, among other uses.

WALL JUMP

Jump and kick the wall, and it will send you high to the opposite side. That action was introduced with the arrival of 3D *Mario* games, and you can use it here too.

Transformation action to match the style!
PROPELLER MARIO

When Mario gets a Propeller Mushroom, Mario dons a Propeller Suit. After a huge jump into the air, you descend slowly to the ground. You can attack enemies by quickly descending.

COURSE THEMES

 GROUND

 UNDERGROUND

 UNDERWATER

 GHOST HOUSE

AIRSHIP

CASTLE

AND MORE

IF YOU CAN CLEAR THE GNAT ATTACK MINIGAME, YOU'RE AWARDED WITH BUILDER MARIO!

Shake a Muncher and three flies appear. If you can swat all of them, you can play the same fly-swatting minigame found originally in *Mario Paint* for the SNES.

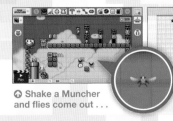

⬆ Shake a Muncher and flies come out . . .

LEVEL 1

⬅ If you swat all the flies in time, a minigame starts.

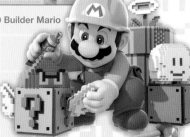

⬅ A huge boss appears! Once you clear all three stages, you can obtain Builder Mario.

➡ Builder Mario

ONTENTS

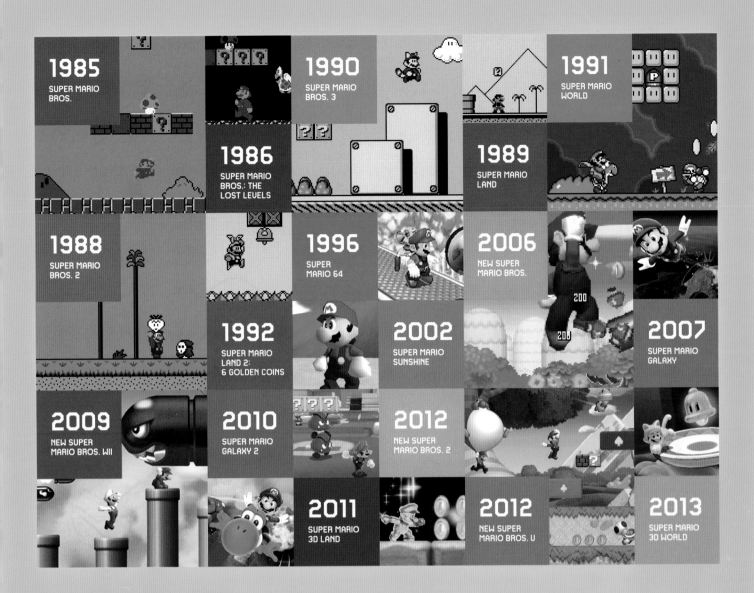

1985
SUPER MARIO BROS.

1986
SUPER MARIO BROS.: THE LOST LEVELS

1990
SUPER MARIO BROS. 3

1991
SUPER MARIO WORLD

1989
SUPER MARIO LAND

1988
SUPER MARIO BROS. 2

1996
SUPER MARIO 64

2006
NEW SUPER MARIO BROS.

1992
SUPER MARIO LAND 2: 6 GOLDEN COINS

2002
SUPER MARIO SUNSHINE

2007
SUPER MARIO GALAXY

2009
NEW SUPER MARIO BROS. WII

2010
SUPER MARIO GALAXY 2

2012
NEW SUPER MARIO BROS. 2

2011
SUPER MARIO 3D LAND

2012
NEW SUPER MARIO BROS. U

2013
SUPER MARIO 3D WORLD

OVERVIEW
OF ALL 17 TITLES

The character names and illustrations given for each title in this book are generally representative of how they appeared at the time. Terms that did not receive an official English name are derived from the direct Japanese translation.

30-YEAR SERIES TIMELINE

The Beginning

It's been over thirty years since the introduction of *Super Mario Bros.* in Japan on September 13, 1985 (October 18, 1985, in North America). Although it started as a 2D side-scrolling action series, it has evolved into a 3D world, from pixel art to polygon-rendered 3D graphics, and then back again to a 2D world in an advanced form. As time passed, the series changed in both form and features.

The intent of this book is to take a close look at the process by which the series has evolved and document the history of this beloved franchise. We want this to be the ultimate encyclopedia about the *Super Mario Bros.* series.

It would give us great pleasure if this book could remind you and the friends you played with of the good old days, or perhaps become a vehicle for communication between generations as you play it with your family. If it helps those who love the *Mario* games in any way, that would be the highest honor we could receive.

How This Book Is Organized

Each of the seventeen official games in the *Super Mario* series is described according to the categories listed below. Although most of the images and names are kept the same as they were at the games' release, there are a few that have been updated since then. The information in this book is the product of research by the Japanese editorial department, the American editorial department, and a team of English localizers and fact checkers.

Each game is organized according to the following four categories:

No. 1 Introduction	An introduction to the game and overview of the story.	No. 3 World	We explain each level, the tricks and traps, and other aspects that make up the game.
No. 2 Characters	Here we describe the player characters, power-ups, and the enemy characters that appear in the game.	No. 4 And More	Here we point out things that left lasting impressions, special skills and techniques, and other parts of the game worth a closer look.

THE SUPER MARIO BROS. SERIES

This is a quick look at all seventeen games in the series, released between 1985 and 2015. Many of the titles here have different versions that came later, but we're presenting them as they were originally published.

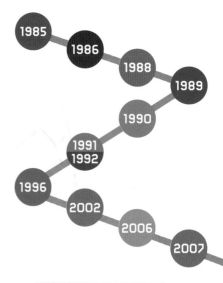

1985
1986
1988
1989
1990
1991
1992
1996
2002
2006
2007

1985 P. 16–23

Super Mario Bros.
NES
Side-Scrolling 2D Action

1986 P. 24–31

Super Mario Bros.: The Lost Levels
NES
Side-Scrolling 2D Action

1988 P. 32–39

Super Mario Bros. 2
NES
Side-Scrolling 2D Action

1989 P. 40–45

Super Mario Land

Game Boy
Side-Scrolling 2D Action

1990 P. 46–57

Super Mario Bros. 3

NES
Side-Scrolling 2D Action

1991 P. 58–71

Super Mario World

SNES
Side-Scrolling 2D Action

1992 P. 72–80

Super Mario Land 2:
6 Golden Coins

Game Boy / Side-Scrolling 2D Action

1996 P. 82–94

Super Mario 64

Nintendo 64
3D Action

2002 P. 96–108

Super Mario Sunshine

GameCube
3D Action

2006 P. 110–121

New Super Mario Bros.

Nintendo DS
Side-Scrolling 2D Action

2007 P. 122–139

Super Mario Galaxy

Wii
3D Action

2009 P. 140–153

New Super Mario Bros. Wii

Wii
Side-Scrolling 2D Action

2009
2010
2011
2012
2013

2010 P. 154–174

Super Mario Galaxy 2

Wii
3D Action

2012 P. 190–203

New Super Mario Bros. 2

Nintendo 3DS
Side-Scrolling 2D Action

2011 P. 176–188

Super Mario 3D Land

Nintendo 3DS
3D Action

2012 P. 204–219

New Super Mario Bros. U

Wii U
Side-Scrolling 2D Action

2013 P. 220–236

Super Mario 3D World

Wii U
3D Action

Meet the Mario Family!

We'll be starting off with Mario, Luigi, Princess Peach, the Koopas, and all the regular characters, including the best supporting characters and enemy characters that have appeared throughout the *Super Mario Bros.* series! Although we'll go into all of the other characters that appear in the games later in this book, here are all the main characters, without whom it wouldn't be a *Super Mario* game.

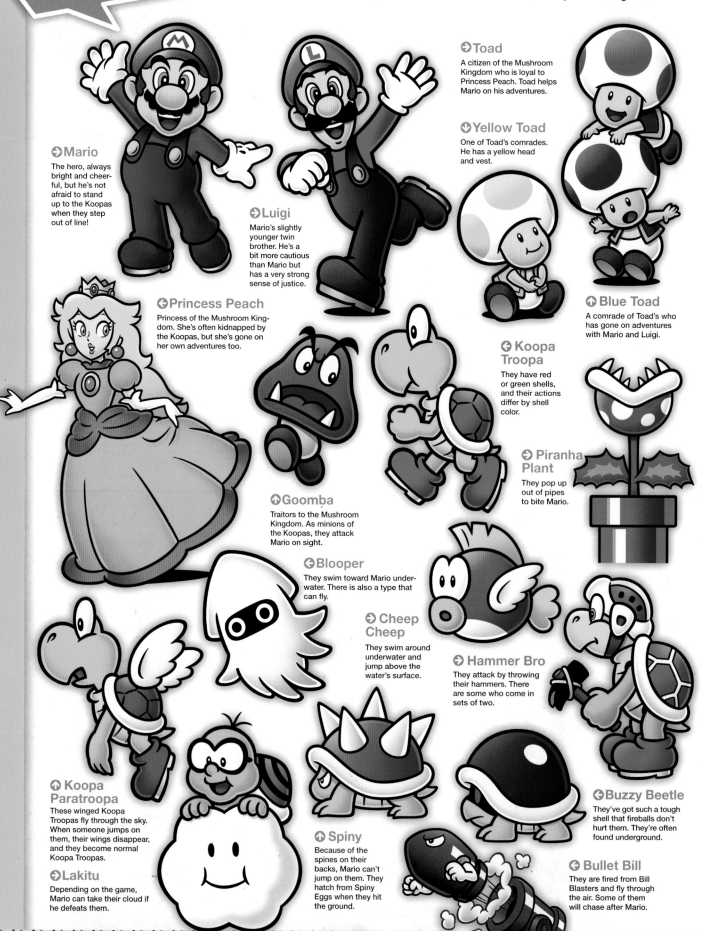

Mario
The hero, always bright and cheerful, but he's not afraid to stand up to the Koopas when they step out of line!

Luigi
Mario's slightly younger twin brother. He's a bit more cautious than Mario but has a very strong sense of justice.

Toad
A citizen of the Mushroom Kingdom who is loyal to Princess Peach. Toad helps Mario on his adventures.

Yellow Toad
One of Toad's comrades. He has a yellow head and vest.

Blue Toad
A comrade of Toad's who has gone on adventures with Mario and Luigi.

Princess Peach
Princess of the Mushroom Kingdom. She's often kidnapped by the Koopas, but she's gone on her own adventures too.

Koopa Troopa
They have red or green shells, and their actions differ by shell color.

Goomba
Traitors to the Mushroom Kingdom. As minions of the Koopas, they attack Mario on sight.

Piranha Plant
They pop up out of pipes to bite Mario.

Blooper
They swim toward Mario underwater. There is also a type that can fly.

Cheep Cheep
They swim around underwater and jump above the water's surface.

Hammer Bro
They attack by throwing their hammers. There are some who come in sets of two.

Koopa Paratroopa
These winged Koopa Troopas fly through the sky. When someone jumps on them, their wings disappear, and they become normal Koopa Troopas.

Lakitu
Depending on the game, Mario can take their cloud if he defeats them.

Spiny
Because of the spines on their backs, Mario can't jump on them. They hatch from Spiny Eggs when they hit the ground.

Buzzy Beetle
They've got such a tough shell that fireballs don't hurt them. They're often found underground.

Bullet Bill
They are fired from Bill Blasters and fly through the air. Some of them will chase after Mario.

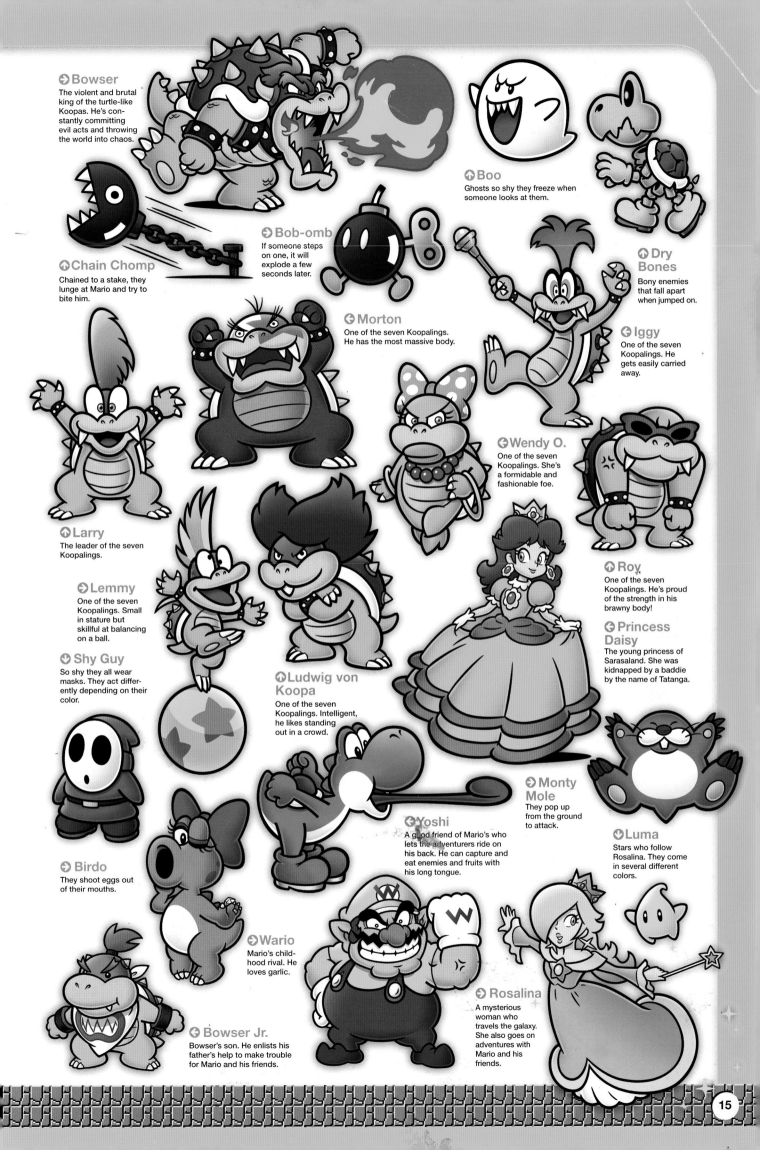

Bowser
The violent and brutal king of the turtle-like Koopas. He's constantly committing evil acts and throwing the world into chaos.

Boo
Ghosts so shy they freeze when someone looks at them.

Chain Chomp
Chained to a stake, they lunge at Mario and try to bite him.

Bob-omb
If someone steps on one, it will explode a few seconds later.

Morton
One of the seven Koopalings. He has the most massive body.

Dry Bones
Bony enemies that fall apart when jumped on.

Iggy
One of the seven Koopalings. He gets easily carried away.

Wendy O.
One of the seven Koopalings. She's a formidable and fashionable foe.

Larry
The leader of the seven Koopalings.

Lemmy
One of the seven Koopalings. Small in stature but skillful at balancing on a ball.

Shy Guy
So shy they all wear masks. They act differently depending on their color.

Ludwig von Koopa
One of the seven Koopalings. Intelligent, he likes standing out in a crowd.

Roy
One of the seven Koopalings. He's proud of the strength in his brawny body!

Princess Daisy
The young princess of Sarasaland. She was kidnapped by a baddie by the name of Tatanga.

Yoshi
A good friend of Mario's who lets the adventurers ride on his back. He can capture and eat enemies and fruits with his long tongue.

Monty Mole
They pop up from the ground to attack.

Luma
Stars who follow Rosalina. They come in several different colors.

Birdo
They shoot eggs out of their mouths.

Wario
Mario's childhood rival. He loves garlic.

Bowser Jr.
Bowser's son. He enlists his father's help to make trouble for Mario and his friends.

Rosalina
A mysterious woman who travels the galaxy. She also goes on adventures with Mario and his friends.

SUPER MARIO BROS.™

Package

Game Pak

Instruction Booklet

System: Nintendo Entertainment System

Release Date: October 18, 1985 (Japan: September 13, 1985)

No. of Players: 1–2

INTRODUCTION

STORY

*This text is taken directly from the instruction booklet.

One day the kingdom of the peaceful mushroom people was invaded by the Koopa, a tribe of turtles famous for their black magic. The quiet, peace-loving Mushroom People were turned into mere stones, bricks and even field horse-hair plants, and the Mushroom Kingdom fell into ruin.

The only one who can undo the magic spell on the Mushroom People and return them to their normal selves is the Princess Toadstool, the daughter of the Mushroom King. Unfortunately, she is presently in the hands of the great Koopa turtle king.

Mario, the hero of the story (maybe) hears about the Mushroom People's plight and sets out on a quest to free the Mushroom Princess from the evil Koopa and restore the fallen kingdom of the Mushroom People.

You are Mario! It's up to you to save the Mushroom People from the black magic of the Koopa!

FEATURES

THE GAME THAT STARTED IT ALL!

Super Mario Bros. is a side-scrolling 2D action game that was built to be played on the newly released NES game console. Afterward it became the foundation for the entire series. Part of the game's fun came from the fireworks, Warp Zones, and other hidden features that made it an enduring topic of discussion in schoolyards everywhere. It became a huge hit, selling a total of over forty million units and spreading the name Mario all over the world.

SUPER SIDE-SCROLLING ACTION!

Mario was originally "Jumpman," the hero of the arcade game *Donkey Kong. Super Mario Bros.* was built on the satisfaction the player got from successfully jumping over obstacles. At that time, the NES featured a lot of fixed-screen games. This game, however, had right-scrolling movement that progressed at the speed that Mario moved as he jumped and dashed his way toward the goal. This became the benchmark for all the side-scrolling action games that followed to this very day.

YOUR PICK OF POWER-UPS!

This game featured items that could power Mario up. Among other things, he can become giant-sized with a Magic Mushroom or pick a Fire Flower and become Fiery Mario. All kinds of items can give him unexpected abilities that aid him on his adventure. Fiery Mario's ability to defeat enemies by throwing fireballs inspired tons of new items that appeared in later installments!

CHARACTERS

PLAYER CHARACTERS

Twins Mario and Luigi set out on their adventure!

LUIGI
When there's a second player, they play as Mario's younger brother. He plays exactly the same as Mario.

MARIO
A single player takes the role of Mario. He sets off to rescue Princess Toadstool with his formidable jumping.

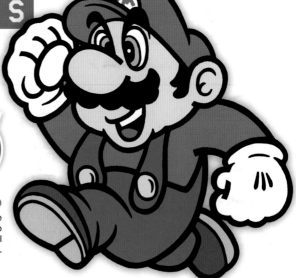

POWER-UPS

When you get ahold of these hidden items, you can gain all kinds of powers!

MARIO

This is Mario's form when he starts his adventure. If Mario's hit by an enemy, you'll lose a life.

SMALL LUIGI

SUPER MARIO ITEM → MAGIC MUSHROOM

Mario gets bigger and can take a hit without losing a life. It also allows him to break brick blocks.

SUPER LUIGI

FIERY MARIO ITEM → FIRE FLOWER

Mario can attack enemies by throwing fireballs. He can fire two fireballs at once.

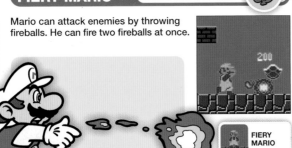

FIERY MARIO

FIERY LUIGI

INVINCIBLE MARIO ITEM → STARMAN

For a short while, Mario's body starts flashing colors, and he defeats any enemy just by touching them.

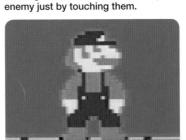

LUIGI

ENEMIES

These are the enemy characters Mario may face during his adventure. They were introduced in the original instruction booklet in a similar way.

BLOOBER
Chases stubbornly after Mario: a guy to look out for. You can't kill him by jumping on top of him.

BOWSER
The sorcerer king holding Princess Toadstool captive. He spits fire.

BULLET BILL
Chases after Mario slowly but steadily. You can kill him by jumping onto him from above.

BUZZY BEETLE
Quite the toughy, fireballs don't even faze him.

CHEEP-CHEEP (GRAY)
Moves like the red Cheep-Cheep but is a slower swimmer.

CHEEP-CHEEP (RED)
Usually found in the water, but also sprouts wings and flies. Can't be killed from above while she's in the water.

FAKE BOWSER
The boss waiting at the end of certain castles. Worlds 1–5 use fire; worlds 6–7 throw hammers.

HAMMER BROTHERS
These wily twin-brother turtles come at you throwing hammers.

KOOPA PARATROOPA (GREEN)
He wings around aimlessly and comes at you suddenly. Stomp on him and he loses his wings.

KOOPA PARATROOPA (RED)
This turtle is under control, but likes to take it easy. Stomp on him and he loses his wings.

KOOPA TROOPA (GREEN)
Soldier of the Turtle Empire, his orders are to find and destroy Mario. Jump on him and he stops moving for a while.

KOOPA TROOPA (RED)
This turtle is chicken! He gets scared and runs back and forth. Jump on him and he stops moving for a while.

LAKITU
The mysterious turtle who controls the clouds. He chases after Mario and drops Spiny's eggs on top of him.

LITTLE GOOMBA
A mushroom who betrayed the Mushroom Kingdom. One stomp and he dies.

PIRANA PLANT
Man-eating plants that live in flowerpots. They show their faces without warning. You can't kill them by jumping on them.

PODOBOO
Protector of the great sorcerer Koopa king, he comes flying out of the lake of fire inside the Koopa king's castle.

SPINY
Lakitu's pet, but a wild fighter. You can't kill him by jumping on top of him.

SPINY'S EGG
Eggs of the turtle Spiny, pet of Lakitu. You can't destroy them by jumping on them.

OTHER CHARACTERS

Citizens of the Mushroom Kingdom living under the domination of the Koopas.

PRINCESS TOADSTOOL
Princess of the Mushroom Kingdom, she is the only one who can break the spell of the evil Koopa king.

MUSHROOM RETAINERS
Seven Mushrooms who originally served in the court of Princess Toadstool, but are now under the spell of the evil Koopa king.

 WORLD

COURSES

Each of the eight worlds have four different courses, so thirty-two courses await our hero!

WORLD 1

W1-1

The iconic first course is aboveground. Get your power-ups and defeat the enemies.

W1-2

An underground course. The lines of brick blocks make the passageways narrower.

W1-3

A course that tests Mario's athleticism with lots of variable ground and moving platforms.

W1-4

The castle course has Fire Bar after Fire Bar, and at the end, a Fake Bowser awaits.

WORLD 2

W2-1

An aboveground course where the Green Koopa Paratroopas fly. Look for vines hidden in some of the blocks!

W2-2

An underwater course Mario swims through. Cheep-cheeps and Bloobers populate these waters.

W2-3

The Cheep-cheeps fly through the air around the broken bridge. Be sure you watch your footing!

W2-4

Podoboos appear here, shooting up out of the lava. Watch your timing as you go forward.

WORLD 3

W3-1

A nighttime, aboveground course. This is the first appearance of the Hammer Brothers, who try to block Mario's way.

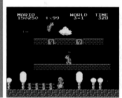

W3-2

Not a whole lot of traps, but enemy after enemy comes for Mario! Use a shell to clear enough of the enemies away at once and you can get a 1-Up!

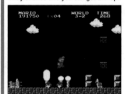

W3-3

A dynamic nighttime course with scales that add to the thrills!

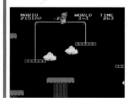

W3-4

Be careful of the Fire Bars that swing from above and below as Mario heads for the course's final battle.

WORLD 4

W4-1

A Lakitu streaks through the sky chasing Mario and throwing Spiny's eggs as he goes.

W4-2

An underground course with a lot of hidden items! Can you find the Warp Zones?

W4-3

Jump from mushroom to mushroom and balance the scales in this tricky course.

W4-4

This course has multiple paths, but if you choose the wrong one, Mario will be going in circles.

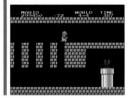

WORLD 5

W5-1

With lots of enemies heading toward Mario, use a shell and try for the 1-Ups! Bullet Bills also make their first appearance.

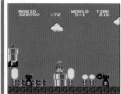

W5-2

Lots of Hammer Brothers attack Mario! It's got secret areas in the sea and sky, too.

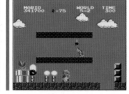

W5-3

The platforms are smaller than W1-3, and Bullet Bills fill the sky.

W5-4

It's the same layout as W2-4, but with a lot more Fire Bars.

WORLD 6

W6-1
Lakitu attacks in this nighttime course! Climb over the block mountains.
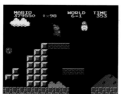

W6-2
This course has more pipes than normal, many of which hide secret areas inside.
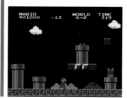

W6-3
Get your exercise on the white platforms! Look out for the Bullet Bills in the second half of the course.
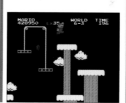

W6-4
The layout is the same as W1-4, but with a lot more Fire Bars and Podoboos.
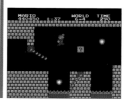

WORLD 7

W7-1
An aboveground course with all the Bill Blasters you'll ever want to see.

W7-2
A water course that looks a lot like W2-2, but with a lot more Bloobers.

W7-3
Get reacquainted with the remains of broken bridges and flying Cheep-cheeps. You'll also see Koopa Troopas and Koopa Paratroopas.

W7-4
A looping castle course. Choose between the divergent paths, but only one will get you to the end!
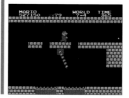

WORLD 8

W8-1
There's not much room to land during this long course. Don't take too long, though; time is counting down!
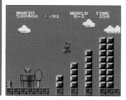

W8-2
The skies are filled with Lakitus ready to greet Mario. There are a lot of Bill Blasters in the way, too.
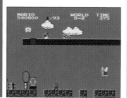

W8-3
With the castle's walls looming, Mario is right on the doorstep of Bowser's Castle! A gang of Hammer Brothers come to attack him.

W8-4
The final stage is Bowser's Castle. Mario can't go forward unless he goes into the right pipe.

ITEMS & OBSTACLES

You're going to find some useful items and hazardous obstacles while running through the courses.

? BLOCK
Hit them to get coins or power-ups to come out.

1-UP MUSHROOMS
This item gives you an extra life. They're often well-hidden in unexpected places.

10-COIN BLOCK
Hit it repeatedly to earn up to ten coins!

AXE
There's an axe on the bridge behind Bowser. Use it to drop the bridge and clear the course.

BILL BLASTER
Bill Blasters fire off Bullet Bills in Mario's direction.

BOWSER'S FLAMES
They appear in the second half of the castle courses. Avoid this extra obstacle!

BRICK BLOCK
They usually shatter when Super Mario hits them, but some contain hidden items.

COINS
Glittering all over the place in each course. If you can gather one hundred, Mario gets an extra life.

FIRE BAR
Rotating lines of fireballs that go clockwise or counterclockwise, and some are longer in length.

FIRE FLOWER
Power-up with one to turn Mario into Fiery Mario!

FLAGPOLE
The instant Mario grabs it, you've cleared the course! The higher you jump on, the more points you get.

HIDDEN BLOCK
There are invisible blocks hidden everywhere. Hit them, and they can give you coins and other items.

JUMPING BOARD
When Mario hops on, he bounces. If you time the jump well, he can jump even higher.

MAGIC MUSHROOM
With this, Mario is powered up to Super Mario!

PIPE
They come in many different lengths. They can also lead to hidden areas.

PLATFORM
Some move in one direction while others can travel back and forth.

SCALES
A set of platforms connected by a rope. When one goes down, the other goes up.

STARMAN
This power-up makes Mario invincible for a short time.

VINE
These can lead to a bonus area if Mario climbs them. You may also find warp zones with them.

WARP PIPE
These pipes are connected to Warp Zones. Mario can enter them to be whisked to another world.

AND MORE

MEMORABLE MOMENTS

Here are some scenes fans are sure to remember! These iconic places and moments set the standard for many adventures to come.

SECRET AREAS

Hidden among the pipes are ones that will lead Mario to a bonus areas filled with coins. Sometimes pipes will lead to water areas, and sometimes they're hidden shortcuts!

HIDDEN 1-UPS!

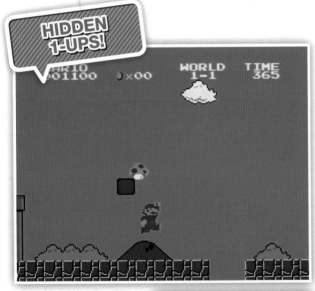

There's a hidden 1-Up Mushroom in the first area of each world, which can be quite difficult to obtain. If you use a warp to get to the world or lose all your lives and get a "Game Over," you won't be able to find the 1-Up Mushroom. There are also hidden conditions. For example, if you don't get a certain number of coins in the previous world's third course, the 1-Up Mushroom won't appear.

IMPOSTERS!

There's a Bowser at the end of every castle course, but the Bowsers in Worlds 1 through 7 are fakes! If Mario throws five fireballs at them, he can defeat them and reveal their true identity—there's a different imposter in each world.

CLIMB INTO THE CLOUDS!

There are vines hidden in World 2-1 and World 3-1 that Mario can use to climb into the clouds. These lead to bonus areas where Mario can ride a platform and collect coins. There are a total of five vines, but the one in World 4-2 leads to a Warp Zone.

HARD MODE

Once Mario rescues Princess Toadstool, you can begin a new adventure in Hard Mode. Goombas become Buzzy Beetles, all of the enemies move faster, and the platforms get smaller. All of this combined makes the game that much harder. Also, if you press the B Button on the title screen, you can choose between worlds.

HELPFUL HINTS & TECHNIQUES

There are many hidden components to this game. Here we discuss moves that were called "secret tricks" at the time.

THE WARP ZONE

There are two hidden areas where you can find Warp Pipes to places farther on in the game. The first is in World 1-2. If you run over the ceiling past the pipe that leads up to the goal, you'll reach the Warp Zone. There are three pipes warping to Worlds 2 through 4. Another is in World 4-2. If you run along above the ceiling, you can warp to World 5. If you find the hidden Warp Zone at the top of a hidden vine, you can get to Worlds 6 through 8.

A HANDY ELEVATOR

If you step on a Bullet Bill in World 6-3, it stops in mid-air. If you keep jumping on it, a line extends downward and it can be used like a down elevator.

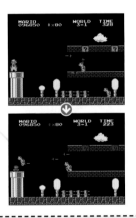

HAMMER BROTHERS ON THE MOVE

Hammer Brothers usually jump and throw their hammers from the same spot, but if you wait a while, they'll bring the fight to you.

FIREWORKS SHOW

When you finish the course and your time ends in a 1, 3, or 6, a matching number of fireworks go off.

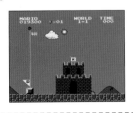

THE CROWN

If you have ten or more lives, the tens' spot is replaced by a crown.

A MIRACULOUS TRANSFORMATION

In levels like World 6-1, if you hit the bottom-left brick block from below, the Spiny transforms into a Koopa Troopa. In the same way, hitting the leftmost block in the middle of World 1-1, it transforms a Goomba into a Koopa Troopa.

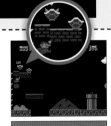

UNLIMITED 1-UPS

On the steps, if you keep jumping on a Koopa Troopa or Buzzy Beetle shell, you can get continuous 1-Ups. Try standing on a step, and when the shelled fiends are one step away, jump on them. If you can time it right, you can keep bouncing, getting yourself a series of 1-Ups. This is easiest on levels such as World 3-1 and World 7-1.

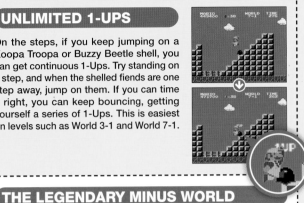

THE LEGENDARY MINUS WORLD

At the end of World 1-2, just before you reach the pipe that leads to the goal, break all but the rightmost brick blocks above the pipe, then push Mario backward at it. You'll pass through the wall arriving at the Warp Zone area. If you can get Mario into a pipe before the words appear, World -1 comes on the screen, and you enter an unusual water course—the legendary "Minus World." When using the Famicom Disk System version, the courses are different.

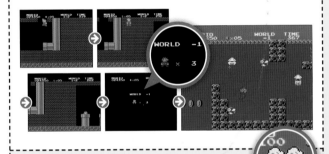

CLEVER GRAPHICS

The graphics for the clouds floating in the air and the bushes on the ground are the same graphic with the color changed. It was a clever trick that saved space on the highly limited capacity of the game's ROM chips.

CONTINUE

If you get a "Game Over" in World 2 or beyond, hold down "A" and you'll start back at the first course of that world.

SMALL FIERY MARIO

This is a little-known technique that allows you to shoot fireballs even when you're Small Mario. In W1-4, become Super Mario (or Fiery Mario) and allow Bowser to hit you when you hit the axe. Mario will become transparent when he rescues the Mushroom retainer. At the beginning of the next course, you'll appear as Super Mario, despite the fact Mario should be small. The game will spawn a Magic Mushroom, and when you pair it with a Fire Flower, you'll become a small version of Fiery Mario, growing briefly every time to attack. If Mario's hit by an enemy, he'll revert to Super Mario again.

スーパーマリオブラザーズ™ 2

Package

Disk

Instruction Booklet

System: Famicom
Disk System

Release Date:
Japan: June 3, 1986
Player Count: 1

★ INTRODUCTION

S T O R Y
*This text is translated from the Japanese instruction booklet.

The Mushroom Kingdom was a peaceful place until the day that Bowser used his powerful magic and invaded, along with his clan of huge turtles. Bowser's magic turned the harmless mushroom people into rocks, bricks, and plants, and the Mushroom Kingdom fell into ruin.

The only one who can break the magic spell and revive the mushroom people is the Mushroom Kingdom's Princess Toadstool, but she's now a prisoner of the Koopa king.

But Mario has stood up and raised his hand, ready to defeat the members of the turtle clan, rescue Princess Peach, and once again restore peace to the Mushroom Kingdom.

The Mario you see on TV is you. You are the only one who can complete this quest!

F E A T U R E S

THE LOST LEVELS

Released in Japan in 1986, this game was the second installment of the *Super Mario* series. American audiences did get to experience an updated version of this game with the 1993 release of *Super Mario All-Stars* for the SNES, although that version featured improved graphics and gameplay. An unmodified release didn't occur in America until 2014, when the game was released for the Wii U Virtual Console in its original form. For these reasons, we've left the images and details in this section true to the original Japanese release, save for one thing—we've kept the American title *Super Mario Bros.: The Lost Levels* to avoid confusion with what we know as *Super Mario Bros. 2*.

FOR SUPER PLAYERS!

In Japan, this was the second side-scrolling 2D action game in the Mario series, this time made for the Famicom Disk System game console. The "For Super Players" sticker on the cover meant it was designed for those gamers who had already played *Super Mario Bros.* all the way through; it's definitely more difficult than the previous game. The basic system is the same, but now Poisonous Mushrooms hurt Mario if he touches them, and strong winds can blow him off course—just two of the many difficult new tricks and traps. As long as you fulfill all the conditions, you can play a total of fifty-two courses.

A SINGLE PLAYER GAME

Unlike the original game where two players could take turns playing as Mario and Luigi, in this game a single player can choose to play as Mario or Luigi. The two have different abilities: for example, Luigi jumps higher than Mario, but he can't stop as well as Mario can. This is the first time that Luigi had different gameplay mechanics than Mario, and those characteristics are reflected in most of the games that came after.

 # CHARACTERS

PLAYER CHARACTERS

Choose between the two brothers to start your adventure! In this game, they have different characteristics.

LUIGI
He can jump higher than Mario but slides farther.

MARIO
As he did last time, he uses jumps and dashes to rescue Princess Toadstool.

POWER-UPS

These items can transform Mario and Luigi with their power!

MARIO

This is Mario's state when the game begins. He can't break brick blocks, and if he's hit by an enemy, you lose a life.

 LUIGI

SUPER MARIO ITEM ⬢ MAGIC MUSHROOM

Mario can destroy brick blocks now. Since he's bigger, he has to duck to get through tight spaces.

 SUPER LUIGI

FIERY MARIO ITEM ⬢ FIRE FLOWER

He can attack by throwing fireballs, although there are some enemies who aren't affected by this attack.

 FIERY MARIO

FIERY LUIGI

INVINCIBLE MARIO ITEM ⬢ STARMAN

For a short time, Mario's body starts glowing and he can defeat any enemy just by touching them.

 INVINCIBLE LUIGI

OTHER CHARACTERS

Mario is trying to save these citizens of the Mushroom Kingdom.

PRINCESS TOADSTOOL
Princess of the Mushroom Kingdom. She has been captured by Bowser.

MUSHROOM RETAINERS
They served Princess Toadstool, but they've been taken hostage.

E N E M I E S

These enemies appear throughout the game. Some, like the Sky Bloobers, appear here for the first time. The items below are based on those found in the *Super Mario Bros.* manual.

BLOOBER

He undulates up and down in the water and chases after Mario.

BOWSER

The Koopa King awaits Mario in the final castle. He attacks with fire and hammers.

BULLET BILL

Flies straight. Some are fired out of Bill Blasters.

BUZZY BEETLE

Fireballs have no effect, but if Mario steps on them, they hide in their shell for a while.

CHEEP-CHEEP (GRAY)

A gray-colored Cheep-cheep in water courses. They swim slower than the red kind.

CHEEP-CHEEP (RED)

Some swim straight through the water. Others swim back and forth.

FAKE BOWSER

They attack with fire or hammers. When defeated, they show who they really are.

FAKE BOWSER (BLUE)

Fake Bowsers with blue bodies. They are found in three places and attack with fire and hammers.

HAMMER BROTHERS

They attack by throwing hammers and sometimes advance toward Mario.

KOOPA PARATROOPA (GREEN)

They sometimes advance in big bounding leaps from the ground, or fly right and left in one spot.

KOOPA PARATROOPA (RED)

These winged Koopa Troopas fly through the sky.

KOOPA TROOPA (GREEN)

He walks straight off cliffs and goes into his shell for a while when jumped on.

KOOPA TROOPA (RED)

A soldier in the Koopa forces. He turns back when he comes to a cliff.

LAKITU

Moving through the sky, he drops Spiny's eggs. He can get close to the ground, too.

LITTLE GOOMBA

A traitor to the Mushroom Kingdom. He walks in a straight line.

PIRANA PLANT

These plants pop up out of pipes. They don't appear if Mario is right next to the pipe.

PIRANA PLANT (RED)

Frightening flora that appear even when Mario's next to the pipe.

PODOBOO

Glowing red fireballs that fly out of lava. They protect Bowser.

SKY BLOOBER

Pink Bloobers who bob and weave in the sky. Jump on them to defeat them.

SPINY

The spines on his shell prevent Mario from jumping on him.

SPINY'S EGG

Lakitu throws these. They become Spinies when they hit the ground.

⭐ WORLD

COURSES

There's a wider range of courses than before, totaling fifty-two. You must fulfill certain conditions before you can reach World 9 or the lettered Worlds A-D.

W1-1
The first aboveground course. This is the first appearance of Poisonous Mushrooms.

W1-2
An underground course made up of pipes, platforms, and narrow landing spots.

W1-3
An athletic-style course through the air, with Sky Bloobers floating around.

W1-4
A Fake Bowser's castle. There are a lot of Fire Bars, but the only enemies are Koopa Troopas.

WORLD 2

W2-1
A seaside course. Use the Jumping board to cross the ponds.

W2-2
An aboveground course with a lot of Koopa Troopas. Use hidden blocks to get across.

W2-3
The Cheep-cheeps fly through the air near pieces of broken bridges. Koopa Paratroopas are also in the way.

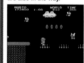

W2-4
Koopa Troopas and Fire Bars try to block Mario's way through the narrow passages.

WORLD 3

W3-1
An aboveground course with a lot of pipes. There's a Warp Pipe back to W1 in there, too.

W3-2
A water course, but not just with Bloobers and Cheep-cheeps—Koopa Troopas, too.

W3-3
An athletic course that involves jumping on platforms and utilizing Scales and Jumping boards.

W3-4
The road splits, and Mario can only move forward if you choose the correct path.

WORLD 4

W4-1
Be careful of the Lakitus and Red Pirana Plants as you try to get past the pipe area.

W4-2
Bullet Bills, Lakitus, Hammer Brothers and more! A lot of enemies appear in this course.

W4-3
An athletic course using scales. Watch out for the Bullet Bills in the second half.

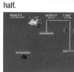

W4-4
A course with narrow passages and enemies awaiting you.

WORLD 5

W5-1
An aboveground course with strong winds. Get past dead ends by discovering hidden blocks.

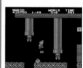

W5-2
An underground course. Red Pirana Plants lurk in pipes, blocking the way.

W5-3
If you don't choose the right pipe, Mario will be caught in a loop.

W5-4
Small blocks suspended above lava line the path. Watch out for the Fire Bars, too!

WORLD 6

W6-1
The wind blows Mario forward as he jumps from platform to platform.

W6-2
This water course is lined with coral reefs above and below.

W6-3
Cheep-cheeps fly through the sky as Mario jumps between pieces of broken bridges.

W6-4
A loop course. Choose your path wisely to avoid enemies and traps.

WORLD 7

W7-1
Not only does the wind blow Mario around, but Cheep-cheeps and Bullet Bills fly in his direction.

W7-2
This course is divided into two areas. Choose the correct pipe to move onwards.

W7-3
Small platforms to land on, and powerful Jumping boards to lift Mario up.

W7-4
A castle course with narrow passageways blocked by Fire Bars.

WORLD 8

W8-1
Get past wide valleys by jumping on Koopa Paratroopas. There's a hidden warp here, too.

W8-2
Find the vines and make for the hidden goal.

W8-3
A course above the clouds. Hammer Brothers attack, one after the next.

W8-4
A course divided into a number of areas. Find the pipes to keep going.

WORLD 9

W9-1
At first you think this odd course is aboveground, but you learn it's actually underwater!

W9-2
There are a lot of pipes, and Lakitus come to attack Mario as he swims through this course.

W9-3
An open-air castle with wind. The only enemies are Blue Bowsers!

W9-4
A vast collection of enemies reside here! The rocks spell out "Thank You" in Japanese.

28

WA-1
The start of a parallel world. There are a lot of Turtle Tribe enemies such as Koopa Troopas.

WA-2
Thin passageways filled with Hammer Brothers and Bullet Bills.

WA-3
A course in the clouds. The strong winds blow Mario right into the flying Cheep-cheeps.

WA-4
A complex course with treacherous footing and flying Bullet Bills.

WB-1
An aboveground course with platforms made of blocks. Plenty of hidden items here.

WB-2
A water course with a lot of coins protected by Koopa Troopas and Koopa Paratroopas.

WB-3
A tricky course where Mario has to make long jumps to and from narrow landing spots.

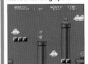

WB-4
It seems like this course has Mario caught in a loop . . . but entering pipes sends him back.

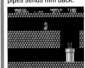

WC-1
Countless pipes stick up and hang down. It's a concentrated mass of Red Pirana Plants.

WC-2
An athletic course with Cheep-cheeps in the first half, traded for Bullet Bills in the second.

WC-3
A course much like W7-2, but here Mario's chased by Lakitus and blown by the wind.

WC-4
A course like 7-4, but there are very few safe areas here.

WD-1
An aboveground course which will test your techniques for both jumping and defeating enemies.

WD-2
Jumping boards help Mario get across the wide lake just in front of the goal.

WD-3
Bullet Bills are set up in sequence and Hammer Brothers attack!

WD-4
It starts in a castle, but then leads aboveground and underground until the final battle.

ITEMS & OBSTACLES

These are some of the items that appear on the courses. Some of these creatures and traps are mean, like Poisonous Mushrooms and wind.

? BLOCK
When Mario hits them, coins or items come out. Poisonous Mushrooms come out, too.

1-UP MUSHROOM
They give you an extra life. Their color changes underground.

10-COIN BLOCK
A block that yields up to ten coins.

AXE
These are set at the very end of castle courses. Trigger it to clear the course!

BILL BLASTER
The cannons that fire off Bullet Bills. You can find these underground and in castles now.

BOWSER'S FLAMES
They come flying in Mario's direction in the second half of the castle courses.

BRICK BLOCK
Small Mario can't break these. Sometimes items can come out of them.

COINS
Set all along the course. Some come out of blocks. Get one hundred for a 1-Up.

FIRE BAR
Straight lines of fire that spin. Some are longer in length, and some can spin faster.

FIRE FLOWER
This power-up turns Mario into Fiery Mario!

FLAGPOLE
The instant Mario touches it, you've cleared the course! Sometimes it's even found underwater.

HIDDEN BLOCK
You think there's nothing there, but a block appears when Mario hits them. He can stand on them, too.

JUMPING BOARD
When Mario gets on, he bounces. If you time the jump well, he can spring really high.

MAGIC MUSHROOM
Power up to Super Mario with this! Unlike the last game, it now has a face.

PIPE
Pipes usually house Pirana Plants, but some transport Mario to a new area. Pipes hang from the ceiling, too.

PLATFORM
They move on a set path, and some fall when Mario gets on them. Some can also be found underwater.

POISONOUS MUSHROOM
Touching one damages Mario. Underground, they appear blue.

SCALES
Standing on one weighs it down while raising the other. Linger too long and the ends fall off!

STARMAN
This power-up makes Mario invincible for a short time.

SUPER SPRING
A well-timed jump on one of these can spring Mario off the top of the screen.

VINE
Vines grow from certain blocks. Mario can climb them to reach a new area.

WIND
In certain places during the courses, strong winds push Mario's body forward.

MEMORABLE MOMENTS

This game was filled with memorable scenes— some even appeared for the first time in this game! You'll also learn how to reach parallel worlds.

BEWARE THE POISONOUS MUSHROOM

This dangerous mushroom is hidden in ? Blocks and can cause damage if Mario touches it. Additionally, it looks different underground than it does above ground. In the underground courses, the Poisonous Mushroom can be easily mistaken for a 1-Up Mushroom. Because the Poisonous Mushroom is an item, it will disappear when you produce another item.

FLYING BLOOBERS

Bloobers usually chase Mario when he's swimming through the water, but in this game, they appear in aboveground courses. They chase Mario through the air in just the same way that they do in the water. In this case, you can defeat them by jumping on them, so they're much easier to deal with.

RED PIRANA PLANTS

Red Pirana Plants appear for the first time in this game! Even when Mario is standing right next to the pipe, they still appear, so they're a bit more troublesome an enemy to deal with. Now, these red-colored enemies have become commonplace in the *Super Mario* series.

THE MYSTERIOUS BLUE BOWSERS!

Just before the final battle with Bowser in W8-4, Mario fights a Bowser with a blue body. Mario also encounters Blue Bowsers in W9-3 and WD-4. Whatever they are, they have the same powers as Bowser, but their real identities are a mystery . . .

VERY RARE WORLDS!

There are thirty-two courses between W1 and W8, and if you clear them all without warping (or going back in a warp), you can go to W9 after the ending is over. One course looks like it's aboveground, but it's actually underwater. In fact, most of them have a motif of courses from the previous game, the original *Super Mario Bros.*, but gone a bit buggy. You start with Mario having only one life left, and if you make it all the way through, you get an onscreen message from the staff!

A PARALLEL WORLD

After clearing course W8-4 and returning to the title screen, you'll see a number of stars to the upper-right of the logo. If there are more than eight stars, you can take up the challenge of a parallel world (WA through WD) by pressing the Start Button while holding down the A Button. By the way, even if you collect more than twenty-four stars, the number by the logo won't go over twenty-four.

HELPFUL HINTS & TECHNIQUES

These useful tips will help you make it through this difficult game. Additionally, things have changed between this and the last game.

CONSECUTIVE 1-UPS

As in the first game, you can put a shell between two blocks (or other obstacles) to get a 1-Up. If you use the Red Koopa Troopa right after starting, the rest of your Mario adventure will be much less stressful.

THESE BLOCKS ARE A BREEZE

If you place Mario on top of blocks when the wind blows, and repeatedly press the left button on the +Control Pad, Mario can enter the blocks and go through them. Depending on where you are, this can be very helpful.

BEYOND THE FLAGPOLE!

Getting beyond the flagpole was really hard in the previous game, but in this one, it's really easy! Luigi can jump over the pole with ease, and Mario can, too, by using the Super Spring or Hidden Blocks. There are even Warp Zones beyond the pole!

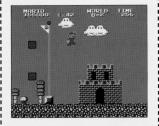

THE REVERSE WARP ZONE

Most Warp Zones send Mario forward to new worlds, but there are a few reverse Warp Zones that send him back to earlier worlds. A warp in W3-1 will send him back to W1-1, and one in W8-1 will take him back to 5-1. Be careful!

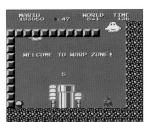

1-UP AT THE FLAGPOLE

When you reach the flagpole, if the number of coins on your counter has matching numbers, and if the last digit of the timer also matches that number when Mario grabs the pole, then you get a 1-Up. As a bonus, the fireworks also go off!

THE HAMMER THAT DOESN'T HURT

If Mario is all the way to the left side of the screen, the hammers might hit him, but they don't do any damage (but a tackle by the Hammer Brothers will hurt).

HARD-TO-DETECT WARP ZONES

There are normal Warp Zones in this game, but compared to the previous game, they're harder to find. Course W1-2 has a Warp Zone that sends Mario to W2, W3, and W4, but they're all hidden separately. There's also a warp in W5-1 that goes to W6, but the Warp Pipes that go to W7 and W8 are found in W5-2 (all hidden, too). A Warp Zone in WA-2 goes to WB, one in WA-3 goes to WC, and one in WB-4 warps to WD. But there are also reverse warps, so watch out!

FIREWORKS SHOW REDUX

Upon reaching the flagpole, if the last digit of your accumulated coins matches the last digit of the timer, fireworks are sent up. If the matching numbers are odd, three fireworks go up. If the matching numbers are even, six fireworks go up.

TIGHT SPACES

If the far-left side of the screen has a wall (or blocks or pipes) with just enough space for Mario to get in between, Mario gets pulled in. By jumping, you can move Mario upward, and if there's a ceiling, pressing and holding left on the +Control Pad while doing a number of jumps will reveal that he can pass right through the wall.

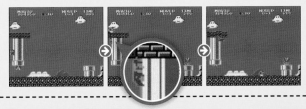

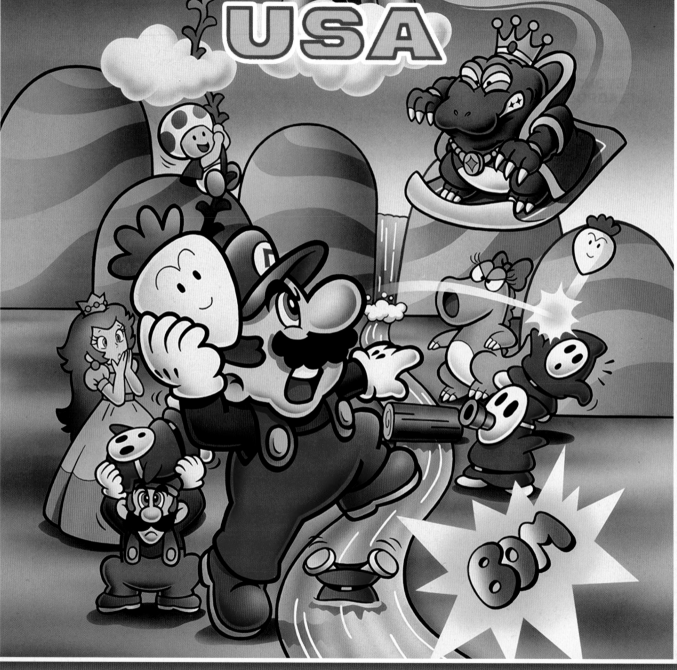

スーパーマリオ®

SUPER MARIO™
USA

Package

Game Pak

Instruction Booklet

System: Nintendo Entertainment System
Release Date: October 9, 1988 (Japan: September 14, 1992)
Player Count: 1

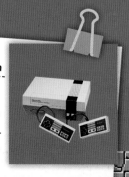

INTRODUCTION

S T O R Y
*This text is taken directly from the instruction booklet.

One evening, Mario had a strange dream. He dreamt of a long, long stairway leading up to a door. As soon as the door opened, he was confronted with a world he had never seen before spreading out as far as his eyes could see. When he strained his ears to listen, he heard a faint voice saying "Welcome to 'Subcon,' the land of dreams. We have been cursed by Wart and we are completely under his evil spell. We have been awaiting your arrival. Please defeat Wart and return Subcon to its natural state. The curse Wart has put on you in the real world will not have any effect upon you here. Remember, Wart hates vegetables. Please help us!" At the same time this was heard, a bolt of lightning flashed before Mario's eyes. Stunned, Mario lost his footing and tumbled upside down. He awoke with a start to find himself

sitting up in his bed. To clear his head, Mario talked to Luigi, Toad, and Princess about the strange dream he had. They decide to go to a nearby mountain for a picnic. After arriving at the picnic area and looking at the scenery, they see a small cave nearby. When they enter this cave, to their great surprise, there's a stairway leading up, up and up. It is exactly like the one Mario saw in his dream. They all walk together up the stairs and at the top, find a door just like the one in Mario's dream. When Mario and his friends, in fear, open the door, to their surprise, the world that he saw in his dream spreads out before them!

F E A T U R E S

HARVESTING ACTION!

This 2D side-scrolling action game takes place in the rich dream world called Subcon. The world-view and system are a little different from the standard *Super Mario Bros.* game, and this title acts as a kind of side-story. The action of this game comes from rooting out both enemies and vegetables in a "harvesting action game." You can't jump on enemies to defeat them in this game—instead, you harvest vegetables and use them to attack. This game also introduces a life system different from the other 2D scrolling action games.

THE FOUR MAIN CHARACTERS

Four characters share in this adventure! Mario, Luigi, Princess Toadstool, and Toad each have different rates of dashing, jumping, carrying, and pulling. Since you can choose your character at the beginning of each course, you can choose the character best suited to face each particular obstacle and enemy.

SUPER MARIO USA

Released in 1988 for the Nintendo Entertainment System, *Super Mario Bros. 2* was based on the game *Yume Kojo Doki-Doki Panic* ("Dream Factory Heart-Racing Panic"). This was the second game in the Super Mario series for American audiences, but in Japan, it was the sixth. After becoming massively popular in the US, it was finally reverse-imported to Japan in 1992. However, as there was already a game entitled *Super Mario Bros. 2* in Japan—what we know as *Super Mario Bros.: The Lost Levels*—this game was released as *Super Mario USA*.

CHARACTERS

P L A Y E R C H A R A C T E R S

You can choose from a cast of four player characters, each with different abilities: jumping strength, pulling strength, carrying strength, and dash speed.

MARIO

He has average abilities all around. If he's carrying something, he's not able to jump as high as he normally would.

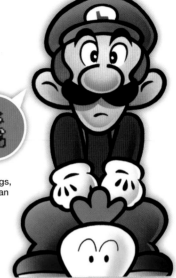

LUIGI

When he pumps his legs, he can jump farther than everyone else, but his dashing and carrying powers are weak.

O T H E R C H A R A C T E R S

Other characters who become Mario's allies.

PRINCESS TOADSTOOL

She's rated the lowest when it comes to her carrying power and dash speed, but she can stay afloat in midair for a few seconds.

Residents of the dream kingdom that have been captured by Wart.

P O W E R - U P S

Unlike in other games in this series, no power-up can give Mario or his friends extra abilities or a fresh, new look. However, their appearances do change depending on how many lives they have.

TOAD

He picks items up and dashes faster than the rest—even when carrying an item—but he can't jump very high.

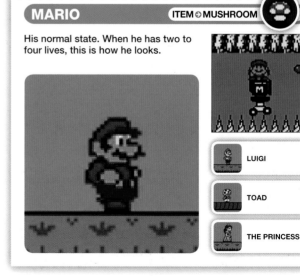

MARIO ITEM → MUSHROOM

His normal state. When he has two to four lives, this is how he looks.

LUIGI

TOAD

THE PRINCESS

SMALL MARIO

With just one life left, Mario shrinks! He still has the same abilities, but if he's injured or bumps into an enemy just one more time, you lose the game.

SMALL MARIO

SMALL LUIGI

SMALL TOAD

SMALL PRINCESS

INVINCIBLE MARIO ITEM→STARMAN ⭐

For a limited time, Mario becomes invincible. He can defeat any enemy just by knocking into them.

INVINCIBLE LUIGI

INVINCIBLE TOAD

INVINCIBLE PRINCESS

E N E M I E S

Mario may cross paths with these enemies during a course. While several of these enemies go on to make appearances in other titles, for some, it's the only time they're seen on-screen.

ALBATOSS
By order of Wart, some of these birds work as Bob-omb carriers. Others are just aerial nuisances.

AUTOBOMB
Shyguy's favorite ride. It is also referred to as a "bad dream machine" and shoots fireballs in Mario's direction.

BEEZO
It attacks by flying in a straight, horizontal line. These flying creatures can be gray or green.

BEEZO (RED)
These foes resemble Shyguys with wings, and attack by dive-bombing Mario.

BIRDO
This one spits out fire, not eggs, and can also be green, depending on the course.

BIRDO (PINK)
The pink-bodied Birdo waits for Mario at the end of certain courses and attacks by shooting eggs from its mouth.

BIRDO (RED)
The red-bodied Birdo spits out a mix of eggs and fire.

BOB-OMB
This hothead has a terrible temper. He chases Mario and, after a while, explodes.

CLAWGRIP
This crab is the boss of W5 and is surprisingly skilled at throwing rocks.

COBRAT
This snake lies in wait in the sand or in vases, but when Mario approaches, he bursts out and launches a projectile.

FLURRY
This snow monster chases after Mario on the ice.

FRYGUY
Created by Wart, this fire entity is the boss of W4. He flies around spitting fireballs.

HOOPSTER
A basketball-sized creature that resembles a ladybug. He lives on vines, crawling up and down and blocking the way.

MASK GATE
Usually a helpful tool, this bird-shaped gate can sometimes attack.

MOUSER
This prideful mouse is the boss of W1 and W3. He attacks by throwing lots of bombs.

NINJI 1
This fast-moving little devil persistently chases Mario.

INTRODUCTION CHARACTERS WORLD AND MORE

NINJI 2

This curious creature stays in one spot and jumps up and down repeatedly. A strange guy.

OSTRO

This creature serves as a means of transportation in the world of dreams. Shyguys often ride him.

PANSER (GRAY)

The only plant life Wart created for the world of dreams. It moves around spouting fire.

PANSER (PINK)

This version chases Mario, fireballs erupting from its petals. It'll continue moving even if it reaches a ledge.

PANSER (RED)

This stationary version shoots its fireballs at Mario in a very high arc.

PHANTO

Normally dormant, this phantom mask guards keys. If Mario takes a key, it stirs and pursues him relentlessly.

PIDGIT

This raven-like creature can't fly on its own, so Wart gave it a flying carpet. Mario can steal the carpet.

POKEY

This walking cactus is covered in thorns. Watch out! Those thorns hurt!

PORCUPO

His body is entirely covered with spines, so Mario can't climb on his back.

SHYGUY (PINK)

This foe moves back and forth on the hills, turning around when he encounters an obstacle.

SHYGUY (RED)

This little fellow wears a mask because he's shy. If he reaches a ledge, he just keeps on walking.

SNIFIT (GRAY)

These creatures wear masks and jump before spitting a bullet. Learn the timing of the bullets to avoid them.

SNIFIT (PINK)

They move back and forth on the hills, turning around when encountering an obstacle.

SNIFIT (RED)

They shoot bullets as they move across the course. Even if they encounter a ledge, they keep walking.

SPARK

It moves in a circular motion around walls and floors. Some move fast, others slow.

TROUTER

This jumping fish can be found in rivers and waterfalls. It interferes with Mario, but can also help him cross water.

TRYCLYDE

The fireball-spitting boss of W2 and W6. Tryclyde's cunning and offensive capabilities are three times normal strength.

TWEETER

This mask-wearing bird has wings, but moves in short hops. Try to get on top of its head.

WART

This W7 boss attacks by opening his huge mouth and firing bubbles. He hates vegetables.

WORLD

C O U R S E S

There are seven worlds with a total of twenty courses waiting for you. The courses are long and have no time limits, so feel free to stroll along at your leisure!

WORLD 1

W1-1
This course takes place in a grassland with high hills. The second half of the course includes a mountain so high that it goes above the clouds.

W1-2
Mario crosses the huge valley on a Pidgit's flying carpet. A cave awaits him beyond the Mask Gate.

W1-3
The floating logs and Trouters can be used to cross the waterfalls. Once inside the building, go up to search for the key.

WORLD 2

W2-1
A desert course. Once inside the pyramid, dig up the sand to head underground.

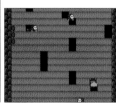

W2-2
A desert course studded with Cobrat vases. More digging is required in the second half.

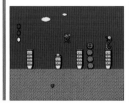

W2-3
Red Beezos zip through the sky in this desert course. Inside the pyramid, dig through the sand to find the key.

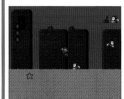

WORLD 3

W3-1
Jump from cloud to cloud, up the waterfall and into the sky. Once above the clouds, Gray Pansers block the way.

W3-2
This course is set both above and underground. Use the ladders to move underground and advance.

W3-3
This course is made up of many interconnected rooms. Choose the doors wisely to move along.

WORLD 4

W4-1
Flurries run around above the water. There is no boss in this course—just the hordes of enemies as Mario tries to move forward.

W4-2
In the first half, Pink Beezos swarm the screen. In the second half, a pod of friendly whales creates a path made up of water spouts.

W4-3
Mario flies over the sea on a Birdo's egg, then must scale the treacherous, slippery ice tower.

WORLD 5

W5-1
A waterfall flows inside this cave. Mario must use the logs and Trouters to get across.

W5-2
Ostros run around this nighttime grassland. Up in the trees, Hoopsters move up and down the vines.

W5-3
Flights of Albatosses come to drop a barrage of Bob-ombs. In the second half, Mario makes his way through an enormous tree.

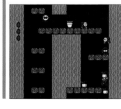

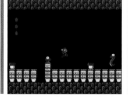
WORLD 6

W6-1
A desert region with a lot of quicksand. A key can be found inside one of the numerous vases.

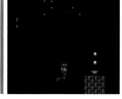

W6-2
An Albatoss provides passage across the vast open sky. Other Albatosses and Beezos try to hinder Mario's progress.

W6-3
A desert cave with lots of Bob-ombs. Hoopster-laden vines lead up into the sky.

W7-1

This course is set in the world above the clouds. Jump from cloud to cloud, heading for the Snifit palace.

W7-2

An enormous Snifit palace. Mini bosses are lurking in several different places.

ITEMS & OBSTACLES

Here's a list of handy items, tools, and other interesting things that appear during this adventure. Since there aren't a lot of power-ups in this game, skillful use of the items and other features is crucial.

1-UP MUSHROOM

When a 1-Up Mushroom appears, Mario gets an extra life!

BOMB

A few seconds after they are picked up, they flicker and explode. They can be used to destroy walls or defeat enemies.

BONES

These remains sometimes come in handy as stable footing. Other times, they are swept away by the sand.

BRICK WALLS

They're blocking the way. A well-timed bomb blast or an exploding Bob-omb will open up the passage.

CHAINS

Grab on and climb up or down.

CHERRIES

Collect five cherries to earn a Starman.

COINS

Using the coins collected in Sub-Space, try your luck on the Bonus Game to win extra lives.

CONVEYERS

Get on, and Mario is automatically sent in one direction. There are left-moving types and right-moving types.

CRYSTAL BALL

Birdo spits these out upon defeat. Sometimes they're just left on a pedestal.

GRASS

Found here and there on every course. Harvest it to find items.

KEY

Mario needs this to open locked doors. His running speed does not change even if he is carrying a key.

LADDER

Grab on to one to climb up or down. They may be connected to a different area.

LOCKED DOORS

Mario can't open these doors unless he is holding the key.

LOG

They appear falling down with the flow of a waterfall. Mario can use them to get across.

MAGIC POTION

Throw a magic potion and a door appears. Going through the door will take Mario to Sub-Space.

MASK GATE

Pick up a crystal in order to pass through the gate. Entering usually means you've cleared the course.

MUSHROOM BLOCKS

They can be used as steps and for attacking the enemy.

MUSHROOMS

These appear when you warp to Sub-Space at a certain spot. At full health, Mario's life meter increases by one.

POW BLOCK

When Mario throws this, the earth shakes and all on-screen enemies are defeated.

QUICKSAND

If Mario steps in it, his body starts to sink little by little. One type of sand has a much faster flow.

ROCKET

They sometimes appear when harvesting grass. Mario automatically boards it and blasts off to a new area.

SAND

Pyramids and desert courses feature lots of sand. Mario can dig down through it.

SMALL HEART

This item appears when eight enemies have been defeated. The life meter recovers by one.

SMALL VASE

These pots produce enemies, one after the next. Mario can't go inside them.

SPIKES

If Mario touches these, he takes damage. He can ride enemies, like Shyguys, to make his way across.

STARMAN

A Starman will appear when Mario collects five cherries. Grab it to become invincible for a short time.

STOPWATCH

This handy item appears when five ripe vegetables have been picked. It freezes enemies for a short time.

TURTLE SHELLS

When thrown, they skim along the ground and hit anything in their path.

UNRIPE VEGETABLES

They are not fully grown, but can still be used to defeat enemies.

VASE

Mario can enter these, although some of them house Cobrats.

VEGETABLES

Ripe vegetables. If Mario harvests five, a stopwatch appears.

VINES

Mario can climb up or down vines. Hoopsters sometimes live on them, blocking the way.

WHALES

They live in the water and Mario can walk on their backs. Every now and then they spout water.

AND MORE

This game is quite different from all other games in this series. Here are several notable scenes to illustrate why.

MUSHROOMS IN SUB-SPACE!

When Mario throws a magic potion and creates a door, he enters Sub-Space, a dark, mirrored version of the dream world. Coins and 1-Up Mushrooms can be found there. The location of mushrooms is predetermined, so you have to be clever about where to open the door. By the way, the background music in Sub-Space is the same as the standard above-ground music in *Super Mario Bros.*

POW PACKS A PUNCH!

The POW Block, which made its appearance in the NES version of *Super Mario Bros.*, reappears here as a usable item. It hasn't changed much—it still takes out all the on-screen enemies in a single blow. It later reappears in *New Super Mario Bros. 2*, *Super Mario 3D World*, and many others.

PLAY THE SLOT MACHINE!

After clearing a course, you can use the coins you've collected in Sub-Space to play the slot machine. With the proper combinations, you earn bonus lives.

THE WINNER IS...

At the end of the game, you can see how many courses each character cleared. The one with the most courses is crowned the biggest "Contributor"!

JUST A DREAM?

After the game's end, all of a sudden you see Mario asleep in bed. It's possible that the dream country, Subcon, has all just been a part of Mario's dream.

HELPFUL HINTS & TECHNIQUES

Here are some helpful techniques to use during this unique adventure! In particular, this game has a very distinctive warping method. Although you can warp throughout the series, the technique for this game is completely its own.

A WARP ZONE . . . IN A VASE?

Certain vases send Mario to Sub-Space, then warp him. A vase in W1-3 sends him to W4; W3-1 sends him to W5; W4-2 sends him to W6; and W5-3 sends him to W7. It's possible to warp in those four locations.

SELF-DESTRUCT!

When Mario's in his victory pose, grab controller two and press up on the +Control Pad, A, and B Buttons all at the same time. As a result, you'll lose all your remaining lives. There are times when you find you're stuck in a course and can't advance, but this method is useful when you want to start the game over completely from the beginning.

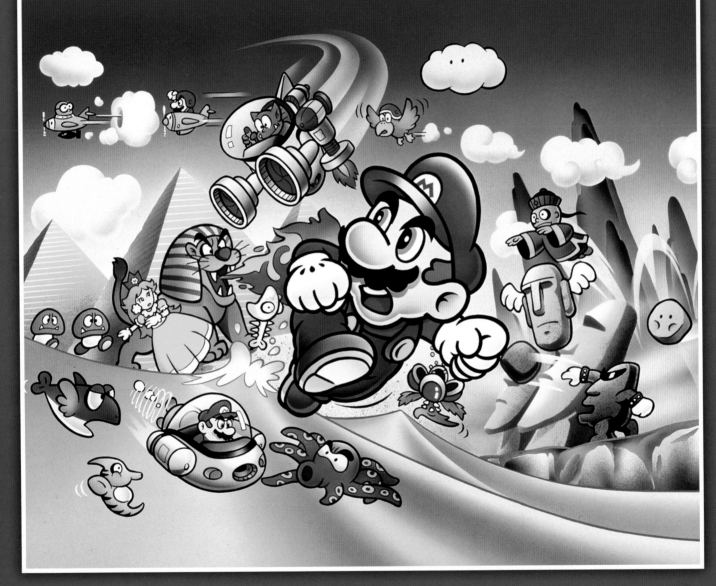

SUPER MARIOLAND ™

Package

Game Pak

Instruction Booklet

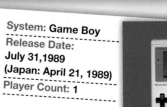

System: Game Boy

Release Date:
July 31,1989
(Japan: April 21, 1989)

Player Count: 1

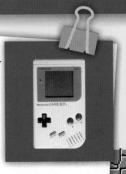

INTRODUCTION

S T O R Y

*This text is taken directly from the instruction booklet.

Once upon a time, there was a peaceful world called Sarasaland. In this world there were four kingdoms named Birabuto, Muda, Easton, and Chai. One day, the skies of Sarasaland were suddenly covered by a huge black cloud. From a crack in this cloud, the unknown space monster Tatanga emerged to try to conquer Sarasaland. Tatanga hypnotized the people of all the kingdoms so that he could control them in any way he liked. In this way he took over Sarasaland. Now, he wants to marry Princess Daisy of Sarasaland and make her his queen.

Mario came to know of these events, and has started on a journey to the Chai Kingdom where Princess Daisy is held captive, in order to restore peace to Sarasaland.

Can Mario defeat Tatanga, release the people from his interstellar hypnosis, and rescue Princess Daisy? It's all up to you and Mario's skill. Go for it, Mario!!

F E A T U R E S

HANDHELD GAMING

This game was released as a launch title for the Game Boy, and it was the first handheld Super Mario game. It was presented as a new type of action game, different from the console games. The new world for Mario's adventure was a little different from the Mushroom Kingdom!

SAVE SARASALAND!

The stage for this adventure is Sarasaland. The interstellar alien Tatanga has abducted Princess Daisy, and in order to rescue her, Mario must face challenges in four different kingdoms. Throughout the game, Mario must use vehicles, including an airplane, and make his way through a shooting challenge. Even on a small black-and-white screen, a huge adventure awaits, taking you through the land, sea, and air!

 # CHARACTERS

PLAYER CHARACTERS

MARIO

In this story, Mario's adventure unfolds for him alone.

POWER-UPS

You start as Small Mario. Find a Super Mushroom to become Super Mario, and then grab a flower to become Superball Mario! On certain courses you can also board vehicles to help you on your journey!

MARIO

This is his state at the start of the game. Touch an enemy once and lose a life.

SUPER MARIO
ITEM ➔ SUPER MUSHROOM

Mario's body grows, and now he can break blocks. When he touches an enemy, he shrinks back to regular Mario.

SUPERBALL MARIO
ITEM ➔ SUPERBALL FLOWER

Mario can attack enemies by throwing superballs that bounce over the screen. In addition to attacking enemies, you can collect coins with superballs, too.

INVINCIBLE MARIO
ITEM ➔ STAR

For a short while, Mario's body blinks and he can defeat any enemy with a simple touch.

A POWER-UP VEHICLE! MARINE POP

A submarine that carries Mario through the water. Fire torpedoes at enemies and break blocks.

A POWER-UP VEHICLE! SKY POP

A plane that allows Mario to fly through the sky with ease. Break blocks or attack enemies with its missiles.

ENEMIES

These are the enemy characters that Mario will encounter. For many of them, this is the only game where they appear.

BATADON

A winged stone statue. It tries to crush Mario from above.

BROKINTON

This cloud conceals a chicken dispenser.

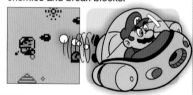

BUNBUN

It flies through the sky dropping arrows.

CHIBIBO

These timid mushrooms toddle across the ground.

CHICKEN

One of Tatanga's war birds. It can fly straight, but as it nears Mario it flies in an arc.

CHIKAKA

It floats through the sky. Because of the protective barrier, you need ten missiles to defeat one.

DRAGONZAMASU
The boss of the Muda Kingdom. It moves up and down along the wall as it breathes fire.

FLY
This blood-sucking fly leaps toward Mario.

GANCHAN
They fall out of the sky, then bounce and roll. Mario can ride on them, too!

GAO
It stays still and shoots fireballs at Mario.

GINA
They're fired out of blaster cannons and fly in a straight line.

GUNION
It undulates through the water. If Mario hits it with two torpedoes, it will split in two and attack.

HIYOIHOI
The boss of the Easton Kingdom. It throws Ganchans at Mario.

HONHEN
The skeleton that's left after Tatanga eats a Torion. It jumps out of the water.

KING TOTOMESU
Boss of the Birabuto Kingdom. It jumps up and down while spitting fireballs.

KUMO
These spiders live in caves. They make small jumps to get to Mario.

MEKABON
A robot that attacks Mario with its own head. Jumping on its flying head alone isn't enough to defeat it.

NOBOKON
A turtle with a bomb on its back. If Mario jumps on top, it will explode after a short fuse.

NYOLIN
Once it sees Mario, it spits a poison ball at him. They're cowards, so they don't move.

PAKKUN FLOWER
They poke their heads out from pipes. If Mario's touching the pipe, it won't emerge.

PINOPI
It jumps around. If Mario stomps on top, it stops moving, but after a while starts up again.

POMPON FLOWER
It walks for a bit, then stops. It blows poison pollen into the air above itself.

REVERSE PAKKUN
A Pakkun Flower that descends from an upside-down pipe.

ROCKETON
Planes manned by Tatanga's military escort. They fire cannonballs.

SUU
They stay on the ceiling until they hear something approaching. Then they descend. You'll find them in caves.

TAMAO
An immortal lifeform that protects Dragonzamasu. It moves diagonally.

TATANGA
This alien shoots strange projectiles from his war-robot Pagosu.

TOKOTOKO
A stone statue that swings its fists to run. Defeat it by jumping on top.

TORION
These man-eating fish always swim in groups of three. Once they hit the edge of the screen, they make a U-turn.

YURARIN
This minion of Dragonzamasu swims through the water diagonally.

YURARIN BOO
Yurarin's big brother moves vertically and breathes fireballs.

OTHER CHARACTERS

PRINCESS DAISY
She's being held captive by Tatanga. Mario must rescue her!

WORLD

COURSES

There are four kingdoms, each with three courses—so a total of twelve levels await you. They each have a different flavor, depending on the world.

WORLD 1
BIRABUTO KINGDOM

W1-1
The first level has pyramids in the background. Traverse hills filled with Chibibos.

W1-2
There's no ground here! Cross wooden platforms and dodge the Bunbuns attacking from above.

W1-3
The interior of a pyramid, filled with traps. The crumbling ceiling blocks the way for intruders.

WORLD 2
MUDA KINGDOM

W2-1
Make your way across the platforms as Honhen jump up from the water.

W2-2
There's a UFO right at the start, and during the course a Mekabon robot comes swaggering in.

W2-3
Board the Marine Pop and make your way through the water. Shoot torpedoes at the enemies and blocks in the way.

WORLD 3
EASTON KINGDOM

W3-1
The rocky environs of the Easton Kingdom. The stone enemies attack Mario . . . and sometimes save him!

W3-2
Spiderlike enemies, including Suu and Kumo, are plentiful in this cave.

W3-3
A shrine in the sky, with lots of lifts. Hiyoihoi waits at the end.

WORLD 4
CHAI KINGDOM

W4-1
Pipes line this level that resembles a bamboo grove. Pinopis jump around, too.

W4-2
There are lots of small platforms and Pompon Flowers here. The passage gets very tight in the second half, with a lot of Roto-Discs.

W4-3
The last level is a final battle above the clouds. Use the Sky Pop to scatter enemies in Mario's path.

ITEMS & OBSTACLES

You'll encounter all of these on your journey. The 1-Up isn't a mushroom this time—it's a heart! There are a lot of other unique items in this game, too.

? BLOCK
A block with a question mark on it. You can get coins or items out of them.

1-UP HEART
Grab one for an extra life. Most of them are well-hidden.

BLOCK
Mario can break them if he is powered up. Sometimes there are items inside.

BOSS SWITCH
Sneak behind the boss and jump on the switch to defeat it.

COIN
With every hundred you collect, you get a 1-Up. Mario can gather them with a superball, too.

ELEVATOR
When Mario climbs on, it rises straight up. Sometimes they emerge from hidden blocks.

FALLING CEILING
These blocks fall from above when Mario gets close. If one hits, he'll take damage.

FALLING PLATFORM
These platforms fall almost as soon as Mario sets foot on them. Jump off directly onto the next platform.

FALLING SPIKE
They drop from the ceiling when Mario's close. He'll take damage if one touches him.

GINA CANNON
They come out of pipes and shoot Ginas.

HIDDEN BLOCK
Jump where there doesn't appear to be anything and you might discover one of these.

LIFT
Some of these platforms move left and right; others move up and down. They start to move once Mario steps on.

MULTI-COIN BLOCK
They're blocks that give up a series of coins when Mario hits them repeatedly.

PIPE
Enemies poke their heads out of these. Some are connected to rooms with treasure.

PIPE FIST
These clenched hands come out of pipes and try to smash Mario.

ROTO-DISC
These balls of fire rotate around a block.

SPIKE FLOOR
A floor that's covered in spikes. Step on it and Mario will get hurt.

STAR
This power-up makes Mario invincible for a short time.

SUPER MUSHROOM
Use this to power up to Super Mario!

SUPERBALL FLOWER
This is the power-up that makes Superball Mario!

🪙 AND MORE

This game definitely has some unique worlds! Still, there are familiar features from the previous *Super Mario* games.

INVINCIBLE MUSIC

When Mario becomes Invincible Mario, the music that plays comes from the classic *Orpheus in the Underworld* by Jacques Offenbach, most famous as the Cancan music, after the French cabaret dance.

POST-GOAL BONUS

There are two entrances to the goal area, and if Mario enters the top door, you can play a bonus game. If you manage to stop with good timing, you might get a 1-Up, a 2-Up, a 3-Up, or even a Superball Flower!

IMPOSTOR DAISY!

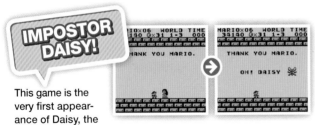

This game is the very first appearance of Daisy, the princess of Sarasaland. But in the Birabuto, Muda, and Easton Kingdoms, each has an enemy disguised as Daisy to confuse Mario.

SHOOT YOUR WAY THROUGH

In W2-3 and W4-3, Mario must board a vehicle and fire projectiles to defeat enemies in courses that play like shooting games. The final confrontation with Tatanga is also a shooter, as Mario fires missiles at his space-ship while dodging his attacks.

THE COIN ROOM

In W4-2, there's a hidden room which fills the screen almost completely full of coins. Superballs are required to get them all.

A HIDDEN WORLD

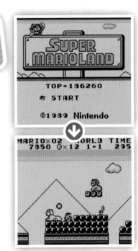

After Mario defeats Tatanga, the Mushroom Castle on the title screen turns into a Mario Castle and he can enter a world with a lot more enemies than before. Gaos now appear in W1-1, for example, so the difficulty has been greatly increased.

HELPFUL HINTS & TECHNIQUES

Here's some useful information that might help you enjoy the game more. Some of these techniques can't be used until specific conditions are met.

SELECT YOUR COURSE

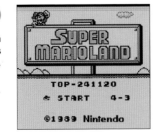

Once you've cleared the Hidden World, you can select and access any course from the title screen.

CONTINUE

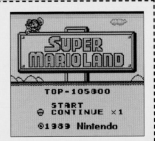

After you score over 100,000 points, you'll unlock the option to continue your game.

スーパーマリオブラザーズ
SUPER MARIO BROS.™ 3

Package

Game Pak

Instruction Booklet

System: Nintendo Entertainment System

Release Date: February 12, 1990 (Japan: October 23, 1988)

Player Count: 1–2

INTRODUCTION

S T O R Y

*This text is taken directly from the instruction booklet.

The Mushroom Kingdom has been a peaceful place thanks to the brave deeds of Mario and Luigi. The Mushroom Kingdom forms an entrance to the Mushroom World where all is not well.

Bowser sent his seven children to make mischief as they please in the normally peaceful Mushroom World. They stole royal magic wands from each country in the Mushroom World and used them to turn their kings into animals. Mario and Luigi must recover the royal magic wands from Bowser's seven kids to return the kings to their true forms.

"Goodbye and good luck!" said the Princess and Toad as Mario and Luigi set off on their journey deep into the Mushroom World.

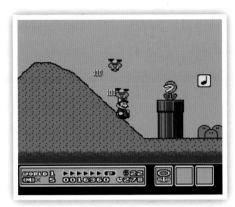

F E A T U R E S

A BIGGER GAME!

In the third installment of the NES series, there's more of everything: enemies, power-ups, and courses! In addition to the familiar characters that you know and love, this game features some new faces: the seven Koopalings, Bob-ombs, and Boo! There are also new obstacles, including the Koopa crew's airships.

With the introduction of Raccoon Mario, you can now fly through the sky, further expanding Mario's capabilities. *Super Mario Bros. 3* was a big technical step forward, at a then-huge three megabits.

INTRODUCING THE WORLD MAP!

This game introduces a powerful new world map! Now you can see a clear path toward each castle. The map also pinpoints the Toad Houses, where you can get items. But the biggest advantage is the power-ups: you can trigger them right on the map, so that you start a new course already powered-up!

CHARACTERS

PLAYER CHARACTERS

The two brothers, Mario and Luigi, go on adventures in the Mushroom World.

OTHER CHARACTERS

Allied characters who appear in the story.

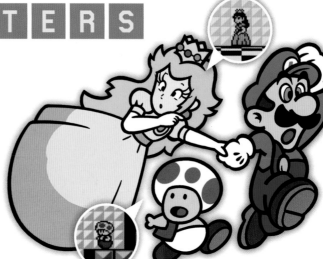

MARIO
Player One's character. You can identify him by his red shirt and hat.

LUIGI
Player Two's character. His green shirt and hat are his trademarks.

THE PRINCESS
Princess of the Mushroom Kingdom. She sends you a letter and items each time you rescue a royal.

TOAD
Servants of the royal houses in each country. You can get useful items from Toad Houses!

THE KINGS
Each country is ruled by a king, but they've been transformed by the bullying Koopas.

 GRASS LAND

 DESERT LAND WATER LAND GIANT LAND

 SKY LAND ICE LAND PIPE LAND

POWER-UPS

Certain items transform Mario and give him special powers. If he takes damage from an enemy while powered up, he turns back to normal.

MARIO

This is Mario's state when the game begins, also known as Small Mario or Regular Mario. He can't break brick blocks.

LUIGI

SUPER MARIO
ITEM ► SUPER MUSHROOM

With the help of a Super Mushroom, Mario's body becomes bigger. Now he can break brick blocks.

SUPER LUIGI

FIRE MARIO
ITEM ► FIRE FLOWER

Fire Mario can attack enemies by throwing fireballs at them. He can also destroy ice blocks with fireballs.

FIRE LUIGI

RACCOON MARIO
ITEM ► SUPER LEAF

Raccoon Mario has some new moves: the tail attack and the ability to fly!

RACCOON MARIO RACCOON LUIGI

INVINCIBLE MARIO
ITEM → STARMAN

For a short while, Mario can defeat any enemy just by touching it. Also, his jumping is different from other powered up versions of Mario: he somersaults through the air.

INVINCIBLE LUIGI

TANOOKI MARIO
ITEM → TANOOKI SUIT

This suit gives Mario all the powers of Raccoon Mario, plus the ability to turn into a statue! If he pounds the ground while in statue form, it creates a very strong attack that defeats several enemies at once.

TANOOKI MARIO

TANOOKI LUIGI

FROG MARIO
ITEM → FROG SUIT

This item allows Mario to easily swim through the water. Simply use the +Control Pad. When you press the A Button, Mario swims faster and it's even possible to swim against the current. But Frog Mario is not so good on dry land.

FROG MARIO

FROG LUIGI

HAMMER MARIO
ITEM → HAMMER SUIT

Mario can throw the hammer as an attack. Hammers fly in an arc, so he can defeat many enemies that can't be reached with fireballs. Also, the shell hat and shell on his back help protect against fire attacks when he squats down.

HAMMER MARIO

HAMMER LUIGI

USE A TRAP AS A POWER-UP!
SHOE MARIO
ITEM → KURIBO'S SHOE

Kuribo's Shoe only appears in W5-3. If Mario hits the Goomba that is wearing Kuribo's Shoe from underneath, he can steal the shoe, and then stomp on nearly all enemies and walk over Munchers. Once you finish the course, the transformation dissolves.

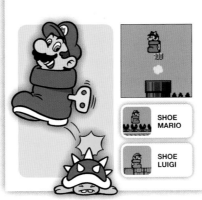

SHOE MARIO

SHOE LUIGI

A SPECIAL POWER-UP!
P-WING

This is an item you can use on the world map. This bumps the power meter up to max all the time, so Mario can fly continuously. But once you've cleared the level, the wing's effect wears off, and Mario becomes regular Raccoon Mario.

LUIGI

E N E M I E S

These are the enemy characters Mario meets throughout the Mushroom World. This is the first appearance for Boos, Chain Chomps, and many others!

ANGRY SUN
It stands guard at the top of the screen. When Mario reaches a certain point, it suddenly drops and attacks.

BLOOBER
A familiar foe, they undulate in the water and chase after Mario.

BLOOBER WITH KIDS
It leads its children through the water. As the parent moves, so do the kids.

BOB-OMB
Once you hit one, it's just a matter of time until it explodes. Sometimes they come flying out of cannons.

BOO DIDDLY
An extremely shy ghost. But turn your back, and it's on the attack!

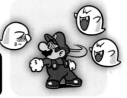

INTRODUCTION CHARACTERS WORLD AND MORE

BOOM BOOM

This boss controls the mini-fortress in each world. His attack is different based on where you meet him.

BOOMERANG BRO

These enemies throw boomerangs instead of hammers. Watch out for the boomerangs on their way back!

BOSS BASS

It swims along the surface of the water and attacks by jumping. If found underwater, call them Big Berthas.

BOWSER THE KOOPA KING

Bowser is once more the source of Mario's troubles. Can Mario defeat him again?

BULLET BILL

They're fired out of Bill Blasters and fly in a straight line, although sometimes they make a U-turn.

BUSTER BEETLE

They wander around looking for ice blocks to throw at Mario.

BUZZY BEETLE

He lives underground. If you jump on him, he goes into his shell, and then you can pick him up.

CHAIN CHOMP

He's restrained by a chain attached to a block. After a few bounces, he shoots forward to bite at Mario.

CHEEP-CHEEP

Some swim straight through the water, while others jump above the surface at Mario.

CHEEP-CHEEP (GREEN)

They swim slowly right and left through the water.

DRY BONES

A turtle skeleton that appears in castles and towers. When you jump on it, it crumbles, but pretty soon it comes back to life.

FIRE BRO

Their red bodies indicate how they attack: by shooting fireballs at Mario!

FIRE CHOMP

It drifts through the air, and when it gets close to Mario, it shoots a fireball.

FIRESNAKE

A line of fire that comes bouncing towards Mario.

GIANT KOOPA TROOPA (GREEN)

Even though it's much bigger, it acts just like other green Koopa Troopas.

GIANT KOOPA TROOPA (RED)

Although its body is enormous, it doesn't move any differently than a regular red Koopa Troopa.

GOOMBA

They walk in a straight line. Sometimes a stream of them comes out of a pipe, one after the next.

GRAND GOOMBA

This huge Goomba appears in Giant Land. It acts like a regular Goomba.

HAMMER BRO

They attack with hammers thrown in arcs. Usually they come in a pair.

HOT FOOT

Usually Hot Foot stays on a burning candle. But if you turn your back, Hot Foot will start walking.

IGGY KOOPA

The boss in the Land of the Giants. He jumps and attacks with magic.

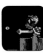

JELECTRO

They stay still underwater. Touch one, and Mario takes damage.

KOOPA PARATROOPA (GREEN)

They cross the ground in big, leaping bounds, flying toward Mario to attack!

KOOPA PARATROOPA (RED)

They fly back and forth. If Mario jumps on one, it becomes a normal Koopa Troopa.

KOOPA TROOPA (GREEN)

They keep walking, even off a cliff. They hide in their shells when Mario attacks.

KOOPA TROOPA (RED)

They patrol one area, back and forth.

KURIBO'S GOOMBA

A Goomba is hiding inside this shoe! It jumps in big, sweeping arcs.

LAKITU

He moves through the sky, dropping two kinds of Spiny Eggs.

LARRY KOOPA

The youngest Koopaling has taken over Grass Land. He jumps and attacks with his wand.

LAVA LOTUS

A relative of the Piranha Plants that blooms underwater. When Mario comes close, it releases four lava bits.

LEMMY KOOPA

Lemmy shoots high-bouncing balls from his wand in Ice Land.

LUDWIG VON KOOPA

He's the boss of Pipe Land, and the oldest Koopaling. He attacks with magic, and can jump to make the ground shake.

MORTON KOOPA JR.

He's taken over Desert Land. He jumps up and attacks with his wand while still in the air.

MICRO-GOOMBA

They're scattered around by Para-Goombas. If they're stuck to Mario, he slows down and can't jump very high.

MUNCHER

They stay still, but if Mario touches one, he takes damage. Some of them live in pipes.

NIPPER PLANT

They jump and attack when Mario tries to leap over them.

PARA-BEETLE

Buzzy Beetles that fly through the sky. They may drop for a second, but they'll rise again.

PARA-GOOMBA

It jumps up and down along the ground. If Mario jumps on top, its wings fall off.

PARA-GOOMBA WITH MICRO-GOOMBAS

This flying pest scatters Micro-Goombas through the air.

PILE DRIVER MICRO-GOOMBA

They use blocks as camouflage, and then jump as Mario approaches.

PIRANHA PLANT

They poke their heads out of pipes. The red ones have longer stems than the green.

PIRANHACUS GIGANTICUS (GREEN)

While Mario is touching its pipe, this Piranha won't emerge.

PIRANHACUS GIGANTICUS (RED)

This huge Piranha Plant moves in and out of its pipe.

PODOBOO

Balls of fire that jump out of lava lakes. There's also a type that drops off the ceiling.

PTOOIE

Some walk and some stay in pipes, but they all blow thorny balls in the air above their mouths.

ROCKY WRENCH

Mole-like crewmembers of the Koopa military crew. They poke their heads out and throw wrenches.

ROTO-DISC

These whirling traps rotate around pillars or blocks, and can come in pairs.

ROY KOOPA

The master of Sky World, Roy attacks Mario with ground-shaking stomps and blasts of magic.

SCATTER BLOOBER

A Bloober that leads its small children around, then fires them off in an attack.

SLEDGE BRO

They throw hammers to attack. When they jump and hit the ground, the earth shakes.

SPIKE

He walks around underground, but the moment he sees Mario, Spike throws his spiked ball at him.

SPINY

Mario can't jump on top because of the spikes, but he can pick it up after a tail attack.

SPINY CHEEP-CHEEP

Swift-swimming and spiny, these are tougher than regular Cheep-cheeps.

SPINY EGG

Lakitu throws these down at Mario. They turn into Spinies when they hit the ground.

SPINY EGG (GREEN)

When Lakitu throws these green eggs, they roll around on the ground for a while.

STRETCH

It moves back and forth, then pokes its head out of a white floor. If Mario touches its head, he takes damage.

THWOMP

A nasty block of blue stone that falls when Mario gets too close. Some move sideways or diagonally.

UPSIDE-DOWN BUZZY BEETLE

When Mario gets too close, it retreats into its shell and falls to the ground.

UPSIDE-DOWN SPINY

A Spiny that walks along the ceiling. When Mario approaches, it falls.

VENUS FIRE TRAP

They attack by breathing fire. There are a few different sizes, and they're very dangerous!

WENDY O. KOOPA

She conquered Water Land. Watch out when she attacks with a ring that bounces all over the screen.

WHITE PIRANHA

They stay still as they wait for Mario to approach, and then they spit fire at him.

WORLD

C O U R S E S

Mario and Luigi travel through eight different kingdoms. In the first seven worlds, your goal is to defeat the Koopalings in their airships and retrieve the stolen magic wands.

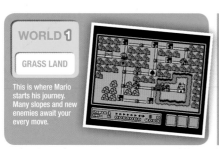

WORLD 1
GRASS LAND

This is where Mario starts his journey. Many slopes and new enemies await your every move.

W1-1
Travel along a line of colorful platforms. If you take flight as Raccoon Mario, you'll find platforms up in the sky, too.

W1-2
Goombas come out of pipes to walk along the slopes of this hilly course.

W1-3
This level has a lot of hidden routes. Some are in the sky, and others hiding behind the background . . .

W1-4
This scrolling course keeps Mario running. Use the lifts to stay on track, and look before you leap!

W1-FORTRESS
Podoboos pop out of the lava, and Roto-Discs spin through Mario's narrow path.

W1-5
Travel above and below ground in this odd grayish world with an underground lake.

W1-6
Be careful which rail lifts you ride through the sky. Some of them fall once they reach the end of the line.

W1-AIRSHIP
There's a Koopaling waiting at the end of this airship. Avoid the cannon fire and rescue the King of Grass Land.

WORLD 2
DESERT LAND

Watch out for quicksand, wind, and the pyramid's tricks.

W2-1
Make your way over the criss-crossed pipes, and keep an eye out for Pile Driver Micro-Goombas.

W2-2
Riding on the lifts will help Mario avoid Cheep-cheeps in this desert oasis.

W2-FORTRESS
Thwomp, Boo Diddly, and Dry Bones make their first appearances in this world filled with sharp spikes.

W2-3
The platforms in this level are built like pyramids.

W2-DESERT
At the start of the level, an Angry Sun glares from the sky. Suddenly, it starts to attack!

W2-4
There are two paths through this level: above and below. The upper path has tons of coins to collect.

W2-5
Chain Chomps wait to attack Mario throughout this course. There are a few beanstalks hiding here, too.

W2-PYRAMID
You've made your way into the complicated interior of the pyramid. Clear out the blocks that are stopping Mario's progress.

W2-AIRSHIP
Make your way through tons of Bill Blasters and Rocky Wrenches on Morton's airship to rescue the King of Desert Land.

WORLD 3
WATER LAND

This world is all wet! Only a great swimmer will be able to get through.

W3-1
Bloobers and Lava Lotuses wait for Mario in this underwater course.

W3-2
Advance across this seaside level on rail lifts, and dodge the Cheep-cheeps that fly up at Mario.

W3-3
Platforms float on top of the water, and Boss Bass is trying to get Mario!

W3-FORTRESS 1
Choose the right door to find the room where Mario can fight Boom Boom.

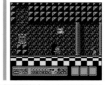

W3-4
A grassy seaside course. The second half is a rain of Spinies at the hands of Lakitus.

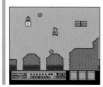

W3-5
Swim through the narrow openings between countless Jelectros in their underwater habitat.

W3-6
There are two paths of platforms in this scrolling course.

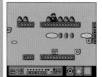

W3-7
Spike appears high in the grassy hills. There's also a hidden area at the end.

W3-FORTRESS 2
This fortress has sunk underwater. Find your way between the Stretches!

W3-8
Cross the seas on floating platforms that have a tendency to sink. And watch out for Boss Bass!

W3-9

Bob-ombs roam around this level. Through the pipes you can find an underground water area.

W3-AIRSHIP

Sneak through narrow passages with cannons firing from two directions to save the King of Water Land.

WORLD 4
GIANT LAND

A large kingdom where the terrain and blocks are huge! Even the enemies are giant.

W4-1

Enemies, traps, and items are huge now! There's a reservoir up above the waterfalls.

W4-2

Make your way forward over the floating and sinking platforms, as Cheep-cheeps come at Mario.

W4-3

A cave with tricky footing. Upside-Down Buzzy Beetles and Upside-Down Spinies try to fall on Mario's head.

W4-FORTRESS 1

Thwomps will try to crush him and Hot Foots sneak up from behind as Mario travels through narrow passages.

W4-4

This underwater course is full of huge coral reefs. Lakitu throws Spiny Eggs from the sky.

W4-5

Bill Blasters never stop shooting Bullet Bills . . . and some of them make U-turns!

W4-6

Here you'll find enemies both big and small. Choose the correct door to go back and forth between the two.

W4-FORTRESS 2

Make your way above the lava on donut lifts. There's also a hidden door that leads to a bonus area.

W4-AIRSHIP

Rescue the King of Giant Land after avoiding the rocket engines on every side of this airship.

WORLD 5
SKY LAND

This world has courses on the ground and in the clouds. Go between them via the tower.

W5-1

Pass over a lake using the blue blocks built up like a mountain. Chain Chomps come to bite Mario from below.

W5-2

A nest of Buster Beetles waits for Mario at the end of a long fall.

W5-3

This course is split into an upper and a lower section, and it's the only place where Kuribo's Shoe appears.

W5-FORTRESS 1

A fortress where the blocks form hills and valleys. Avoid the Roto-Discs.

W5-TOWER

Climb up to the top of the tower, and then go through the pipe to a world above the clouds.

W5-4

Use the Rotating Lifts to travel above the clouds.

W5-5

The donut lifts line Mario's path, and enemies like Koopa Paratroopas attack him.

W5-6

Jump on the backs of Para-Beetles to keep up with this scrolling level.

W5-7

Pile Driver Micro-Goombas and Bullet Bills attack Mario in this stronghold made of blocks.

W5-FORTRESS 2

Avoid the Podoboos bursting out from both above and below as Mario makes his way across the lava.

W5-8

It's tricky to avoid the Lakitus and their rain of Spiny Eggs as Mario travels through the sky.

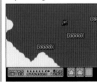

W5-9

Head diagonally upwards as Mario jumps from lift to lift. This demanding level never stops moving.

W5-AIRSHIP

Survive the barrage of cannons from Roy's airship to find the King of Sky Land.

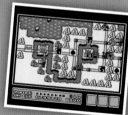

WORLD 6
ICE LAND

This slippery world is covered in ice and snow.

W6-1

Ptooies walk along this snowy course with slippery footing.

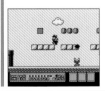

W6-2

Board the cloud lifts to get ahead in this scrolling level with both an upper and a lower route.

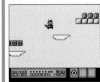

W6-3

This level is full of lifts and narrow, icy passages.

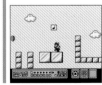

W6-FORTRESS 1

The lifts will help Mario dodge Podoboos. Jump to avoid the Roto-Discs!

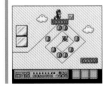

W6-4

Lots of lifts and moving platforms make timing essential in this ice course.

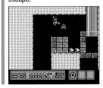

W6-5

An underground level that's infested with Buster Beetles. Find the hidden pipe to escape.

W6-6

A cave with an underwater lake. Cheep-cheeps jump between pools of water.

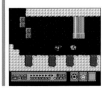

W6-7

Avoid the Fire Chomp's attacks and cross the dangerous donut lifts.

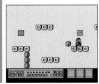

W6-FORTRESS 2

A fortress completely covered in ice. Sliding Thwomps block your way.

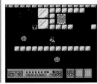

W6-8

A gentle grassy slope, but Walking Piranhas and Buster Beetles make it hard to move forward.

W6-9

This course is half underwater. Find the pipe that leads to your goal!

W6-10

Coins and Munchers are frozen inside the ice blocks here.

W6-FORTRESS 3

There are Stretches and conveyor belts above the sharp spikes, so watch Mario's footing as he proceeds.

W6-AIRSHIP

This blue airship looks cold! But rocket engines help to warm things up.

WORLD 7

PIPE LAND

This kingdom is filled with pipes and maze-like courses.

W7-1

An upward-scrolling course where Mario climbs to the top using the pipes.

W7-2

Travel above and below ground through pipes, back and forth.

W7-3

You can be Invincible Mario for the entirety of this grassland course.

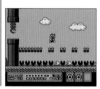

W7-4

Spiny Cheep-cheeps are swimming around this underwater scrolling course.

W7-5

This maze is a series of small rooms. Travel between them with pipes.

W7-FORTRESS 1

Brick blocks are everywhere in this fortress. Mario has to fly to reach the end.

W7-6

Going off one side of the screen makes Mario appear on the other in this upward-scrolling course filled with arrow lifts.

W7-7

Use Invincible Mario to get through the area that's completely filled with Munchers.

W7-8

The whole Piranha Plant family is in this course: Ptooies, Walking Piranhas, and more.

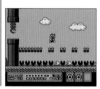

W7-9

Make your way through the cracked pipes in this maze.

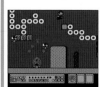

W7-FORTRESS 2

Pipes with Piranha Plants in them are lined up above a bed of lava.

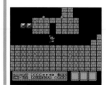

W7-PIRANHA PLANT 1

You get an item at the end of this short level.

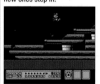

W7-PIRANHA PLANT 2

A world of Munchers awaits in this course lined with pipes.

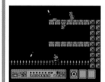

W7-AIRSHIP

Turn the nuts on the Bolt Lifts to move forward. Ludwig von Koopa's series of airships is guarding the King of Pipe Land.

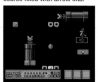

WORLD 8

DARK LAND

Bowser, the King of the Koopas, waits for Mario here. Tanks and warships come at him in waves.

W8-BIG TANKS

Make your way down a long line of tanks loaded with cannons and Rocky Wrenches.

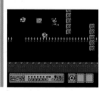

W8-BATTLESHIPS

A trio of warships cruise through the water. As Mario defeats the Rocky Wrenches, new ones step in.

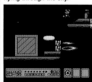

W8-HAND TRAP 1

A short course filled with all of the members of the Hammer Bros. family.

W8-HAND TRAP 2

Cross the lava while dodging Podoboos.

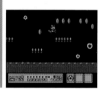

W8-HAND TRAP 3

Cheep-cheeps fly out of the water as you go through this short course.

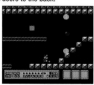

W8-AIRSHIPS

This course scrolls a little faster than normal. Make your way across a formation of jets flying through the sky.

W8-1

A dark course with lots of Bill Blasters and Boo Diddlys.

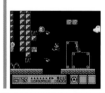

W8-2

A long, hilly road where Venus Fire Traps wait for Mario. There are Angry Suns, too.

W8-FORTRESS

Choose one of two paths through this fortress, and then make your way through the doors to the back.

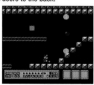

W8-SUPER TANK

Cannons fire from the ceiling as Mario crosses this very long tank.

W8-BOWSER'S CASTLE

Stone Bowser statues try to keep Mario from moving in the final course. There are two ways to get to Bowser's room.

ITEMS & OBSTACLES

You can get items from Toad Houses, which can be found on the world map.

? BLOCK

When Mario hits them, coins or items come out. Hit them from the side with Mario's tail or a shell, or jump from below.

1-UP MUSHROOM

They grant Mario an extra life. If you find a giant ? block, three of these might come out.

10-COIN BLOCK

A block that spouts a series of coins as Mario hits it. They look like regular brick blocks.

ANCHOR
Mario can use this from the map to keep the Koopaling Airships still.

BILL BLASTER
The cannons that fire Bullet Bills. There are different types: long and short.

BLUE LIFT
A lift that suddenly appears when Mario stands on it. It goes upward quickly, taking him to a specific place.

BOLT LIFT
Get on and jump, and it moves to the right. If Mario hits them from below, they move left.

BOWSER STATUE
They shoot lasers diagonally. Sometimes they block laser beams, too.

BRICK BLOCK
They break when Mario hits them. When he hits a P-Switch, they turn into coins.

CANNON
They shoot cannonballs that fly horizontally.

CLOUD LIFT
Elevators in the shape of clouds that move sideways across the sky. Mario won't fall if he's on one.

COIN
They're everywhere! Some even come out of blocks. Collect one hundred for a 1-Up.

CONVEYOR BELT
They can move either right or left. You can stop them if you find the right switch block.

DIAGONAL CANNON
These cannons point diagonally and shoot either cannonballs or Bob-ombs. Bob-ombs fly in an arc.

DIRECTIONAL LIFT
Arrow lifts move in the direction of the arrow. Directional lifts change direction as Mario jumps.

DONUT LIFT
When Mario jumps on, they shake, and eventually fall.

FIRE FLOWER
This is the power-up that makes Fire Mario!

FIREBALL
These come flying in a straight line toward Mario at the end of Bowser's Castle.

FROG SUIT
Don this suit to power up into Frog Mario.

FROZEN BLOCK
Mario can kick them or carry them. They vanish with time.

GIANT ? BLOCK
Special items can be found inside.

GIANT BRICK BLOCK
They're just big. Otherwise, they're no different than regular brick blocks.

GIANT PIPE
A huge pipe. Mario can't go in, but sometimes Piranha Plants can come out of them.

GOAL CARD
They're at the end of each course. There are three types: mushroom, flower, and star.

HAMMER
Use this to break the boulders that block Mario's way on the world map.

HAMMER SUIT
A power-up that turns Mario into Hammer Mario.

ICE BLOCK
Mario tends to slip on these transparent blocks. Use a fireball to melt them.

INVISIBLE BLOCK
You think there's nothing there, but a block appears. There are also hidden Jump Blocks.

JUGEM'S CLOUD
Use this on the world map to skip one stage of a world and keep moving.

JUMP BLOCK
They're springy! Time your jump just right and bounce very high. Some of them hold items.

KURIBO'S SHOE
Defeat Kuribo's Goomba to get this power-up, then jump high and stomp on Piranha Plants!

LARGE CANNON
They shoot very large cannonballs that travel in a straight, horizontal line.

LAVA
Red lakes inside castles and fortresses. Touch them, and you lose a life.

LIFT
Some move right and left, others up and down. Some fall after Mario gets on, and others float.

MAGIC JUMP BLOCK
A Jump Block that is very well hidden.

MAGIC WHISTLE
If you use this on the world map, it takes Mario to World 9, the Warp Zone.

MUSIC BOX
Use this on the map to put wandering Hammer Bros. to sleep.

P-WING
A high-powered item to use on the world map. It keeps Mario's power meter full so he can fly.

PIPE
Enemies can come out of them, and Mario can sometimes move to new areas through them.

QUICKSAND
When Mario steps in it, he sinks. If he sinks too far, he loses a life. Do many jumps in quick succession to rise.

RAIL LIFT
Elevators that ride in the direction of their rails. Some only start moving after you get on.

RED BRICK
Mario can't affect them, but Bowser's ground pound attack will break them.

ROCKET ENGINE
These jets shoot fire periodically. Some are placed vertically, and others horizontally.

ROTATING CANNON
Four cannon bores that rotate. They fire in two directions at once.

ROTATING LIFT
Platforms that spin. If Mario hits one, it will send him flying. Some tilt back and forth as he walks on them.

SILVER COIN
A blue-ish coin that appears for a short time when a switch is activated.

SPIKES
Mario takes damage if he happens to touch them. They can be found on the ceiling or floor.

STARMAN
This power-up grants temporary invincibility, and can be found in ? Blocks.

STREAM PIPE
A strong current issues forth from the pipe. Everyone gets washed downstream, except for Frog Mario.

SUPER LEAF
Use this to power up to Raccoon Mario!

SUPER MUSHROOM
Become Super Mario with this power-up!

SWITCH BLOCK
Jump on it, and blocks become coins. Some of them activate machines.

TANOOKI SUIT
A power-up that allows Mario to become Tanooki Mario.

TWEESTER
If Mario gets caught in this whirlwind, it sends him backwards. He can get past it with a dash jump.

TWO-DIRECTION CANNON
Cannons that are set diagonally. They can fire in different directions.

VINE BLOCK
Hit the block and a vine rises out of it. Once Mario has grabbed on, he can climb up or down.

WATERFALL
Water that flows down from above. It's found in a limited number of courses.

WHITE BLOCK
If Mario gets on top and squats for a while, he can move behind the scenery.

WOOD BLOCK
Mario can't break them. But if he hits certain ones from the side, they produce an item.

AND MORE

 MEMORABLE MOMENTS

These are some of the new features and visuals that left an impression. A lot of these are things that you might never notice just playing the game casually.

 LAY OF THE LAND

New landscapes have been added, including slopes! The hills and valleys create a much richer-feeling world. Mario can also defeat enemies by sliding down inclines.

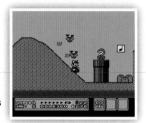

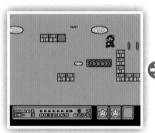 **SCROLLING LEVELS**

They scroll up, down, and even diagonally. For the first time, a course scrolls even when Mario stays still. That means you can't get too far ahead, or backtrack. If Mario gets caught between a difficult obstacle and the end of the screen, you'll lose a life.

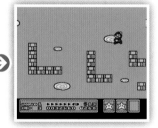

 GOAL CARDS

Each time you reach the goal at the end of a course, you collect a card. Try to get three of a kind! A set of mushrooms gives you two extra lives, flowers give you three, and stars give you five. If you can't make three of a kind, you just get a 1-Up.

 ANGRY SUN ON THE ATTACK

At first, the sun in the sky in Desert Land looks like part of the background. But in the second half of the level, it swoops down to attack! Defeat the Angry Sun by hitting it with a shell.

 RELEASE THE CHAIN CHOMPS!

Usually, Chain Chomps are tied in place . . . but if you wait too long, the chain breaks and they get to wander free.

 NOSTALGIA BROS.

In the two-player version, if you line up Luigi (or Mario) at the top of the world map screen and press the A Button, you get the good old *Mario Bros.* game! The screen converts into the old Mario Bros. motif, and you can both play this minigame at the same time. Defeat five enemies or outlast your opponent to win. The winner chooses the next spot on the map. It's also possible to attack your opponent or steal their goal cards.

 A MAP OF JAPAN?

The last section of Water Land is a set of islands that's shaped a bit like Japan. The castle is about where Kyoto would be (and that's where the Nintendo headquarters is located!). And the king looks suspiciously like Mario . . .

 ROCK BREAKER

There are rocks on the world map that block Mario's way, but you can break them using the hammer. You might find a shortcut, or even a hidden Toad House.

ANOTHER ROYAL KIDNAPPED!

Princess Toadstool asked Mario and Luigi to rescue the kings, and she sent letters with items as a reward. But after you clear World 7, a letter arrives to let you know that the Princess has been kidnapped. Mario and Luigi must head to Bowser's castle to rescue her.

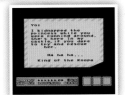

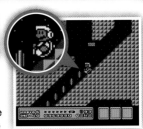

HAMMER SLIDE

Normally, Hammer Mario can't slide. But if you happen to get the Hammer Suit while you're already sliding, you can see what kind of pose Hammer Mario would strike mid-slide.

THE KING'S SPEECH

If you defeat a Koopaling as Tanooki Mario, Frog Mario, or Hammer Mario, the rescued royal's dialogue will change depending on the suit Mario is wearing.

HELPFUL HINTS & TECHNIQUES

These techniques will aid you on your quest. Also, some hidden parts of the game won't appear until certain conditions are met.

HIDDEN HOUSES

On some courses, if you collect a certain number of coins, a white Toad House appears on the world map. The minimum numbers are: W1-4 (44 coins), W2-2 (30 coins), W3-8 (44 coins), W4-2 (24 coins), W5-5 (28 coins), W6-7 (78 coins), and W7-2 (78 coins). You get P-Wings from odd-numbered worlds, and Anchors from even-numbered worlds.

WARP WITH A WHISTLE

When you use the Warp Whistle, Mario flies to W9, the Warp Zone. Here, you can warp to other worlds. Depending on the world in which you used the whistle, your options are different. From W1, you can go to W2, W3, or W4. From W2 through W6, you can go to W5, W6, or W7. From W7 through W9, you can warp to W8. You can find Warp Whistles in W1-3, W1-Fortress, and with the Fire Bros. in W2.

GOOMBAS' BLOCKS DON'T SHINE!

The blocks that Pile Driver Micro-Goombas hide behind look just like regular brick blocks, but if you look closely you can tell them apart. Regular blocks reflect light, and the Goombas' blocks don't. And if you pause the game, the Goombas' blocks disappear.

A MYSTERIOUS WHITE BLOCK

If Mario squats on certain white platforms, he can go behind the background, where enemy attacks can't hurt him. There are five places where you can do this: W1-1, W1-3, W3-10, W5-7, and W7-8. If you continue behind the scenes in W1-3 all the way to the goal, you can get yourself a Warp Whistle.

N-MARK SPADE PANELS

In every world, an N-Mark Spade Panel appears if you get a score over 80,000. Play a game of concentration and match cards to get more items.

TREASURE SHIPS FOR MAXIMUM COINS

When you clear a course, if the tens and ones digits of your coin counter are the same, and they also match the tens digit in your score, then the Hammer Bros. space on the world map turns into a Treasure Ship. There are 188 coins on each ship. Each ship also houses a set of Boomerang Bros.—if you defeat them, you get an item.

SAFE UNDER BOWSER'S FEET

In the final battle, Bowser pounds the ground and breaks the bricks there. When Bowser comes down on the blocks, Mario can squat and avoid taking damage. But be careful, because he is still vulnerable to Bowser's fireballs!

BONUS BROS.

If the Hammer Bros. are in a certain place on the world map, you can find a brick block that contains a power-up.

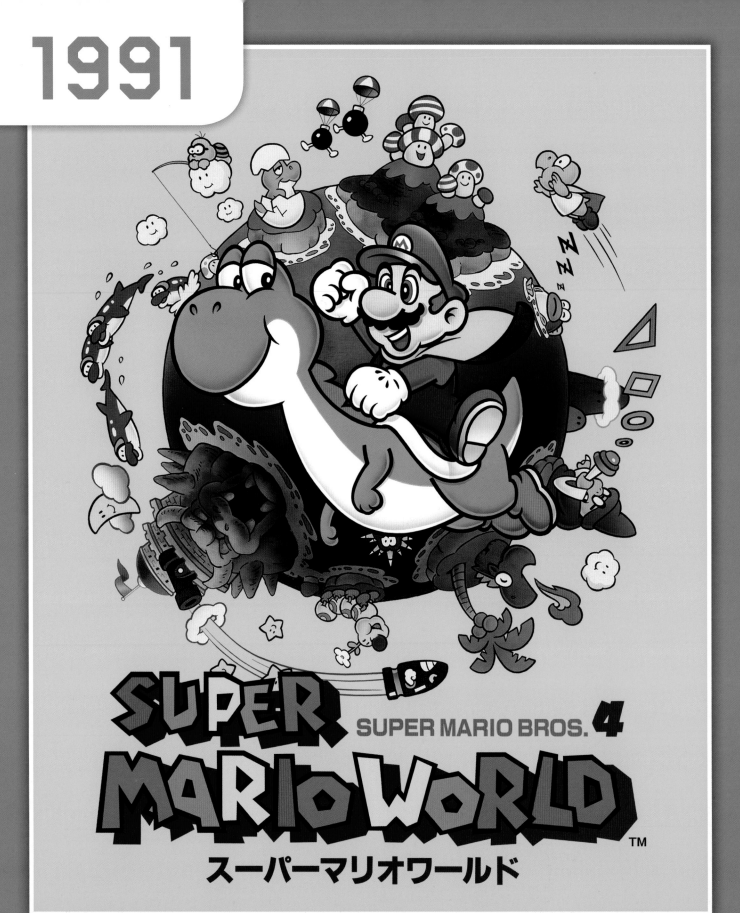

SUPER MARIO WORLD

SUPER MARIO BROS. **4**

スーパーマリオワールド

™

Package

Game Pak

Instruction Booklet

System: Super Nintendo Entertainment System

Release Date:
August 13, 1991
(Japan: November 21, 1990)

Player Count: 1-2

INTRODUCTION

S T O R Y

*This text is taken directly from the instruction booklet.

After saving the Mushroom Kingdom from Bowser and the rest of the Koopas in *Super Mario 3*, Mario and Luigi needed to recuperate from their adventures. Together they agreed that the best place to vacation was a magical place called Dinosaur Land.

But while Mario and Luigi reclined on the beach for a relaxing nap, Princess Toadstool disappeared, apparently seized by evil forces. After searching for hours for their missing friend, Mario and Luigi came upon an enormous egg in the forest.

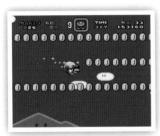

Suddenly the egg hatched, and out popped a young dinosaur named YOSHI, who proceeded to tell Mario and Luigi a sad tale of how his dinosaur pals were sealed in similar eggs by a group of monstrous turtles.

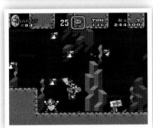

"Monstrous turtles!" exclaimed Luigi. "Bowser and his bunch have returned!" Mario slowly nodded his head in agreement and, along with Luigi and Yoshi, set off across Dinosaur Land to find the Princess and to free Yoshi's friends. As they began their journey, Yoshi handed Mario a beautiful cape. "This may help you," Yoshi said. "Some say it has magical powers."

With a little luck (and help from a magic cape), our hearty crew can defeat the seven worlds of Bowser's Krazy Koopa Kritters. Many locations are well-hidden so explore everywhere and try everything. Not all locations have to be explored to rescue the dinosaurs and save Princess Toadstool, but there are many "starry" treasures to be found in far-reaching places. You'll need to search all areas to find out what kinds of treasures are there…in Super Mario World.

F E A T U R E S

AN ADVENTURE IN DINOSAUR LAND

A side-scrolling 2D action game that went on sale at the same time as the Super Nintendo Entertainment System, or SNES, this adventure takes place in the lush, sprawling Dinosaur Land! Joining Mario on this epic journey is a brand new friend, a dinosaur named Yoshi. The SNES has a power-up for both graphics and music, which give you a far richer and more vivid environment. It also includes a backup feature that allows you to save your games mid-adventure!

CAN DINOSAUR LAND BE . . . ALIVE?

The setting for this adventure is Dinosaur Land, a weird and wonderful island that could very well be alive. Mountains rise higher, bridges suddenly appear, and as your adventure proceeds, the lay of the land changes. In this game, there aren't any specific "worlds." Instead, Mario wanders through a large island with interconnected areas like the Donut Plains and Vanilla Dome. Along the way, Mario may sometimes find keys that open up paths to secret goals. As these routes are uncovered, you can chart a path to Bowser's Castle that is all your own!

YOSHI: YOUR NEW BEST FRIEND!

This game marks the first appearance of Mario's new friend and fellow adventurer, Yoshi! Acting as Mario and Luigi's trusty steed, he can eat enemies and fruit by lashing out his long tongue. Yoshi has since appeared in many of Mario's adventures. He also became a very popular character who starred in his own spinoffs, such as *Yoshi* and *Yoshi's Story*.

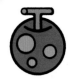 # CHARACTERS

PLAYER CHARACTERS

Mario and Luigi set out on a quest to find the missing Princess Toadstool and to rescue Yoshi's friends.

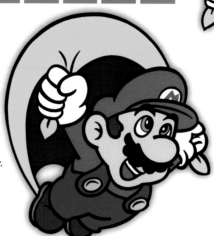

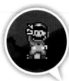

MARIO
Player One's character. He's now able to do a spin jump!

LUIGI
Played by Player Two. His abilities are the same as Mario's.

POWER-UPS

When Mario obtains power-ups, they transform him and give him special powers. If Mario is hurt by an enemy while powered up, he turns back to normal.

MARIO

This is Mario's state when the game begins. He can't break Rotating Blocks with his spin jump, and if he hits an enemy, you lose a life.

 LUIGI

SUPER MARIO (ITEM ▶ SUPER MUSHROOM)

If Mario passes a checkpoint gate or grabs a Super Mushroom, he gets a power-up. His spin jump can now break the Rotating Blocks.

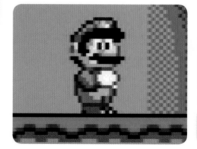

 SUPER LUIGI

FIRE MARIO (ITEM ▶ FIRE FLOWER)

Mario can attack enemies by throwing fireballs at them. The enemies defeated with fireballs become coins (although there are several enemies unaffected by fireballs).

 FIRE LUIGI

CAPED MARIO (ITEM ▶ CAPE FEATHER)

With the cape, Mario can fly and attack enemies from above. If he soars high into the air and then descends, he can extend his flying time for much longer.

 CAPED MARIO

 CAPED LUIGI

INVINCIBLE MARIO ITEM → SUPER STAR ☆

For a short while, Mario can defeat any enemy just by touching them. If eight enemies are defeated in succession, you get a 1-Up after the eighth defeated enemy.

INVINCIBLE LUIGI

BALLOON MARIO ITEM → POWER BALLOON ℗

Upon swallowing the Power Balloon, Mario swells up and can drift through the air for a short time. At first, he goes up and up, then he can move right, left, or down.

BALLOON LUIGI

YOSHI'S CREW

A brand-new friend to have adventures with—Yoshi! Yoshi hatches from green-spotted eggs found in Prize Blocks. There are also three uniquely colored Yoshis which can only be found on Star Road.

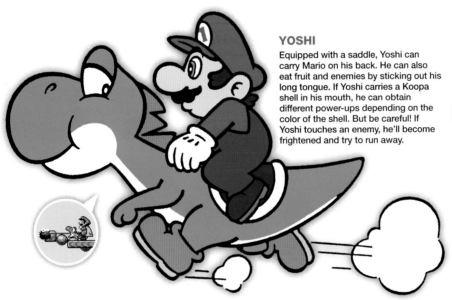

YOSHI

Equipped with a saddle, Yoshi can carry Mario on his back. He can also eat fruit and enemies by sticking out his long tongue. If Yoshi carries a Koopa shell in his mouth, he can obtain different power-ups depending on the color of the shell. But be careful! If Yoshi touches an enemy, he'll become frightened and try to run away.

BABY YOSHI

When one hatches from a red, blue, or yellow-spotted egg, Mario can pick him up and bring him along. If he eats five enemies, Grab Blocks, or any single power-up item, he grows into a full-sized Yoshi.

RED YOSHI

He breathes fire no matter what color Koopa shell he eats! He breathes out three fireballs at once, and when those fireballs hit an enemy, the enemy turns into a coin.

YELLOW YOSHI

He can pound the ground and emit clouds of damage-dealing dust, no matter what color Koopa shell he eats! The sand blast attacks enemies both in front and behind.

BLUE YOSHI

He has the ability to fly no matter what color Koopa shell he eats! If Yoshi's Wings are discovered in a Prize Block, he becomes Blue Yoshi.

OTHER CHARACTERS

Mario's allied characters who appear in the story.

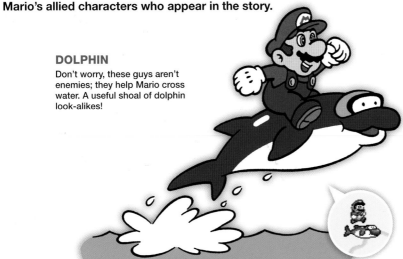

DOLPHIN

Don't worry, these guys aren't enemies; they help Mario cross water. A useful shoal of dolphin look-alikes!

PRINCESS TOADSTOOL

The Princess of the Mushroom Kingdom. She came to vacation with Mario and Luigi, but suddenly disappeared. It has to be the work of the Koopas!

ENEMIES

These are the enemies appearing throughout the game. Since it takes place in Dinosaur Land, many have a dinosaur-like appearance!

AMAZING FLYIN' HAMMER BROTHER

He rides atop Flying Platforms and throws hammers left and right.

BANZAI BILL

A huge Bullet Bill. They pack a punch, but can be defeated with a well-timed jump.

BLARGG

This lava-dwelling beast keeps an eye out for Mario, then opens his huge mouth to attack.

BLURP

These fish swim horizontally through the water and often appear in schools.

BOB-OMBS

These little guys are a real blast! They explode and scatter stars after a set time.

BONY BEETLE

They walk a little, then sprout spikes on their backs. If Mario jumps on them, they fall apart for a while.

BOO BLOCK

When Mario faces them, they become blocks. When he turns his back, they chase him.

BOO BUDDIES

When Mario turns his back, these ghosts give chase! One type runs in a circle and another type bounces.

BOWSER

He boards the Koopa Clown Car to attack Mario. Return fire by throwing Mechakoopas back at him.

BULLET BILL

They fly in a straight line. There are types that fly diagonally, too.

BUZZY BEETLE

They mostly appear underground. If Mario jumps on one, it retreats into its shell, but it never reemerges.

CHARGIN' CHUCK

These all-stars bar Mario's way and use a variety of bull-headed attacks.

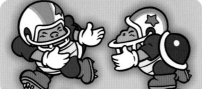

CHEEP CHEEP

These fish typically swim along a set path, but they can also flop about above ground.

CLIMBING KOOPA (GREEN)

To defeat these Koopas, jump on them or punch them through the fence.

CLIMBING KOOPA (RED)

These Koopas climb fencing. The red one is a little faster than the green one.

DINO-RHINO

These dragons are from Chocolate Island. Jump on Dino-Rhino and it becomes Dino-Torch.

DINO-TORCH

These tiny dragons are the junior versions of Dino-Rhino. Watch out, they breathe fire!

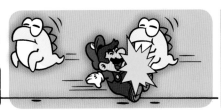

DRY BONES

Jump on it and it falls to pieces for a while. There's also a type that throws bones.

EERIE

This dinosaur spook roams haunted houses, flying toward Mario as he approaches.

FIRE JUMPIN' PIRANHA

After spitting fireballs to the right and left, they descend slowly back into their pipes.

FISH BONE

These skeletal fish appear in the waters of fortresses and castles, and swim in a straight line.

FISHIN' BOO

This ghost floats above Mario's head with a spooky flame at the end of its fishing pole.

FISHIN' LAKITU

These Lakitu have fishing rods baited with 1-Up Mushrooms.

FLYING GOOMBA

A Goomba with wings. If Mario jumps on one, it loses its wings and becomes a normal Goomba.

FUZZLE

They cling to and travel along tracks. Very few attacks can harm them.

GOOMBA

Jump on it to make it roll. Mario can also hold it or throw it.

GRINDER

They move along tracks or the surface of the ground. They spin so fast, Mario can't defeat them.

HOTHEAD

They rotate in a circle along the terrain. They're bigger than Li'l Sparkies, but move much more slowly.

IGGY KOOPA

The boss of Yoshi's Island. Mario has to fight him on a tilting island surrounded by lava.

JUMPIN' PIRANHA PLANT

These tropical plants come madly whirling out of pipes.

KOOPA

Jump on a Koopa and it pops out of its shell. An unshelled Koopa will climb into an empty shell.

KOOPA (YELLOW)

When a Koopa enters a yellow shell, it becomes invincible and chases after Mario.

KOOPA PARATROOPA (GREEN)

They have wings, but if Mario jumps on one, it becomes a normal Green Koopa.

KOOPA PARATROOPA (RED)

It moves by either flying or bounding across the ground.

KOOPA TROOPA (BLUE)

A fast-walking Koopa that turns around if it comes to an edge in the terrain.

KOOPA TROOPA (GREEN)

A green-shelled Koopa that marches along the ground.

KOOPA TROOPA (RED)

A red-shelled Koopa that turns around when he comes to an edge in the terrain.

KOOPA PARATROOPA (YELLOW)

These winged Koopas walk, but can also jump over obstacles.

LAKITU

If Mario defeats it with a shell or block, he can ride its cloud. Some types pop out of pipes, too.

LARRY KOOPA

The boss of the Valley of Bowser. Mario must fight him on a tilting island surrounded by lava . . . but with Lava Bubbles to dodge!

LAVA BUBBLE

A ball of fire that jumps up from the lava. One type hits a wall and bounces back.

LEMMY KOOPA

The boss of Vanilla Dome. He tries to dupe Mario by using dummy versions of himself.

LI'L SPARKY

A small ball of electricity that rolls along the terrain.

LUDWIG VON KOOPA

The boss of Cookie Mountain. After he shoots fireballs, he disappears into his shell to deploy a vicious spin attack.

MAGIKOOPA

Strange flashes of light shoot from this sorcerer's wand, changing blocks into enemies. Magikoopa can appear in an instant.

MECHAKOOPA

These mechanical Koopas follow Mario. When he jumps on them, they stop moving and can be picked up.

MEGA MOLE

A huge mole that charges forward. Mario can stand on its head as a way to traverse a tricky course.

MONTY MOLE

This is a mole that bursts out of the ground. There are even bigger ones underground.

MORTON KOOPA JR.

The boss of Donut Plains. He springs into the air in an attempt to body-slam Mario.

MUNCHERS

They don't move from where they are, but if Mario touches one, he'll be damaged. They can't be defeated.

NINJI

They jump up and down in place. They are only found in the final passages of Bowser's castle.

PARA-BOB-OMB

These explode and scatter stars after a set time. They use parachutes to drop from the sky.

PARA-GOOMBA

Goombas with parachutes that float down to the ground. Once they hit the ground, they become Goombas.

PIRANHA PLANTS

They live in upside-down pipes and pop their heads out for a fixed amount of time.

POKEY

These cactuses have long, spiny bodies, and when Yoshi eats a segment, they get shorter.

PORCUPUFFER

Swims along the surface, chasing after Mario. Be careful! Its back is covered in spikes.

RED SPIKE TOP

A turtle with a big spike on its shell. It can also walk on walls and ceilings.

REX

You can only meet this kind of enemy in Dinosaur Land. Stomp on a Rex twice to defeat him. Rex has wings, but can't fly.

 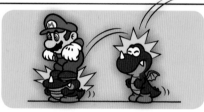

REZNOR

The bosses found at the end of fortresses. They come in sets of four, breathing fireballs from their rotating platforms.

RIP VAN FISH

This little fellow is always taking a nap, but when Mario comes along, he wakes up and sets off in hot pursuit.

ROY KOOPA

The boss of the Forest of Illusion. Each time Mario jumps on him, the room gets smaller.

SPINY

They have a spiny shell. Some are born from Spiny Eggs and others just appear.

SPINY EGG

Lakitu throws these dangerous eggs at Mario. When they hit the ground, they hatch and become Spinies.

SUMO BROTHER

When this strange little fellow stamps its foot, lightning strikes, and it turns wherever it hits into a sea of flames.

SUPER KOOPA

A Koopa that can fly once it puts on the magic cape. Jump on one that's wearing a flashing cape and you'll get a cape feather.

SWOOPER

Usually found resting upside down on the ceiling, this creature dives and attacks Mario when he comes too close.

THE BIG BOO

A huge spook called the Big Boo. If you look at him, he acts shy and turns away.

THWIMP

Tiny versions of Thwomps. They jump in arcs while moving right and left.

THWOMP

A nasty stone ghost that guards castles and fortresses. If Mario comes close, Thwomp will try to crush him.

TORPEDO TED

These torpedoes first appear in Soda Lake. After they're shot from Launch Pads, they travel in a straight line.

URCHIN

This giant urchin doesn't move very fast, so if Mario swims by carefully, there should be no problem.

VOLCANO LOTUS

A stationary plant that releases four balls of fire at set intervals.

WENDY O. KOOPA

The boss of Chocolate Island. She's a lot like Lemmy, but there are more Lava Bubbles in her room.

WIGGLER

This caterpillar is normally very quiet, but turns red and angry if jumped on.

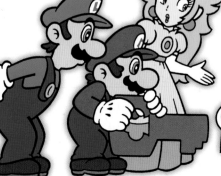

WORLD

C O U R S E S

Dinosaur Land is made up of a number of areas. There are hidden goals in some of the courses.

YOSHI'S ISLAND

A small island where Mario can visit Yoshi's house. Kappa Mountain is located on the upper left.

YOSHI'S ISLAND 1

 The course that begins Mario's adventure. It's home to many Banzai Bills and Rexes.

YOSHI'S ISLAND 2

 A forest overrun with Koopas. In this course Mario rescues Yoshi, who is trapped in an egg.

YOSHI'S ISLAND 3

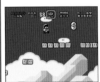 An athletic course in which Mario must traverse rotating lifts and stretch blocks.

YOSHI'S ISLAND 4

 Floating Mines drift along the surface of the water as Mario jumps from island to island.

IGGY'S CASTLE

 Mario must climb the fence suspended over lava. In the second half, huge wooden columns descend from the ceiling.

YELLOW SWITCH PALACE

 The palace housing the Yellow Switch. When Mario presses the P Switch, tons of coins appear.

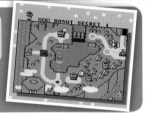

DONUT PLAINS

Great plains with a huge lake in the middle.

DONUT PLAINS 1

 A Super Koopa fly-zone! There's also a bonus area with lots of coins.

DONUT PLAINS 2

 An auto-scrolling cave course. Yellow platforms block Mario's progress. If Mario isn't careful, they can crush him!

DONUT GHOST HOUSE

 A haunted house filled with Boo Buddies. Mario must unlock the house's mystery to reach the goal.

DONUT PLAINS 3

 Mario must ride rotating lifts, rail lifts, and all sorts of other lifts to advance to the goal.

DONUT PLAINS 4

 Rolling hills and valleys make up this course. Goombas and Flying Goombas dot the landscape.

MORTON'S CASTLE

 Mario must scale the moving platforms upward through the castle.

DONUT SECRET 1

 A lake bottom filled with Blurps and Cheep Cheeps. Rip van Fish can also be found napping. Don't wake them!

DONUT SECRET HOUSE

 A haunted house with all kinds of Boo Buddies. Mario must find the hidden door to make his escape.

DONUT SECRET 2

 An ice cave with slippery footing. Spike Tops climb the walls.

GREEN SWITCH PALACE

 The palace housing the Green Switch. If Mario can make use of the shells lying around, he may be able to get some 1-Ups.

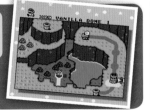

VANILLA DOME

An underground cave. If Mario can find and clear the secret courses, he emerges on top of the mountain.

VANILLA DOME 1

 A long series of cave passages with Buzzy Beetles walking along the narrow confines.

VANILLA DOME 2

 A cave at the bottom of a lake. Mario can make his getaway both underwater and on land.

VANILLA GHOST HOUSE

 Mario must jump across small platforms, avoiding Boo Buddies and floating Big Bubbles along the way.

VANILLA DOME 3

 To clear this course, Dinosaur Land's longest, Mario must ride the Skull Raft through a Blargg-infested lava lake.

VANILLA DOME 4

 Bullet Bills zoom around this challenging course. Take cover! At times, they're coming from all directions!

LEMMY'S CASTLE

 Magikoopas block Mario's path. Their magic attacks must be avoided, but can also prove useful in escaping.

INTRODUCTION CHARACTERS WORLD AND MORE

VANILLA SECRET 1

Use the Jumping Boards to spring up through the course. Once cleared, Mario emerges in Vanilla Heights.

RED SWITCH PALACE

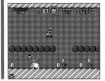

The Red Switch can be found in this palace, but first, Mario needs to get past the Koopa regiment.

VANILLA SECRET 2

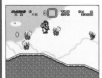

A grassland with a lot of slopes. Mario faces a huge battalion of Koopa Paratroopas in the second half.

VANILLA SECRET 3

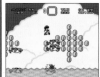

While Mario crosses over the ocean on the backs of Dolphins, a Porcupuffer skims the water's surface.

VANILLA FORTRESS

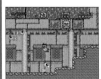

A flooded fortress with a lot of Ball 'n' Chains. Thwomps try to fall on Mario, even underwater.

TWIN BRIDGES AND COOKIE MOUNTAIN

Two bridges span the mountains. Mario will have to make his way across one way or the other.

CHEESE BRIDGE AREA

In the first half of this course, Mario must choose his path carefully! Ropes must be used to cross the second half.

COOKIE MOUNTAIN

The Sumo Brothers stomp their feet and Monty Moles burst out of the ground en masse in this panicky course.

LUDWIG'S CASTLE

To get to the end, Mario passes three very different areas. There are a lot of spikes in this castle.

SODA LAKE

In this underwater course, Torpedo Teds rocket toward Mario from left and right!

BUTTER BRIDGE 1

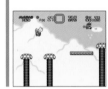

If Mario lingers too long on one of the scale-style platforms, the second platform will rise too high to cross.

BUTTER BRIDGE 2

Super Koopas fly around above this bridge, while Beach Koopas search for shells to chase after Mario.

FOREST OF ILLUSION

With numerous hidden goals and complicated roads, it's easy to get lost in this mysterious forest.

FOREST OF ILLUSION 1

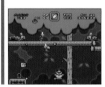

The trees seem alive in this forest. Watch out for Wiggler!

FOREST OF ILLUSION 2

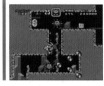

An underwater course much like a maze. Urchins block the narrow passages.

FOREST OF ILLUSION 3

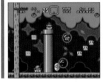

Enemy-filled bubbles pop and deploy their cargo once they hit a surface. Mario needs to find the hidden goal to get out of the forest.

FOREST OF ILLUSION 4

Lakitu are everywhere, coming from the sky and emerging from pipes, lobbing Spiny Eggs at Mario!

ROY'S CASTLE

Self-propelling Snake Blocks carry Mario across the fiery lake, Lava Bubbles flying in his path.

FOREST GHOST HOUSE

These narrow passages are filled with ghosts, and at the end, a huge group of Boo Buddies swarm Mario.

FOREST SECRET AREA

Mario must choose between two fast-flying lifts to clear this dizzying midair course.

FOREST FORTRESS

Grinders buzz around this cramped fortress. There are huge wooden beams falling in the first half.

BLUE SWITCH PALACE

The palace that houses the Blue Switch. If Mario uses the P Switches in the correct order, he can get some 1-Ups.

CHOCOLATE ISLAND

Filled with challenging courses, this brown, mountainous landscape is anything but sweet!

CHOCOLATE ISLAND 1

Dino-Rhinos and Dino-Torches attack! Mario is sent flying out of a Cannon Pipe across a bottomless pit.

CHOCO-GHOST HOUSE

Gaps in the floor move under Mario's feet, Eeries fly toward him from the side, and Fishin' Boos come from above.

CHOCOLATE ISLAND 2

The route changes depending on the amount of time left and the number of coins Mario has.

CHOCOLATE ISLAND 3

A tricky course filled with rotating lifts. Mario won't be able to go on unless he gets to the correct goal.

CHOCOLATE FORTRESS

A fortress with skewers and blazing fireballs. Thwomps and Thwimps fill the second half of the course.

CHOCOLATE ISLAND 4

A zigzagging cave with steep, tilted terrain. Use the diagonal lifts to get over the lava.

CHOCOLATE ISLAND 5

Items and Spinies are surrounded by blocks. Be careful using the P Switch!

WENDY'S CASTLE

Spiked Pillars and Grinders fill this course. A castle where Mario is assaulted by sharp objects.

CHOCOLATE SECRET

In the first half, Mario needs to jump over the platforms without stopping, or else they'll all sink into the lava.

SUNKEN GHOST SHIP

Tons of Boo Buddies lurk around this strange-looking sunken ship, which is the gateway to the Valley of Bowser.

VALLEY OF BOWSER

Bowser lurks here in his base—the eighth and final castle.

VALLEY OF BOWSER 1

Mega-Moles and Chargin' Chucks are found throughout this mazelike set of caves.

VALLEY OF BOWSER 2

As the only way out, a tunnel, moves up and down, Mario has to quickly find his path through so he won't be crushed.

VALLEY GHOST HOUSE

Press the P Switch and then dash! Mario has to find the right goal out of all the possible doors.

VALLEY OF BOWSER 3

A difficult, high-energy course filled with lifts that countdown before dropping.

VALLEY OF BOWSER 4

A cave with wellsprings of lava. Chargin' Chucks send rocks rolling toward Mario.

VALLEY FORTRESS

A fortress with huge, thorny spikes that slam up and down continuously from the floor and ceiling.

LARRY'S CASTLE

The Snake Blocks lead Mario through the course, but he must avoid the rotating Ball 'n' Chains on his way to the Boss.

BOWSER'S CASTLE

In both the first half and second half, there are four numbered doors. Choose any door to advance. Some routes are easier than others.

STAR WORLD

A special area up in the sky. In order to find this secret area, Mario must locate and clear certain hidden goals.

STAR WORLD 1

Dig your way into the massive number of Rotating Blocks by performing spin jumps.

STAR WORLD 2

The seabed is flat and easy to cross, but Mario's way is hindered by huge schools of Cheep Cheeps and Rip Van Fish.

STAR WORLD 3

The goal is just a few steps in front of Mario, but the hidden goal is way up in the sky above.

STAR WORLD 4

A strenuous course with a lot of Koopa Paratroopas. Mario can cross by using the rotating lifts.

STAR WORLD 5

Cross the valley by changing the Control Coins into blocks.

SPECIAL WORLD

A special area filled with very difficult courses!

GNARLY

In order to reach the exit, Mario has to climb up to the top and come way back down again.

TUBULAR

Mario must find and use the Power Balloons to cross the sky. Don't pause, just keep using them!

WAY COOL

Mario can change the routes with switches to make his way. If he makes a mistake, he falls headlong down the hole.

AWESOME

Enemies are overloaded on the slippery, frozen platforms. Cheep Cheeps swarm Mario in the second half.

GROOVY

The course that's featured on the title screen. The second half is filled with Pokeys.

MONDO

A course with a moving water current, where the floodwaters rise and fall. Mario should go right or left depending on the water level.

OUTRAGEOUS

A dark forest filled with tons of attacking Bullet Bills. The Fire Snakes on the ground are challenging as well.

FUNKY

The final course in the game. At the very end, there is a message to you, the player, written in coins.

ITEMS & OBSTACLES

Items and other things you find on the courses. Since Mario can take many more actions now, there are more traps, obstacles, and features!

! BLOCK
There are four colors, but the yellow and green ones have power-ups.

! SWITCH
Jumping on the ! Switch activates the ! Blocks of that color.

1-UP MUSHROOM
They give you an extra life. These can be found in Prize Blocks, Switch Palaces, and many other places.

10-COIN BLOCK
A block that spouts a series of up to ten coins as Mario hits it.

3-UP MOON
This will give you three extra lives.

BABY YOSHI
Feed him five items or any power-up item, and he grows into an adult Yoshi.

BALL 'N' CHAIN
These spiked balls spin around in a circle. Mario can pass unscathed through the chain part.

BERRY (GREEN)
If Yoshi eats one of them, the remaining course time is extended by twenty seconds.

BERRY (PINK)
If Yoshi eats two of them, he lays an egg that contains a bonus cloud.

BERRY (RED)
If Yoshi eats ten of them, he lays an egg with an item in it.

BIG BUBBLE
Huge green spheres that undulate in the air. They're found in Ghost Houses.

BILL BLASTER
The cannons that fire off Bullet Bills. They come at different heights.

BONUS BLOCK
If Mario gets thirty coins in one course, he can punch this to get a 1-Up Mushroom.

BONUS CLOUD
They float through the sky, dropping Smile Coins. If Mario collects all the coins, he gets a 1-Up Mushroom.

BOWSER STATUE (GOLD)
These statues follow Mario. If one touches him, he takes damage.

BOWSER STATUE (GRAY)
These stationary statues spit fireballs at regular intervals.

BUBBLE
Enemies and items float along within them. If Mario touches a bubble, its contents are released.

CAPE FEATHER
This magic feather powers Mario up to Cape Mario. An extra one can be stored.

CHAINSAW
They run along tracks. If Mario touches one, he takes damage.

COINS
Gather 100 regular coins and you'll earn an extra life.

COLUMN
These huge pillars are lowered from the ceiling. If Mario's underneath when they hit the ground, he loses a life.

CONTROL COIN
A line of coins that appear and advance depending on Mario's movements.

COUNTDOWN LIFT
Land on one and the clock starts ticking. When it reaches zero, it falls.

DECOY DOLL
They appear in Lemmy and Wendy's rooms. As the name indicates, they aren't real Koopalings.

DIAGONAL LIFT
Platforms that move in a diagonal direction. There are two types.

DOTTED LINE BLOCK
Find the Switch Palaces to fill these blocks in! Some blocks have items inside.

DRAGON COIN
Gather five Dragon Coins in one course and you'll earn an extra life. Dragon Coins also count as regular coins.

EMPTY BLOCK
Once a block is hit, it looks like this. Mario can climb on them.

ESCALATOR
Placed on steep slopes. If Mario boards one, it sends him upward automatically.

FENCE
Mario can climb up these panels. If he punches them, he can attack enemies climbing on the other side.

FIRE FLOWER
This power-up turns Mario into Fire Mario! An extra Fire Flower can be stored.

FIRE SNAKE
Their movement is made up of small jumps. After jumping, they emit a small flame.

FIREBALL
These fireballs fly straight ahead, sometimes from the mouths of Bowser Statues.

FLOATING ISLAND
They float on the water's surface, but once Mario lands on one, his weight causes it to sink.

FLOATING MINE
They float downstream and fall from the sky. Touch one and Mario takes damage.

FLYING ? BLOCK
Mario can catch a lift on these winged blocks. Hitting one will remove its wings.

FLYING PLATFORM
These lifts can carry Mario through a course. If the Amazin' Flyin' Hammer Bros. are aboard, the lifts swing in an arc.

GHOST GAP
These are only found in Ghost Houses. They're holes in the floor that move right and left.

GIANT GATE
Pass through to clear a course. Touch the tape to receive stars.

GRAB BLOCK
Mario can hold or throw this block.

HIDDEN BLOCK
There doesn't seem to be anything there . . . but if Mario jumps, a block appears. Some also contain coins or items.

ICE BLOCK
Slippery blocks that Mario can break with a spin jump.

JUMP BLOCK
This block bounces along and sometimes throws out items.

JUMPING BOARD
Time it right and Mario can do a super high jump.

KEY
Mario must be holding a key to pass through the keyhole.

KEYHOLE

If Mario holds a key and touches the keyhole, he has found a hidden goal!

KOOPA SHELL

An empty Koopa shell that can be picked up or thrown. Some can be found lying right in the middle of a course.

LAUNCH PAD

These skull-marked boxes fire Torpedo Teds. A gloved hand reaches out of it, launching the missile.

LAVA

One touch and Mario will have to retry the course. Lava Bubbles and Blarggs reside in lava-covered courses.

MAGIC BALL

A curious treasure found within the sunken ship. Get this item to clear the course.

MESSAGE BLOCK

This gives Mario hints and advice during the game.

MIDWAY GATE

If Mario crosses the checkpoint, he becomes Super Mario. Mario will restart from this point when retrying the course.

MUSHROOM SCALE

They come in sets of two. When Mario gets on one, it moves downward, and the other moves up.

O/X BLOCK

In bonus rooms, Mario can hit them to try to line up three "O" marks in a row. If he does, he gets a 1-Up Mushroom.

ON/OFF SWITCH

A switch to turn mechanisms on and off. It also switches platform routes.

P SWITCH

This switch turns certain objects into coins and vice-versa.

P SWITCH (GRAY)

If Mario uses this switch, enemies turn into silver coins.

PIPE

Mario can stand on them or use them as a way to warp from one place to another.

PIPE CANNON

A cannon-like pipe that shoots Mario out at high speed.

PLATFORM

Some types run back and forth, others fall an instant after Mario lands on them, and some types float on water.

POWER BALLOON

Mario's body will swell up when he has these, which will allow him to drift through the sky for a fixed amount of time.

PRIZE BLOCK

Hit this from beneath to get a coin or item.

RAIL PLATFORM

These lifts advance Mario through a course. Their movement is directed by railings.

REVOLVING DOOR

Mario can punch this square panel of fence and it will spin him to the other side.

ROPE

When Mario grabs one of these ropes, it runs along the rails. He can climb up and down along the ropes while riding.

ROTATING BLOCK

Hit this block and it will rotate for a fixed amount of time.

ROULETTE BLOCK

The items run through a quick sequence until Mario hits it. The item he receives changes depending on his timing!

SILVER COIN

Gray P Switches turn enemies into silver coins. Grabbing many silver coins in one go yields multiple 1-Ups.

SKEWER

They extend from the ground and the ceiling. Mario takes damage if he gets poked by one.

SKULL RAFT

This platform helps Mario traverse lava. If it heads down a slope, the skulls separate a bit.

SNAKE BLOCKS

A line of connected blocks you can stand on. When you get on board, it travels a specific route.

SPIKE

If Mario touches them, he takes damage. There's a type that also falls from the ceiling when Mario is nearby.

SPIKED PILLAR

They slam down with force! If Mario touches one, he takes damage.

SPOT LIGHT

It shines, illuminating the area around Mario. If you hit the block, it flashes.

SPRING BOARD

Jumping on these boards launches Mario into the air. The closer Mario is to the end of the board, the higher he jumps.

STRETCH BLOCK

They stretch out into a wide platform then shrink again at set intervals. Some stretch horizontally and others vertically.

STRONG CURRENT

Water flows strongly in one direction, rising and receding as Mario proceeds.

SUPER MUSHROOM

With this, you can power up to Super Mario! You can stock up with an extra.

SUPER STAR

They make Mario invincible.

SWINGING PLATFORM

Lifts that rotate. Some lifts only move when Mario jumps on board.

TRIANGULAR BLOCK

These allow Mario to run up walls. If Yoshi steps on one, he jumps high into the air.

VINE

A beanstalk appears from the block and stretches up to the sky. Mario can grab on and climb up.

YOSHI'S EGG

There's always something fun inside one of these! If the Yoshi you are riding lays an egg, you get a special item.

YOSHI'S WINGS

These wings allow Yoshi to fly.

AND MORE

MEMORABLE MOMENTS

Unforgettable scenes, updated features, and the first appearance of a brand-new friend, Yoshi! Here are some of the most noteworthy highlights from the game.

MEET YOSHI

Mario's adventure kicks off at Yoshi's home. A message block lets you know that he's off on a journey, but the first time you actually see Yoshi is on Yoshi's Island Course 2.

SCAREDY YOSHI

Yoshi doesn't accompany Mario into ghost houses, fortresses, or castles. He patiently waits for his friend outside.

POCKETS ON MARIO'S BUTT!

In this game, getting a view of Mario's rear end—especially when he's climbing chain-link fences—reveals that there are pockets on his overalls.

BONUS GAME TIME

If Mario crosses the goal tape at the very top, he gets fifty bonus stars and a 3-Up. When he crosses the goal with more than a hundred bonus stars, the bonus game starts. Whenever three of the same image line up either vertically, horizontally, or diagonally, he receives a 1-Up Mushroom.

KOOPAS ON TWO LEGS

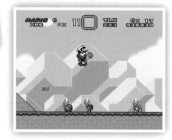

This is the first game that depicts Koopas walking on two legs. When Mario jumps on them, the Koopas are ejected from their shells. This game also features four shell colors, and each has special properties. There's a lot to learn about Koopas in this game!

RIDE ON LAKITU'S CLOUD!

If Mario defeats Lakitu by hitting him from below with an empty Koopa shell, the Lakitu falls, but the cloud remains. Then he can board the cloud and ride on it. This feature was passed down to the *New Super Mario Bros.* series.

THE BIG BOO PEEKS

Like all the Boo Buddies, the Big Boo gets really shy when Mario turns to face him. But if he keeps looking, for just a moment, Big Boo will lower his hands and glance to see what he is doing.

MARIO EXPERTS ONLY!

Upon finding the hidden goal in Star World Course 5, Mario can go to an even harder Special World. If you wait a while on the Special World map, you begin to hear a new arrangement of the original *Super Mario Bros.* above-ground background music.

LOOK FAMILIAR?

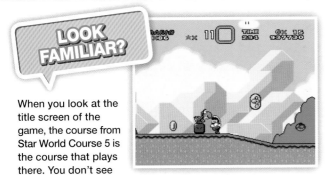

When you look at the title screen of the game, the course from Star World Course 5 is the course that plays there. You don't see this from just looking at the title screen, but the second half of the course is filled with Pokeys.

WELCOME TO WONDERLAND

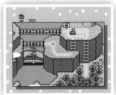

When you clear all the courses in the Special World, you gain access to the secret world. The colors of Dinosaur Land change, and some of the enemy graphics change, too. The Koopas are all wearing masks that look like Mario!

HELPFUL HINTS & TECHNIQUES

Here are some techniques to help you get through Dinosaur Land! The button instructions refer to the SNES, for which the game was originally intended.

THE WRIGGLER STEP SEQUENCE

In the Forest of Illusion, there are a series of Koopas and Wrigglers. If Mario steps on the Wigglers enough, not only do their expressions change, so do the sprites representing 1-Ups. This action gives you additional lives and increases your coin score at the same time.

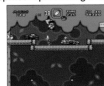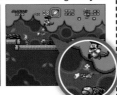

THE REGENERATING P SWITCH!

P Switches normally vanish when Mario steps on them. However, if Yoshi accompanies Mario, he can quickly eat the P Switch immediately after Mario steps on it, but before it disappears. Yoshi can then spit a fresh P Switch out, ready to be switched again.

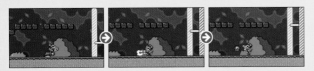

THREE IN A ROW!

If Mario can change the blocks in the bonus area so that all three are reading "O" marks, you get a 1-Up Mushroom. It's hard to get it right by attacking them the regular way, but if Mario uses a cape twirl attack from the left side of the block, the correct symbol appears.

FIND THE TOP SECRET AREA!

Clearing the hidden goal in the Donut Plains Ghost House opens the way to the Donut Plains Top Secret Area. It's a small, one-screen course with nothing more than some Prize Blocks containing a Yoshi and power-up items. Simple, yet effective!

THE MATERIALIZING 1-UP MUSHROOM

When Mario goes through certain areas or makes a full revolution around certain blocks, suddenly a 1-Up Mushroom will appear out of nowhere. There are fourteen locations for this in all.

A PERFECT SCORE . . . 96!

The number next to your save file is the number of goals you've been through, including both normal and hidden goals. Courses with both a regular goal and a hidden goal get you two more. After going through all of the goals, the highest number you can get is 96.

CAPE FLYING 101

While Mario is flying with the cape, you can press the X Button (or if you're flying using the X Button, then press the Y Button) to change Mario's direction. Additionally, if you press the B Button, it will slow Mario's flight every time you press the button.

MARIO'S JUGGLING ACT

Mario can carry items and climb vines, but usually not both at the same time! However, by throwing an item into the air and climbing a vine while holding the Y Button, he can accomplish this feat. Mario will catch the item and climb the vine while holding it.

ITEM SWAP!

If Mario is holding items such as a shell or a P Switch when he crosses the Giant Gate, they change to a power-up item. What they change into depends on how Mario is powered up at the time. Additionally, if Mario goes through the Giant Gate as Balloon Mario, an item appears out of thin air.

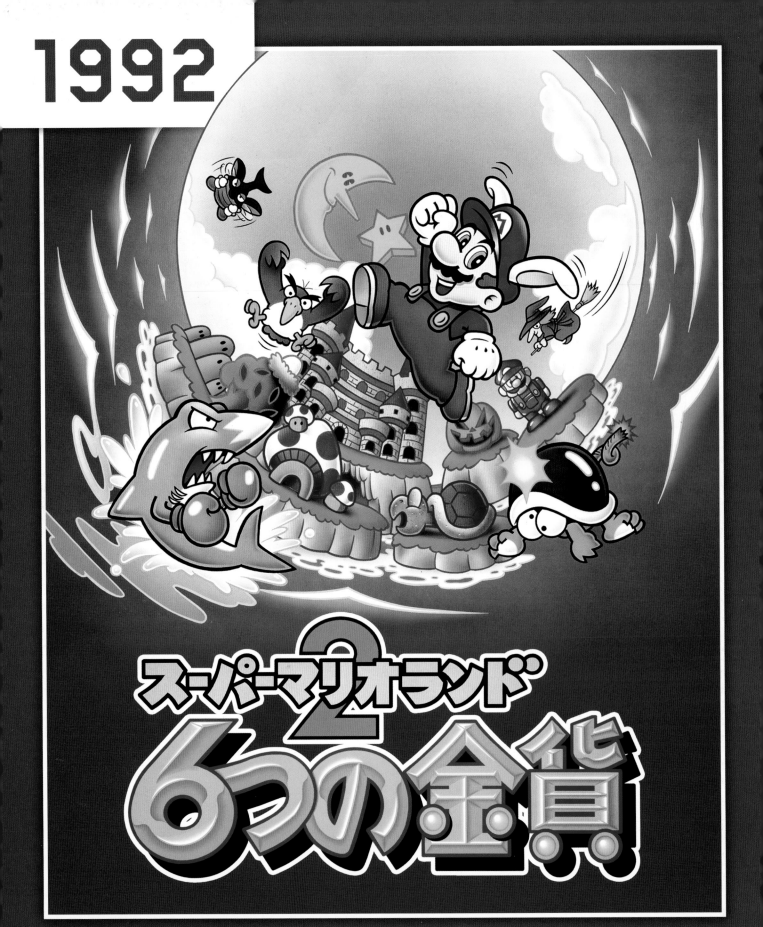

スーパーマリオランド2 6つの金貨

Package

Game Pak

Instruction Booklet

System: Game Boy

Release Date:
November 1, 1992
(Japan: October 21, 1992)

Player Count: 1

INTRODUCTION

STORY

*This text is taken directly from the instruction booklet.

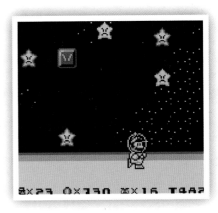

Danger! Danger!

While I was away crusading against the mystery alien Tatanga in Sarasaland, an evil creep took over my castle and put the people of Mario Land under his control with a magic spell. This intruder goes by the name of Wario. He has been jealous of my popularity ever since we were boys, and has tried to steal my castle many times. It seems he has succeeded this time.

Wario has scattered the 6 Golden Coins from my castle all over Mario Land. These Golden Coins are guarded by those under Wario's spell. Without these coins, we can't get into the castle to deal with Wario.

We must collect the 6 coins, attack Wario in the castle, and save everybody!

FEATURES

MARIO VS. WARIO

This is the second game in the *Super Mario Land* series, which started with the release of the Game Boy system. After the previous game, Wario took over Mario's castle and now Mario's on a quest to get it back. To do so, he'll have to collect all six golden coins, which will become the keys to victory! Mario must defeat the boss characters of all six zones. You can begin the adventure anywhere you like.

NEW FEATURES

The character sprites are larger than those in *Super Mario Land*, and the setting feels a lot closer to *Super Mario World*. Other features include a world map and the ability to save—this game has evolved for a new age! On the other hand, you don't get a 1-Up just for collecting one hundred coins. Still, it's equipped with an easy mode and has many other unique features.

CHARACTERS

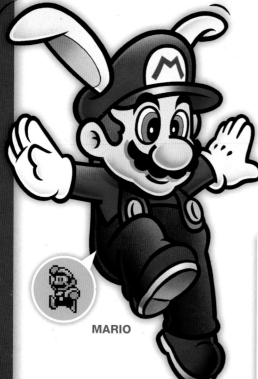

MARIO

This game follows the tradition set by *Super Mario Land,* making it a solo adventure for Mario.

POWER-UPS

Some special items grant unique abilities. In certain areas, they take on unusual shapes.

MARIO

This is how Mario starts the game. He cannot break blocks or perform a spin jump.

SUPER MARIO
ITEM ➡ MUSHROOM

This allows Mario to break blocks with moves like the spin jump. If Fire Mario or Bunny Mario grab a mushroom, they'll turn back into Super Mario.

FIRE MARIO
ITEM ➡ FIRE FLOWER

He can attack enemies with fireballs and break fire blocks. You can identify him by the feather in his cap.

INVINCIBLE MARIO
ITEM ➡ STAR

Mario can defeat enemies just by touching them. If he defeats five in a row, you'll get a 1-Up.

BUNNY MARIO
ITEM ➡ CARROT

Bunny Mario can jump much higher, and if you hold the button down, he'll bounce in a sequence of jumps. After he jumps, if you hold down the button, he'll float gently to the ground.

A BUILT-IN POWER-UP SPACE MARIO

In the Space Zone, Mario can't dash, but his jumps are longer and slower.

A BUILT-IN POWER-UP AQUA MARIO

This version of Mario swims through the water. He can't attack by jumping and stomping on enemies.

A BUILT-IN POWER-UP BUBBLE MARIO

Mario floats through the air inside a bubble. The bubble will burst if it touches something, like water or an enemy.

ENEMIES

You'll encounter these enemies on the courses. With a few exceptions, the enemies are unique to their zones. This creates an abundance of different enemies to defeat!

ANT
They walk along the ground. Identify them by their antennae.

AQUA KURIBO
A type of Goomba that lives in the whale's belly. They move like regular Goombas.

BATTLE BEETLE
They start out walking, but when one reaches a cliff, it spreads its wings and takes off.

BE
These enemies don't attack. When Mario gets too close, they just fly away.

BEAR
If Mario defeats one, he can take its ball and roll along on top.

BERO
These ghostly paper lanterns stick their tongues out. Mario takes damage if he touches its tongue.

BIBI
They protect the entrance to the beehive by diving toward Mario to attack.

BIRD
The boss of the Tree Zone. It moves back and forth in big, sweeping arcs.

BLURP
They swim through the water, pausing every now and then.

BOMUBOMU
They can fire cannonballs horizontally or diagonally. They come in three different shades.

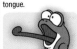
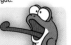

BOO
When Mario's looking at one, it stops moving. Turn away, and it comes after him.
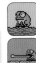

BOPPING TOADY
They jump around constantly. Every now and then, they stop and stick out their tongue.
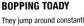

BUCHO
One of the Three Little Pigheads. This one lives in a wooden house and moves in short hops.

BUICHI
They can't move much, but when Mario approaches they fall straight down.

BULLET BILL
They shoot out of Bill Blasters and fly straight forward.

BUPON
This member of the Three Little Pigheads lives in a brick house and moves with big, arching bounces.

BURO
One of the Three Little Pigheads, who lives in a straw house. He rolls around on the ground.

CHEEP CHEEP
They can move vertically or horizontally, and when they hit an obstacle they turn around.

CHIKUNTO
This type of Ant walks for a while, then stops and shoots spikes from its body.

DOKANTO
Ants with cannons on their heads that shoot little cannonballs.

DONDON
These flying enemies move in straight lines through the sky.

FIREBALL BOY
These fireballs move in a figure-eight shape through the air.

FALLING SPIKE
They camouflage with other spikes on the ceiling, and when Mario gets close they try to fall on him.

FIRE PIRANHA PLANT
They pop their heads out of pipes to shoot fireballs at Mario.

FLOATING FACE
They bounce off the walls in their rooms.

FURIKO
These are a smaller version of the Furizo.

FURIZO
A spiked ball that moves in a half-circle shape.

GENKOTTSU
A fist with spiked brass knuckles that moves up and down quickly. It's activated by a switch.

GOOMBA
They walk along the ground, furrowing their eyebrows. There are many ways to defeat them.

GORONTO
This Ant uses his shovel to dig up rocks and boulders, then sends them after Mario.

GRUBBY
A slug with stingers. Don't step on one—it will hurt!

HONEBON
These skeletal fish swim diagonally through the water.

JACK-IN-THE-BOX
They leap out of ? Blocks and bounce around.

KARAKARA
After a big jump, they open their umbrellas and drift slowly down.

KARAMENBO
A pillar covered in thorns. When Mario gets close, it tries to fall on top of him.

KEIPU
She steals 1-Up hearts from Mario, then retreats at lightning speed.

KIDDOKATTO
A tiny soldier that marches blindly forward.

KOOPA TROOPA
They walk in a straight line and turn around when they reach a cliff. When Mario stomps on one, it hides in its shell.

KUROKYURA
It stays in one place and sends Minikyuras after Mario.

KYORORO
It waits until it sees Mario, then charges quickly toward him!

KYOTONBO
They fly slowly toward Mario.

MASKED GHOUL
They walk straight ahead. Despite their fearsome appearance, Mario can defeat them with just one stomp.

MINIKYURA
These small bats released by the Kurokyura fly diagonally upward.

MOGYO
A cow-like fish with huge horns that swims back and forth through the tree sap.

NEIJI
A screwlike enemy that shoots out of the ground and jumps very high.

NO.48
Aliens who come from the same sector of space as Tatanga. Exploding stars come out of their heads.

NOKO BOMBETTE
A turtle with a bomb on its back. Beware! This armed reptile explodes if Mario stomps on top.

OCTOPUS
The Turtle Zone's boss. It shoots baby octopuses out of its mouth to attack.

PARAGOOMBA
When Mario jumps on one, it loses its wings and becomes a normal Goomba.

PIKKU
This enemy looks like an octopus tentacle. It jumps left and right.

PIRANHA PLANT
They pop out of pipes. Sometimes they descend from upside-down pipes.

PORO
These spaceships move around small areas in the Space Zone.

RAGUMO
When Mario gets close, they come out of the ground and advance toward him.

RERERE
These magic brooms were ordered by the Witch to clean up. They move in arcs.

SATELLITE
They can be found orbiting around spheres. If Mario touches the spikes, he takes damage.

SEWER RAT
The boss of the Macro Zone runs up walls and through pipes that take him to the other side of the screen.

SHARK
They swim back and forth through the water. When Mario approaches, they zoom toward him.

SKELETON BEE
Even if Mario stomps on this bony bumble bee, it will come back to life.

SPIKED BALL
They move up and down on chains. They pause for a moment before turning around.

SPIKEY
They build up power for an electric shock. Mario can't jump on them when they're curled up.

SPINY CHEEP CHEEP
When they're puffed up, they move up and down. When they're deflated, they move left and right.

SUTAZU
These stars floating in space are enemies, so if Mario touches one he'll take damage.

TAMARA
Eggs from the Bibi. They jump straight up from their tall nests.

TATANGA
The boss of the Space Zone. He attacks with two different types of projectiles.

TATENOKO
They zigzag along a set path. If Mario touches one, he takes damage.

TEREKURIBO
A Goomba that's become a ghost. It moves in zigzags through the air.

TORIUO
Part fish, part bird. They jump along the water's surface.

TOSENBO
They block Mario's path by expanding. When they shrink, Mario can get through.

UNERA
A cute baby insect. They crawl around in the beehive.

UNIBO
They're still until Mario approaches, then they start to move up and down.

WAKIRI
Buzz saws that move in a straight line. They are found on the ground and ceiling.

WARIO
He has three different types of attacks and special black power-up items.

WITCH
The boss of the Pumpkin Zone. She teleports and throws magical fireballs.

YASHICHI
Their blades spin as they move along shafts, either vertical or horizontal.

OTHER CHARACTERS

One other character supports Mario during his adventure.

HEAVY ZED
An owl found in the Tree Zone. He's usually asleep, but if Mario climbs on, he'll wake up and give Mario a ride.

WORLD

COURSES

There are six distinctly different Zones, plus Wario's Castle. All in all, thirty-two levels await!

MARIO LAND

The island where Mario's adventure begins. There are two courses here.

GATE COURSE

The entrance to Mario Land. You'll encounter many of your favorite Mario enemies.

SCENIC COURSE

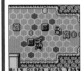

A scrolling course that's full of Goombas and Paragoombas.

TREE ZONE

This stage is a huge tree! Climb through the levels to reach the top.

TREE TRUNK COURSE

Many enemies live at the base of this huge tree. There are two paths: aboveground and underground.

ROOTS COURSE

Inside the tree there are areas filled with sap and thorny footholds.

BEE HIVE COURSE

The Bibi live in this hive. It's full of little rooms.

LEAF COURSE

Trek through the top of the tree, jumping between leaves and lifts.

OWL COURSE

Footholds are hard to find in the treetop. Heavy Zed helps Mario across the sky.

SECRET COURSE 1

These hills are infested with Koopa Troopas! Get through easily by slinging shells.

SPACE ZONE

Don your space suit and blast off! The controls feel different here.

BUBBLE COURSE

Become Bubble Mario and travel above the sea. There are two end goals in this level.

MOON COURSE

This zigzagging course is filled with spikes. Jump high in the low gravity!

STAR COURSE

As Mario flies through space, he's surrounded by Sutazu. This course never stops scrolling.

SECRET COURSE 2

Lots of coins are lined up here, but Mario can't reach them if he falls into the lower path.

MACRO ZONE

Tiny Mario has an adventure in a huge house. The Ants are enormous!

MANHOLE COURSE

Follow a path below the ground. This course is filled with Ants.

FLOWER COURSE

Travel through the water pipes and the yard to reach the house. Watch out for the potted Piranha Plants!

FIREPLACE COURSE

From arrow blocks to fire, there are lots of mechanisms and traps in this level.

ATTIC COURSE

Huge books are piled up, and Keipu are hiding in some of the blocks.

SECRET COURSE 3

A scrolling course where the route is different depending on Mario's power-up.

PUMPKIN ZONE

A creepy building filled with ghostly enemies. It has two spooky secret courses.

BAT COURSE

Traverse the narrow passages, dodging the spiked balls and falling spikes.

GRAVEYARD COURSE

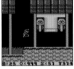

A graveyard where ghosts and monsters gather. Get across on the roofs.

HAUNTED HOUSE COURSE

Terekuribo and Boos are loitering in this mansion. Don't trust the footholds!

WITCH'S MANSION COURSE

This is where the Witch lives. It's filled with suspicious cauldrons and other vessels.

SECRET COURSE 4

A bonus course up in the sky, with loads of coins.

SECRET COURSE 5

Open a path with fireballs to get through the fire blocks that fill this course.

MARIO ZONE

A huge tin toy in the shape of Mario.

GEAR COURSE

The gears turn and move the Tatenokos and Yashichis.

GUMBALL COURSE

This course has a long line of gumballs to walk across. Ride a ball over the thorns.

CRANE COURSE

A narrow course where enemies move back and forth. Use the crane machines to progress.

BLOCK COURSE

A course made from toy bricks. There are a lot of sharp-edged enemies, like Wakiri.

TURTLE ZONE

A zone under the sea. There's a huge sunken ship down here!

CHEEP CHEEP COURSE

There are Blurps and Cheep Cheeps in the shallows. Avoid the boulders as you go.

SUNKEN SHIP COURSE

This maze-like level takes Mario through the water and over dry land.

INTRODUCTION CHARACTERS WORLD AND MORE

WHALE COURSE

Mario goes inside the whale. Lots of sharp ribs poke out from above and below.

SECRET COURSE 6

Coins are lined up to form letters. Read the message as Mario moves through.

WARIO'S CASTLE

Once Mario's gathered all six coins, you can enter the final battle!

INSIDE WARIO'S CASTLE

There are three levels. The traps and enemies change from one room to the next.

ITEMS & OBSTACLES

Here are some of the items and other elements that appear in the levels. This game feels very different from *Super Mario Land,* but the fact that the 1-Up is a heart is the same.

? BLOCK

Most hold coins or items . . . but some contain a Jack-in-the-Box!

1-UP HEART

They give you an extra life.

3-UP HEART

Find them in the bonus games. When you get one, you gain three lives.

ARROW BLOCK

Get on and Mario moves in the direction of the arrow. They point either left or right.

BILL BLASTER

Two-barrel cannons that fire Bullet Bills toward Mario.

BLOCK

Small Mario can't break these, but any other Mario can. Sometimes they hold items.

BONE BLOCK

When Mario steps on, it starts to crumble.

BONE LIFT

A platform that starts to fall as Mario steps on. Sometimes it rises a bit before the fall.

BONUS BELL

If Mario rings the bonus bell before reaching the goal, you get to play the bonus game.

CARROT

These turn Mario into Bunny Mario.

CHAIN BALL

When Mario steps on, it starts moving. It follows the chains in a zigzag motion.

MID-POINT BELL

If Mario rings it, then loses a life, you start again at the bell rather than the course start.

CLOUD LIFT

Clouds that move right and left. Mario can hop on and ride them.

COIN

You can collect up to 999 to use in the slot game.

CONVEYOR BELT

Step on and they take Mario a short distance. Some go right, while others go left.

CRANE

If Mario stands below, it will pick him up and carry him along the track.

FIRE

You'll find it on some courses. If Mario touches it, he'll take damage.

FIRE BLOCK

They can only be destroyed by fireballs. Some contain items.

FIRE FLOWER

Mario can use this to turn into Fire Mario.

FIRE PIRANHA PLANT

They come in two different sizes, and spit fireballs from their mouths.

FLASHING BLOCK

They vanish sometimes, but Mario can stand on them even when they're invisible.

GEAR (HORIZONTAL)

If Mario gets on, he's moved left or right. If he stays too long, they fall.

GEAR (VERTICAL)

When Mario stands on one, he moves down. If he goes below halfway, he falls off.

GOAL

The official end of the course. There's usually a bonus bell nearby.

GOLDEN COIN

Defeat each zone's boss to collect all six and enter Wario's Castle.

HIDDEN BLOCK

They appear out of nowhere. Some contain items.

HIDDEN GOAL

This door marked by a star allows you to reach a hidden course.

HIPPO STATUE

Bubbles come out of its nose. Touch one to become Bubble Mario.

LANCE

They move in a set rhythm. If Mario touches one, he'll take damage.

LAVA

It appears in the Manhole Course and in Wario's Castle. If Mario touches it, he'll lose a life.

LIFT

These thin platforms start to move once Mario boards them. Sometimes they fall instead.

LIGHT BULB

They appear in Wario's throne room. They swing left and right, then fall when Wario stomps.

MONEY BAG

Bags that hold fifty coins. Most of them are hidden.

MUSHROOM

Grab one and power up to Super Mario.

PIPE

Some hide Piranha Plants, but Mario can move through others.

PROPELLER LIFT

They move right or left. Stand on top and it carries Mario. They're narrow but can move very fast.

SAP

Mario's movement slows when he's in sap. Bounce across the top with a series of jumps.

SPIKED BALL

They cause damage if Mario touches one. Some are up in the air.

SPIKES

Touch them and he'll take damage. They look different depending on the area.

STAR

It powers you up to Invincible Mario. Find one by defeating one hundred enemies.

WITCH'S CAULDRON

Find them when you battle the Witch. After a fire is lit below, it overflows and the lid flies up.

AND MORE

MEMORABLE MOMENTS

Here are some of the scenes that made a strong impression, as well as other features unique to this game. We haven't forgotten that this is the first appearance of Wario!

GRAB SHELLS... AND WEAR THEM!

In this game, when Mario picks up a shell, he doesn't hold it in his hands—he places it on his head. If he jumps and hits a block with a shell on his head, the shell vanishes.

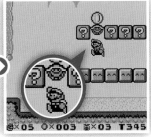

TWO BONUS GAMES

In most of the courses, there's a bonus bell just before reaching the goal. If Mario rings it, you get to play a bonus game. One is a crane game, where you have to time it just right to pick up an item. The other is a follow-the-path game. The more items you already have, the more 3-Up hearts are available in the crane game.

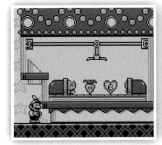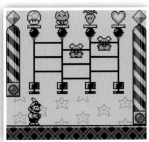

PLAY THE CASINO

In most other games in the series, collecting one hundred coins will grant you a 1-Up. In this game, there are four kinds of slot machines to play: thirty coins, fifty coins, 200 coins, and 999 coins. The items you receive vary between the machines.

MARIO'S FIRST MOONWALK

The Space Zone is the first time in the series that Mario goes into space. He wears a space suit and moves along in low-gravity jumps.

REMATCH WITH TATANGA!

In *Super Mario Land*, the final boss was Tatanga. He returns here as boss of the Space Zone! He's exchanged Pagosu for a new machine, and he's ready for a rematch with Mario!

SPOOKY MUSIC

In the Pumpkin Zone's Haunted House stage, the background music is a rearrangement of the coin room music from *Super Mario Land*. This is the only course in the game with that music.

THE N&B BLOCK

In the Block Course in the Mario Zone, "N&B" is written on one brick. It's a reference to a series of block-based toys that Nintendo put out starting in 1968.

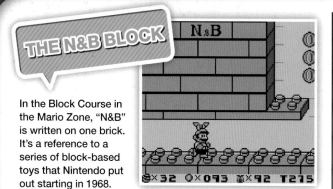

WARIO'S DEBUT

This is the first appearance of the self-proclaimed "greatest rival to Mario," Wario. He becomes a main character in *Super Mario Land 3: Wario Land*. After that, he continues as the lead character in the Wario Land series. Witness here the start of Wario's constant quest for coins and a castle.

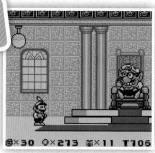

A CHANGING MAP

Every Zone has secret courses (with the exception of the Mario Zone). When you clear one and then go back to the map, you may notice a change. In the Pumpkin Zone, for example, the pumpkin's eyes have pupils and Boos come out to dance.

BOMB MARIO?!

On the File Select screen, if you press the "clear" button, Mario's body transforms into a bomb. If he enters a pipe in that form, the corresponding save file is erased.

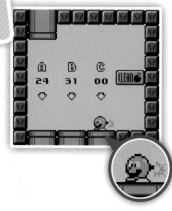

HIDDEN BACKGROUND MUSIC

If you leave the Game Over screen as it is for about two and a half minutes, strange music will start playing. The melody is used as a hidden BGM in other games and is not limited to the Mario series.

HELPFUL HINTS & TECHNIQUES

This is the only game in the series with an Easy Mode, but you might still want to know these tricks for your adventure.

EASY MODE

If you press the Select Button on the File Select screen, Mario becomes small and the game is now set in Easy Mode. There are fewer enemies and the traps become slower and easier to handle.

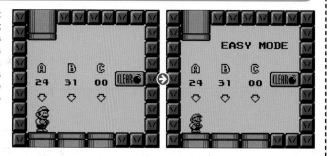

DEMO PLAY

On the title screen, if you press certain buttons along with Select, you can play on the Demo Screen. Pressing up on the +Control Pad sends you to the Gate Course. Up and A together unlocks the Bubble Course. Up and B together will get you to the Cheep Cheep Course. And pressing Up, A, and B, as well as Select, takes you to the Manhole Course.

INTRODUCTION CHARACTERS WORLD AND MORE

THE MARIO FAMILY'S
SPIN-OFF GAMES

There are a lot of characters in the Mario Family who broke out to become the stars of their own games. This is one family brimming with adventures!

LUIGI

Usually Luigi is lost in the shadow of his big brother, Mario. But that all changed with a game called *Luigi's Mansion*, which debuted in 2001 for the Nintendo GameCube console. This time around, Mario is lured and captured inside a creepy mansion estate, so Luigi must face his fears to go on an ever-expanding adventure. Luigi is armed with a ghost vacuum cleaner—the Poltergust 3000—a weapon developed by Professor Elvin Gadd, the ghost scientist. Fun fact: it was Professor E. Gadd who developed "F.L.U.D.D." for Mario in the Nintendo GameCube game, *Super Mario Sunshine*.

In 2013, the next game in the series, *Luigi's Mansion: Dark Moon*, debuted for the Nintendo 3DS system. 2013 marked thirty years since Luigi was introduced, and to commemorate it, he starred in *New Super Luigi U* for the Wii U console as the main character.

LUIGI'S MANSION
NINTENDO GAMECUBE
NOVEMBER 18, 2001
©2001 NINTENDO

LUIGI'S MANSION: DARK MOON
NINTENDO 3DS
MARCH, 24, 2013
©2013 NINTENDO

PEACH

Princess Peach was a playable character in *Super Mario Bros. 2*, but her first turn as the main character wasn't until 2005 when *Super Princess Peach* debuted on Nintendo DS. In this 2D scrolling action game, it was up to Peach to rescue Mario and Luigi—turns out, it was their turn to be kidnapped by Bowser! In her great efforts to rescue Mario and Luigi, she commanded her emotional powers, or Vibes, in order to power-up. She faced the ever-expanding adventure with her parasol partner, Perry.

SUPER PRINCESS PEACH
NINTENDO DS | FEBRUARY 27, 2006
© 2005 NINTENDO

TOAD AND CAPTAIN TOAD

The first time Toad was the main character of a story was in 1994 when *Wario's Woods* was released for the NES and SNES. It was a puzzle-action game in which Toad had to fight monsters to save the Peaceful Woods from the iron clutches of Wario. Toad makes good use of the experience he earned in *Super Mario Bros. 2*, using his abilities to throw enemies, bombs, and other things.

Captain Toad—not to be confused with Toad himself—made his first appearance in *Super Mario Galaxy*, but he became the main character in the 2014 Wii U adventure game *Captain Toad: Treasure Tracker*. In it, Captain Toad and Toadette wandered through what appeared to be miniature garden dioramas in search of Power Stars. Its story is closely connected to *Super Mario 3D World*, and in certain portions the power-ups and enemies are the same.

WARIO'S WOODS
NES
DECEMBER 10, 1994
©1994 NINTENDO

CAPTAIN TOAD: TREASURE TRACKER
WII U
DECEMBER 5, 2014
©2014 NINTENDO

YOSHI

It was only one year after Yoshi's debut in *Super Mario World* before he starred as the main character in his own self-titled adventure, *Yoshi!* After that, Yoshi is hard at work in puzzle games such as *Yoshi's Cookie* and *Tetris Attack*. An action game, *Super Mario World 2: Yoshi's Island*, followed and spawned an entire series of games; in them, Mario and his friends are still babies and Yoshi throws eggs to attack enemies and interact with the environment. Eventually, this series became the most representative of Yoshi's games.

YOSHI
NES
JUNE 1, 1992
©1991 NINTENDO

SUPER MARIO WORLD 2: YOSHI'S ISLAND
SNES
OCTOBER, 4, 1995
©1995 NINTENDO

WARIO

In *Super Mario Land 2: 6 Golden Coins*, Mario's castle was stolen by a guy he'd known since childhood—Wario. The sequel, *Wario Land: Super Mario Land 3*, was released in 1994; at that point, Wario took his place as the lead character of the series. After that, it came to be called the *Wario Land* series. In these games, Wario chases after money and adventure. In 2003's *WarioWare, Inc: Mega Microgame$!* for Game Boy Advance, Wario made himself the president of his own company, WarioWare, Inc. As a result, *WarioWare* became a series of games featuring all kinds of plots where Wario tries to get his hands on more and more money.

WARIO LAND: SUPER MARIO LAND 3
GAME BOY
MARCH 13, 1994
©1994 NINTENDO

GAME & WARIO
WII U
JUNE, 23, 2013
©2013 NINTENDO CO-DEVELOPED BY INTELLIGENT SYSTEMS

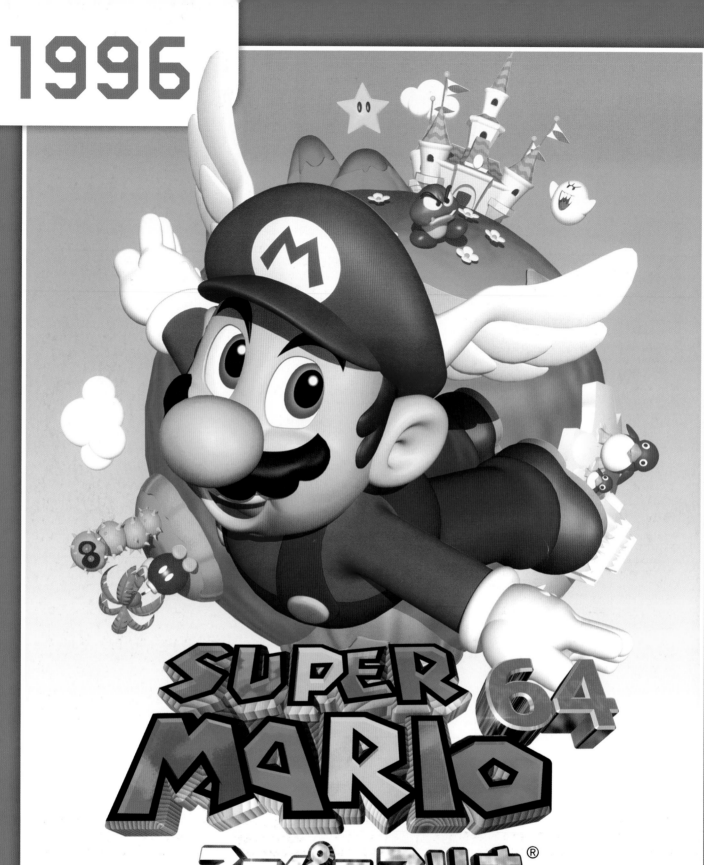

SUPER MARIO 64

スーパーマリオ®

Package	Game Pak	Instruction Booklet

System: **Nintendo 64**
Release Date:
September 29, 1996
(Japan: June 23, 1996)
Player Count: **1**

INTRODUCTION

S T O R Y

*This text is taken directly from the instruction booklet.

Will Princess Toadstool be kidnapped again? Is there no end to the constant feuding between Mario and Bowser?

"Mario, please come to the castle. I've baked a cake for you. Yours truly, Princess Toadstool."

"Wow, an invitation from Peach! I'll head out right away. I hope she can wait for me!"

Mario is so excited to receive the invitation from the Princess, who lives in the Mushroom Castle, that he quickly dresses in his best and leaves right away.

"Hmmm, something's not quite right here . . . It's so quiet . . ."

Shaking off his uneasy premonition, Mario steps into the silent castle, where he is greeted by the gruff words, "No one's home! Now scram! Bwa, ha, ha."

The sound seems to come from everywhere.

"Who's there?! I've heard that voice somewhere before . . ."

Mario begins searching all over the castle. Most of the doors are locked, but finding one open, he peeks inside. Hanging on the wall is the largest painting he has ever seen, and from behind the painting comes the strangest sound that he has ever heard . . .

"I think I hear someone calling. What secrets does this painting hold?"

Without a second thought, Mario jumps at the painting. As he is drawn into it, another world opens before his very eyes.

And so begins the grandest of all adventures!

Once inside the painting, Mario finds himself in the midst of battling Bob-ombs. According to the Bob-omb Buddies, someone . . . or something . . . has suddenly attacked the castle and stolen the "Power Stars." These stars protect the castle; with the stars in his control, the beast plans to take over the Mushroom Castle.

To help him accomplish this, he plans to convert the residents of the painting world into monsters as well. If nothing is done, all those monsters will soon begin to overflow from inside the painting.

"A plan this maniacal, this cunning . . . this must be the work of Bowser!"

Princess Toadstool and Toad are missing, too. Bowser must have taken them and sealed them inside the painting. Unless Mario recovers the Power Stars immediately, the inhabitants of this world will become Bowser's army.

"Well, Bowser's not going to get away with it, not as long as I'm around!"

Stolen Power Stars are hidden throughout the painting world. Use your wisdom and strength to recover the Power Stars and restore peace to the Mushroom Castle.

"Mario! You are the only one we can count on."

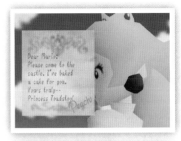

F E A T U R E S

MARIO IN THE THIRD DIMENSION

Super Mario 64 is the first 3D action game in the series, and was a launch title for the Nintendo 64 console. The analog Control Stick opened up new options for Mario's movements. This game also greatly expanded the types of actions in Mario's repertoire, with new maneuvers like the triple jump and wall kick. Another milestone: this is the very first game to include Mario's voice!

POWER STARS IN THE PICTURES!

Join Mario on an adventure to collect the Power Stars and rescue Peach. Search for the Power Stars hidden within each course through different types of challenges: defeat enemies, solve puzzles, and find hidden mechanisms. There are a lot of Power Stars to find: 120 in all!

MARIO RUMBLES

About a year after the game's initial release, a Rumble Pak compatible version of the game was released in Japan. This new version didn't just make the controller vibrate: it also added new dialogue for both Mario and Peach and changed other details including the sound effects and image for Jolly Roger Bay.

 # CHARACTERS

PLAYER CHARACTER

MARIO

This is how Mario looks normally. When he takes damage, his power meter goes down; when it reaches zero, you lose a life.

MARIO
Mario is equipped with new actions as he enters this brand-new 3D world on a quest to collect all the Power Stars and rescue Peach.

POWER-UPS

Some blocks contain special hats that Mario can wear to gain different powers.

WING MARIO ITEM ⇨ WING CAP

If Mario makes a triple jump, or is fired out of a cannon, he can fly. Use the Control Stick to steer.

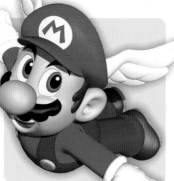

VANISH MARIO ITEM ⇨ VANISH CAP

Mario becomes see-through, and he can walk through enemies or hazards without taking damage. He can even go through fences, bars, and some walls.

METAL MARIO ITEM ⇨ METAL CAP

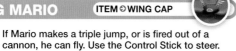

Mario's body turns to metal, and he can defeat enemies by ramming into them. But his body is heavy, so he sinks in water and walks along the seabed instead of swimming.

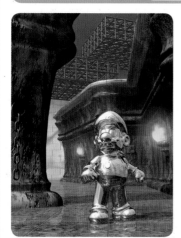

IN-COURSE POWER-UP SHINY SHELL ITEM ⇨

Mario can ride a shiny shell along the ground or over the water. He can defeat enemies by ramming into them, but his ride disappears if he hits a wall.

OTHER CHARACTERS

BOB-OMB BUDDY
This pink Bob-omb is Mario's ally. He'll let you use his cannon.

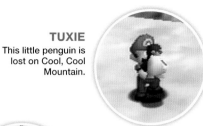

TUXIE
This little penguin is lost on Cool, Cool Mountain.

DORRIE
Dorrie lives in an underground lake in the Hazy Mazy Cave, and lets Mario ride on his back.

HOOT
Grab on, and Mario can fly with him for a little while.

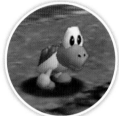

MOTHER PENGUIN
This penguin parent is looking for her lost baby.

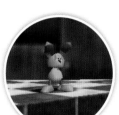

MIPS
Princess Peach's pet rabbit can be found in the basement of the Mushroom Castle.

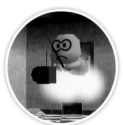

LAKITU BRO
These Lakitus carry cameras and film Mario.

KOOPA THE QUICK
This one loves to run, so he challenges Mario to race.

PRINCESS PEACH
The ruler of the Mushroom Kingdom. She's been kidnapped by Bowser.

YOSHI
After you've gathered all 120 Power Stars, you can meet him on the castle roof.

MANTA RAY
It swims slowly through the water, leaving a trail of water rings.

SNOWMAN
Its original body has melted, so it's looking for a new body.

UKKIKI
This monkey plays on the summit of Tall, Tall Mountain.

TOAD
Citizens of the Mushroom Kingdom. They're trapped inside the castle.

ENEMIES

These are the enemy characters Mario meets on his quest. This is the first time many familiar characters were rendered in 3D!

AMP
Balls that put out a lot of electricity. They circle around a set point.

BIG BOB-OMB
The king of the Bob-ombs. If he grabs Mario, he'll toss him away.

BIG BOO
A huge Boo. They shrink and slow down with each hit from Mario.

BIG BULLY
This large Bully pushes Mario toward the lava with more power than a regular Bully.

BIG GOOMBA
Mario's punch won't hurt them. But if he defeats them with a ground pound, they produce a blue coin.

BOB-OMB
If Mario gets close, the fuse lights. They start to smoke, run after Mario, and finally explode. They can be carried.

BOO
When Mario's back is turned, they come after him. But if he looks at them, they become translucent and stop moving.

BOOKEND
They jump off the bookshelf in an attempt to bite Mario. There's also a smaller type that jumps straight ahead.

BOSS BASS
Also known as Bubba, they swim underwater, and try to gulp Mario down into their large mouths.

BOWSER

He breathes fire. Mario battles him three times during the game, and in each battle his style of attack is different.

BULLET BILL

Once they're fired out of Bill Blasters, they fly after Mario.

BULLY

They try to ram Mario and send him flying. Mario can defeat them by pushing them into the lava.

CHAIN CHOMP

They're chained, but will try to bite Mario anyway. If he pounds the spike into the ground, they run away.

CHEEP CHEEP

They swim slowly through the water, and don't attack Mario.

CHILL BULLY

These are Bullies found in snowy levels. They move and can be defeated like regular Bullies.

CHUCKYA

They rush toward Mario; if they catch him, they'll toss him quite a ways.

EYEROK

Because of their craggy bodies, they look like they could crush Mario. But their eyes are a weak point.

FLY GUY

They fly through the air, spitting out fireballs and trying to ram into Mario.

FWOOSH

A small, angry cloud that blows powerful gusts of air to knock Mario off of cliffs.

GOOMBA

They wander around until they see Mario, then they suddenly charge him.

GRINDEL

These stone monsters usually move up and down, but some of them move side to side.

HEAVE-HO

If Mario stands on its platform, it throws him. After moving around for a bit, they stop and wind up again.

KLEPTO

These condors fly over the desert. They swoop down, trying to hit Mario and steal his cap.

KOOPA TROOPA

With a successful attack, its shell pops off and Mario can grab it.

LAKITU

They float around on their clouds, throwing Spiny Eggs. If Mario attacks them, the cloud vanishes.

MAD PIANO

A ghost is hiding in this piano. When Mario gets close, it starts to move and tries to bite him!

MICRO GOOMBA

These small Goombas try to charge and attack Mario, but they can't do any damage.

MICRO KOOPA

A small Koopa Troopa. When they are attacked, they vanish, shell and all.

MICRO PIRANHA PLANT

They appear out of the ground and breathe fire. The fireball may be small, but it still causes damage.

MONEYBAG

At first, they're disguised as coins. When Mario approaches, they reveal themselves and leap away.

MONTY MOLE

They pop their heads up out of the ground and throw rocks at Mario.

MR. BLIZZARD

They pop out of the snow and throw snowballs at Mario.

MR. I

They watch Mario and shoot bubbles. Mario can defeat them by running in circles until they start to roll.

PIRANHA FLOWER

Large versions of the Piranha Plant. They come out of the ground and spit fireballs.

PIRANHA PLANT

They're usually sound asleep, but when Mario gets close they wake up and try to bite him.

POKEY

As Mario attacks the body, it gets shorter. He can defeat it faster by attacking the head.

SCUTTLEBUG

They wander around caves, until they see Mario and scuttle toward him.

SKEETER

They slide on top of the water, and can move on the land, too.

SNUFIT

They float through the air and fire a series of small balls at Mario.

SPINDEL

They roll with a roar, back and forth.

SPINDRIFT

These appear in snowy levels. If Mario jumps on top, he spin jumps high into the air and floats slowly down.

SPINY

They're born when Spiny Eggs hit the ground. They walk slowly.

SPINY EGG

When they hit the ground, they turn into Spinies. Sometimes they are underwater, too.

SUSHI

They swim through the water. They don't attack, but Mario takes damage if he touches one.

SWOOPER

These bats wait on the ceiling until Mario gets close, then they fly at him.

THWOMP

They move up and down. Mario can walk safely on top, but if he's below when one drops he'll be crushed.

TOX BOX

A box that rolls along paths in desert levels. They're hard to avoid, so aim for the hollow spot.

UKIKI

If Mario picks one up, it will steal his cap and run away!

UNAGI

They have long, huge bodies. Their nests are found in undersea shipwrecks and holes in the rocks.

WHOMP

When they see Mario, they run toward him and fall on their faces. Their backs are their weak point.

WHOMP KING

He moves just like normal Whomps do, but since he's so big it's harder to avoid getting crushed.

WRIGGLER

They run around, and when Mario jumps on them, they get very mad and chase after him.

WORLD

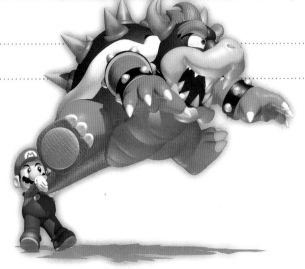

COURSES

There are several stars hidden in each course.

COURSE 1

BOB-OMB BATTLEFIELD

Bob-ombs are battling on this grassy plain with a huge mountain rising out of it.

1 BIG BOB-OMB ON THE SUMMIT

Avoid the big iron balls rolling down the mountain. When Mario reaches the summit, battle the Big Bob-omb.

2 FOOTRACE WITH KOOPA THE QUICK

Koopa the Quick is proud of his speed and challenges Mario to race to the top of the mountain.

3 SHOOT TO THE ISLAND IN THE SKY

Reach the island in the sky using the Bob-omb Buddy's cannon.

4 FIND THE 8 RED COINS

Search out all of the red coins that are hiding on this course.

5 MARIO WINGS TO THE SKY

Find a Wing Cap to become Wing Mario and fly through five rings of coins in the sky.

6 BEHIND CHAIN CHOMP'S GATE

Use the Chain Chomp to break through the iron bars and release the caged Power Star.

COURSE 2

WHOMP'S FORTRESS

There are lots of rocky characters in this stone fortress.

1 CHIP OFF WHOMP'S BLOCK

Battle the Whomp King, the ruler of the rocks, on top of his fortress.

2 TO THE TOP OF THE FORTRESS

Climb rocky ledges to claim the Power Star at the top of the fortress.

3 SHOOT INTO THE WILD BLUE

Aim the cannon at the Power Star on the terrace, and then blast off!

4 RED COINS ON THE FLOATING ISLE

Jump between platforms and floating islands to collect all eight red coins.

5 FALL ONTO THE CAGED ISLAND

Ride with the owl to a floating island. Time Mario's fall just right to land safely.

6 BLAST AWAY THE WALL

When Mario uses a cannon to bust through the wall, a hidden Power Star appears.

COURSE 3

JOLLY ROGER BAY

There's a sunken pirate ship at the bottom of the bay.

1 PLUNDER IN THE SUNKEN SHIP

Hunt for the Power Star in a shipwreck that's filled with Unagi.

2 CAN THE EEL COME OUT TO PLAY?

Lure the Unagi out of its cave to find the Power Star that's stuck to its tail.

3 TREASURE OF THE OCEAN CAVE

Make your way through caves filled with traps to claim the Power Star.

4 RED COINS ON THE SHIP AFLOAT

Gather the red coins aboard the pirate ship and hidden inside clams.

5 BLAST TO THE STONE PILLAR

Aim at the pillar and fire Mario from the cannon to reach the Power Star on a rocky outcropping.

6 THROUGH THE JET STREAM

A Power Star at the bottom of the sea requires Metal Mario to walk along the sea floor.

COURSE 4
COOL, COOL MOUNTAIN

Penguins live on this snowy mountain.

1 SLIP SLIDIN' AWAY

Slide down the icy pathway inside the cottage. There's a shortcut along the way.

2 LI'L PENGUIN LOST

Find the Li'l Penguin on the mountaintop and carry her back down to the Mother Penguin.

3 BIG PENGUIN RACE

Race the Big Penguin down the slide inside the cottage. He's a world-champion sledder.

4 FROSTY SLIDE FOR 8 RED COINS

Search every nook and cranny on the mountain to gather all of the red coins.

5 SNOWMAN'S LOST HIS HEAD

Reunite the Headless Snowman with his head, and you're rewarded with a Power Star.

6 WALL KICKS WILL WORK
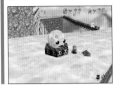
Use wall kicks to reach a hidden area in the back of the mountain.

COURSE 5
BIG BOO'S HAUNT

The Boos live in a creepy mansion with three floors and a basement.

1 GO ON A GHOST HUNT

Hunting the Boos of the mansion leads to a battle with the Big Boo.

2 RIDE BIG BOO'S MERRY-GO-ROUND

Have a rematch with the Big Boo on the merry-go-round.

3 SECRET OF THE HAUNTED BOOKS

Books have fallen off the shelves, and Mario must return them to their spots to find a hidden room with a Power Star.

4 SEEK THE 8 RED COINS

Avoid the traps in the spooky mansion while collecting the red coins.

5 BIG BOO'S BALCONY

It's round three with the Big Boo. This time, you battle on the mansion's balcony.

6 EYE TO EYE IN THE SECRET ROOM

Vanish Mario can sneak into a secret room in the attic, where he must defeat a Mr. I.

COURSE 6
HAZY MAZE CAVE

Mario enters the dim recesses of a cavern. Dorrie lives in an underground cave here.

1 SWIMMING BEAST IN THE CAVERN

Make your way to the underground lake in the lowest depths of the cave. Dorrie will help Mario retrieve the Power Star.

2 ELEVATE FOR 8 RED COINS

Ride the lifts to collect the red coins floating in the air.

3 METAL-HEAD MARIO CAN MOVE!

Metal Mario is heavy enough to press a switch underwater, unlocking the room that holds the Power Star.

4 NAVIGATING THE TOXIC MAZE

Find the Power Star at the end of a maze filled with toxic clouds.

5 A-MAZE-ING EMERGENCY EXIT

The maze's emergency exit reveals a new route.

6 WATCH FOR ROLLING ROCKS

There's a Power Star hidden somewhere past all those boulders.

COURSE 7
LETHAL LAVA LAND

An entire world stretches out around a volcano, above the lake of lava. Watch out for the narrow paths!

1 BOIL THE BIG BULLY

Mario's in a battle with the Big Bully—they are trying to throw each other into the lava.

2 BULLY THE BULLIES

Mario has to stay out of the lava, but a squad of three Bullies is trying to push him in!

3 8-COIN PUZZLE WITH 15 PIECES
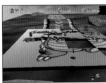
Collect the red coins floating above the moving pieces of the Bowser puzzle.

4 RED-HOT LOG ROLLING

Roll on top of the logs to get across the lava. Be sure to keep your balance!

5 HOT-FOOT-IT INTO THE VOLCANO

Inside the volcano, climb the ledges and platforms to reach the Power Star at the very top.

6 ELEVATOR TOUR IN THE VOLCANO

Ride the lifts through the volcano to find a Power Star.

COURSE 8
SHIFTING SAND LAND

Quicksand can drag Mario under in this desert course that sprawls around a huge pyramid.

1 IN THE TALONS OF THE BIG BIRD

Try to catch the Klepto that's flying around with a Power Star in its talons.

2 SHINING ATOP THE PYRAMID

Climb up the outside of the pyramid to reach the Power Star at the top.

3 INSIDE THE ANCIENT PYRAMID

Follow a narrow path through the inside of the pyramid.

4 STAND TALL ON THE FOUR PILLARS

Once Mario stands atop each of the pillars, a secret entrance is revealed. Enter to battle an Eyerok.

5 FREE FLYING FOR 8 RED COINS

Some of the red coins on this course are in the sky, so Mario will need to fly to reach them.

6 PYRAMID PUZZLE

Discover the secrets of the pyramid to reach the Power Star.

COURSE 9
DIRE, DIRE DOCKS

This course is split into two areas: the open seas and the cavernous docks.

1 BOARD BOWSER'S SUB

Swim through narrow passages to reach Bowser's Sub. There's a Power Star on board.

2 CHEST IN THE CURRENT

Open the treasure chests in the correct order amidst the whirling tides.

3 POLE-JUMPING FOR RED COINS

The submarine has left the docks, so Mario can use the poles to reach the red coins.

4 THROUGH THE JET STREAM

Swim through water rings to unlock the Power Star, then don the Metal Cap to sink down and claim it.

5 THE MANTA RAY'S REWARD

Swim through a series of water rings as you follow the Manta Ray.

6 COLLECT THE CAPS . . .

Use the Metal Cap and the Vanish Cap to make your way through the water, aiming for the caged Power Star.

COURSE 10
SNOWMAN'S LAND

A snowy landscape with a mountain in the middle. It's cold here!

1 SNOWMAN'S BIG HEAD

Climb the Snowman's mountain with the help of a penguin to obtain the Power Star at the top.

2 CHILL WITH THE BULLY

Battle the Chill Bully on top of the slippery ice.

3 IN THE DEEP FREEZE

Blocks of ice around the Power Star make a 3D maze.

4 WHIRL FROM THE FREEZING POND

Spindrifts can help Mario jump over the high wall on the edge of the lake.

5 SHELL SHREDDIN' FOR RED COINS

Mario will need to ride a shell to reach the red coins on the freezing lake.

6 INTO THE IGLOO

Search for the Power Star inside the mazelike home of the Spindrifts.

COURSE 11
WET-DRY WORLD

The depth of the water depends on the height Mario jumps through the painting . . . or how the crystal taps are set.

1 SHOCKING ARROW LIFTS!

Make your way across arrow lifts floating in the air. Amps try to block Mario's path.

2 TOP O' THE TOWN

Travel all the way up to the very highest ledge to reach the Power Star.

3 SECRETS IN THE SHALLOWS & SKY

Five secrets are hidden throughout the town. Search from the tippy-top down to the ground to find them all.

4 EXPRESS ELEVATOR— HURRY UP!

Mario needs to ride the floating platform in order to reach the Power Star inside the elevator shaft.

5 GO TO TOWN FOR RED COINS

Drain the water out of downtown in order to find all of the red coins.

6 QUICK RACE THROUGH DOWNTOWN!

Use Vanish Mario to pass through the cage bars as you dash through downtown.

INTRODUCTION CHARACTERS **WORLD** AND MORE

COURSE 12

TALL, TALL MOUNTAIN

A tall, rocky mountain where mushrooms grow. Start at the foot of the mountain, and circle around it to climb.

⭐1 SCALE THE MOUNTAIN

Mario has to use long jumps as you climb to reach the top of the mountain.

⭐2 MYSTERY OF THE MONKEY CAGE

Capture the Ukkiki playing at the mountain's summit. Something nice happens when Mario lets him go . . . !

⭐3 SCARY 'SHROOMS, RED COINS

Gather the red coins on the cliff edges as Mario jumps from mushroom to mushroom.

⭐4 MYSTERIOUS MOUNTAINSIDE

Find the hidden slide inside the mountain. If you choose the correct path down the slide, a Power Star waits at the end.

⭐5 BREATHTAKING VIEW FROM BRIDGE

Leap off the bridge to reach the Power Star hidden inside the waterfall.

⭐6 BLAST TO THE LONELY MUSHROOM

There's a Power Star on top of that mushroom in the distance. Use the cannon to get there.

COURSE 13

TINY-HUGE ISLAND

Choose the correct painting, then use pipes to get between Tiny Island and Huge Island.

⭐1 PLUCK THE PIRANHA FLOWER

Hunt down all of the fire-breathing Piranha Flowers on both Huge Island and Tiny Island.

⭐2 THE TIP-TOP OF THE HUGE ISLAND

Climb the Huge Island mountain towards the summit. Be careful of the oversized enemies.

⭐3 REMATCH WITH KOOPA THE QUICK

The ever-confident racer challenges Mario to a rematch on his home turf. Race for the Power Star on Huge Island.

⭐4 FIVE ITTY BITTY SECRETS

Secrets are hidden on Tiny Island for Mario to find.

⭐5 WIGGLER'S RED COINS

Jump between platforms in the cave at the heart of Huge Island to collect the red coins.

⭐6 MAKE WIGGLER SQUIRM

Wiggler is angry that his house was flooded, so Mario must battle him.

COURSE 14

TICK TOCK CLOCK

Jump into a clock to enter this course. The position of the minute hand determines how fast the mechanisms move.

⭐1 ROLL INTO THE CAGE

Climb toward the Power Star using pendulums, cogwheels, and conveyor belts.

⭐2 THE PIT AND THE PENDULUMS

Jump between two swinging pendulums to reach the Power Star.

⭐3 GET A HAND

Avoid the Amp as Mario rides the hands of the clock.

⭐4 STOMP ON THE THWOMP

There's a Power Star at the highest point of the clock. A Thwomp helps you get to the very top.

⭐5 TIMED JUMPS ON MOVING BARS

Cross a series of lifts and moving platforms to make your way to the caged Power Star.

⭐6 STOP TIME FOR RED COINS

Collect the red coins among the spinning clockworks. It's easy if Mario enters the clock on the hour and the mechanisms are still.

COURSE 15

RAINBOW RIDE

There are lots of tricks and traps throughout this large course up in the clouds.

⭐1 CRUISER CROSSING THE RAINBOW

Board the flying carpet and aim for the airship, avoiding the obstacles along the way.

⭐2 THE BIG HOUSE IN THE SKY

A different flying carpet will take Mario to the Power Star on the roof.

⭐3 COINS AMASSED IN A MAZE

Climb up and down through the maze to find all of the red coins.

⭐4 SWINGIN' IN THE BREEZE

Use the donut blocks and tilting platforms to make your way through the sky.

⭐5 TRICKY TRIANGLES!

Flip the pyramid blocks upside down, and then use them as stepping stones to reach the Power Star.

⭐6 SOMEWHERE OVER THE RAINBOW

Shoot Mario out of the cannon on the airship, through the rainbow ring and onto a small island.

MUSHROOM CASTLE

Several extra levels and stars are hidden in the Mushroom Castle.

THE PRINCESS'S SECRET SLIDE

There's a slide hidden behind the stained-glass window. If Mario slides fast enough, he can find a second Power Star.

THE SECRET AQUARIUM

Find the red coins before Mario runs out of air.

TOWER OF THE WING CAP

Wing Mario can fly to the red switch at the center of the tower.

BOWSER IN THE DARK WORLD

Avoid the traps on the narrow pathway in order to reach Mario's first battle with Bowser.

CAVERN OF THE METAL CAP

Metal Mario can travel through the caves to find a green switch.

VANISH CAP UNDER THE MOAT

Collect the red coins, then Vanish Mario can pass through the cage to grab the Power Star.

BOWSER IN THE FIRE SEA

The platforms sink into the lava as Mario walks across them. At the end of the path is the second battle with Bowser.

WING MARIO OVER THE RAINBOW
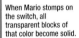
Wing Mario can pass over the clouds floating in the sky to gather the red coins.

BOWSER IN THE SKY

The final battle with Bowser! Navigate the tricks and traps to rescue Peach.

ITEMS & OBSTACLES

You'll encounter these on your quest. Since Mario has so many new moves, there are more obstacles for him to thwart.

! SWITCH
When Mario stomps on the switch, all transparent blocks of that color become solid.

1-UP MUSHROOM
Grab one to get an extra life.

ARROW LIFT
When Mario steps on, they move in the direction of the arrow.

BLOCK
Mario can break them with a punch or other attack.

BLUE BLOCK
When Mario hits one, a Vanish Cap appears. Pick up the cap to become Vanish Mario.

BLUE COIN
Each one Mario collects increases the coin counter by five.

BLUE COIN SWITCH
Ground-pound on one and blue coins appear for a limited time.

BOMB
When battling Bowser, throw him into these to cause damage.

BOWSER PUZZLE
Mario can ride on the sliding puzzle pieces.

BUBBLE
Air bubbles are trapped inside underwater treasure chests. They can restore Mario's health.

CANNON
The Bob-omb Buddies keep these ready. They fire Mario through the sky.

CLAM
They're found on the seabed. As they open and close, you can see the item hiding inside.

COIN
They restore Mario's health. Collect one hundred coins and a Power Star appears.

CONVEYOR BELT
Ride them in the direction of the arrow.

CRAZED CRATE
If Mario holds on while it bounces three times, it will break and release five coins.

CRYSTAL TAP
When Mario touches these mechanisms in the sunken city, the water level changes.

DIRECTIONAL LIFT
There are switches with arrows on each side. It moves in the direction of the switch Mario pushes.

DONUT BLOCK
As Mario steps on, they start to fall away.

FIRE
If it hits Mario, he takes damage and runs around for a bit.

FLYING CARPET
When Mario's on board, it travels along the rainbow path. If he leaves for too long, it disappears.

FREEZING WATER
If he touches this extremely cold water, Mario will lose health.

GREEN BLOCK
When Mario hits one, a Metal Cap appears. Pick up the cap to become Metal Mario.

IRON BALL
They roll downhill with a lot of momentum.

JET STREAM
The strong current will carry Mario with it. Metal Mario is heavy enough that he's not affected.

INTRODUCTION CHARACTERS **WORLD** AND MORE

KEY

One appears when Mario defeats Bowser. They unlock new areas in Mushroom Castle.

KILLER CHAIR

When Mario gets close, it suddenly rises into the air and hurtles toward him.

KUROMAME

This black sphere shoots fire when Mario approaches.

LAVA

If Mario touches it, he leaps high into the air!

LIFT

Some of these platforms start moving after Mario steps on. Others are always moving.

LOG

If Mario jumps on top and runs, the log starts to roll and move along.

MARIO'S CAP

It can be stolen or lost. Mario only needs to touch it to get it back.

PENDULUM

They swing back and forth inside the Tick Tock Clock.

PIPE

They take Mario from one area to another.

POLE

Grab on and climb up or down. Mario can also jump from pole to pole.

POST

Mario can drive them into the earth with a Ground Pound.

POWER STAR

Mario's reward at the end of each level. There are 120 in all.

PURPLE SWITCH

Stepping on these triggers a change to the course.

PYRAMID BLOCK

Flip a switch to turn them upside down and walk across the flat side.

QUICKSAND

If Mario steps in, he sinks—sometimes slowly, sometimes quickly.

RED BLOCK

When Mario hits one, a Wing Cap appears. Pick up the cap to become Wing Mario.

RED COIN

Eight of these are hidden in each course; collect them all to reveal a Power Star.

ROLLING BOULDER

Dodge them in Hazy Maze Cave.

ROTATING BLOCK

They come in different shapes and they rotate in a fixed rhythm.

ROTATING PLATFORM

The speed of these platforms depends on when Mario enters the course.

SECRET

As Mario finds each one, a counter appears.

SEESAW

These platforms tilt with Mario's weight as he walks across them.

SHINY SHELL

Mario can find one if he defeats a Koopa Troopa or smashes a yellow block. Hop on to surf over the ground or water.

SIGN

There are helpful hints written on them.

SLIDING SLOPES

These icy slopes come one after another. If one hits Mario, he'll be forced to slide along with it.

SLIDING STONE

They come out of the wall and try to shove Mario out of the way.

SMALL BLOCK

They can be picked up and carried. If Mario throws them, they slide along the ground and break when they hit a wall.

SNOWMAN'S MOUNTAIN

This mountain in Snowman's Land tries to blow Mario away.

SPINNING HEART

Pass through to recover health.

STAR MARKER

This is the place where a Power Star appears after Mario has collected all eight red coins on a course.

STONE BLOCK

Mario can't destroy this block . . . but it's possible to push it!

SWING LIFT

They rock back and forth. If Mario is standing on one, be careful not to slip.

TOXIC CLOUD

Mario can't breathe inside this poisonous fog, so he takes damage.

TRANSPARENT BLOCK

They don't do anything. They only become solid after a switch is triggered.

TREASURE CHEST

Find them at the bottom of the sea. If you open them in the right order, you'll find a Power Star.

TREE

Grab on to climb up or down. There are different types on some courses.

VOLCANO

Mario can jump inside when it's not erupting.

WARP POINT

Some spots will teleport Mario to another location.

WATER BOMB

They can bounce a few times before breaking.

WHIRLPOOL

If Mario gets too close, it draws him in.

WIND

With the help of a gust, Mario can go up some otherwise unclimbable slopes.

WIRE NET

Mario can move along as he hangs from the bottom or walks on top of it.

WOODEN PLANK

Attack it once, and it starts to wobble. Attack again, and it falls to become a bridge.

YELLOW BLOCK

They might contain coins, Power Stars, shells, or 1-Up Mushrooms!

 # AND MORE

MEMORABLE MOMENTS

Do you remember these iconic scenes? There's so much Mario can do in this game, so here are just a few highlights.

MARIO'S FACE

Mario's head appears on the title screen, and you can stretch it! This was designed to help players become familiar with the Nintendo 64 controller.

MARIO TAKES A NAP

If you leave Mario alone for about thirty seconds, he sits down and dozes off, but he doesn't sleep on courses with cold weather. If you wait even longer, Mario lays down, fast asleep.

RAGE OF THE MOTHER PENGUIN

On Cool, Cool Mountain, if Mario brings the Li'l Penguin back to her mother, and then tries to take her away again, the mother will get angry and chase after him.

THE PENGUIN COPIES YOU!

If you do a slide attack near the Li'l Penguin, it tries to do the same thing.

MARIO UNDERGROUND!

Normally when Mario falls from a great height, he takes some damage. But when he falls into sand or snow, he doesn't take damage. If he falls during a slide attack, his head gets buried and his legs stick out.

CATCH MIPS

There's a yellow rabbit in the basement of Mushroom Castle. It runs away as you get close, but if you chase and catch it, you'll get a Power Star. The rabbit is named MIPS, after the Nintendo 64's microprocessor ("Microprocessor without Interlocked Pipeline Stages").

MARIO LOSES HIS CAP!

Mario's cap can be stolen by Klepto the Condor in Shifting Sand Land, blown off by the wind on Snowman's Mountain, and stolen by Ukkiki on Tall, Tall Mountain. Mario takes more damage when he is hit bareheaded, so make sure to find his stolen hat before you leave the course.

WHAT'S THAT ON THE WALL?

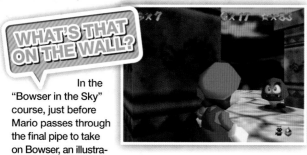

In the "Bowser in the Sky" course, just before Mario passes through the final pipe to take on Bowser, an illustration on a pillar shows a previous battle between the famous foes.

YOSHI ON THE ROOF!

After you've collected all 120 Power Stars, Yoshi appears on the roof of Mushroom Castle. The cannon on the beach will send Mario up to meet his friend, who delivers a message from the Nintendo staff and a gift of one hundred extra lives.

HELPFUL HINTS & TECHNIQUES

These tips might help you on your quest to find all 120 Power Stars and to discover the secrets of Mushroom Castle!

ALL 120 POWER STARS?!

After you collect all 120 Power Stars, Mario can meet up with Yoshi. But that's not the only thing that changes. The Big Penguin on Cool, Cool Mountain gets bigger, and if Mario challenges Bowser to a rematch, he has something new to say.

DOUBLE POWER-UP

In the Dire, Dire Docks, a green block and a blue block are very close together. If you use them both, it's possible to become Vanish Metal Mario.

THE GLITTERING TRIPLE JUMP

After Mario has talked with Yoshi and the life counter hits 100, you might notice something different about the triple jump. Now it sparkles, and Mario doesn't take damage from a big fall.

BUTTERFLY TRANSFORMATION

If you see a group of three butterflies, try to catch one. It might transform into a 1-Up Mushroom . . . or a bomb.

1,000 COINS

In the original Japanese release, if you collect more than 1,000 coins in the "Bowser in the Dark World" course, an M appears in your life counter. This means that the counter has flipped! Now, grabbing a 1-Up Mushroom will decrease the number of lives that you have, and if you lose a life the counter increases.

HAT IN HAND

In Snowman's Land, if Mario teleports after losing his cap, an extra cap appears on the ground. When he picks up the cloned cap, you see a rare sight: Mario walking with the cap in his hand.

CREDITS CAMERA

While the credits are scrolling, the Control Stick on a controller plugged into the 2P port can move the camera. See if you can find Mario hiding in the background!

MARIO'S SPORTS GAME HISTORY

Being both ambitious and multitalented, Mario has tried his hand at all sorts of sports competitions. Here we take a look at most of the sporting matches in which Mario has taken part. The release dates noted below reflect the US releases.

GOLF

The sports game that Mario has played the most is golf. The first game he starred in was the 1987 game *Family Computer Golf: Japan Course* for the Famicom Disk System. They even had an event where players could send their high scores through a data communications device, a "Disk Fax" in stores, so they could compare scores from all over Japan. This progressed to 2014's *Mario Golf: World Tour* for Nintendo 3DS where huge tournaments could be held over the internet. Mario's game has evolved with a move from a bird's-eye view to the 3D screen and the use of items for his shots. The new games have also incorporated the meter that helps the player determine the power and impact of a golf shot, tracing an unbroken line from Mario's original game.

NES OPEN TOURNAMENT GOLF
NINTENDO ENTERTAINMENT SYSTEM
SEPTEMBER 29, 1991
© 1991 NINTENDO

MARIO GOLF: WORLD TOUR
NINTENDO 3DS
MAY 2, 2014
© 2014 NINTENDO/CAMELOT

BASEBALL

In the long history of Mario, there have been only two Mario baseball games, but between the two, more than fifty characters have appeared. Sure, you have Mario and Bowser, but Toadsworth, Pianta, Monty Mole, Dry Bones, and many others have stepped up to the plate. You can choose your team from your favorite *Super Mario* family characters. Each character has different strengths and weaknesses, and if you don't choose the batting lineup and positions carefully, you're not going to play a very effective game of baseball!

MARIO SUPERSTAR BASEBALL
NINTENDO GAMECUBE
AUGUST 29, 2005
© 2005 NINTENDO © 2005 NAMCO

MARIO SUPER SLUGGERS
Wii
AUGUST 25, 2008
© 2008 NINTENDO © 2008 NAMCO BANDAI GAMES, INC.

TENNIS

The first time Mario appeared in a tennis game was in the NES game, *Tennis*, but only as the referee. Then in 1995, *Mario's Tennis* came out for the Virtual Boy, which was the first time Mario appeared as a player. He had changed his overalls for tennis gear and played with other members of the *Super Mario*

family. In the year 2000, *Mario Tennis* debuted for the Nintendo 64 game system. Not only did it feature characters like Daisy and Birdo, but it also included the very first appearance of Waluigi. It included a total of sixteen different characters of the *Super Mario* family, the most of any game up to that time. *Mario Tennis Open* was released for the Nintendo 3DS in 2012 and featured the star character, Luma.

MARIO TENNIS
NINTENDO 64
AUGUST 28, 2000
© 2000 NINTENDO/CAMELOT

MARIO TENNIS OPEN
NINTENDO 3DS
MAY 20, 2012
© 2012 NINTENDO/CAMELOT

SOCCER

In 2005, Mario made his first venture into the world of soccer with *Super Mario Strikers* for Nintendo GameCube. Because of its rough play, it got a reputation as being a "fighting" soccer game. Mario abandoned his overalls and instead donned a uniform, and with his Super Strike—among other eye-catching attacks—he really threw himself into the game of no-holds-barred soccer. He also appeared in *Mario & Sonic at the London 2012 Olympic Games*, which was more of a standard soccer game.

SUPER MARIO STRIKERS
NINTENDO GAMECUBE
DECEMBER 5, 2005
© 2005-2006 NINTENDO

MARIO STRIKERS CHARGED
Wii
JULY 30, 2007
© 2007 NINTENDO

BASKETBALL AND OTHER SPORTS

In *Mario Hoops 3-on-3*, a 2006 release for Nintendo DS, Mario decided to try his hand at basketball. The player could choose from twenty-one characters, some even coming from the *Final Fantasy* series, to join your team to play 3-on-3 rules for basketball. In 2005, the Nintendo GameCube version of *NBA Street V3* included some Super Mario family characters to play games of street basketball alongside of NBA players. Mario also upped his basketball game in *Mario Sports Mix*. This game featured Mario playing volleyball, hockey, and dodgeball all on the same disc.

MARIO HOOPS 3-ON-3
NINTENDO DS
SEPTEMBER 11, 2006
© 2006 NINTENDO © 2006 SQUARE ENIX

MARIO SPORTS MIX
Wii
FEBRUARY 7, 2011
©2010 NINTENDO. ©2010 SQUARE ENIX. FINAL FANTASY CHARACTERS © SQUARE ENIX. DRAGON QUEST CHARACTERS © ARMOR PROJECT/BIRD STUDIOS/SQUARE ENIX

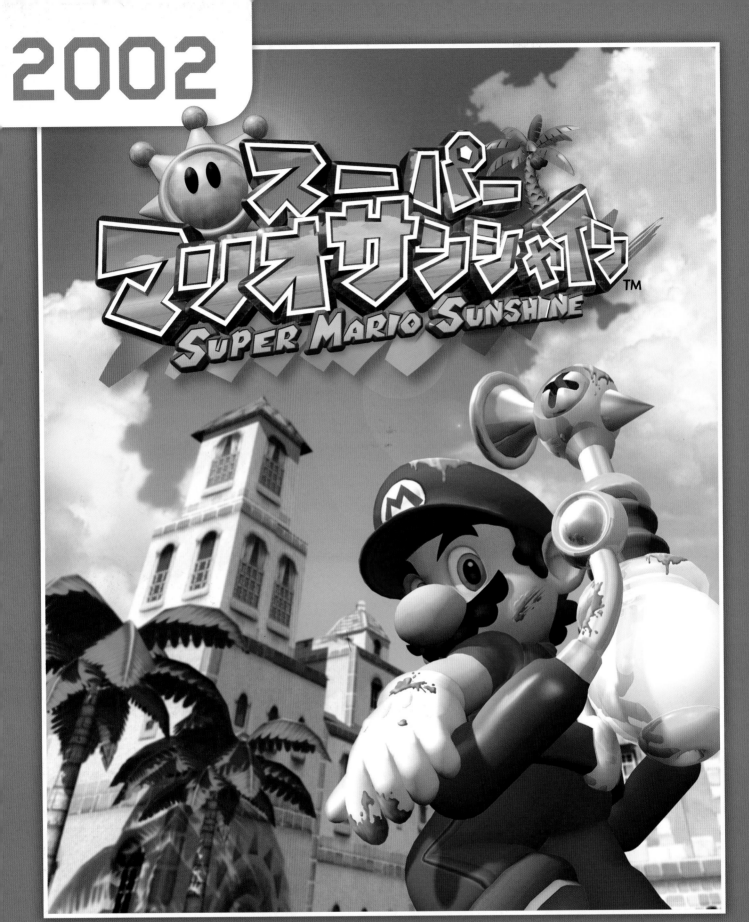

スーパー
マリオサンシャイン™
SUPER MARIO SUNSHINE

Package

Game Disc

Instruction Booklet

System: Nintendo GameCube
Release Date:
August 26, 2002
(Japan: July 19, 2002)
Player Count: 1

INTRODUCTION

STORY

*This text is taken directly from the instruction booklet.

Close your eyes and imagine . . . soothing sunshine accompanied by the sound of waves gently breaking on the shore. High above, seagulls turn lazy circles in a clear blue sky. This is the Isle Delfino.

Far from the hustle and bustle of the Mushroom Kingdom, this island resort glitters like a gem in the waters of a southern sea.

Mario, Peach, and an entourage of Toads have come to Isle Delfino to relax and unwind. At least, that's their plan . . . but when they arrive, they find things have gone horribly wrong . . . According to the island inhabitants, the person responsible for this mess has a round nose, a thick mustache, and a cap . . .

What? But . . . that sounds like Mario!?

The islanders are saying that Mario's mess has polluted the island and caused their energy source, the Shine Sprites, to vanish.

Now the falsely accused Mario has promised to clean up the island, but . . . how?

Never fear! FLUDD, the latest invention from Gadd Science, Inc., can help Mario tidy up the island, take on baddies, and lend a nozzle in all kinds of sticky situations.

Can Mario clean the island, capture the villain, and clear his good name? It's time for another Mario adventure to get started!

FEATURES

WRONGFULLY ACCUSED!

With beautiful blue skies, the resort Isle Delfino is the stage for an ever-expanding 3D action game. Even though they came for vacation, the Mushroom Kingdom crew get caught up in a crime. As Mario tries to find the true culprit, he also must gather up items called Shrine Sprites. The key to the mystery comes in the form of someone (or something) that looks just like Mario. The dramatic story unfolds with a lot of movie-grade cut-scenes, now with the visual power boost of the Nintendo GameCube console!

MARIO'S CREW

Your partner in this adventure is the water pump Mario straps to his back. FLUDD sprays water, propelling Mario around the world and cleaning up the thick goop polluting the island. Barring a brief appearance in *Super Mario 64*, Yoshi appears for his first 3D adventure.

CHARACTERS

PLAYER CHARACTER

Mario gets caught up in a criminal case while he's trying to take a vacation. He and the water pump FLUDD go on an adventure together!

MARIO

Mario carries FLUDD on his back throughout his adventure to clean up the polluted island.

FLUDD

The mad scientist E. Gadd created this all-purpose pump, FLUDD. You can do all kinds of things with its water spouts.

FLUDD POWER-UPS

FLUDD shoots water forward with the normal nozzle, but there are three other types of nozzles that can be switched out, too. You can attach a secondary nozzle in addition to the squirt nozzle; it can be switched out with a nozzle box.

SQUIRT NOZZLE

This nozzle fires forward. It can clean up pollution and also attack enemies. This nozzle is always installed on FLUDD.

HOVER NOZZLE

With this downward-pointing nozzle, not only can you clean up pollution below you, but you can also float in the air on a jet of water for a short while.

ROCKET NOZZLE

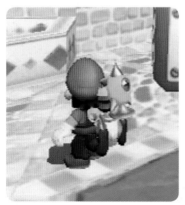

This nozzle blasts water downward, sending Mario straight up high in the sky. It takes some time to charge before it can blast off.

TURBO NOZZLE

It blasts water behind Mario with great force, allowing him to dash at extremely high speed. It's possible to use this to dash over the surface of the sea.

YOSHI

Yoshi hatches out of an egg. He can eat enemies by capturing them with his long tongue. He can also spit out juice, which has similar effects as FLUDD. Depending on the fruit he eats, he'll change into three different colors, and certain enemies react differently depending on his color and the type of juice he spits. If too much time passes or he spits out too much juice, his stomach meter can run to empty. In that state, he may vanish if he falls into the water.

 ORANGE YOSHI

 PINK YOSHI

PURPLE YOSHI

ENEMIES

Mario may meet these enemy characters during a course. You'll cross paths with familiar enemies like Boos and Bloopers, but some characters look and act a little differently in this game.

BEE
Bees are never found far from their hives. If Mario brings down the hive with a spray of water, they swarm him.

BLOOPER
They creep along the ground. If Mario gets close, they try to spray him with ink.

BOB-OMB
They march around, and after a while, explode. They will stop moving if Mario sprays water on them.

BOO
These ghastly foes drift through the air and get in Mario's way. Some types turn into coins and others are see-through.

BOO (PINK)
If Mario sprays water on these pink Boos, they transform into platforms for a short time.

BOWSER
The final boss. He breathes powerful gusts of fire at Mario from the middle of his hot tub.

BOWSER JR.
The culprit behind Shadow Mario's vandalism! During the final battle, he shoots Bullet Bills from a small boat.

BULLET BILL
Fired from Bill Blasters, these enemies fly straight in Mario's direction.

BULLET BILL (BLUE)
These enemies can be used to fill up FLUDD's water tank if defeated. They also produce 1-Up Mushrooms.

BULLET BILL (GOLD)
These Bullet Bills only make rare appearances. If they are defeated, Mario earns eight coins.

BULLET BILL (PURPLE)
Once fired from Bill Blasters, these homing missiles chase Mario wherever he goes.

CATAQUACK (BLUE)
When Mario comes close, they try to hurl him high into the air. They do not damage Mario.

CATAQUACK (RED)
These Cataquacks try to toss Mario into the air, but do damage in the process.

CHAIN CHOMP
Once cool to the touch, Mario can pry up their stakes and haul these fiery-bodied foes around by the chain.

CHAIN CHOMPLET
These mini Chain Chomps are searing-hot, but Mario can cool them off and redirect them by pulling their chains.

CHEEP CHEEP
These fish usually just swim through the water, but one type jumps out. Mario can't defeat them.

COO COO
These birds fly through the sky dropping goop. If Mario hits them with water, they leave coins behind.

EELY-MOUTH
This giant eel lives at the bottom of Noki Bay. His oral hygiene is terrible. Cleaning his teeth is a dangerous job!

ELECTRO-KOOPA (BLUE)
These Koopa have electrified shells. If Mario is nearby, they'll throw their shells in an attempt to electrocute him.

ELECTRO-KOOPA (GREEN)
This troublesome turtle causes Pinna Park's Ferris Wheel to break down. It sleeps above a metal grate.

ELECTRO-KOOPA (RED)
They pace along fences. Mario can defeat them by kicking them from the other side of the fence.

GLORPEDO
They roll down hills, leaving trails of pollution as they go. If Mario jumps on them, they collapse into mud-like puddles.

GOOBLE
They emerge from puddles of goop and try to attack Mario. They come in a variety of colors.

GOOPER BLOOPER
This squid attacks by whipping its tentacles around. Mario can defeat it by pulling its lips back and snapping them.

JUMPING BLOOPER
They come from the sea. Mario can stand on them by dousing them with water, which makes them float on the surface.

KING BOO
He spins the slot machine, and depending on the results, enemies or rewards pop out. He hates hot peppers.

KLAMBER
They move along walls and fences. Mario can defeat them if he attacks from the other side of the fence.

LAVA CHEEP CHEEP
These fire-covered Cheep Cheeps swim through lava. Mario can cool them off with a spray of water.

MECHA-BOWSER

A giant, fire-breathing, Bowser-shaped robot that can be found in Pinna Park.

MONTY MOLE

They work the cannons that shoot Bullet Bills and Bob-ombs.

PETEY PIRANHA

This poisonous Piranha Plant spews polluted goop. Mario can spray water directly into his mouth to defeat him.

PHANTAMANTA

It spreads electric goop as it prowls Sirena Beach. When sprayed, it splits into several smaller versions of itself.

PIRANHA PLANT

They emerge from the goop, spitting out seeds in attack.

PIRANHABON

These Piranha Plant heads roll along covered in goop.

PLUNGELO

They use their plunger feet to wobble along tilted mirrors. Their feet can be dislodged with a quick ground pound.

POINK

They attach themselves to FLUDD, but Mario can pump them up with water and launch them.

POKEY

If Mario gets too close, they rise right up out of the ground, throwing their long bodies at him.

POKEY HEAD

When Mario's nearby, they appear out of the ground and chase him around using short bounces.

POLLUTED PIRANHA

Piranha Plants completely covered in goop. Spray them with water to see what they really look like.

SEEDY POD

They usually remain stationary, but when Mario approaches, they quickly burrow into the ground and shoot out their seeds.

SHADOW MARIO

An enemy who bears a striking resemblance to Mario. Spray him with enough water and he surrenders.

SKEETER

They skitter along the surface of the water. They stop moving if Mario sprays them, but they can't be defeated.

SLEEPY BOO

They snooze in narrow passageways, blocking the way. Yoshi can get them out of the way by eating them.

SMOLDERIN' STU

These Strollin' Stus have fire shooting from their heads. Extinguish the flame by drenching them with water.

SNOOZA KOOPA

Despite looking like an egg, that's actually a Koopa's shell! These sleepy foes only wake up when soaked with water.

SOARIN' STU

They swoop in and dive bomb Mario. Sometimes they just fly back and forth, right and left.

STROLLIN' STU

They try to attack Mario with a body slam. Sometimes they'll hitch a ride on each other, forming a tower.

SWIPIN' STU

They also swoop in and dive bomb Mario, but if they make contact, they steal Mario's cap.

WIGGLER

This angry caterpillar runs on the beach. If Mario waters the Dune Bud nearby, Wiggler trips on it.

WIND SPIRIT

They appear in midair, circling Mario before trying to physically attack him.

WIRE TRAPS

These obstacles move along wires. There are red and blue types, one of which chases Mario.

OTHER CHARACTERS

These are characters you meet on Isle Delfino.

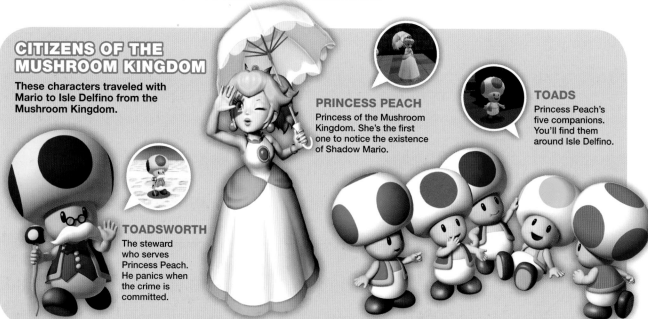

CITIZENS OF THE MUSHROOM KINGDOM

These characters traveled with Mario to Isle Delfino from the Mushroom Kingdom.

TOADSWORTH

The steward who serves Princess Peach. He panics when the crime is committed.

PRINCESS PEACH

Princess of the Mushroom Kingdom. She's the first one to notice the existence of Shadow Mario.

TOADS

Princess Peach's five companions. You'll find them around Isle Delfino.

PIANTAS

They're mountain people, said to have been made from the mountain itself. They have strong bodies and are brimming with curiosity. Although sociable, they tend to be blunt.

BEACH RESTAURANT PIANTAS

A married couple with children who run two restaurants on Gelato Beach. The husband runs the second shop.

DOOT-DOOT SISTERS

A group of sisters who wow the crowds with a hula dance during the festival.

SUNGLASSES VENDOR

You'll find him on every episode. Once the islanders understand that Mario isn't the culprit, he'll lend Mario sunglasses.

ISLE DELFINO POLICE CHIEF

The chief of police on Isle Delfino.

UKULELE PIANTA

He plays a happy ukulele tune. He has a twin brother in Pianta Village.

MUSHROOM DEALER PIANTA

He carries mushrooms on his back, and is often found running around full tilt.

PIANTA CAPTAIN

A self-described adventurer. He seems like a seaman, but nobody knows who he actually is.

ISLE DELFINO POLICE ROOKIE

A rookie policeman on Isle Delfino. He's a worrier.

HOTEL MANAGER

The manager of the Hotel Delfino. He asks Mario for a lot of favors.

THE MAYOR OF PIANTA VILLAGE

The head man of Pianta Village. He's always troubled by the village's problems.

NOKIS

They're people of the sea who wear pretty shells. They can be weak and timid, but they are very knowledgeable.

DUNE BUDDY

He loves all the Dune Buds on Gelato Beach, so he watches over them.

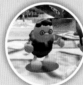

NOKI ELDER

An old man who lives in Noki Bay and spends all his time fishing.

PINNA PARK'S DIRECTOR

He thinks Mario is putting on a show!

MAI-MAI MIRU-MIRU MAKI-MAKI

THE PACKEES

A group of three brand-new idols. Mai-Mai is the group's leader.

SHELL FLAUTIST

He plays in Pinna Park and other places around Isle Delfino.

NOKI ELDER'S GRANDSON

He's his grandfather's disciple. He's married and has children.

PINNA PARK WORKER

He goes to work (a part-time job) in an original uniform.

MOMMY NOKI

A Noki with a baby. Rumor has it she's the wife of the Noki Elder's grandson.

OTHERS

Some odd characters on Isle Delfino.

BOATHOUSE OWNER

He'll sell Shine Sprites for ten blue coins each.

GREAT SUNFLOWER AND SUNFLOWER KIDS

These big sunflowers found in Pinna Park are being terrorized by enemies.

SAND BIRD

A legendary bird whose body is made of something very much like sand.

IL PIANTISSIMO

A mysterious guy in a Pianta costume who's a very fast racer.

MUDBOAT SHACK OWNER

He runs the boat rental place in Noki Bay.

INTRODUCTION CHARACTERS WORLD AND MORE

☀ WORLD

C O U R S E S

Each course contains many Shine Sprites just waiting to be found.

DELFINO PLAZA

Delfino Plaza is something of a home base. If you can clean up the graffiti, you will open warp gates to hidden areas that yield Shine Sprites.

SUPER SLIDE

Zoom down this long slide, but watch out for the pitfalls as you go!

TURBO TRACK

Using the Turbo Nozzle, clear this track with a series of jumps. Small footholds are the only landing zones!

RED COIN FIELD

Carefully hunt for the red coins hidden in the tall grass. Defeating some enemies may yield more coins.

PACHINKO GAME

Using the Hover Nozzle, gather up the red coins inside the pachinko game. Aiming for the ball return cups will allow Mario to hover again.

LILY PAD RIDE

Board a lily-pad boat and gather the red coins without falling into the poisonous water.

DELFINO AIRSTRIP

This is where Mario's adventure first began. Return there to start a red coin-collecting mission.

BIANCO HILLS

A hilly region resplendent with greenery and clear streams. There's a huge windmill in the center of the lake.

EPISODE 1
ROAD TO THE BIG WINDMILL

Spray the Polluted Piranha three times to defeat it and access the bridge to the windmill.

EPISODE 2
DOWN WITH PETEY PIRANHA!

Tread lightly down this polluted path! Petey Piranha awaits Mario at the top of the windmill.

EPISODE 3
THE HILLSIDE CAVE SECRET

Enter the cave near the lake to complete an odd, yet complex course.

EPISODE 4
RED COINS OF WINDMILL VILLAGE

There are eight coins hidden in and around the village. Some are on rooftops, some on cliffs …

EPISODE 5
PETEY PIRANHA STRIKES BACK

In this rematch with Petey Piranha, he flies around the village spewing goop and stirring up tornadoes.

EPISODE 6
THE SECRET OF THE DIRTY LAKE

Beyond the polluted lake and in the cave, an obstacle course made up of rotating Red-Blue Platforms awaits.

EPISODE 7
SHADOW MARIO ON THE LOOSE

Shadow Mario is running loose in the village! Mario must chase after him, spraying as he goes, in order to stop him.

EPISODE 8
THE RED COINS OF THE LAKE

Use the ropes to gather up all the red coins that appear above the lake.

RICCO HARBOR

A harbor full of docked ships. There's scaffolding to climb, as well as a crane that moves back and forth.

EPISODE 1
GOOPER BLOOPER BREAKS OUT

The sea is thick with goop, and Mario discovers the reason why: a Gooper Blooper!

EPISODE 2
BLOOPER SURFING SAFARI

Race on the back of a Blooper! If Mario makes good time on the track, he's rewarded with a Shine Sprite.

EPISODE 3
THE CAGED SHINE SPRITE

Mario hitches a ride on the crane's hook and then climbs across the scaffolding to make his way to the huge cage.

EPISODE 4
THE SECRET OF RICCO TOWER

Using the newly acquired Rocket Nozzle, Mario blasts off to the top of the tower! Then, rotating wooden blocks provide a tricky challenge.

EPISODE 5
GOOPER BLOOPER RETURNS

Rematch with the Gooper Blooper! This time, he has a new attack!

EPISODE 6
RED COINS ON THE WATER

Using the Blooper as a surfboard, Mario's goal is to gather all eight red coins.

EPISODE 7
SHADOW MARIO REVISITED

Shadow Mario leads a grand chase over the scaffolding.

EPISODE 8
YOSHI'S FRUIT ADVENTURE

Recruit Yoshi for a juicy adventure! Spitting juice at Cheep Cheeps turns them into platforms. Use the juice to retrieve the Shine Sprite as well.

GELATO BEACH

White sands and an open sea are found in this area filled with natural beauty.

EPISODE 1
DUNE BUD SAND CASTLE SECRET

Spraying Dune Buds with water creates a sand castle. The platforms leading to the Shine Sprite are sand blocks.

EPISODE 2
MIRROR MADNESS! TILT, SLAM, BAM!

Plungelos are obstructing the wobbly mirrors! Knock them off the mirrors to redirect sunlight on the tower.

EPISODE 3
WIGGLER AHOY! FULL STEAM AHEAD!

An angry Wiggler is on the loose on the beach! Mario can knock him over by watering some Dune Buds.

EPISODE 4
THE SAND BIRD IS BORN

Mario rides on the back of a huge Sand Bird in order to gather the eight red coins in midair.

EPISODE 5
IL PIANTISSIMO'S SAND SPRINT

Il Piantissimo thinks he's fast! Mario races him up the beach, but he has to get there first to win!

EPISODE 6
RED COINS IN THE CORAL REEF

Red coins are scattered around the beach and coral reef. Some are even swimming with the fish!

EPISODE 7
IT'S SHADOW MARIO! AFTER HIM!

Mario must chase after Shadow Mario once again, climbing cliffs and running up hills in order to douse him with more water.

EPISODE 8
THE WATERMELON FESTIVAL

It's the start of the Watermelon Festival! Only the biggest watermelon, delivered to the beachfront smoothie hut, can win!

PINNA PARK

An amusement park on a small island. It has all kinds of attractions, including a big roller coaster.

EPISODE 1
MECHA-BOWSER APPEARS!

This huge, fire-breathing robot stays put while Mario zips around in the roller coaster. Then, Shadow Mario's true identity is revealed.

EPISODE 2
THE BEACH CANNON'S SECRET

Defeat Monty Mole and enter the cannon's turret. The platforms in this secret course vanish and reappear!

EPISODE 3
RED COINS OF THE PIRATE SHIPS

Eight red coins are hidden in the Pirate Ship ride and among the fences surrounding it.

EPISODE 4
THE WILTED SUNFLOWERS

Rescue the wilted sunflowers by spraying and defeating the Snooza Koopas asleep on the beach.

EPISODE 5
THE RUNAWAY FERRIS WHEEL

Mario can scale the Ferris Wheel by flipping the fence panels. At the top, defeat the green Electro-Koopa.

EPISODE 6
THE YOSHI-GO-ROUND'S SECRET

Return Orange Yoshi to the Yoshi-Go-Round to find the secret course, which is made up of floating, revolving blocks.

EPISODE 7
SHADOW MARIO IN THE PARK

Shadow Mario appears in the park again. Mario gives chase, dousing him with even more water.

EPISODE 8
ROLLER COASTER BALLOONS

Mario must attempt to pop all twenty balloons before completing three circuits on the roller coaster!

SIRENA BEACH

The quiet sunset-soaked beach where Hotel Delfino is located.

EPISODE 1
THE MANTA STORM

Every time Mario sprays the Phantamanta, it splits into smaller and smaller mantas! Defeat them all.

EPISODE 2
THE HOTEL LOBBY'S SECRET

With a little bit of water, the Pink Boos transform into platforms. The next part of the course features a variety of blocks to cross.

INTRODUCTION CHARACTERS WORLD AND MORE

EPISODE 3
MYSTERIOUS HOTEL DELFINO

With Yoshi's help, Mario searches the hotel for the Shine Sprite.

EPISODE 4
THE SECRET OF CASINO DELFINO

With a little luck (and a lot of water), win big on the slot machine. A pipe will open, allowing Mario to cross the tricky obstacles.

EPISODE 5
KING BOO DOWN BELOW

Mario and King Boo do battle underneath the hotel. Spicy foods are his weakness—use that to beat him!

EPISODE 6
SCRUBBING SIRENA BEACH

It's a race against the clock! Clean up Sirena Beach before the time limit expires.

EPISODE 7
SHADOW MARIO CHECKS IN

Mario chases his shadowy adversary all over the hotel. Boos linger in the hallways, impersonating the impersonator.

EPISODE 8
RED COINS IN THE HOTEL

Collect all eight red coins scattered around the hotel before the buzzer.

NOKI BAY

A mysterious place with high cliff walls and a deep, deep sea. This is the home of the Noki people.

EPISODE 1
UNCORK THE WATERFALL

Small ledges and other obstacles dot the cliff. At the top, Mario battles Monty Mole, who sits atop a cannon.

EPISODE 2
THE BOSS OF TRICKY RUINS

The Tricky Ruins leave Mario only narrow cracks to navigate through. At the top, Gooper Blooper seeks revenge.

EPISODE 3
RED COINS IN A BOTTLE

Equipped with a special helmet, Mario enters a small bottle and must use FLUDD to gather all eight red coins.

EPISODE 4
EELY-MOUTH'S DENTIST

The monster lurking on the sea floor has a huge dental problem. Mario must use FLUDD to clean the creature's teeth.

EPISODE 5
IL PIANTISSIMO'S SURF SWIM

It's a race against Il Piantissimo! Head for the flag across the sea to win.

EPISODE 6
THE SHELL'S SECRET

A complicated ropes course leads into this giant Conch shell. Inside, a series of wall jumps is the only way up the rotating platforms.

EPISODE 7
HOLD IT, SHADOW MARIO!

This time, Mario must use the Hover Nozzle to chase Shadow Mario up the cliffs.

EPISODE 8
THE RED COIN FISH

Gather all eight red coins found at the bottom of the sea. Some of the coins are even locked in a fishy formation!

PIANTA VILLAGE

The hometown of all the Piantas is deep in the mountains. There are huge palm trees and mushrooms growing here.

EPISODE 1
CHAIN CHOMPLETS UNCHAINED

The Chain Chomplets are raging through town. Mario can cool them off with water, then lead them to the lake.

EPISODE 2
IL PIANTISSIMO'S CRAZY CLIMB

It's Mario's third race with Il Piantissimo. The finish line is the top of a huge palm tree!

EPISODE 3
THE GOOPY INFERNO

The entire town is covered in red-hot goop, and Mario has to rescue the mayor—without FLUDD!

EPISODE 4
CHAIN CHOMP'S BATH

Like its smaller cousins, the Chain Chomp needs to cool his head! Once he's blue, Mario can lead him to the hot-springs bath.

EPISODE 5
SECRET OF THE VILLAGE UNDERSIDE

With Yoshi in tow, head to the underside of the village. In the next area, Chuckster Piantas help Mario through the course.

EPISODE 6
PIANTAS IN NEED

Ten Piantas are buried in burning goo! Rescue them all before time runs out.

EPISODE 7
SHADOW MARIO RUNS WILD

Shadow Mario leaves a trail of fiery graffiti! Mario must chase after him, spraying FLUDD relentlessly.

EPISODE 8
FLUFF FESTIVAL COIN HUNT

Collect all the red coins hidden in the Fluff Festival. The Shine Sprite appears on top of a fluffy cloud.

CORONA MOUNTAIN

An active volcano with huge pools of lava. Mario has to jump and climb the clouds to reach the top where the final battle awaits him.

ITEMS & OBSTACLES

Items and other things you find on the courses. A lot of these respond in one way or another to being sprayed with water.

1-UP MUSHROOM

Found in blocks or when ground-pounding nails, these mushrooms give you an extra life.

BALLOON

They appear in Pinna Park, Episode 8. Mario uses the roller coaster to pop them.

BASKET

Bullet Bills can destroy these. Sometimes, there'll be an item inside.

BELL

Pouring water or hitting these with a waterwheel produces 1-Up Mushrooms or coins.

BIRD

If sprayed, these birds drop an item. Each color bird produces a different item.

BLOOPER RACER

Mario can race these Bloopers quickly across the water's surface. They come in three colors.

BLUE COIN

These appear when completing certain tasks, like cleaning up graffiti. Trade ten for a Shine Sprite.

BOWSER'S HOT TUB

Bowser relaxes here. If Mario touches the green goo, he takes damage.

BLOCK

If Mario hits them from below, they break, but from above, a ground pound won't even crack them.

BURNER

These platforms spout fire, which goes out after a short while.

BUTTERFLY

They come in three colors. If Yoshi eats one, an item comes out—different items for each color.

CLAM CUPS

Spray water on them, and the clams open up. Some contain coins or even blue coins.

CLOUD

These platforms within Corona Mountain expand when Mario pours water on them.

COIN

These fill the health meter by one. Collect fifty for a 1-Up, and a hundred for a Shine Sprite.

CRATE

A ground pound will break them. Sometimes they contain an item.

CUBE LIFT

These cube-shaped platforms rotate and move when Mario gets on.

DUNE BUD

When Mario waters them, these small sprouts undergo a strange transformation.

ELECTRIC GRAFFITI

When Mario touches this, not only is he shocked for a moment, but he also takes damage.

FENCE

Mario can climb on them, under them, on the walls, and even sometimes on the ceiling.

FLOATY FLUFF

These puffy plants float with the wind! Mario can grab on and take a ride.

FLOWER

Spray water on them, and a coin comes out. Sometimes they are Pokeys in disguise!

FORCEFIELD

If Mario touches it, he takes damage. It can be melted with Yoshi's juice.

FRUIT

Six types of fruit can be found scattered among the courses. Some of them become trees.

FRUIT VAT

If Mario ground-pounds the switch in the upper section, fruit comes out.

GOOP

If Mario gets in it, he slips and his body gets polluted. He can wash it off with water.

GRAFFITI

Regular or blue coins appear as Mario cleans these messes up.

GRAFFITI (SHAPES)

Mario is rewarded with blue coins if he cleans up one of the two types.

GROUND POUND PLATFORM

Ground-pound these targets to destroy the platform underneath.

HOOK

Mario can hitch a ride on these huge hooks.

 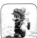

HOVER NOZZLE CRATE

A blue-colored box. If Mario jumps on it, a hover nozzle comes out.

ICE BLOCK

When Mario pours water on these, they slowly melt. Sometimes they have items inside.

LAVA

A lake of lava found on Corona Mountain. If Mario falls in, you must start over.

LAVA GRAFFITI

This red-hot goop deals damage, but vanishes if Mario sprays it with water.

LILY PAD

Mario can steer these large lily pads with water, but they can sink and vanish.

MANHOLE

By doing a ground pound on these, Mario can enter the underground passageway.

MARIO'S CAP

Certain enemies may steal Mario's cap! Once defeated, the enemy drops it.

MIRROR

Plungelos walk around on these huge round mirrors, and their weight makes them tilt.

MOVING FENCE

When Mario hits them, they start to move along a track. A short while after they stop, they fall.

MUD BOAT

Mario can steer these boats with a jet of water from FLUDD. They sink if they hit a wall.

NAIL

Mario can pound them in with a ground pound, and when he does, some produce items.

PIPE

A green pipe leads to a different area; an orange one leads to a different course.

PIRATE SHIP

They swing left and right in huge arcs, and sometimes do a complete revolution.

POISONED RIVER

This toxic water flows underneath the lily pad on the Delfino Plaza Mini-Course.

POISONED WATER

These damage-inducing bodies of water can be found in places such as Noki Bay.

RED COIN

Collect eight and a Shine Sprite appears. They also appear in special Mini-Courses and episodes.

RED SWITCH

A ground pound will flip the switch; red coins will appear for a while.

RED-BLUE PLATFORMS

These red and blue lifts take turns rotating.

REVOLVING DOOR

Hit it, and it will spin Mario to the other side. Some can be found on walls and others on ceilings.

REVOLVING FENCE

When Mario sprays water on it, this fence rotates ninety degrees.

ROCKET NOZZLE CRATE

A red-colored box. If Mario jumps on it, a rocket nozzle comes out.

ROLLER COASTER

Mario can fire water rockets from the car as it zooms around the track.

ROPE

They hang a little slack, but Mario can move across them. Jumping on these will launch Mario into the air.

SAND BLOCK

Once touched, these platforms crumble. Wait too long, and they vanish.

SHINE SPRITES

Small facets of sun power that can be found scattered around the island.

SIGN

These signs can be found scattered around courses and provide important information.

SLOT MACHINE
Spray the drums to turn them. Coins or enemies may come out, depending on the results.

SPIKES
They shoot out of platforms at regular intervals. Don't touch them, or else you'll lose a life.

SPRAY POINT
Mario can fill up FLUDD's tanks using these water spouts.

SPRINGBOARD
Get on, and Mario is flung high into the air. If sprayed with water, they shrink and can be carried to other places.

SWING
If Mario sprays them with water, they swing. Building up momentum sends them even higher.

TILE SET GAME
Mario sprays water on the sixteen panels to get them to rotate. If he can complete the puzzle, a pipe appears.

TRAP
They suddenly appear in certain places and send Mario flying a long way.

TRAMPOLINE
Mario can bounce high into the air. They come in all sorts of designs, but the effect is the same.

TREE
Mario can grab on and climb them. If the tree has sharp branches, Mario can't climb to the top.

TRICKY RUINS
Once sprayed, ruins appear. The shape of the ruins depends on the location.

TURBO DOORS
These doors break apart when Mario Turbo Dashes through them.

TURBO NOZZLE CRATE
A gray-colored box. If Mario jumps on it, a turbo nozzle comes out.

WANTED POSTERS
Wanted posters showing the vandal's picture. Some of them produce coins if sprayed.

WATER BARREL
They're filled with water. Break them to spill their contents. They can be carried.

WATER BOTTLE
The small type fills FLUDD's tanks half-way. The large type fills FLUDD up completely.

WATER LIFTS
Operate these lifts by filling the jugs up with water.

WATER ROCKET
These rockets are loaded into the roller coaster, and can be fired from FLUDD.

WATERMELON
Damage these to break them apart, revealing a coin. They come in several different sizes.

WATERMELON BLOCK
Mario can break these with a ground pound.

WINDOW
Sometimes, spraying water into open windows produces coins.

YELLOW SWITCH
A ground pound will flip the switch; coins will appear for a while.

WATER BOTTLE (row 3)

YOSHI-GO-ROUND
An amusement park ride with mechanical Yoshis.

YOSHI'S EGG
Yoshi craves a specific kind of fruit! If Mario brings the fruit shown in the thought bubble, Yoshi hatches.

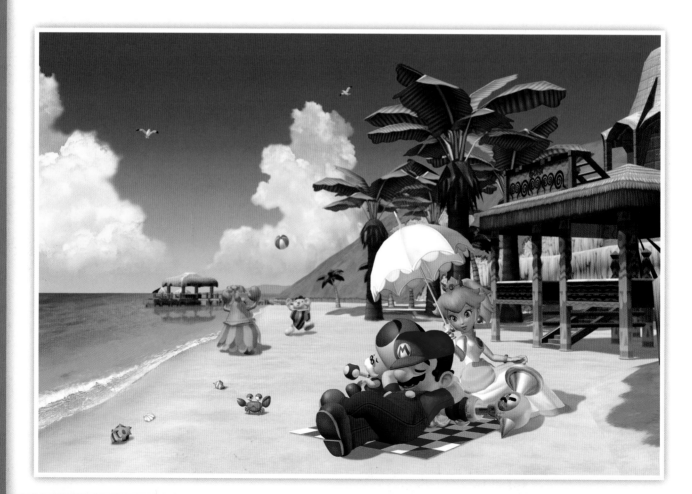

AND MORE

MEMORABLE MOMENTS

These scenes really made an impression. There are a lot of iconic moments featuring Shadow Mario . . . but who was he, really?

THE DOLPHIN ISLAND

Isle Delfino, the setting for this adventure, is in the shape of a jumping dolphin. Its name means dolphin as well. Sometimes you can see over hills or across the water to other areas of the island. You can see Ricco Harbor from the Bianco Hills, and you can see Sirena Beach from Pinna Park.

A STRANGE OLD MAN

FLUDD comes from Gadd Science, Incorporated. Its inventor, E. Gadd, is the same guy who made Luigi's weapons in the Nintendo GameCube game *Luigi's Mansion*. Bowser Jr. also mentions that he got his equipment from a strange old man in a white coat, so it's possible that his magic paintbrush came from the same company.

Thank you for purchasing this item from Gadd Science, Incorporated.

When I draw with this, all my wishes come true!

MARIO'S PROFILE

When you register as the user of FLUDD, an interesting profile of Mario comes up on screen. When you look closely at the Japanese text, it has some interesting info on Mario. You'll see, "Favorite food: spaghetti, least favorite food: poison mushrooms, weight: it's a secret, height: unknown, number of previous jobs: unknown," and more.

PEACH IN A PONYTAIL!

Both Mario and Princess Peach have dressed to match the tropical climate of this game. Peach wears a sleeveless dress and her hair is tied up in a ponytail. After this game, she appears with a ponytail for sports games such as *Mario Kart* and *Mario Tennis*.

BOWSER JR.'S GRAFFITI

Throughout the game, Bowser Jr. does a lot of vandalizing—and creates a lot of enemies in the process! As a result, their design is slightly different than in other games in the series. Yoshi also vanishes when he falls into the water for the same reason.

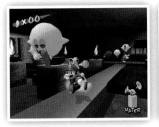

SECRET COURSES

There are secret courses hidden in some areas. As you enter, Shadow Mario steals FLUDD, so Mario has to find his way to the Shine Sprite without his watery companion's help. But after Mario has cleared the course, FLUDD reappears on his back so he can take on the next mission with its help.

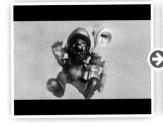

WORN-OUT VOICE

When Mario has taken enough damage that he's close to losing a life, he's more exhausted and his voice changes to match.

SHADOW MARIO'S IDENTITY REVEALED

At the start of the game, the vandal's identity is a mystery. But when his identity is finally revealed, it turns out to be Bowser's son, Bowser Jr.! Apparently, Bowser told his son that Mario was a bully who kidnapped Peach. This game is Bowser Jr.'s first appearance, and the design of his scarf is different than what it became for later games.

SHADOW MARIO IS A THIEF!

Shadow Mario is always running around vandalizing Plaza Delfino. He will grab your Yoshi eggs or FLUDD power-ups, but you can stop him and get them back by spraying enough water on him.

MARIO CAN RIDE YOSHI

This is the first time in a 3D action game where Mario can actually ride Yoshi. Using fruit juice and his long tongue as weapons, he joins Mario for the adventure.

FAMILIAR SHAPES

If you look at Sirena Beach from the right angle, you can make out the shape of a Nintendo GameCube controller. And take a look at the Hotel Delfino, too—it looks like the console!

MARIO'S HAT SWIPED!

On the beach at Pinna Park, there's a version of Soarin' Stu called Swipin' Stu that attacks Mario and steals his cap. Without it, Mario takes a bit of extra damage. After Stu has taken the hat, his face changes to look more like Mario's.

FLOODED PLAZA DELFINO

If you have completed all the missions that involve capturing Shadow Mario, you return to Plaza Delfino and find it entirely flooded. In the flooded state, you're able to chase Shadow Mario all the way to Corona Mountain and take on the final course.

HELPFUL HINTS & TECHNIQUES

These rare events only occur when you've met certain conditions. This is the only game in the series where you can see Mario in sunglasses!

SUNGLASSES AND HAWAIIAN SHIRTS

Once you talk to the Sunglasses Vendor Pianta, he'll loan Mario his sunglasses as long as you've gathered thirty Shine Sprites. Put them on and the screen gets slightly darker. After you clear the game, Mario dons the shades and a Hawaiian shirt. If you talk to the Sunglasses Vendor again, you return to Mario's normal look.

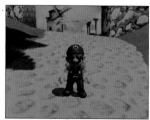

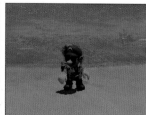

COLLECT ALL 120 SHINE SPRITES?!

There are 120 Shine Sprites to be found in the game. Once you've gathered them all, your save file gets a special mark, and there's a new cutscene after the credits scroll.

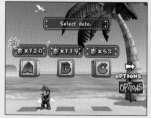

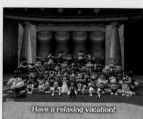

SUPER MARIO
SERIES FLYER GALLERY

These flyers were distributed to toy stores, game shops, and other software retailers to introduce the series. They came in A4 size, and they explained what made each game so fun to play.

SUPER MARIO BROS. 3

SUPER MARIO BROS.

SUPER MARIO BROS. 2
SUPER MARIO BROS.: THE LOST LEVELS IN THE US

SUPER MARIO WORLD

SUPER MARIO USA
SUPER MARIO BROS. 2 IN THE US

SUPER MARIO LAND 2: 6 GOLDEN COINS

SUPER MARIO SUNSHINE

BOOKLETS

For later games that came after those advertised in the flyers above, the distributed promotional material was changed to booklets. They were published as catalogs or in other formats covering either a single game or several games at once, depending on the time of release. They sometimes came in concert with TV commercials, or featured famous celebrities on the covers of the booklets.

NEW SUPER MARIO BROS.

NEW SUPER MARIO BROS. U

109

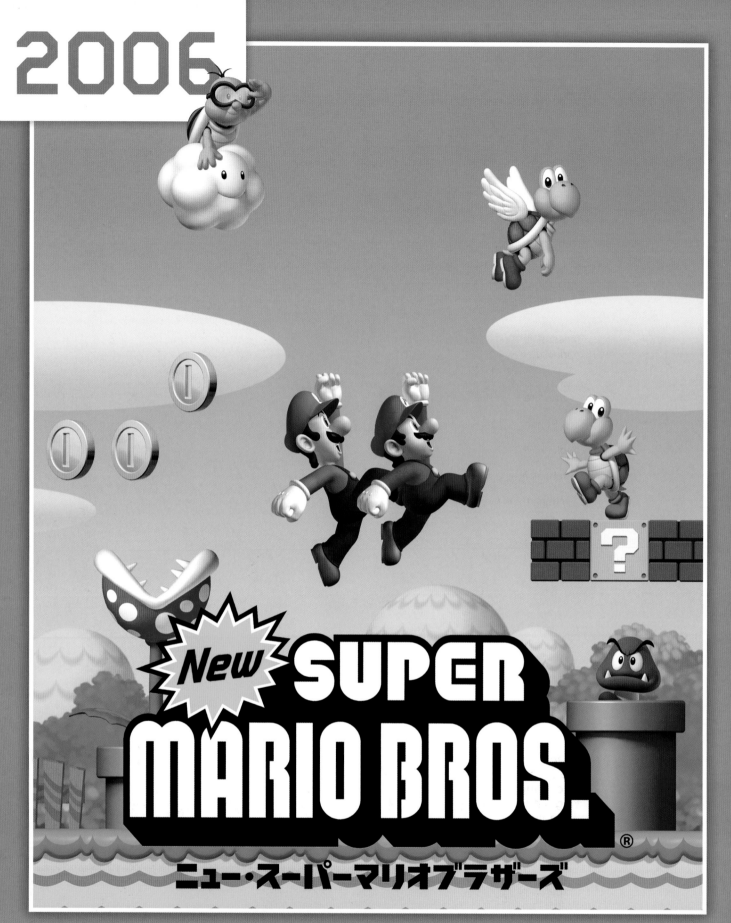

New SUPER MARIO BROS.®

ニュー・スーパーマリオブラザーズ

Package

Game Card

Instruction Booklet

System: Nintendo DS
Release Date:
May 15, 2006
(Japan: May 25, 2006)
Player Count: 1–4

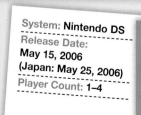

INTRODUCTION

STORY

*This text is taken directly from the instruction booklet.

Emergency News Flash!

Princess Peach has been kidnapped! While enjoying a nice walk with Mario, the beloved ruler of the Mushroom Kingdom was whisked away by an unknown assailant. How could this happen with Mario around?

According to eyewitnesses, the walk was going swimmingly when Mario and the princess spotted smoke billowing out of Peach's Castle. The mustachioed marvel immediately jumped into action and sped off toward the fire. The moment he left her side, the princess vanished!

Who's behind Princess Peach's disappearance?

Who's behind the attack on Peach's Castle?

Are the two incidents related?

Didn't Bowser Jr. once think that Princess Peach might be his mother?

Looks like Mario's going to need all the Mega Mushrooms he can find to get to the bottom of this mess!

FEATURES

RETURN OF THE SIDE-SCROLLER

After *Super Mario Land 2: 6 Golden Coins*, there wasn't another 2D side-scrolling action game starring Mario for fourteen years. In *New Super Mario Bros.*, Mario returns to the original format to battle Goombas and Koopa Troopas across eight worlds in this ever-expanding adventure. The controls are the +Control Pad and two buttons, so of course you can still dash and carry objects. Some actions from the 3D games, such as the ground pound and wall jump, were incorporated as well.

MINIGAMES FOR ALL

In addition to the main story mode where Mario rescues Princess Peach, there are two multiplayer modes available through wireless connection.

MARIO VS. LUIGI
The two brothers play against each other. Big Stars appear randomly all over the course. Move quickly and grab them before your opponent does.

MINIGAMES
There are over twenty in all: puzzles and action games from all sorts of genres. Some can play up to four players.

CHARACTERS

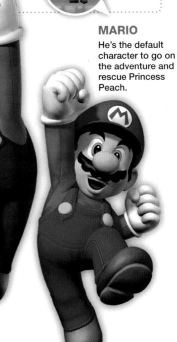

PLAYER CHARACTERS

You'll start the game as the brother you know best: Mario! This time, Luigi isn't just Player Two. If you use the code below, you can take Luigi on an adventure instead of Mario.

MARIO

He's the default character to go on the adventure and rescue Princess Peach.

LUIGI

On the "file select" screen, if you simultaneously press the L, R, and A Buttons, you can choose to play as Luigi. His abilities are the same as Mario's.

POWER -UPS

Mario is powered up when you use certain items. If you find another item while he's already powered up, it goes into your stock so you can use it later.

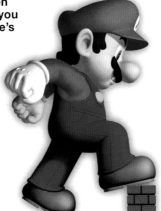

MARIO

Mario starts the game in his standard form. He can't break blocks when he's this size, and if he's hit by an enemy, you'll lose a life.

 MARIO

 LUIGI

SUPER MARIO ITEM → SUPER MUSHROOM

Mario grows to twice his size when he gets a Super Mushroom. He can break brick blocks now, but if he's hit by an enemy, he'll shrink back down to his regular size.

 SUPER MARIO

 SUPER LUIGI

FIRE MARIO ITEM → FIRE FLOWER

Mario can attack enemies by hurling fireballs at them. A coin appears when he defeats enemies with a fireball.

 FIRE MARIO

 FIRE LUIGI

INVINCIBLE MARIO ITEM ➔ STARMAN

Mario's body starts glowing, and he can defeat any enemy just by touching them. If Mario defeats eight enemies in a row, you get a 1-Up Mushroom. His dash speed is increased, and he twirls when he jumps.

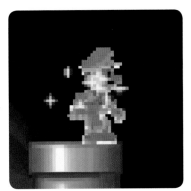

 INVINCIBLE LUIGI

MEGA MARIO ITEM ➔ MEGA MUSHROOM

Grab a Mega Mushroom and Mario grows to a colossal size. Mega Mario smashes enemies, blocks, and even pipes simply by touching them. A meter keeps track of how much he destroys. When the Mega Mushroom wears off, a 1-Up Mushroom appears for each block filled on the meter.

 MEGA MARIO

 MEGA LUIGI

MINI MARIO ITEM ➔ MINI MUSHROOM

Use a Mini Mushroom to shrink Mario down to micro size. Because of his tiny size, Mario floats when he jumps and can run on water. But he can't defeat enemies with a simple jump anymore, and any damage means you lose a life.

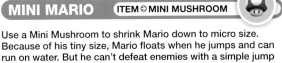

 MINI MARIO

 MINI LUIGI

SHELL MARIO ITEM ➔ BLUE SHELL

When Mario's wearing a blue Koopa shell on his back, he can crash into enemies with it and defeat them as he goes. If he squats, he goes into his shell and is protected from some attacks. He can also swim a little faster.

 SHELL LUIGI

OTHER CHARACTERS

Mario's allies who help him on his adventure.

DORRIE

There are dangerous poisonous swamps, but Mario can get across them on Dorrie's back. If Mario does a ground pound, Dorrie lowers her neck and speeds up.

BIG WIGGLER

This Wiggler has a very long body that carries Mario along. If Mario times his jump with Wiggler's wave-like motion, he can jump very high.

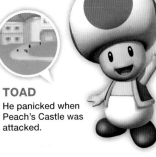

TOAD

He panicked when Peach's Castle was attacked.

TOADSWORTH

He stays in the Toad Houses and gives Mario items. Which item you get depends on what kind of Toad House you visit.

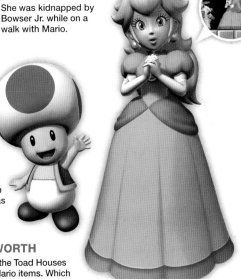

PRINCESS PEACH

She was kidnapped by Bowser Jr. while on a walk with Mario.

ENEMIES

Here are the enemies that Mario encounters on his journey. There are different boss characters waiting in each world, and Bowser and Bowser Jr. are both in the final tower!

AMP
They stay still, and their bodies are covered in electricity.

BALLOON BOO
When Mario is looking, they puff up. When Mario turns his back, they deflate and chase after him.

BANZAI BILL
A huge Bullet Bill. They can be defeated just like regular Bullet Bills, with a stomp from above.

BIG DEEP CHEEP
These Deep Cheeps are larger than average. The territory they patrol is larger, too.

BIG DRY BONES
A larger Dry Bones. They don't fall apart when Mario does a normal stomp—you have to ground-pound.

BIG PIRANHA PLANT
They're rooted in the ground, so they reach to bite Mario with their long stems.

BIG THWOMP
When these large Thwomps fall, they can break blocks.

BIG UNAGI
These huge Unagis destroy everything in their path as they swim.

BIG WHOMP
It walks back and forth, waiting for Mario to come close so it can fall on top of him.

BLOCKHOPPER
They pretend to be blocks until Mario gets close, then they show their true form.

BLOOPER
They follow Mario through the water, bobbing up and down.

BLOOPER NANNY
Four Blooper Babies follow them as they swim. They flash a warning, and then split up and attack Mario.

BOB-OMB
After a hit from Mario, they steam for a little while, then explode. Their blasts can break blocks.

BOO
They chase after Mario while his back is turned. Sometimes they hide inside blocks.

BOOMERANG BRO
They attack with boomerangs.

BOWSER
The boss of W1 and W8. He breathes fire to attack Mario, and can jump very high.
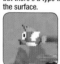

BOWSER JR.
He's the boss of the towers. He hides in his shell to protect himself, and he throws shells at Mario.

BROOZER
They run up to attack, breaking blocks in their path. It takes three stomps from Mario before one will go down.

BULLET BILL
They fly in straight lines. Some are fired out of Bill Blasters.

BUZZY BEETLE
They mostly appear in underground courses. Some walk across the ceiling, then fall to the ground.

CHAIN CHOMP
They try to bite Mario. Three ground pounds on the post allows them to escape.

CHEEP CHEEP
Usually they swim slowly underwater, but there's a type that jumps up from the surface.

CHEEP CHOMP
They try to gobble Mario up with their big mouths.

CHEEPSKIPPER
The boss of World 3. He jumps out of the water and tries to tackle Mario.

CLIMBING KOOPA (GREEN)
They climb up and down or right to left along fences.

CLIMBING KOOPA (RED)
They're much faster than Green Climbing Koopas.

CROWBER
After they crisscross in the sky, they swoop down to attack Mario.

DEEP CHEEP
When they see Mario, they swim directly toward him.

DRY BONES
When Mario jumps on one, it falls apart. But after a while it will come back to life.

DRY BOWSER
This boss looks a lot like Bowser. He throws bones at Mario, and fireballs don't have any effect on him.

FIRE BRO
They attack Mario by shooting fireballs at him.

FIRE SNAKE
They're made entirely of flames! They make bounding leaps to chase after Mario.

FLAME CHOMP
They float around near Mario and spit fireballs at him.

GOOMBA
They walk slowly along the ground, and jump in time with the music.

HAMMER BRO

They throw hammers to attack. Every now and then they jump.

KAB-OMB

Falling volcanic rocks or fireballs light their fuse, and then they go on a rampage.

KOOPA PARATROOPA (GREEN)

They're a lot like the red ones but if you jump on one, its wings fall off and it becomes a normal Koopa Troopa.

KOOPA PARATROOPA (RED)

They can fly, or just bounce across the ground.

KOOPA TROOPA (GREEN)

They keep on walking, even off the edge of a cliff. If Mario jumps on one, it hides inside its shell.

KOOPA TROOPA (RED)

They walk back and forth on level areas. Sometimes the music inspires them to strike a pose.

LAKITHUNDER

The boss of World 7. He throws Spiny Eggs, drops lightning, and even dives down to attack Mario!

LAKITU

They throw Spiny Eggs from the sky. Steal Lakitu's Cloud by defeating it.

LAVA BUBBLE

A ball of fire that jumps out of a pool of lava.

MEGA CHEEP CHEEP

These large-sized Cheep Cheeps don't move any differently than their smaller relatives.

MEGA GOOMBA

The boss of World 4 is so big that a normal stomp just won't do the trick.

MINI GOOMBA

These Goombas are so small that even Mini Mario can defeat one by jumping on it.

MONEYBAGS

They run away with bouncing leaps. An item appears after Mario defeats one.

MONTY TANK

The boss of World 6 is in a tank that fires Bullet Bills. He also throws Bob-ombs at Mario.

MUMMIPOKEY

The boss of World 2. He pops out of the sand and attacks by spitting rocks at Mario.

PARAGOOMBA

These Goombas have wings, but they don't quite fly—they just bounce very high.

PETEY PIRANHA

The boss of World 5 flies for a little while in the air, then suddenly comes down hard.

PIRANHA PLANT

Some are planted in the ground, and others come out of pipes.

POKEY

Mario can attack each segment of the body, but if he attacks the head he quickly defeats the entire Pokey.

SCUTTLEBUG

They lower themselves down from above on a web. Sometimes they reach all the way to the ground.

SKEETER

They skate across the surface of the water. Every so often, they drop a bomb.

SLEDGE BRO

They throw hammers. When they ground-pound, they hit the ground with a strong earth-rumbling stomp.

SNAILICORN

They charge toward Mario when they catch sight of him. If Mario jumps on one, it is pushed back a long way.

SNOW SPIKE

They pull snowballs out of their mouths and throw them. The snowball grows as it rolls through the snow.

SPIKE BASS

They move along the surface of the water, occasionally jumping up to attack Mario.

SPIKE TOP

The big spike on top protects them from Mario's stomps. They can walk on walls and ceilings.

SPINY

They have a spiny shell, so Mario will take damage if he jumps on them. Use fireballs to defeat them safely.

SPINY EGG

Lakitus throw them from above. When Spinies enter water, they curl back into Spiny Eggs.

SPLUNKIN

These jack-o'-lanterns plod along the ground. If Mario stomps on them once, they get mad and move faster.

SQUIGGLER

They climb out of pipes, and then crawl around slowly.

SUSHI

They swim straight through the water, and twirl in time with the music.

SWOOP

They hang from the ceiling and wait. When Mario approaches, they swoop down at him and then fly away.

THWOMP

They fall when Mario gets close, then they slowly rise back up.

UNAGI

Some stick their heads out of holes in the rocks and bite at Mario. Others swim slowly through the water.

VENUS FIRE TRAP

They spit fireballs towards Mario.

WHOMP

They try to fall face-first onto Mario. You can use them as a platform while they're on the ground.

WIGGLER

Normally they stroll along calmly, but if Mario attacks they become bright red Angry Wigglers.

WORLD

C O U R S E S

The game is split into eight worlds, each containing roughly ten courses. If you want to get to the special courses marked with letters, you will need to either spend Star Coins or find hidden entrances.

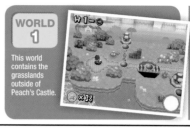

WORLD 1

This world contains the grasslands outside of Peach's Castle.

W1-1

The first grassland course. It's a breeze if Mario uses a Mega Mushroom.

W1-2

There are lots of blocks in this level. If Mario goes above the ceiling past the exit, he'll find a hidden goal.

W1-3

It's a lot easier to get through if you jump rhythmically in time with the tilting mushrooms.

W1-🏰

As Mario works his way to the top, don't get caught by the moving blocks in the middle.

W1-4

This hilly course features the first appearance of the Mini Mushroom.

W1-5

Mario can leap forward with the help of trampoline mushrooms.

W1-👹

Ropes and moving wall sections allow Mario to stay above the lava.

W1-A

Sushis swim past Mario in this scrolling underwater course.

WORLD 2

A desert world covered in shifting sands. Can Mario find an oasis?

W2-1

A desert level where Pokeys big and small block Mario's way.

W2-2

Steal Lakitu's Cloud to reach the coins in the sky.

W2-3

Narrow passageways connect big and small rooms in this mazelike course.

W2-4

Dunes appear when Mario hits ? Switches.

W2-🏰

Make your way through Ferris wheel lifts and rotating platforms.

W2-5

Beware the Blockhoppers—they're disguised as normal ? Blocks!

W2-6

Fly through the sky on a huge lift. Piranha Plants try to hitch a ride, too.

W2-👹

Spiked balls of all sizes roll through the castle.

W2-A

Avoid the Spike Bass, then use the spin blocks to helicopter through the air.

WORLD 3

This world has an island feeling, as the ocean spreads out before you.

W3-1

At first, it's filled with peaceful Cheep Cheeps, but then Cheep Chomps swim toward Mario.

W3-2

Cross all different types of moving mushrooms to reach the goal.

W3-🏰

Climb up the fences and watch out for Climbing Koopas.

W3-3

Rushing water slows Mario's progress as Bloopers take aim at him.

W3-🏠

An odd mansion with a confusing layout. Solve the mystery to reach the end.

W3-👹

Mario must make his way through a path filled with Skewers and Whomps.

W3-A

Skeeters skim along the water's surface while Mario bounces over barrels and lifts.

W3-B

Pipes serve as Mario's platforms. Watch out for Piranha Plants!

W3-C

Spike Bass and Cheep Cheeps patrol the shallow water.

WORLD 4

A creepy jungle world, with a poison swamp everywhere you look.

W4-1

This forest is full of danger: a poisonous swamp below, and Scuttlebugs above.

W4-2

Mario must cross mushroom platforms that tilt as he steps on. Try not to slip!

W4-3

Big Unagi moves through the water like he owns the place.

W4-🏰

Mario must climb the fences to stay above the rising lava.

W4-4

Do your best to get Mario through this forest without angering the Wigglers too much.

W4-🏠

These small rooms are full of tricks. Navigate with platforms and pipes.

W4-5

Bob-ombs can help break blocks and open a way through this underground level.

W4-6

Dorrie will help Mario pass through this poison swamp.

W4-👹

Swing across the lava, then watch out for Thwomps!

W4-A

Keep Mario above the swamp as he jumps across water wheels.

WORLD 5

A world covered in snow. There are a lot of slippery spots in this world.

W 5-1

There's snow on the ground and falling from tree branches, so Mario has to watch his footing.

W5-2

An icy cave where Spike Tops wander around and Swoops dive at Mario.

W5-

A lift takes Mario to the top, but avoid the Dry Bones and spiked balls as you rise.

W 5-3

The icy floor makes for an exhilarating slide downward.

W5-

Let the Broozers break the blocks so Mario can continue forward.

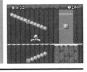

W5-4

Avoid the Bullet Bills as Mario makes his way over mushroom platforms that move up and down.

W5-

The conveyor belts in this ice castle can speed Mario up, or slow him down.

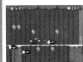

W5-A

Leap across this course on mushroom platforms that grow and shrink.

W5-B

Koopa Troopas block Mario's way over icy footing.

W5-C

Broozers go wild in this underground course.

WORLD 6

A mountainous world of rocks and caves. There's a lot of climbing up and down in these levels.

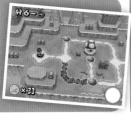

W6-1

Bullet Bills never stop coming as Mario climbs over cliffs and ledges.

W6-2

The water level changes in this shallow lake. Spiny Eggs float on the surface.

W6-

Skewers crash out from the right and left as Mario climbs. Find the safe areas!

W6-3

A forest scene filled with Piranha Plants. Part of the course is underground.

W6-4

There aren't many enemies here, just rocky ledges and Fire Bars.

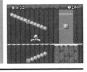

W6- 2

Make your way upward by climbing the conveyor belts. Watch out for Dry Bones!

W6-5

Deep Cheeps chase after Mario from both sides.

W6-6

Mario can get to the top with the help of spin blocks, pipe cannons, and pipes.

W6-

Use the moving stone lifts to help Mario cross over the lava.

W6-A

The quicksand spreads across the entire screen! Two Lakitus attack Mario simultaneously.

W6-B

Use the dangling poles and leaning mushrooms to get between icy mountain ledges.

WORLD 7

A world above the clouds. Lots of jumping is in store for Mario here!

W7-1

Mario must ride the moving Flatbed Ferries across this level.

W7-

Search for the goal among the hidden blocks, doors, and other secrets.

W7-2

You'll need good balance to help Mario get all the way to the top.

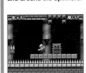

W7-3

Ride on the Big Wiggler's back and have an adventure together!

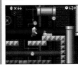

W7-

Use the lifts to move up, down, left, and right around obstacles.

W7-4

Use the spin blocks to send Mario from mushroom platform to mushroom platform.

W7-5

Use the power of Bob-ombs to unlock hidden areas.

W7-6

Koopa Paratroopas bounce along on the tops of mushroom platforms, and Mario can too!

W7-7

Mario must use lifts to make it through this scrolling course.

W7-

Ride the Snake Blocks to pass across the spikes and around the Spinners.

W7-A

All of the connected pipes and passages make this level like a maze.

WORLD 8

The techniques needed to clear this dark and smoky world are quite complicated.

W8-1

Bullet Bills fill the screen as Crowbers attack from the skies.

W8-2

The switches change the water level, so use that to keep Mario moving.

W8- 1

The stone blocks move back and forth. Mario can use them as footholds on his way up.

W8-3

An underwater cave filled with Unagis. At the end, there's a Mega Unagi who chases Mario!

W8-4

Scuttlebugs drop down on you from above, and Mario must leap across some big gaps.

W8-

The Flatbed Ferries change position when Mario hits the switches.

W8-5

Mario must jump off unstable platforms and wobbly stones before they fall.

W8-6

Climb to escape the rising lava.

W8-7

This mountainous level is filled with Koopa Troopas, Sledge Bros., and many more enemies.

W8-8

Mario's footholds keep getting destroyed by flying rocks from the volcano.

W8- 2

Board the Snake Blocks and follow their complicated route to avoid all obstacles.

W8-

These mysterious rooms turn 180 degrees. In the final room, Mario faces Bowser Jr. . . . and Bowser!

INTRODUCTION CHARACTERS **WORLD** AND MORE

ITEMS & OBSTACLES

Items and other things that you find on the courses. Some will help Mario, but some will make you lose a life with just one touch.

! SWITCH
When Mario hits it, dotted line blocks become solid for a while.

? BLOCK
These blocks can contain coins or items.

? SWITCH
When Mario flips the switch, he sets a mechanism into action.

1-UP MUSHROOM
Grab one of these to gain an extra life.

10-COIN BLOCK
A block that spouts a series of up to ten coins as Mario hits it.

BARREL
They float on the surface of water. They bob and sink under Mario's weight.

BANZAI BILL CANNON
These cannons blast out Banzai Bills. They fire towards Mario.

BILL BLASTER
These cannons fire Bullet Bills. They come at different heights.

BLOCKED PIPE
The opening is covered. Mario can use a pump to clear it away.

BLUE SHELL
Mario can use this to power up into Shell Mario.

BLOCK
Super Mario can smash them. Some hold items.

BURNER
Some are always shooting a pillar of fire; others send fire out periodically.

COIN
Some are set all along the courses. Others appear after Mario defeats an enemy with a fireball.

CONVEYOR BELT
When Mario gets on, he moves with it, either left or right.

CURRENT PIPE
A strong current flows through the pipe. If Mario swims into it, the current pushes him along.

CYCLONE
If Mario gets caught in one, he's thrown high up into the air.

DANGLING ? BLOCK
This wildly swinging ? Block stops in place when Mario hits it.

DONUT BLOCK
When Mario gets on, they turn red. Soon, they start to fall.

DOTTED-LINE BLOCK
They're dotted outlines of blocks. When the switch is hit, red blocks appear.

DRAWBRIDGE
They open and close at regular intervals.

EXPANDING MUSHROOM
They stretch into long platforms, then shrink back into tiny mushrooms.

FALLING LOG
As Mario runs over them, they shudder and then fall into the water.

FALLING ROCK
When Mario gets on, it starts to tilt. If it tilts too far, Mario falls off—sometimes into lava!

FENCE
Mario can grab on and move in any direction. When Mario punches, he attacks enemies climbing on the other side.

FENCE GATE
Mario can spin around to the other side of a fence by hitting one.

FERRIS WHEEL
These four platforms rotate constantly.

FIRE BAR
Spinning lines of fireballs. There are a variety of sizes.

FIRE FLOWER
This is the power-up that makes Fire Mario.

FLATBED FERRY
These platforms move along a track. At the end of the line, the platform falls, taking Mario with it.

FLOATING ARROW LIFT
It moves up slowly. It also goes right or left depending on where Mario stands.

FLYING ? BLOCK (YELLOW)
These ? Blocks with wings fly through the sky.

FLYING ? BLOCK (RED)
They fly above courses on the world map. Hit one to get an item.

GELATIN
When Mario ground-pounds, he sinks into the jelly. It will re-form after a little while.

GIANT FENCE GATE
When Mario hits it, the fence spins around, moving Mario quite a long way.

GIANT SPIKED BALL
These are huge iron balls covered with spikes. They can break blocks as they roll along.

GOAL POLE
When Mario grabs it, he clears the course. He gets more points the higher he grabs.

HANGING PLATFORM
They're held by chains. They tip in the direction of Mario's weight, and even sink into the lava.

HANGING VINE
Just like hanging ropes, but most of them appear in jungles.

HARD BLOCK
They can be broken by a Bob-omb explosion or a volcanic rock.

HAUNTED LIFT
These elevator platforms act oddly, wavering and suddenly falling.

HAUNTED STAIRS
At first it's just a slope, but if Mario presses a ? Switch, stairs appear.

INVISIBLE BLOCK
You think nothing's there, but a block appears when Mario hits it. Some contain coins or other items.

INVISIBLE COIN
Coin shapes marked by a dotted line. As Mario touches them, they turn into real coins.

KEY
A key appears after Mario defeats a boss. When Mario takes the key, he can move on to the next world.

LAVA
Fall in and Mario will take damage! Usually lava can be found in castles.

LEDGE
Mario can't dash along, but he can hang down from the ledge.

LIFT
These platforms move and carry Mario around. Some of them fall shortly after Mario gets on.

LOG
As Mario steps on, it starts to roll. If Mario stays on it too long, he falls off.

MANHOLE
They block shafts, but Mario can pass through them with a ground pound.

MEGA MUSHROOM
This lets Mario power up to Mega Mario for a little while.

MINI MUSHROOM
A very tiny mushroom that Mario can use to power up to Mini Mario.

MINI PIPE
They're much smaller than normal pipes. Mini Mario can enter some of them.

MOVING BLOCK
These big stone blocks move on their own. If Mario gets caught between them, he takes damage.

 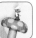

MOVING MUSHROOM
It carries Mario along the course. It bucks up and down and sways left to right as it moves.

OBSTACLE BUBBLE
Huge bubbles that appear in underwater courses. Mario will bounce off if he runs into one.

ONE-WAY PANEL
Mario can only pass through from one direction.

ORANGE PLATFORM
Mario can hit them from below to attack the enemy walking on top.

P SWITCH
When Mario hits one, blocks become coins (and vice versa). They can also make silver coins appear.

PIPE
Mario can enter some, and enemies lurk inside others.

PIPE CANNON
After Mario climbs inside, he's shot out and flies quite a distance!

PLATFORM BLOCK
Each time Mario hits one, another block appears. Eventually it goes back to being a single block.

PLATFORM SWITCH
When Mario flips it, platforms start to move.

PLATFORM WHEEL
They turn and move as Mario jumps between the four platforms.

POINTING HAND
These hands point their fingers at something you can't see: a hidden block!

POISON SWAMP
They appear often in jungles. If Mario falls in, you lose a life.

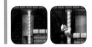

POLE
After Mario grabs on, he can climb up or down.

QUICKSAND
Mario will sink into it, but he can escape with a series of jumps.

RED COIN
After you pass through a red ring, eight red coins appear. If you collect them all, you get an item.

RED RING
Pass through a red ring to make red coins appear.

RED GOAL POLE
If you find a red flag on a Goal Pole, you've just found a hidden goal.

RIPPLING FLOOR
This floor is made of rolling waves. It's easy to get caught and pushed around.

RISING PLATFORM
When Mario gets on, it rises up. They appear in the fight against Mega Goomba.

ROLLING POLE
These poles dangle from wheels that run on rails. If Mario swings it right and left, it moves along the rail.

ROPE
Mario can climb up and down these ropes. After swinging, he can do a very long jump.

ROPE BRIDGE
Mario can walk across them, or bounce to jump very high. If Mario stops for too long, he'll fall off.

ROPE LINE
Mario can grab on with both hands and climb either right or left on it.

ROTATING BILL BLASTER
The bore of the Bill Blaster rotates so they fire right and left.

ROTATING PLATFORM
There are different shapes, but they all rotate in a fixed rhythm.

ROULETTE BLOCK
It scrolls through a collection of items. Mario gets the item that's showing when he hits it.

SAND DUNE
When Mario flips a ? Switch, the ground suddenly rises up or plunges down.

SCALE LIFT
They come in pairs. When Mario's weight pulls one down, the other moves up.

SCYTHE
Platforms that swing slowly right and left.

SHAKING MUSHROOM
They move up and down or left and right at different speeds.

SILVER COIN
These coins appear briefly when you press a P Switch.

SINKING AND RISING MUSHROOMS
When Mario gets on a yellow one, it sinks. When he's on a red one, it rises.

SKEWER
They slam out of the wall with incredible speed.

SKULL SWITCH
They appear during some boss fights. When Mario hits it, the bridge collapses and the boss is defeated.

SNAKE BLOCK
When Mario steps onto these green blocks, they start to move, changing their shape as they go.

SNOWDRIFT
Mario sinks up to his head and finds it very hard to move.

SNOWY BRANCH
The heavy snow layer atop these branches will fall. If Mario is underneath, he'll be buried for a short while.

SPIKED ? BLOCK
Aim for one of the sides without spikes.

SPIKED BALL
These spike-covered iron balls come rolling at Mario.

SPIKES
Mario takes damage if he touches them. Sometimes they are on moving walls.

SPIN BLOCK
Jump on top to fly very high, then descend slowly.

SPINNER
Spiked iron balls on a chain that constantly spins.

STAR COIN
Three are found on each course. You can spend them on the world map to open new paths.

STARMAN
This power-up makes Mario invincible for a short time.

SUPER MUSHROOM
Mario can become Super Mario with help from this mushroom.

TEETER-TOTTER
When Mario is on one, the platform tilts with his weight.

TILTING MUSHROOM
When Mario jumps on, his weight causes the mushroom to tilt over.

TRAMPOLINE
These can allow Mario to jump very high. Mario can pick them up and move them.

TRAMPOLINE MUSHROOM
If Mario jumps with the right timing, he can bounce high into the air.

TURN LIFT
After Mario gets on, it rotates 180 degrees to move him to the area on the other side.

VINE BLOCK
A vine grows from these blocks when they're hit. If Mario hits the top with a ground pound, the vine grows downward.

VOLCANIC ROCK
They fall from the sky after a volcano eruption. If one hits Mario, he takes damage.

WALL-JUMP LIFT
The blocks are set just the right distance to wall kick inside.

WHIRLPOOL
This spiral drags Mario down with a strong pull. If Mario is sucked in, you lose a life.

AND MORE

MEMORABLE MOMENTS

From Mega Mario grabbing the Goal Pole to the final battle with Bowser, this title had a lot of scenes that became the talk of fans everywhere. This game was also the first appearance of Dry Bowser.

REMATCH

Bowser is the boss of World 1, and Mario battles him on a bridge above a pool of lava—just like the first *Super Mario Bros.* game! Press the Skull Switch behind Bowser and see what happens next!

MEGA MARIO CRASHES THE GOAL POLE

Mega Mario can just trample over enemies and traps, and he even blows the Goal Pole away. Mario's surprised at that, and tilts his head in confusion. But in the end, you get five 1-Ups and clear the course.

MINI MARIO IN THE NEXT WORLD

Normally, after you clear World 2, you move on to World 3. But if Mini Mario defeats the boss in World 2, you move on to World 4 instead. Similarly, if Mini Mario beats the World 5 boss, you skip ahead to World 7.

THE DEBUT OF DRY BOWSER

Bowser has fallen into the lava lake, and turned into a skeletal version of himself. From this game onward, Bowser is an even stranger archenemy who always returns to fight Mario again and again. Dry Bowser even appears as a player character in *Mario Kart Wii*, among other games.

NOTHING CAN STOP MEGA MARIO!

Bowser is one of the biggest characters in the game, and your final battle is with him! But Mega Mario can easily crush even Bowser, and he's not affected by the Koopa King's fireballs.

WHAT'S THAT SOUND?

As the credits roll on the lower screen, when you touch the letters, you hear different sounds. And in the upper screen, you see a scene from each of the courses you cleared. If you later clear more courses, they are added to the montage.

LUIGI'S ADVENTURE!

You can play as Luigi in the single-player story mode. While you're on the file select screen, if you press both the L and R Buttons, and hold them while you press the A Button, Mario turns into Luigi and you can play him as the main character. Luigi's abilities are the same as Mario's.

TITLE SCREEN CAMEO

If you let the title screen run without pressing any buttons, after a little while a prologue video starts. Luigi appears from time to time in the video.

FRESH WALLPAPER!

After you clear World 8, if you go back to World 1, you'll find a blue Toad House. There, you can exchange some of your Star Coins for different wallpapers to adorn your lower screen. There are five possible wallpapers, including the original one from the start of the game.

SALUTATIONS FROM MARIO

When you close the Nintendo DS clamshell during the game, you hear Mario's voice say "Bye-bye!" When you open it again, he says, "It's me, Mario!"

HELPFUL HINTS & TECHNIQUES

When you meet certain conditions, you can unlock special parts of the game. But how many people fixate on the time remaining when Mario touches the Goal Pole . . . ?

SHOOT TO NEW WORLDS!

If you find the hidden goals in certain courses, you can open up a hidden route to a warp cannon. Use it to blast yourself from one world to another. There are five possible cannons: Worlds 1 and 2 go to World 5, World 3 goes to World 6, World 4 goes to World 7, and World 5 goes to World 8.

TRY CHALLENGE MODE

After you beat the game, if you press START from the world map, then enter L, R, L, R, X, X, Y, Y in that order, it unlocks a secret Challenge mode. You'll enter a version of the game where the camera won't move backwards. If you catch Mario between the edge of the screen and a wall, you can "walk through walls" like in the first Super Mario Bros. game.

A HIDDEN MUSHROOM APPEARS!

If at the moment you clear a course the last two digits in the timer are the same, a Toad House will appear. The digits 1, 2, and 3 produce red Toad Houses; 4, 5, and 6 create green Toad Houses; and 7, 8, and 9 make orange Toad Houses. Also, the *Super Mario Bros.* theme will play and the same number of fireworks explode.

STARS ON YOUR SAVE FILE

The file select screen gives you stars to show how much of the game you've completed. If you clear World 8, you get one star. If you've found every secret exit and opened every path on the world map, you get two stars. If you've found and spent all of the Star Coins, you get three stars.

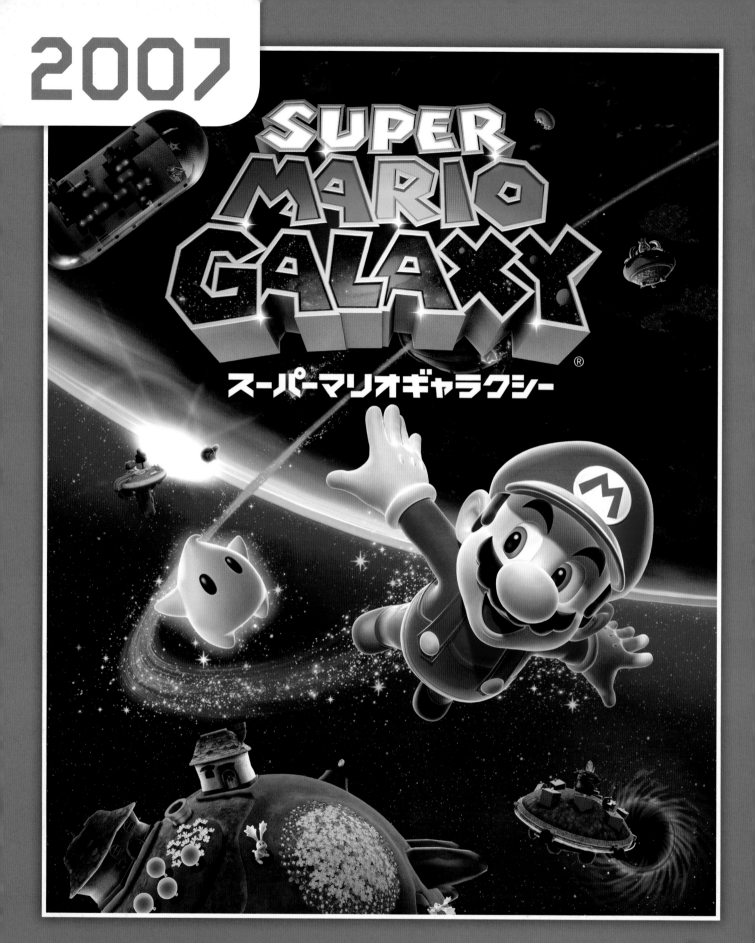

SUPER MARIO GALAXY®
スーパーマリオギャラクシー

Package

Game Disc

Instruction Booklet

System: **Wii**
Release Date:
**November 12, 2007
(Japan: November 1,
2007)**
Player Count: **1–2**

 # INTRODUCTION

STORY

*This text is taken directly from the instruction booklet.

Every hundred years, a huge comet flies by in the skies above the Mushroom Kingdom. One year, that comet filled the entire sky, and from it fell a stream of shooting stars. The Toads scooped up the Star Bits and brought them to the castle, where they were reborn as a great Power Star. It was a happy time in the Mushroom Kingdom. Then one night Mario received a letter . . .

Dear Mario,
I'll be waiting for you at the castle on the night of the Star Festival. There's something I'd like to give you.
From Peach

With invitation in hand, Mario headed off to the castle just as the Star Festival was getting into full swing. Surrounded by Toads gleefully trying to catch falling Star Bits, Mario was looking forward to the night's festivities.

But then, something happened . . .

Every hundred years, a comet appears in the skies above the Mushroom Kingdom.

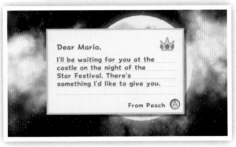

Dear Mario,
I'll be waiting for you at the castle on the night of the Star Festival. There's something I'd like to give you.

From Peach Ⓐ

FEATURES

A SPACE ADVENTURE

Mario shoots into space on an expansive 3D adventure! With help from Rosalina and the Lumas, stationed in the Comet Observatory, Mario ventures through the universe searching for Power Stars.

One of the key new actions is the spin, triggered by shaking the Wii Remote. With a spin you can defeat enemies or flip switches to make your way through a course. This is also the first 3D action game in the series that allows for two players; the second player helps Mario out with the Wii Remote's pointer.

COURSES WITH GRAVITY

Countless planets floating in space await Mario on his adventure. There are spherical planets, places where gravity changes when you cross a line, toylike planets, and planets made of water, among many others . . . Shapes, sizes, and direction of gravity are just some of the things that change as Mario collects Power Stars. The background music offers a lot of variation in its orchestration as well. Mario's majestic adventure through the universe is picking up speed!

CHARACTERS

P L A Y E R C H A R A C T E R S

The hero of the game is Mario. Sometimes Luigi helps in getting a Power Star, and sometimes he gets into trouble and needs Mario to rescue him. After you've collected all 120 Power Stars, Luigi can conduct the adventure as a player character, too.

MARIO

With help from Baby Luma, he uses his special jumps and spins to go on an adventure through space.

LUIGI

He can jump higher than Mario, but he also slides a bit more.

P O W E R - U P S

When you grab certain items, you can power up Mario or Luigi into different forms. With some, you only have the power-up for a set length of time, and then the heroes return to their original forms.

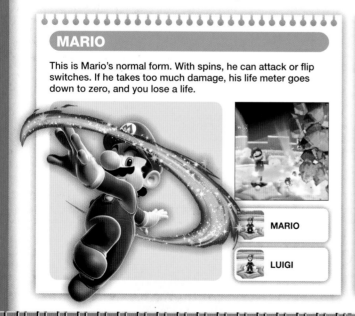

MARIO

This is Mario's normal form. With spins, he can attack or flip switches. If he takes too much damage, his life meter goes down to zero, and you lose a life.

MARIO

LUIGI

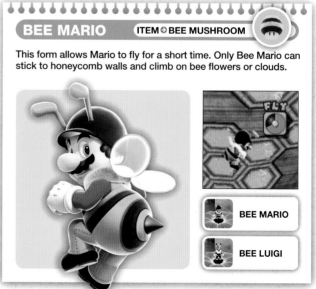

BEE MARIO　ITEM ▶ BEE MUSHROOM

This form allows Mario to fly for a short time. Only Bee Mario can stick to honeycomb walls and climb on bee flowers or clouds.

BEE MARIO

BEE LUIGI

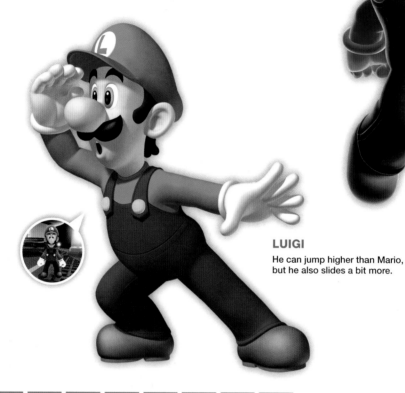

FIRE MARIO — ITEM → FIRE FLOWER

Mario can hurl fireballs to defeat enemies or flip switches. This power-up only lasts for a little while.

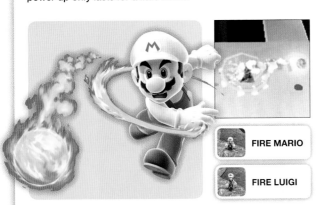

FIRE MARIO

FIRE LUIGI

ICE MARIO — ITEM → ICE FLOWER

When Mario touches something, it gets covered in ice! He can move over the surface of water or lava by freezing it, and wall jump up waterfalls. The power-up wears off after a short time.

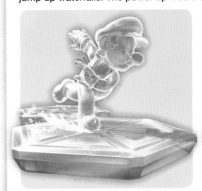

ICE MARIO

ICE LUIGI

BOO MARIO — ITEM → BOO MUSHROOM

Boo Mario will float upward if you press the A Button repeatedly. He'll turn transparent with a spin so he can pass through fences or wires. The power-up goes away when he hits light or water.

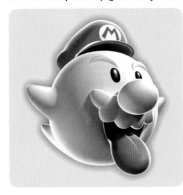

BOO MARIO

BOO LUIGI

SPRING MARIO — ITEM → SPRING MUSHROOM

Mario moves by bouncing along. If you time a jump well, Mario can bounce very high. He does an automatic wall jump when he touches a wall.

SPRING MARIO

SPRING LUIGI

RAINBOW MARIO — ITEM → RAINBOW STAR

For a short time, Mario pulses with all the colors of the rainbow and any enemies he touches are defeated. As he runs, he speeds up.

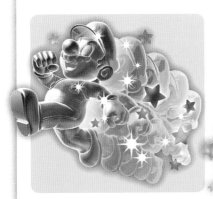

RAINBOW MARIO

RAINBOW LUIGI

FLYING MARIO — ITEM → FLYING STAR

When Mario spins in midair, he starts to fly! This power-up can only be found in the Comet Observatory's Gateway Galaxy. It lasts only a little while, but longer than other power-ups.

FLYING MARIO

FLYING LUIGI

OTHER CHARACTERS

Mario meets these characters on his adventure.

HONEYBEE
Citizens of the Honeyhive Kingdom.

QUEEN BEE
The queen of the Honeyhive Kingdom has some requests for Mario.

STAR BUNNY
These bunnies appear on various planets. Sometimes they ask favors of Mario.

POLARI
An elderly Luma. He shows Mario the Comet Observatory's map.

TOAD BRIGADE
A five-Toad organization with the purpose of searching for Princess Peach. The red Toad is their captain.

TOAD
These citizens of the Mushroom Kingdom have gathered for the Star Festival.

ROSALINA
A mysterious young lady who is in charge of the Comet Observatory. She helps Mario in his journey.

PRINCESS PEACH
The princess of the Mushroom Kingdom, who has been kidnapped by Bowser . . . castle and all!

BABY LUMA
This Luma is entrusted to Mario by Rosalina. He gives Mario the power to spin.

HUNGRY LUMA

These Lumas can become many different things (even planets!) when you feed them Star Bits.

LUMALEE

When you feed Star Bits to these Lumas, they become useful items.

PENGUIN COACH

He teaches penguins (and Mario) how to swim.

PENGURU

A very old penguin with a bit of a lisp.

PENGUIN

A race that inhabits watery worlds. They swim and play in the sea.

GUPPY

A killer whale that challenges Mario to contests.

GEARMO

Robots who speak in a strange accent. They work as janitors.

SPOOKY SPEEDSTER

A Boo that challenges Mario to a race. He's the speed king of the ghosts.

BILL BOARD
A sign that tells you how to roll the Star Ball.

GIL BOARD
A sign that instructs you to do a wall jump.

PHIL BOARD
A sign that teaches you how to ride in a bubble.

JILL BOARD

A sign that teaches you how to use the Boo Mushroom.

LUMACOMÈTE

A purple Luma that can move the Prankster Comets.

COSMIC MARIO

He challenges Mario to races. Cosmic Luigi is even faster!

WORM

He lives inside an apple-shaped planet and comes out when Mario ground-pounds a stump.

RAY

He gives Mario a ride on his back and takes him surfing across the water.

LUMA

Star children found all over the universe. They come in many different colors.

ENEMIES

You'll find these enemies throughout the galaxy. There are many different ways to defeat them: spinning, jumping, or using an item you find.

AMP
Electricity flows over these orbs as they spin around one spot.

BANZAI BILL
Enormous Bullet Bills. They fly straight ahead, twirling as they go.

BARON BRRR
He attacks with icy waves. If Mario can get close and spin, Baron Brrr shrinks and Mario has a chance to attack!

BIG AMP
Big spheres that are covered in electricity. Mario takes damage if he makes contact.

BIG BOULDER
A large version of the Boulder. The red spot is still the weak point.

BIG POKEY
When Mario gets close, it tries to attack by falling on top of him. Mario can strike back with coconuts.

BLOOPER
They swim through the water to chase Mario.

BOB-OMB
If Mario gets close, their bodies start to flash and they chase him until they explode.

BOLT BEAM
Sentry Beams with a strange mechanism. If Mario screws them in, they stop firing.

BOMB BOO
Black Boos that explode if they bump into something. Mario can grab their tongues and swing them around.

BOMP
Pieces of bedrock that come pushing out of walls. Mario can use them as footholds.

BOO
They creep up from behind, but when you look at them they stop. They approach Boo Mario even when he's looking.

BOULDER
Big round rocks that roll around an area. Mario can destroy them with a spin attack on the red spot.

BOULDERGEIST
It manipulates rocks to attack and defend. Mario must swing Bomb Boos to attack it.

BOUNCING SCUTTLEBUG
They just bounce in one place—they don't even attack.

BOWSER
He kidnapped Princess Peach! Mario fights him three times. Bowser shoots fireballs and sends out seismic waves.

BOWSER JR.
Bowser's son. He attacks Mario from the safety of his airship.

BUGABOOM
The king of the Mandibugs. He flies and drops bombs from his belly.

BULLET BILL
They're fired from Bill Blasters. Once one sees Mario, it heads straight toward him.

CATAQUACK
They chase Mario. If he jumps on, they send him flying.

CHEEP CHEEP
They swim back and forth on the surface of the water. When there's no water, they just bounce.

CHIBI CHOMP
Small Chomps. They roll along a set path.

CHOMP
They roll along a path. If two crash into each other, both are destroyed.

CLAMPY
They sit at the bottom of the sea, opening and closing. Some have items inside.

CLUCKBOOM
Chicken-like creatures that fly through the sky dropping bombs.

CRABBER (CYAN)
They run away as Mario approaches. If he can defeat one, you'll get a 1-Up Mushroom.

CRABBER (RED)
They chase Mario in a zigzag pattern. The weak point on their armored bodies is the rear.

DINO PIRANHA
When it spots Mario, it opens its huge mouth and rushes for him. Its own tail can be used against it.

DRY BONES
They chase after Mario. If he stomps on one it falls apart, but soon comes back to life.

FIERY DINO PIRANHA
This Dino Piranha is wreathed in flames. If it touches Mario, he takes damage.

FIRE SHOOTER
Fire shoots out of the nozzle at regular intervals. Mario can't defeat them.

FISH BONE
These fish skeletons that swim around near Kingfin. They dive toward Mario to attack.

FLIPBUG
A small bug that runs away if Mario sees it. They'll attack Bee Mario, though!

FLOATING MINE
They bob up and down in the water. If Mario triggers an explosion, it regenerates.

GIANT GOOMBA
Huge Goombas! Stomping on one doesn't hurt it, but a spin attack will knock it out for a while.

GIANT GRINGILL
Huge Gringills that inhabit the deep waters. You can defeat one by hitting it with a shell.

GOLDEN CHOMP
A gold-colored Chain Chomp. If Mario destroys him, a Power Star appears.

GOOMBA
They charge toward Mario. If he stomps on one, a coin appears.

GOOMBEETLE
Goombas wearing protective helmets. They can't be defeated by a stomp.

GRINGILL
Some swim around, while others come out of holes in the rock.

GROUND URCHIN
These urchins live on dry land. A fireball will defeat them.

ICE BAT
A frozen type of Swoop. If one touches Mario, he freezes.

JAMMYFISH
They patrol underwater areas. If Mario touches one, he takes damage.

JELLYFISH
Giant jellyfish wreathed in electricity. If Mario touches one, he gets shocked and takes damage.

KAMELLA
She teleports around, shooting off fireballs and other attacks. Mario can attack with Koopa shells.

KING KALIENTE
He lives in the lava, and swats away thrown items.

KING KALIENTE (SCORCHED)
A powered-up version of King Kaliente. He can cause a meteor strike now!

KINGFIN
A shark skeleton that lives in the sea. Mario can attack it with a Koopa shell.

KOOPA TROOPA (GREEN)
They walk around a small area. Stomp on one to turn it into a green Koopa shell.

KOOPA TROOPA (RED)

They patrol a particular spot. A stomp on top will turn one into a red Koopa shell.

LASER POD

When Mario approaches, it unleashes a laser beam at him.

LAVA BUBBLE

They come flying out of the lava, then bounce after Mario. Eventually they flame out.

LI'L BRR

They emit an icy cloud as they approach Mario. He can spin to disperse it.

LI'L CINDER

They close in on Mario with their bodies wreathed in flames. Spin attack to blow them out.

MAGIKOOPA

They teleport to move. Their magic makes fireballs or enemies appear.

MAJOR BURROWS

He chases Mario from underground. If Mario does a ground pound close to him, he pops up to the surface.

MANDIBUG

They run straight toward Mario. A regular stomp doesn't hurt them.

MANDIBUG STACK

This Mandibug has a smaller one on its back. Defeat the small one to see the large one get angry!

MECHAKOOPA

They follow Mario and attack by breathing fire. Mario can knock them out with a spin attack.

MEGALEG

A robot with huge legs. If Mario manages to reach the head section, it attacks him with Bullet Bills.

MICRO GOOMBA

Tiny Goombas. Mario can defeat them with one spin, or a stomp.

MONTY MOLE

They appear from holes in the ground and attack by throwing wrenches.

OCTOGUY

They shoot projectiles from a distance. If Mario approaches one, it runs away.

OCTOOMBA

They patrol a small area. When Mario gets close, they try to ram him.

OCTOPUS

They shoot fireballs and coconuts at Mario.

PIRANHA PLANT

When they see Mario, they stretch out their necks and try to bite him.

POKEY

Mario can do spin attacks to knock off their segments, one at a time.

POKEY HEAD

They're the heads of Pokeys. They pop out of the ground and bounce toward Mario.

PORCUPUFFER

An underwater dweller that hides in treasure chests. It puffs up its body and chases after Mario.

PRICKLY PIRANHA PLANT

Giant purple Piranha Plants. When Mario gets close, they try to slam their heads down on him.

PUMPKINHEAD GOOMBA

Goombas with pumpkins on their heads. If Mario stops moving, a small blue flame appears.

RING BEAM

They release an expanding circular beam at regular intervals.

SENTRY BEAM

They send out circular beams. If Mario jumps on top of one, the spring head sends him high into the air.

SENTRY GARAGE

It houses a crew of Topminis that attack Mario. Its head is a spring.

SLURPLE

If Mario touches them, they stick to him and he takes damage. Mario can shake them off with a spin.

SPACE MINE

These mines float in the air. If Mario hits one, it explodes and doesn't respawn.

SPIKY TOPMAN

They spin and try to crash into Mario. If Mario touches the spike on top, he takes damage.

SPRANGLER

Spiderlike creatures that hang from a thread. They attack by swinging their bodies.

SPRING TOPMAN

A type of Topman with springs attached to their heads. If Mario gets on, they send him flying.

STARBAG

They can vanish and reappear. If Mario defeats one, it spills out twenty Star Bits.

SWOOP

When they see Mario, they let out a screech and dive toward him.

TARANTOX

He moves over spider webs, and fires out a poisonous liquid. He has a few weak points.

THWOMP

They stay in one place, rising slowly then falling quickly. If Mario gets crushed, you lose a life.

TOPMANIAC

His blades spin fast! When Mario stomps on him, the blades retract.

TOPMINI

A smaller sized Topman. Mario can touch them without taking any damage; they just bounce around.

TORPEDO TED

Enemies that chase Mario underwater. If they hit anything, they explode!

TOX BOX

These cubes roll along passageways. You'll lose a life if Mario's crushed by one.

TWEESTER

They're smaller than tornados, but they can still send Mario high into the sky.

UNDERGRUNT

They dig routes underground, creating furrows. Their spiky heads protect them from Mario's stomps.

UNDERGRUNT GUNNER (ELECTRIC)

An Undergrunt shoots bolts of electricity from his seat inside.

UNDERGRUNT GUNNER (WATER)

An Undergrunt sits in the cockpit, firing water bubbles.

URCHIN

Their bodies are covered in spines. When they see Mario, they roll toward him.

WATER SHOOTER

They fire off bubbles. If Mario touches the bubble, he is sucked in and pulled along.

WIGGLER

They travel along a set path. When Mario stomps on one, it gets angry and chases after him.

 WORLD

COURSES

Mario flies from the home base Comet Observatory to all of these galaxies during his adventure. He must collect the Power Star at the end of each course.

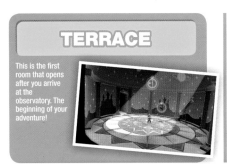

TERRACE

This is the first room that opens after you arrive at the observatory. The beginning of your adventure!

GOOD EGG GALAXY

Use launch stars to get from one tiny egg-shaped planet to the next.

DINO PIRANHA

Mario travels across a series of planets to reach the first boss: Dino Piranha.

A SNACK OF COSMIC PROPORTIONS

Feed Star Bits to the Hungry Luma, then travel to a brand-new planet.

KING KALIENTE'S BATTLE FLEET

A fleet of UFOs is invading! Mario fights his way through it to reach King Kaliente's hiding spot.

DINO PIRANHA SPEED RUN

It's the Dino Piranha course, but this time there's a time limit. Can you complete it in under four minutes?

PURPLE COIN OMELET

Gather one hundred purple coins with the help of Launch Stars.

LUIGI ON THE ROOF

Search the course for Luigi after Mario receives a letter asking for help.

HONEYHIVE GALAXY

Explore the Honeyhive Kingdom, starting with an introduction to the Queen Bee.

BEE MARIO TAKES FLIGHT

Search out a Bee Mushroom in order to get an audience with the queen.

TROUBLE ON THE TOWER

Climb up the sightseeing tower and battle Mandibugs.

BIG BAD BUGABOOM

Bugaboom is out to avenge his defeated Mandibugs. Mario has to battle him in rather close quarters.

HONEYHIVE COSMIC MARIO RACE

Mario must race his shadow double. Can he reach the goal before his cosmic challenger?

THE HONEYHIVE'S PURPLE COINS

Gather the purple coins scattered all over the Honeyhive Kingdom.

LUIGI IN THE HONEYHIVE KINGDOM

Luigi has climbed a tree to escape the Flipbugs. Mario can get a Power Star as a reward for saving him.

LOOPDEELOOP GALAXY

This planet is mostly water. Mario can move around by surfing on a Ray.

SURFING 101

Hop on Ray's back and go surfing. Try to reach the goal without falling off the course.

FLIPSWITCH GALAXY

A small planet with lots of flipswitches. There are some nostalgic images in the background.

PAINTING THE PLANET YELLOW

Trigger the flipswitches on all three sides of the planet so they are the same color.

BOWSER JR.'S ROBOT REACTOR

Megaleg is waiting for Mario. Bullet Bills also come after him on this small planet.

MEGALEG'S MOON

Battle Bowser Jr.'s robot Megaleg. Climb up a leg to reach the head section and attack.

FOUNTAIN

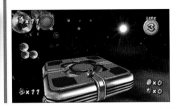

Captain Toad's Starshroom has a garage on the observatory! Now the Toad Brigade can help Mario find Power Stars.

SPACE JUNK GALAXY

Small planets are floating around with space junk. The Toad Brigade is a big help here.

PULL STAR PATH

Use the Pull Stars to slip through narrow passages and rescue the Toad Brigade.

KAMELLA'S AIRSHIP ATTACK

Toads went aboard the ships before Mario arrived. Rescue them as Mario works his way toward the battle with Kamella.

TARANTOX'S TANGLED WEB

Use sling pods to advance through this course. A battle with Tarantox awaits at the end.

PULL STAR PATH SPEED RUN

Can Mario complete the Pull Star Path in less than four minutes?

PURPLE COIN SPACEWALK

There are purple coins scattered throughout this debris field. Collect them all within the time limit.

YOSHI'S UNEXPECTED APPEARANCE

If Mario travels a different route from the Hungry Luma, he reaches a familiar planet—it looks like Yoshi.

BATTLEROCK GALAXY

A space base fully loaded with flying saucers. Mario must overcome the unrelenting enemy attacks in order to collect the Power Stars!

BATTLEROCK BARRAGE

Cross the saucers and dodge projectiles to reach the end of this course.

BREAKING INTO THE BATTLEROCK

Use Bob-ombs to blast open the glass cages, and figure out the strange mechanisms to reach the Power Star.

TOPMANIAC AND THE TOPMAN TRIBE

Clear a path by defeating the Spiky Topmen. At the end, there's a battle with the Topmaniac.

TOPMANIAC'S DAREDEVIL RUN

Accept a challenge from Topmaniac, but this time with only one life. No reviving Mario here!

PURPLE COINS ON THE BATTLEROCK

Use the moving flying saucer as Mario's platform as he gathers all the purple coins in the course.

BATTLEROCK'S GARBAGE DUMP

The Gearmo working in the garbage dump needs help. There's a prize for Mario if he can clean up all the garbage.

LUIGI UNDER THE SAUCER

Rescue Luigi! He's trapped in a glass cage under a saucer.

ROLLING GREEN GALAXY

Mario can jump on top of the rolling ball and ride it across this green planet that resembles a golf course.

ROLLING IN THE CLOUDS

Once Mario is on the Star Ball, make it all the way to the goal without going out of bounds!

HURRY-SCURRY GALAXY

A small planet composed of lots of platforms . . . but most of them disappear!

SHRINKING SATELLITE

Run across the vanishing platforms and collect all of the musical notes.

BOWSER'S STAR REACTOR

Bowser is waiting at the end of this fortress. The gravity in some of the areas changes.

THE FIERY STRONGHOLD

Mario avoids the fire bars as he makes his way to a battle with Bowser.

KITCHEN

This room is across from the bedroom. Here, you'll find dark planets and lots of water.

BEACH BOWL GALAXY

A paradise of sandy beaches where the penguins are practicing their swimming.

SUNKEN TREASURE

Collect the Star Chips that the pirates have left scattered about, then go to the high lookout.

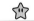

PASSING THE SWIM TEST

Find the golden shell. The Penguin Coach is waiting to tell Mario if he passed the test.

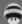

THE SECRET UNDERSEA CAVERN
Smash the spiral rock wall under the sea to find a Launch Star that sends Mario up to a narrow corridor in the sky.

FAST FOES ON THE CYCLONE STONE
The Thwomps and Tox Boxes have all sped up! Avoid them on your way to the goal.

BEACHCOMBING FOR PURPLE COINS
Mario will need to use the Spring Mushroom to reach the purple coins scattered around the beach area.

WALL JUMPING UP WATERFALLS
Ice Mario freezes the waterfalls, allowing him to wall jump up to the Power Star.

GHOSTLY GALAXY
A haunted house where the Boos live. Luigi has gotten lost inside.

LUIGI AND THE HAUNTED MANSION
Transform into Boo Mario and slip through the walls to rescue Luigi.

A VERY SPOOKY SPRINT
Race the Spooky Speedster! Use Pull Stars to be the first to reach the goal.

BEWARE OF BOULDERGEIST
Climb up the wall using the sling pods. Bouldergeist is waiting at the top.

BOULDERGEIST'S DAREDEVIL RUN
This time, Mario has to battle Bouldergeist with only one life. Be careful to dodge all of his attacks!

PURPLE COINS IN THE BONE PEN
Sling Mario around on pull stars, and gather enough purple coins before the timer runs out.

MATTER SPLATTER MANSION
Mario can travel only on the illuminated path. Use keys to open locked doors.

BUOY BASE GALAXY
A floating fortress that has fallen into disrepair. If Mario can destroy the underwater counterweight, it will start working again.
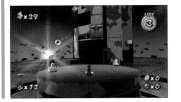

THE FLOATING FORTRESS
Once the fortress is fixed, Mario can gather the blue Star Chips.

THE SECRET OF BUOY BASE
Find the hidden pipe on the floating base. The Bullet Bills protecting the Green Star will attack Mario.

BUBBLE BREEZE GALAXY
A planet covered in a large toxic swamp. Mario can ride the bubbles safely through.

THROUGH THE POISON SWAMP
Use a fan to navigate a bubble-encased Mario through the poisonous swamp.

BOWSER JR.'S AIRSHIP ARMADA
Board Bowser Jr.'s huge fleet. Mario will need to use cannons and elevators to break through.

SINKING THE AIRSHIPS
Go from enemy ship to enemy ship as Mario makes his way to the battle with Bowser Jr.

BEDROOM

Luigi joins the adventure and helps out in the search for Power Stars.

GUSTY GARDEN GALAXY
A world with big, blue skies. Growing plants will help Mario travel between planets.

BUNNIES IN THE WIND
Mario arrives on a cube-shaped garden planet where he plays tag with a Star Bunny.

THE DIRTY TRICKS OF MAJOR BURROWS
Major Burrows has been terrorizing the Star Bunnies. Fight him to save them!

GUSTY GARDEN'S GRAVITY SCRAMBLE
Use the arrows to change the gravitational field and navigate this course full of giant ! Blocks.

MAJOR BURROWS'S DAREDEVIL RUN
Battle Major Burrows again, but with only one life. Be careful when the dust clouds rise.

PURPLE COINS ON THE PUZZLE CUBE
Mario has to collect purple coins in a garden maze on the cube-shaped planet. Can you get 100 before time runs out?

THE GOLDEN CHOMP
If Rainbow Mario can manage to destroy the Golden Chomp, a Power Star will emerge.

FREEZEFLAME GALAXY

This planet runs hot and cold—patches of ice and lakes of lava are all mixed up!

THE FROZEN PEAK OF BARON BRRR

A mission on the ice-cold side. Baron Brrr awaits within the snowy mountain to battle Mario.

FREEZEFLAME'S BLISTERING CORE

Become Fire Mario and light torches to traverse the fiery trail.

HOT AND COLD COLLIDE

Mario must make his way across both fire and ice. Ice Mario can make his own path over the lava.

FROSTY COSMIC MARIO RACE

Skate over the ice to reach the goal before Cosmic Mario.

PURPLE COINS ON THE SUMMIT

Purple coins are scattered all over the ice mountain . . . even at the very top!

CONQUERING THE SUMMIT

There's a Power Star at the peak of the snowy mountain. Find a hidden route to the top.

DUSTY DUNE GALAXY

Mario has to be careful of the shifting sands in this desert world.

SOARING ON THE DESERT WINDS

Use the tornados to get to the top of the tower.

BLASTING THROUGH THE SAND

Follow a path through the flowing sands. The second half is an area of extreme danger, where a fall means losing a life.

SUNBAKED SAND CASTLE

On this course, platforms rise up on pillars of sand. Try not to get squished between the platform and a brick block.

SANDBLAST SPEED RUN

Complete the Blasting Through the Sand course within four minutes.

PURPLE COINS IN THE DESERT

Collect the purple coins scattered across the desert with the help of some handy tornados.

BULLET BILL ON YOUR BACK

Find a hidden stump to uncover a secret mission. Then guide a Bullet Bill to the glass cage to release a Power Star.

TREASURE OF THE PYRAMID

Find the Silver Stars hidden in a capsule-shaped room inside the pyramid.

HONEYCLIMB GALAXY

A series of walls dotted with honeycombs. Bee Mario can climb them.

SCALING THE STICKY WALL

Be careful of enemies as you climb the honeycomb wall! There's a Power Star at the top.

BOWSER'S DARK MATTER PLANT

Use the lifts to get Mario through a section with ever-changing gravity. Then Mario faces Bowser for a second showdown.

DARKNESS ON THE HORIZON

Cross a treacherous path on your way to battle Bowser himself!

ENGINE ROOM

There's a Gearmo inside this room in the central tower.

GOLD LEAF GALAXY

A forest where the leaves are turning red for autumn. There are some very large trees planted here!

STAR BUNNIES ON THE HUNT

Help the Star Bunnies collect blue Star Chips.

CATAQUACK TO THE SKIES

Use the Cataquacks to fling Mario upward, then keep on heading up!

WHEN IT RAINS, IT POURS

Bee Mario has to make his way to the observation deck of the tower to battle the Undergrunt at the top.

COSMIC MARIO FOREST RACE

Cosmic Mario has become a lot faster for this race. Run along the narrow wooden planks toward the goal.

PURPLE COINS IN THE WOODS

Collect the purple coins throughout the forest before time runs out.

THE BELL ON THE BIG TREE

Ride in a bubble around the huge tree to collect the musical notes made by the bell.

SEA SLIDE GALAXY

A huge wheel-like planet with vast blue seas. It's become a playground for penguins.

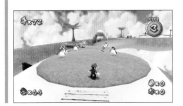

GOING AFTER GUPPY

A killer whale challenges Mario to swim through eight rings in the water.

FASTER THAN A SPEEDING PENGUIN

Three young penguins want to race against Mario. Use a Koopa shell and try to be the first across the finish line!

THE SILVER STARS OF SEA SLIDE

Follow friends' advice to find the Silver Stars hidden on the planet.

UNDERWATER COSMIC MARIO RACE

Race Cosmic Mario through the sea and then up to the tower, where the Power Star is the goal.

PURPLE COINS BY THE SEASIDE

Purple coins have been left all over the place. Use Bee Mario to help gather them all up.

HURRY, HE'S HUNGRY

The Hungry Luma creates a brand-new planet! Gather all of the musical notes off the vanishing platforms.

TOY TIME GALAXY

These planets look like a lot of fun—they're filled with toys and sweets!

HEAVY METAL MECHA-BOWSER

Become Spring Mario to bounce down the path toward a giant toy robot in the shape of Bowser.

MARIO MEETS MARIO

Vanishing and rotating panels make up a nostalgic image of Mario. Collect the Silver Stars.

BOUNCING DOWN CAKE LANE

Bounce all over these baked goods as Spring Mario. There's an Undergrunt Gunner above the last cake.

FAST FOES OF TOY TIME

The Tox Boxes and other enemies have sped up. Outrun them and step on all of the Flipswitches.

LUIGI'S PURPLE COINS

Mario must collect the purple coins lined up on an image of Luigi.

THE FLIPSWITCH CHAIN

Tox Boxes are moving along the narrow blocks. Mario must step on all of the flipswitches.

BONEFIN GALAXY

A creepy planet covered in water. This is where Kingfin lives.

KINGFIN'S FEARSOME WATERS

Battle Kingfin by hitting him with Koopa shells as the bony boss swims around.

BOWSER JR.'S LAVA REACTOR

The planet is covered in lava, and King Kaliente is waiting for his rematch with Mario.

KING KALIENTE'S SPICY RETURN

The platforms keep sinking into the lava as Mario faces off against King Kaliente again.

GARDEN

A strange room at the top of the observatory that's filled with grass.

DEEP DARK GALAXY

There's a creepy underground lake here, and a ghost ship in the back of the caves.

THE UNDERGROUND GHOST SHIP

Mario arrives at a hidden ghost ship where he battles the Koopa sorceress Kamella.

BUBBLE BLASTOFF

Float in bubbles to reach a planet where Mario raises a watermelon to an astronomical size!

GUPPY AND THE UNDERGROUND LAKE

Guppy the killer whale offers up a challenge. Follow him through all the rings he creates.

GHOST SHIP DAREDEVIL RUN

Mario's rematch with Kamella, but with only one life. Avoid the onslaught of magic as Mario sneaks close to attack.

PLUNDER THE PURPLE COINS

Scour the ghost ship and underground lake for purple coins.

BOO IN A BOX

Enter the dark secret room and let some light in. Mario can grab a Power Star when the Boo vanishes.

DREADNOUGHT GALAXY

There are traps and enemies galore in this foreboding engineering marvel.

INFILTRATING THE DREADNOUGHT

Get past the robots and changing gravity of this fortress, then ride the sentry beams to reach the Power Star.

DREADNOUGHT'S COLOSSAL CANNONS

Watch out for gravity changes and cannonballs as Mario uses lifts to move forward.

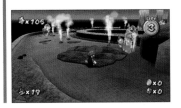

REVENGE OF THE TOPMAN TRIBE

After Mario makes his way through the cannonballs and mines, Topmaniac challenges him to a rematch!

TOPMAN TRIBE SPEED RUN

Clear the Revenge of the Topman Tribe level in six minutes or less.

BATTLESTATION'S PURPLE COINS

Board the lifts to collect the purple coins. Mario can't afford to leave any behind!

DREADNOUGHT'S GARBAGE DUMP

Gearmo returns with a second garbage cleanup request. There's even more garbage this time!

MELTY MOLTEN GALAXY

Fire and arcs of lava block Mario's path through this area.

THE SINKING LAVA SPIRE

Mario must rush to climb a rocky mountain as the lava rises to overtake him. At the top, he'll find a Power Star.

THROUGH THE METEOR STORM

Avoid the meteors that rain down! In the level's second half, Mario rolls a Star Ball over the lava to reach the goal.

FIERY DINO PIRANHA

Move along the rotating platforms to reach a battle with Fiery Dino Piranha.

LAVA SPIRE DAREDEVIL RUN

Reach the top of the lava spire . . . with only one life!

RED-HOT PURPLE COINS

Collect the purple coins from the lava fields. Some are hidden inside the volcano, too.

BURNING TIDE

As the tides of lava rise and fall, Mario must gather all of the Silver Stars.

MATTER SPLATTER GALAXY

A weird planet where the platforms only exist when a spotlight is shining on them.

WATCH YOUR STEP

Mario can only walk on the visible footing to move along. If he wanders outside the light, he'll fall.

COMET OBSERVATORY

The base for adventure. Reach some places from the Gate and some by feeding the Hungry Lumas.

GATEWAY GALAXY

The very first place Mario visits. Reach it from the observatory's Gate.

GRAND STAR RESCUE

Listen to the Lumas' advice, and have Mario make his way to recover the Grand Star.

GATEWAY'S PURPLE COINS

Flying Mario can collect the purple coins. If he gathers them all, he will get a red Power Star.

SWEET SWEET GALAXY

Cookies, chocolate, and other sweet things form Mario's path through this galaxy.

ROCKY ROAD

Leap across the sugary moving platforms. Mario's goal is the cake at the end!

SLING POD GALAXY

There's hardly any place to stand in this area of space. Use the sling pods and Pull Stars to get through.

A VERY STICKY SITUATION

Mario will need the sling pods and Pull Stars to reach the goal, but be careful of all the moving obstacles.

DRIP DROP GALAXY

Gringills and Porcupuffers live on this spherical water planet.

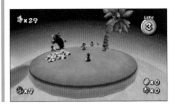

⭐ GIANT EEL OUTBREAK

Mario must defeat three giant Gringills. Once he does, he can grab the Power Star from the sunken ship.

BIGMOUTH GALAXY

This planet is in the shape of a fish opening its huge mouth. There's an underwater section if Mario climbs down the throat.

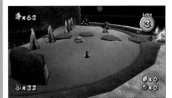

⭐ BIGMOUTH'S GOLD BAIT

Search for the golden Koopa shell, then use it to open the treasure chest.

SAND SPIRAL GALAXY

A galaxy where sands flow like a river. In the center is a spiral of small planetoids.

⭐ CHOOSING A FAVORITE SNACK

Choose your favorite power-up for Mario as he runs up the river of sand. Mario can do a Rainbow Mario dash to the Power Star.

BOO'S BONEYARD GALAXY

Inside this skull-shaped planet, there's a side-scrolling cave that can only be completed by Boo Mario.

⭐ RACING THE SPOOKY SPEEDSTER

The Spooky Speedster challenges Boo Mario to a race.

SNOW CAP GALAXY

A capsule-shaped planet covered in snow. It's full of Star Bunnies!

⭐ STAR BUNNIES IN THE SNOW

Three Star Bunnies are playing hide-and-seek in the snow. Can Mario catch them all in time?

LOOPDEESWOOP GALAXY

A world where you can show off Mario's surfing skills. It's quite a complicated course!

⭐ THE GALAXY'S GREATEST WAVE

Can Mario make a complete circuit before time runs out?

ROLLING GIZMO GALAXY

A planet where Mario can practice riding a Star Ball through a long course.

⭐ GIZMOS, GEARS, AND GADGETS

This planet will really test your skills at rolling on a Star Ball!

BUBBLE BLAST GALAXY

Try your hand at controlling bubbles. Don't hit the electric rails!

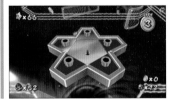

⭐ THE ELECTRIC LABYRINTH

Avoid obstacles as Mario threads a bubble through a needle.

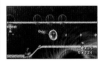

BOWSER'S GALAXY REACTOR

Lava, ice, desert, and other terrains make up this strange world.

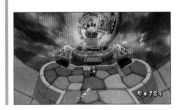

⭐ THE FATE OF THE UNIVERSE

Run through a complicated course to reach the final battle with Bowser. It will decide the fate of the universe!

GRAND FINALE GALAXY

The area around Peach's Castle spreads out before Mario, and the Star Festival is in full swing. All the Toads will want to talk to him!

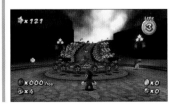

⭐ THE STAR FESTIVAL

Peace has returned to the Mushroom Kingdom and Mario should gather the purple coins in the town and castle gardens.

INTRODUCTION CHARACTERS WORLD AND MORE

You'll find these things on various courses. This is the first game where some of the items and mechanisms are activated using the pointer on the Wii Remote.

? BLOCK
When Mario hits one, an item appears. Sometimes the empty block will stay there.

? COIN
Nobody knows what might happen when Mario grabs one!

1-UP MUSHROOM
Grab one of these to gain an extra life. Sometimes they're hiding in crates or blocks.

BEE FLOWER
Bee Mario can stand on top, but they'll vanish if regular Mario touches them.

BEE MUSHROOM
This power-up turns Mario into Bee Mario.

BLACK HOLE
If Mario falls off the edge of a platform and gets sucked into a black hole, you lose a life.

BLOCK
If Mario hits one, it breaks apart. Leave them intact to use them as footholds.

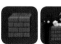

BOARD
They give you hints or advice.

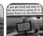

BOLT
Spin one to screw it in, and it may trigger a mechanism.

BOLT LIFT
These platforms look like nuts on a bolt. If Mario runs while turning the nut, he'll move along the bolt.

BOO MUSHROOM
These power-ups turn Mario into Boo Mario.

BOOST RING
They're found underwater. When Mario swims through one, he gets a speed boost.

BUBBLE
Mario can ride inside. Use the pointer to blow air on the bubble to move it or change direction.

CANNON
Jump inside a cannon, then aim with the pointer to send Mario flying!

CLOUD
Bee Mario can use these as platforms. When it's raining, they're rain clouds!

COCONUT/ WATERMELON
Mario can hit them toward enemies with a spin attack.

COIN
When Mario gets a coin, he gets some health back. Collect fifty to earn an extra life.

COIN SPOT
If you hit one of these yellow dots on the floor with a Star Bit, a coin appears.

COSMIC BLOCK
Weird platforms that fit together when Mario gets close, and fly apart when he steps away.

CRATE
Mario can break them with a spin attack or ground pound. Sometimes they hold items.

CRYSTAL
Mario can break them with spin attacks to get what's inside.

ELECTRIC FENCE
Electricity is running through this rail. When Mario touches one, he takes damage.

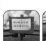

FIRE BAR
These bars of fireballs rotate around a block. They come in different lengths.

FIRE FLOWER
This power-up turns Mario into Fire Mario for a short time.

FIREBALL
These balls of flame come jumping out of lava. Mario takes damage if one touches him.

FLING FLOWER
If you shake the Wii Remote, Mario climbs up the flower. With a jump, he can fly high.

FLYING STAR
This power-up lets you become Flying Mario for a short time.

FLIPSWITCH PANEL
When Mario steps on, it changes color. If a set are all turned yellow, something will happen.

FLOATY FLUFF
Mario can grab on to fly through the air. He can spin to gain some altitude.

FLOWING SAND
It will carry Mario along with the current. It's hard to run against the current, so he moves slowly.

GLASS CAGE
These can be broken by explosions from Bullet Bills or Torpedo Teds.

GOLDEN SHELL
Sometimes you need one to find a Power Star.

GRAND STAR
When Mario finds one, it unlocks a new area in the Comet Observatory.

GRAVITY SPOTLIGHT
Gravity goes in a different direction within the area lit by the spotlight.

GRAVITY SWITCH
When Mario hits the arrow with a spin, it changes the direction of gravity.

GREEN STAR
Mario will need all three Green Stars to get into the Trial Galaxies.

GROUND POUND SWITCH
Mario can trigger something with a ground pound.

HONEYCOMB WALL
Bee Mario can grab on and climb around. While he's on the wall, the fly meter recharges.

ICE FLOOR
Mario slips and slides as he walks on ice. Spin to start skating on the ice.

ICE FLOWER
These turn Mario into Ice Mario for a short time.

IRON BARS/ CRYSTAL WALL
Boo Mario can pass through these walls.

KEY
Mario can use them to open a door or start a machine.

KOOPA SHELL (GREEN)
Attack enemies or open treasure chests with these. They increase Mario's swim speed, too.

KOOPA SHELL (RED)
These shells will home in on enemies when thrown. Hold one while swimming for a speed boost.

LAUNCH STAR
This star launches Mario a great distance—even far enough to reach another planet.

LAVA GEYSER
Hot air erupts from holes in the ground. If Mario touches it, he takes damage and gets thrown into the air.

LEVER SWITCH
Mario's spin attack will flip the switch and make something happen. But once it's triggered, you can't unflip the switch.

LIFE MUSHROOM
It increases Mario's maximum life meter from three to six, and also completely heals him.

LIFT
Mario can ride these platforms as they move. They come in all different shapes and sizes.

METAL ROD
Mario can jump between these to build momentum.

METEOR
Rocks that come crashing down from the sky. Sometimes they destroy Mario's path.

POISON SWAMP
There's nothing you can do if Mario falls in— you'll lose a life.

PIPE
Mario can travel to different areas through pipes.

POLE
Mario can climb up or down. He does a handstand and can jump off from the top.

POWER STAR
When you get one, you've cleared the mission! Once you've gathered enough Power Stars, you can move on to the next galaxy.

PULL STAR
Use the pointer to grab a Pull Star, and Mario will be pulled toward it.

PURPLE COIN
There are certain missions where Mario must collect 100 to make a Power Star appear.

QUICKSAND
If Mario gets pulled in, you'll lose a life. It's usually found in the Dusty Dune Galaxy.

RAINBOW NOTE
When Mario gathers them all, he'll get an item, such as a 1-Up Mushroom or a Power Star.

RAINBOW STAR
Become Rainbow Mario for a little while with the help of this power-up.

RED POWER STAR
This special type of Power Star can only be found at the Gate.

ROPE SWING
When Mario grabs on and swings, it moves back and forth in an arc.

SHRINKING PLATFORM
These platforms shrink down to nothing after Mario steps on.

SILVER STAR
If Mario gathers all five from a certain area, a Power Star appears.

SLING POD
Grab hold and pull the pod with your pointer to sling Mario along his route.

SLING STAR
If Mario gets inside and spins, he'll fly a short distance.

SPIN BLOCK
Star Bits come out of these blocks. Mario can move them to stop Star Bunnies from running away.

SPIN CIRCLE
When Mario spins in the middle of one of these circles, a ring of Star Bits appears.

SPIN VALVE
If Mario stands on top and spins, it triggers a mechanism.

SPOOKY SPOTLIGHT
Some surfaces don't exist when this weird light is not shining on them.

SPOTLIGHT
A Boo will vanish if it's hit by the light. The light can also turn Boo Mario back into regular Mario.

SPOTLIGHT PLATFORM
A beam shoots out from below this platform. If Mario touches it, he takes damage.

SPRING MUSHROOM
Grab one of these to power up into Spring Mario.

SPRING
They move right and left. If Mario touches one, he is bounced back.

SPRINGBOARD
When Mario does a ground pound on one, he leaps high into the air.

SPROUTLE VINE
Shake the Wii Remote and Mario will slide up the vine and launch into a big jump.

STAR BALL
Tilt the Wii Remote to navigate as Mario rolls on top of the ball. A Power Star appears at the goal!

STAR BALL PIT STOP
If Mario hits one while on a Star Ball, he jumps. Sometimes this is the goal.

STAR BIT
Little pieces of stars that fall across the universe. Collect fifty to get a 1-Up.

STAR CHIP
Collect all five from an area and they turn into a Launch Star.

STAR CHIP (BLUE)
Gather all five and a Pull Star will appear.

STONE WHEEL
When Mario does a ground pound on one, items such as Star Bits or sproutle vines appear.

STRETCH PLANT
Mario can use a spin attack to push them into enemies or treasure chests.

STUMP
When Mario does a ground pound on one, it can produce an item or trigger an effect.

SWING
Mario can grab one and swing back and forth to build momentum.

THORNY FLOWER
These plants are covered in sharp spines. If Mario touches one, he takes damage.

TORNADO
When Mario enters one and spins, it sends him flying high into the air. He descends slowly.

TREASURE CHEST
Items and other things are hidden in them. Use a Koopa shell to open them.

WATER SPOUT
They shoot out water periodically. If Mario is on top when it sprays, he is sent flying into the air.

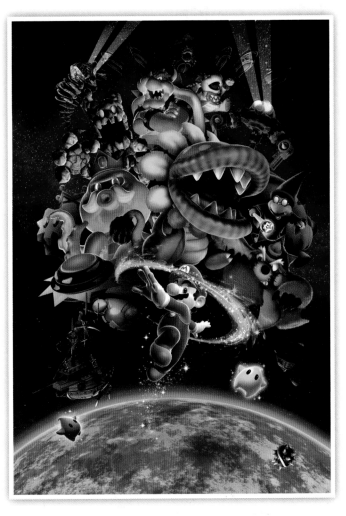

AND MORE

MEMORABLE MOMENTS

Here are some iconic moments from Mario and Luigi's quest to collect all 242 Power Stars. Rosalina features quite a lot in this game!

THE MYSTERIOUS ROSALINA

When Mario is blasted out into space, he meets Rosalina, the woman who runs the Comet Observatory. They work together as Mario makes his way toward the final battle with Bowser. This game is Rosalina's first appearance, and she later becomes a playable character in games such as *Mario Kart Wii* and *Super Mario 3D World*.

STORYTIME

When Mario arrives at the library, he finds Rosalina and a number of Lumas. Rosalina reads from a picture book about a Luma and a little girl. As you unlock the pages of the picture book, Mario will be able to go on even more adventures.

ROSALINA'S PROTECTIVE BUBBLE

If Mario gets too close to Rosalina, there is some sort of bubble protecting her. Star Bits fired from a distance hit her as if there is no barrier.

RESCUE LUIGI!

Luigi's gotten himself separated from the Toad Brigade, and Mario needs to rescue him. After finding him, he'll hang out in the Garage and help Mario find more Power Stars.

TINY TOY TRAIN

There's a small toy train in a hidden alcove in the Toy Time Galaxy. If you go there when you're not Spring Mario, you can find it.

PRANKSTER COMET!

After gathering thirteen Power Stars, comets fly in and change all the rules! There are five different types, including Daredevil Comets (which force Mario to fight a boss with only one life) and Speedy Comets (which turn some levels into speed runs).

LUIGI CALLS FOR HELP

Luigi tries to help Mario collect Power Stars, and he takes it upon himself to go on the hardest missions. During Mario's adventure, every now and then a letter arrives begging him to go to the place in the photograph and help Luigi. But even if Luigi needs to be rescued . . . he's already done the hard work of finding the Power Star!

CHALLENGE THE PLANET OF TRIALS

After gathering all three Green Stars, the Comet Observatory's Planet of Trials opens up. There are three types of trials you can attempt: surfing on a Ray, rolling on a Star Ball, and floating in a bubble.

THE TRUE ENDING?!

If Mario's gathered all 120 Power Stars from the main adventure, you see the final cut scene. But after the credits have rolled, there's another scene, too.

EVEN MORE LUIGI

After you've completed the game by collecting all 120 Power Stars, you can have a new adventure with Luigi. He has slightly different abilities than Mario, and you can collect all 120 Power Stars with him instead of Mario. On the missions where he appears, Luigi encounters his double!

A GRAND FINALE!

If you've collected 120 Power Stars with Luigi, you can experience the Grand Finale! After that, Mario and Luigi have together collected 242 Power Stars and cleared the entire game.

THE TOAD BRIGADE'S PROMOTION

If Mario talks to Captain Toad after finishing the game, you find that all the efforts of the Toad Brigade have been rewarded, and they've been promoted to the Royal Guard.

A CELEBRATORY LETTER

At the very end of the Grand Finale Galaxy, you receive a letter delivered by a Toad. You have to go into your Wii Message Board to read it, and it comes with a photo attachment (the messages are different for Mario and Luigi).

HELPFUL HINTS & TECHNIQUES

Here's a technique that will serve you well when you are racing Cosmic Mario.

OFF LIKE A ROCKET!

When you're racing against Cosmic Mario, press the analog stick and Z Button while the countdown is still going to get into a starting crouch. At the moment the race begins, press the A Button for a rocket start!

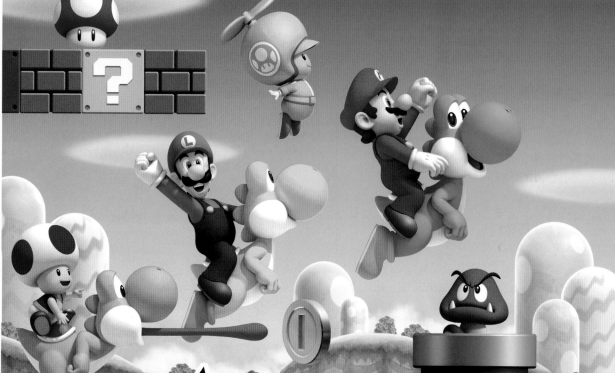

New SUPER MARIO BROS.®Wii

ニュー・スーパーマリオブラザーズ・Wii

Package

Game Disc

Instruction Booklet

System: Wii
Release Date:
November 15, 2009
(Japan: December 3, 2009)
Player Count: 1-4

INTRODUCTION

STORY

Today is Princess Peach's birthday, and the castle is overflowing with presents for the princess.

Mario and Luigi have come to help Peach celebrate her birthday along with the Toads.

That birthday cake is huge! But who sent it? Everyone is shocked as Bowser Jr. and the Koopalings suddenly burst out of the cake!

In the uproar, Princess Peach is kidnapped, and the villains make their getaway in a huge, flying airship.

The castle Toads are all in a panic! Mario, Luigi, Yellow Toad, and Blue Toad all go running after the airship, determined to rescue Princess Peach.

FEATURES

1 TO 4 PLAYERS CAN PLAY MARIO ON THE Wii!

This is the first 2D action game in the series for multiple players. Mario and Luigi are joined by Yellow Toad and Blue Toad, making for a wide-ranging adventure for up to four players. You can help your friends get past tough areas while they're in a bubble, or you all can defeat a bunch of enemies with cooperative ground pounds. Combine your strengths and set your sights on freeing Princess Peach!

MAKE IT A PARTY WITH MULTIPLAYER MODE

Aside from the main game mode where Mario rescues Princess Peach, there are also two multiplayer modes. With these party-type games, you can have fun even outside of the main game!

COIN BATTLE

A competitive mode that up to four people can play. Use any means necessary to grab the Star Coins before your rivals get them!

FREE-FOR-ALL

In this mode, up to four players compete for the highest score. Once the course is cleared, each player's score and number of enemies defeated is displayed—then the winner is crowned!

 # CHARACTERS

PLAYER CHARACTERS

It's not just Mario and Luigi this time—the Toads can also join you on your adventure!

MARIO
He's the main character when only one person is playing.

LUIGI
He helps out in regular play, as well as appearing in multiplayer.

BLUE TOAD
He appears in multiplayer play and has the same abilities as Mario.

YELLOW TOAD
A slightly different Toad who appears in multiplayer play.

POWER-UPS
If you get an item, you are instantly powered up. If you get items at the Toad Houses, you can power up with those items on the world map.

SMALL MARIO

This is how Mario starts off when the game begins. He can't break blocks, and if he's hit by an enemy, you'll lose a life.

 SMALL LUIGI

 SMALL YELLOW TOAD

 SMALL BLUE TOAD

SUPER MARIO ITEM ▶ SUPER MUSHROOM

He's larger than Small Mario, and can now break blocks. But if he takes damage, he becomes Small Mario again. This goes for Super Luigi and the Super Toads, too!

 SUPER MARIO

 SUPER LUIGI

 SUPER YELLOW TOAD

 SUPER BLUE TOAD

FIRE MARIO ITEM → FIRE FLOWER

Mario can attack enemies by throwing fireballs. He can fling fireballs in both directions with a spin jump. Not every enemy can be defeated with fireballs, and if a fireball hits a Bob-omb, that lights its fuse!

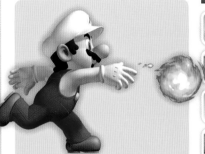

 FIRE MARIO

 FIRE LUIGI

 FIRE YELLOW TOAD

FIRE BLUE TOAD

INVINCIBLE MARIO ITEM → SUPER STAR

Mario begins to glow and can defeat any enemy just by touching them. While invincible, he dashes at a higher speed than normal.

 INVINCIBLE MARIO

 INVINCIBLE LUIGI

 INVINCIBLE YELLOW TOAD

 INVINCIBLE BLUE TOAD

MINI MARIO ITEM → MINI MUSHROOM

Mario's body becomes tiny and light, so he floats longer when he jumps. When he adds a spin jump, he can leap even farther. He can also run on the water's surface. Mini Luigi and the Mini Toads can do the same!

 MINI MARIO

 MINI LUIGI

 MINI YELLOW TOAD

 MINI BLUE TOAD

ICE MARIO ITEM → ICE FLOWER

Mario can throw ice balls that freeze any enemy they hit. Once an enemy is frozen, he can stand on their ice block or throw it to attack other enemies. Ice balls can also defeat fiery enemies.

 ICE MARIO

 ICE LUIGI

 ICE YELLOW TOAD

 ICE BLUE TOAD

PROPELLER MARIO ITEM → PROPELLER MUSHROOM

When a player shakes the Wii Remote, Mario can fly high with a Propeller Jump, and afterward twirl slowly to the ground. Or he can dive swiftly to the ground, hitting whatever is below in a spin attack with the force of a ground pound!

 PROPELLER MARIO

 PROPELLER LUIGI

 PROPELLER YELLOW TOAD

 PROPELLER BLUE TOAD

PENGUIN MARIO ITEM → PENGUIN SUIT

Mario can throw ice balls to attack. He does not slip on ice, and if he dashes and ducks, it becomes a belly slide that can break blocks and defeat enemies. Also, he can swim more quickly underwater.

 PENGUIN MARIO

 PENGUIN LUIGI

 PENGUIN YELLOW TOAD

 PENGUIN BLUE TOAD

YOSHI

Yoshi appears on certain courses. He can use his long red tongue to eat fruits and enemies. He can also grab Fire Piranha Plants' fireballs or Hammer Bros.' hammers and spit them back out to surprise the enemy! If you hold down the jump button while in midair, he can get a bit of extra height and distance by performing a flutter jump.

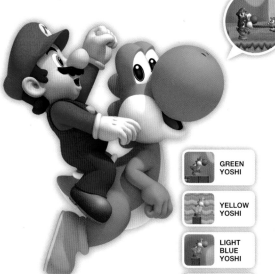

GREEN YOSHI

YELLOW YOSHI

LIGHT BLUE YOSHI

PINK YOSHI

OTHER CHARACTERS

Characters who help Mario out on his adventure.

TOAD
He can be found in Toad Houses, and will give you items to help you on your adventure. Toads can also be found in a block on certain courses.

JUMBO RAY
They swim slowly through the sky. Mario can get on top for a ray ride.

PRINCESS PEACH
She was kidnapped by Bowser's Koopalings in the middle of her birthday party. How rude!

ENEMIES

These are the enemy characters Mario will face on any given course. The seven Koopalings make their grand return, manning the towers and castles of each world.

AMP
Their stationary bodies are covered in harmful electricity and are dangerous to touch.

BANZAI BILL
A huge Bullet Bill. They move just like regular Bullet Bills.

BIG BOO
Large-sized Boos. Even the large get shy when more than one person looks at them . . .

BIG CHAIN CHOMP
One of these pulls Iggy's carriage. It's invulnerable.

BIG CHEEP CHEEP
Large-sized Cheep Cheeps that move like regular Cheep Cheeps.

BIG DRY BONES
A large-sized Dry Bones. They don't fall apart with a normal jump; only a ground pound will crumble them.

BIG FIRE PIRANHA PLANT
Overgrown Fire Piranha Plants. They don't live in pipes, like their smaller counterparts.

BIG FUZZY
These are large versions of the Fuzzies and move exactly the same way.

BIG GOOMBA
They're somewhat bigger than regular Goombas. They split into two regular Goombas when jumped on.

BIG PIRANHA PLANT
They're larger than normal Piranha Plants, but they don't come out of pipes.

BIG THWOMP
They move exactly like regular-sized Thwomps but can also break stone blocks.

BIG URCHIN
These are oversized Urchins that sometimes float on the surface.

BIG WIGGLER
They don't get mad if Mario jumps on them. He can use them like Trampolines.

BLOOPER
They bob up and down in the water, slowly closing in.

BLOOPER NANNY
These are Bloopers with four Blooper Babies in tow. The babies follow the movements of the Nanny.

BOB-OMB
They walk along the ground. If Mario jumps on them, they stop and eventually explode.

BOO
It chases the unwary when their back is turned. Sometimes several of them form a ring.

BOOMERANG BRO
They attack by throwing boomerangs straight ahead.

BOWSER
The boss of W8. He breathes fire to attack, and after Mario defeats him, he becomes giant-sized.

BOWSER JR.

The boss of the flying airships. Bowser Jr. gets into the Junior Clown Car and shoots off fire or springs traps.

BRAMBALL

They walk right and left on long, thorny legs. Their face is vulnerable.

BROOZER

Broozer comes out swinging if Mario gets close. His punches can break stone blocks.

BULBER

A little light on their foreheads shines in the dark sea as they swim straight ahead.

BULL'S-EYE BANZAI

They mostly fly straight, with some homing capabilities.

BULL'S-EYE BILL

These are Bullet Bills that flash red while they change their direction to give chase.

BULLET BILL

Some are fired out of Bill Blasters, and some just come flying in from the unknown.

BUZZY BEETLE

They mostly appear underground. When jumped on, their shell becomes a useful tool.

CHAIN CHOMP

They're tethered to the ground by a staked chain, lunging and biting. Without the stake, they escape.

CHEEP CHEEP

They swim slowly through the water, sometimes leaping into the air.

CHEEP CHOMP

They try to gobble up everything with their big mouths.

CLAMPY

They open and close their mouths at regular intervals. There's often something inside.

CLIMBING KOOPA (GREEN)

These Koopa Troopas move along the front and back of chain-link fences.

COOLIGAN

They slide along the ice. If you jump on them once, they slow down.

CROWBER

After they crisscross the sky, they swoop down to attack.

DEEP CHEEP

They won't chase until someone invades their personal space. There's a slightly larger type, too.

DRY BONES

They're usually found in towers and castles. They fall apart if Mario jumps on them, but eventually come back to life.

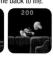

EEP CHEEP

These yellow-orange Cheep Cheeps are startled easily and run away.

FISH BONE

Their eyes turn red when they catch sight of Mario. They attack by charging straight at their target.

FIRE BRO

They attack by throwing bouncing fireballs.

FIRE PIRANHA PLANT

They spit fireballs out of their mouths to attack, sometimes several in quick succession.

FIRE SNAKE

They move in bounding jumps, lighting up the darkness with their flaming bodies.

FLAME CHOMP

They float around in the sky trying to get close. They breathe out the fireballs that make up their tails.

FOO

They blow fog in front of them, impairing Mario's field of view.

FUZZY

They move along tracks, and usually in groups.

GOOMBA

They walk straight along the ground, and they jump at certain beats of the music.

HAMMER BRO

They attack by throwing hammers, and they often come in pairs.

HUCKIT CRAB

They attack by throwing rocks while jumping backward.

HEAVY PARA-BEETLE

These very large Para-Beetles descend when ridden.

ICE BRO

They lob ice balls at Mario, which move in small arcs.

IGGY KOOPA

The boss of W5. He flings magic attacks from his Chain Chomp carriage.

JELLYBEAM

They light up the dark, murky water. The amount of light varies on the direction they're moving.

KAMEK

The boss of W8. He teleports around and uses magic to turn platforms into enemies.

KING BILL

They're even bigger than Banzai Bills. They can't be defeated!

KOOPA PARATROOPA (GREEN)

Some fly through the sky while others bounce along the ground.

KOOPA TROOPA (RED)

Koopa Troopas with a red shell. They're mindful of cliffs and ledges. When jumped on, they hide inside their shells.

KOOPA TROOPA (GREEN)

Koopa Troopas with a green shell sometimes dance in time to the music.

KOOPA PARATROOPA (RED)

They fly through the sky and become normal Red Koopa Troopas when jumped on.

LAKITU

They throw Spiny Eggs from the sky. There's also a type that throws coins.

LARRY KOOPA

The boss of W1. He leaps around shooting magic from his wand.

LAVA BUBBLE
They are balls of fire that jump up from the lava. They can be defeated with an ice ball.

LEMMY KOOPA
The boss of W3. He balances on a big, bouncy ball and shoots more balls out of his wand.

LUDWIG VON KOOPA
The boss of W7. He moves from platform to platform, and shoots magic that goes in four directions.

MECHAKOOPA
They waddle forward, and if jumped on, stop moving for a while. When stopped, they can be picked up and carried.

MEGA GOOMBA
Jumping on them creates two Big Goombas, and a ground pound will turn them into four Goombas.

MICRO GOOMBA
They're tiny Goombas that cling to their victim and slow them down. A spin jump will remove them.

MONTY MOLE
They come bursting out of holes in the rock walls and charge straight into battle.

MORTON KOOPA JR.
The boss of W6. He jumps so hard he makes the ground shake when he lands.

MUNCHERS
They're stuck in the ice, but if the ice is melted, they come back to life. They cannot be defeated.

PARA-BEETLE
They fly through the sky, rising if someone stands on them.

PARABOMB
They float down from the sky on parachutes. When they hit a surface, they become Bob-ombs.

PARAGOOMBA
These Goombas have wings. They bounce along the ground and become normal Goombas when jumped on.

PIRANHA PLANT
Some can be found in pipes while others are planted in the ground.

POKEY
Their tall bodies are made of stacked balls. At certain beats in the music, their bodies turn into oranges!

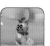

PORCUPUFFER
They swim right and left along the surface of the water. Every now and then they jump to attack.

PRICKLY GOOMBA
These Goombas hide inside a spiky chestnut shell. Hit it with a fireball to force it out!

RIVER PIRANHA PLANT
They float on the water's surface and blow thorny balls up into the air.

ROCKY WRENCH
They appear from the decks of airships and attack by throwing wrenches.

ROY KOOPA
The boss of W2. He sneaks around in the pipes, dropping down to create paralyzing tremors.

SCAREDY RAT
They walk in a line. If you jump on one, they all scurry off in the other direction.

SLEDGE BRO
They throw hammers to attack. Occasionally they jump up high, causing a strong tremor when they land.

SPIKE
They produce Spiked Balls from their mouths and then throw them.

SPIKE TOP
They have a big spike on their shells, and can walk on walls and ceilings.

SPINY
They have a spiny shell on top. Some fall from the ceiling.

SPINY CHEEP CHEEP
They never stop chasing their target. Swim away quickly!

SPINY EGG
The eggs of Spinies thrown by Lakitus. They become Spinies when they hit the ground.

STALKING PIRANHA PLANT
They move right and left, stretching their stalks upward whenever Mario is near.

STONE SPIKE
They throw spiky boulders down from above.

SWOOP
They hang from the ceiling, waiting to attack the unsuspecting.

THWOMP
They try to fall on anyone who passes under, then they slowly rise to their original spot.

URCHIN
A spiny enemy. It undulates within the water.

WENDY O. KOOPA
The boss of W4. She casts spells of rings that bounce around the screen.

WIGGLER
They walk along, calm by default, but get enraged and speed up if jumped on.

WORLD

C O U R S E S

This game is split into nine worlds, each with special aspects. There are certain mechanisms on the World Map that can alter the courses.

WORLD 1
A nice world of grasslands.

W1-1
The first course. These rolling hills can prove tricky to traverse.

W1-2
An underground course with moving platforms. Get a Super Star in the second half and do an invincible dash.

W1-3
Yoshi appears! Hammer Bros. try to get in the way.

W1-🏰
Ascend the tower using the swing lifts.

W1-4
An underwater course where schools of Cheep Cheeps of all types swim.

W1-5
An athletic course with rotating Mushroom Cubes.

W1-6
There are Koopa Troopas and Koopa Paratroopas walking on the rotating ground wheels.

W1-🏯
The cogwheels turn above the lava. Around the center, there are a group of Thwomps to avoid.

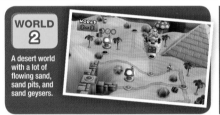

WORLD 2
A desert world with a lot of flowing sand, sand pits, and sand geysers.

W2-1
The spouting sand geysers become platforms.

W2-2
A desert course that spreads a great distance. There are lots of coins hidden underground.

W2-3
A pitch-black cave. Fireballs flung by friend and foe light the way.

W2-🏰
Climb up the fences while dodging large balls of magic.

W2-4
Sandstorms blow across this desert landscape, making it hard to keep balanced.

W2-5
Lakitu flies high above the quicksand, but Yoshi can eat up the Pokeys.

W2-6
The Mushroom Cube rotates as it runs along the track, but it's the only way forward.

W2-🏯
A looping course where one wrong choice leads back to the beginning.

WORLD 3
A snow-covered highland world where it's easy to slip.

W3-1
A course covered in ice. Belly-sliding in a Penguin Suit makes navigating a breeze.

W3-2
A snow-country course with a lot of Bill Blasters placed along it. Ice Bros. also make an appearance.

W3-3
Icicles, both large and small, fall from the ceiling of this underground lake and cave course.

W3-🏚
A creepy mansion where Boos sneak up on the unwary. There are a lot of fake ghost doors.

W3-🏰
The rotating lifts and elevators are the only way to move up to the top.

W3-4
Climb aboard the moving ice cylinders. After the ! Switch is pressed, the way to the real goal is revealed.

W3-5
Get on board the rotating, track-bound Mushroom Cube and head for the sky on this athletic course.

W3-🏯
Get on the Ice Snake Blocks and avoid the huge icicles.

WORLD 4
Sandy beaches surrounded by beautiful blue waters.

W4-1
A course in the shallows with Cheep Cheeps and Spiny Cheep Cheeps. Watch out for the Urchins in the second half.

W4-2
A rocky shore with Cheep Cheeps jumping out of the water. Move along the Donut Blocks to get to the goal.

W4-3
A shallow lake with useful lifts. The Urchins are waiting on the water's surface.

W4-🏰
The conveyor belts can carry the heroes to the next part of the course, but they also carry uniquely shaped iron blocks.

W4-4
An underwater course where Bloopers come out of the pipes.

W4-🏚
A Ghost House infested with Scaredy Rats. There are a lot of moving platforms here.

INTRODUCTION CHARACTERS WORLD AND MORE

W4-5
A seaside course with Yoshi. The Lakitus throw Spiny Eggs from above.

W4-
Skewers come crashing in from both right and left. Avoid them using the fences and lifts.

W4-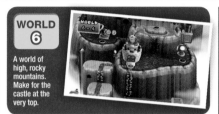
There are Burners situated here and there on this huge airship.

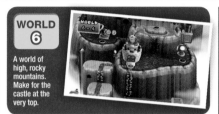

WORLD 5
A jungle world surrounded by trees.

W5-1
A waterfront jungle course with a lot of Stalking Piranha Plants and River Piranha Plants.

W5-2
A cave course with poisoned water below. The Big Wigglers provide safe passage.

W5-3
The Bramballs hog the narrow footholds above the poisoned water.

W5-
There are spiked walls moving right and left, making navigation tricky.

W5-4
Ride the countdown raft over the poisoned water. Defeat all the enemies that board the raft!

W5-5
The only way through is riding on the backs of the Jumbo Rays. Flying Bullet Bills try to get in the way.

W5-
It's dark, the hallways are narrow, and there are lots of doors in this house. Use the limited light to look for the goal.

W5-
The fences move and rotate above the lava. They're the only route to the end.

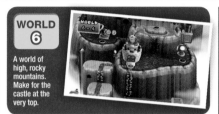

WORLD 6
A world of high, rocky mountains. Make for the castle at the very top.

W6-1
A rocky course filled with Bullet Bills. Stone Spikes throw their boulders down on any climbers.

W6-2
An underground course with a lot of moving surfaces. Spinies and Swoops come down from above.

W6-3
The only route is through narrow passageways within pipes. Expect plenty of Piranha Plants.

W6-4
A rocky and mountainous athletic course. Tons of Monty Moles come bursting out of the rocky walls.

W6-1
Enormous Skewers come crashing from above and below. Tiny alcoves on each side are the only hiding spots.

W6-5
A rocky place where the water level rises and falls. A Porcupuffer swims along the surface.

W6-6
Board the raft and use its spotlight to pass through this pitch-black underground lake.

W6-
The swing lifts move back and forth over a sea of lava. To make matters worse, Spiked Balls crash down from above.

W6-
A constantly scrolling airship course, with large wheels sometimes being the only footing.

WORLD 7
A wide world above the clouds. There are a lot of courses with narrow footholds here.

W7-1
Colorful blocks swing and rotate on this athletic course.

W7-2
Swim inside the Water Balls that float in the air to proceed.

W7-3
An athletic course with mushroom platforms. Avoid the Fuzzies on tracks.

W7-
Tilt the Wii Remote to control the lift. Avoid the many enemies to move upward.

W7-
There are many ups and downs in this Ghost House. Not so many tricks and puzzles, but a lot of enemies.

W7-4
A course where Mario makes his way across colorful pipes. This is where the switch-type Wii Remote-controlled lift appears.

W7-5
The Foos blow their fog here, making it hard to see.

W7-6
Huge flocks of Para-Beetles and Heavy Para-Beetles are flying here. The only route is to jump from one to the next.

W7-
A castle course with strong athletic aspects made trickier by the crashing Skewers.

WORLD 8
There's a sea of lava underfoot in this final world.

W8-1
Clouds of smoke roll in from behind, and debris flies down. The narrow footholds leave no room for mistakes.

W8-2
Spinning rock wheels offer little traction, while Spiked Balls rain down.

W8-3
There are many unstable platforms to cross amid the rising and falling waves of lava.

W8-1
The only way up is to board the huge, moving stone blocks while avoiding the Fire Bars.

W8-4
A cave filled with pitch-dark water. Oftentimes the only light is given off by enemies.

W8-5
The Wii Remote-controlled rail lifts are the only way over the lava in this constantly scrolling course.

W8-6
The lava comes up from the bottom. The only way out is up!

W8-7
Get on the Spine Coaster and avoid the pillars of fire on this wild ride!

W8-
Turn the bolts to open up paths across this airship course.

W8-
It's Bowser's Castle. Mario and his friends cross the Bone Lifts over the lava to get to its deepest depths.

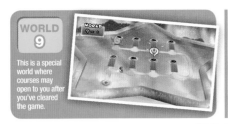

WORLD 9

This is a special world where courses may open to you after you've cleared the game.

W9-1
Cross those colorful rotating blocks to get to the goal.

W9-2
An athletic course above the water. One slip and it's lunchtime for the Porcupuffer!

W9-3
On this course, Banzai Bills and Bull's-Eye Banzais come one after the other.

W9-4
This is a continuous scrolling course with a lot of Bob-ombs.

W9-5
Climb the frozen footholds to find lots of Fuzzies in the second half.

W9-6
Cross over the tiny platforms that dip into the lava below.

W9-7
Run across the ice blocks as Fire Piranha Plants rain down a storm of fireballs.

W9-8
Have fun bouncing on the puffy clouds, but the enormous King Bills seem to come from everywhere.

ITEMS & OBSTACLES

Items and other things you find on the courses. Some of them can be controlled with motions of the Wii Remote.

! SWITCH
They can make a bridge collapse. The one on the W3 World Map makes red dotted-line blocks appear.

? BLOCK
Items can be found in them. Certain special ones may have a Toad imprisoned in them.

? SWITCH
Flip the switch to set one of many different mechanisms temporarily in motion.

1-UP MUSHROOM
Increases Mario's number of extra lives by one. Most of them are hidden.

10-COIN BLOCK
This block spouts up to ten coins while being hit.

BANZAI BILL CANNON
They are the cannons that blast out Banzai Bills.

BARREL
These can be carried and thrown, to roll along the ground or floor.

BARREL RAFT
They float on the surface of the water and sink under the slightest weight.

BILL BLASTER
The cannons that fire off Bullet Bills. There is a type that also extends and retracts.

BILL BLASTER TURRET
There are several bores spinning and sending a Bullet Bill in every direction.

BLOCK
Some of these can produce items. They shatter when hit.

BOLT LIFT
Spin on it to get a mechanism to activate.

BONE PLATFORM
These bony platforms come in varying widths and fall if Mario stands on them for a while.

BOUNCY CLOUD
A bouncy cloud that responds even better to well-timed jumps.

BOWSER'S FLAMES
These are a sequence of fireballs that fly horizontally across the screen.

BURNER
These shoot out a pillar of fire at regular intervals.

CANNON
They shoot out cannonballs or Bob-ombs. There's a type that can swing its barrel.

CHECKPOINT FLAG
If you touch it and later lose a life, you'll resume the course near the flag.

CIRCUS BALL
These are very springy, so try bouncing on one.

COGWHEEL
These are rotating platforms in the shape of cogwheels.

COIN
Grab one hundred coins to get a 1-Up. If you set off a POW Block, it will bring all the coins down.

CONCEALING WALL
Behind these walls lie hidden spaces that are a secret to everyone.

CONVEYER BELT
Moves anyone standing on them left or right.

COUNTER RAFT
The whole thing stops if there are more characters aboard than the number listed.

CRATE
A ground pound breaks them. Some have items inside.

CURRENT PIPE
Anyone caught in the rushing water from these pipes is at the mercy of their currents.

DONUT BLOCK
They fall if stood on too long, but reappear after a while.

DOTTED LINE BLOCK
They turn into red blocks when an ! Switch is hit.

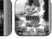

ELECTRIC FENCE
Hit this and be struck with a short shock of electricity that does damage.

ELEVATOR
Some move up and down and others move left and right.

FAKE DOOR
Boos haunt these doors. If Mario tries to go in one, a coin comes out.

FENCE
Grab on and move! Some types slide left and right, and others slide up and down.

FENCE WHEEL
Wheels made of chain-link fence. They spin slowly around and around.

FIRE BAR
They are rotating balls of fire. One type extends in both directions rather than just one.

FIRE FLOWER
Become Fire Mario with this power-up.

FLIP PANEL
They spin in place, giving access to the opposite side of the fence.

FLOATING BLOCK
These are ? Blocks that float on the surface of the water. They rise and fall with the water level.

FLOWER
Do a Spin Jump and they produce a coin. They come in different varieties depending on the course.

FLYING ? BLOCK
? Blocks with wings that fly up and down, or left and right.

FOG
It impairs Mario's vision and hides things like coins. A Spin Jump will blow it away.

FRUIT
Yoshi can eat them. If he eats five, he lays an egg, which contains an item.

GHOST BLOCK
They look like regular ? Blocks but attack when approached.

GHOST VASE
Get too close and these rise in the air and attack. They're found in Ghost Houses.

GIANT ! SWITCH
Your last resort in defeating the giant-sized Bowser at the end of the game.

GIANT SHELL
A huge Koopa Troopa shell that's big enough for four!

GIANT SPIKED BALL
These look like they could just kick aside the normal-sized spiked balls.

GLOW BLOCK
These blocks light up the darkness and can be carried.

GLOW PLATFORM
These light up when a ? Switch is hit, and move along a set route.

GOAL POLE
Grab the pole to clear the course. Reach the very top to get a 1-Up.

HAND-OVER-HAND ROPE
Mario can move left or right while dangling from this rope.

HIDDEN BLOCK
They appear out of thin air, sometimes holding coins or items.

HIDDEN COIN
Coin shapes marked by a dotted line. Pass through the outline and they turn into real coins.

GLOW BLOCK / GLOW PLATFORM continued

HIDDEN GOAL POLE
This Goal Pole can be found in hidden exits, identified by a red flag.

HUGE FLIP PANEL
Hit it and the fence makes a big spin to the opposite side.

HUGE ICICLE
These fall when Mario gets close. After it falls, he can use the wide end as a platform.

HUGE SKEWER
These giant obstacles fill up about half of the entire screen.

ICE BLOCK
Mario can throw them at enemies to defeat them. They also slide along the ground.

ICE FLOOR
A slippery floor. When there are coins or other things inside, a fireball will melt the ice, releasing them.

ICE FLOWER
With this item, Mario powers up to Ice Mario.

ICE LIFT
Large formations of ice that float on the water or slide along an icy floor.

ICE SNAKE BLOCK
A large group of ice blocks linked together. It changes its shape as it moves along.

ICE WALL
Large blocks made of ice. Set off one with a Bob-omb in it for a chain reaction.

ICICLE
They fall from the ceiling when approached. After one falls, it reappears on the ceiling.

JUMP BLOCK
These are bouncy blocks. With the right timing, Mario can jump very high.

KEY
These appear when the boss of the castle is defeated. Take the key to clear the course.

LADYFINGER LIFT
These are found on cliff areas. When Mario gets on, it will fall after a short while.

LAVA
This is a common sight in the castle and other places. Swimming NOT recommended.

LAVA GEYSERS
These come shooting up from the lava. They hurt, but they aren't immediately lethal.

LAVA WAVE
Lava that converges in a peak and then slows. If Mario is hit, you lose a life.

LEDGE
Hang on tight and climb your way across sheer walls with these ledges.

LIFTS
A pair of lifts. When one is weighed down, the other moves up.

MAGIC BEAM
These flying bolts of magic have different colors depending on the course.

MEGA CANNON
Giant-sized cannons that fire giant-sized cannonballs horizontally.

METAL CRATE
These appear running along conveyor belts, one after another. They come in several different shapes.

MINI MUSHROOM
A tiny mushroom that can be used to power up to Mini Mario.

MINI PIPE
Very small pipes that only Mini Mario can enter.

MUSHROOM CUBE
Square platforms that rotate, some while moving along a rail.

MUSHROOM LIFT
These are mushroom platforms that periodically stretch left and right before shrinking.

MUSHROOM SCREW
Hop on and spin to raise one up while lowering another.

P SWITCH
Flip them to turn blocks into coins and vice-versa. They can also make Silver Coins appear.

PADDLE WHEEL
Turn the whole contraption by jumping onto the forward lift.

PALM TREE
Desert and seaside trees with fronds strong enough to stand on.

PENDULUM
Platforms that swing slowly right and left on their chains.

PENGUIN SUIT
This power-up transforms Mario into Penguin Mario.

PIPE
Sometimes enemies come out of them, and sometimes they lead to new places.

PIPE CANNON
Enter to get blasted off like a cannonball.

POISONED WATER
A purple lake in the jungle worlds, fatal to all who fall in.

POLE
Grab on tight and climb up or down.

POW BLOCK
When hit they defeat all the enemies on the screen and cause floating coins to fall to the ground.

PROPELLER BLOCK
Give the Wii Remote a shake while carrying it to fly high up into the air.

PROPELLER MUSHROOM
Use this power-up to become Propeller Mario.

QUICKSAND
Jump repeatedly to keep from sinking.

RAIL BLOCK
These are either ? Blocks or blocks that move along a track.

RAIL LIFT
When Mario boards these, they move along a rail.

RED COIN
Collect all eight coins within the time limit and each player wins an item.

RED RING
Pass through one of these and eight Red Coins appear.

REMOTE-CONTROLLED LIFT
Once the switch is hit, you can control them with your Wii Remote.

REMOTE-CONTROLLED CLOWN CAR
Shake the Wii Remote to do a spin attack.

REMOTE-CONTROLLED ELEVATOR
When your hero gets on, it rises. Control it with the Wii Remote.

REMOTE-CONTROLLED FENCE
Tilt the Wii Remote to move the fence right or left.

REMOTE-CONTROLLED RAIL LIFT
The way you tilt the Wii Remote will move the lift right or left.

REMOTE-CONTROLLED TILT LIFT
The way you tilt the Wii Remote will change the angle of the lift.

RISING/FALLING CEILING
These blocks in the ceiling rise and fall a short way at set intervals.

ROCK WALL
Move up and down along cliffs.

ROLLING HILLS
These are huge, circular pieces of scenery that rotate. Some also act like pulleys.

ROLLING LOG
A tumbling log that's hard to get solid footing on.

ROPE LADDER
Climb this to access the platform above. If Mario's holding on, he won't be blown away in a sandstorm.

ROTATING BURNER
They're always sending out pillars of flame, but this type changes the flame's direction.

ROTATING CANNON
The bores of four cannons rotate so they fire horizontally, vertically, and diagonally—four directions at once.

ROTATING CANNON PIPE
One of the cannon bores is a pipe. The other bores fire big cannonballs.

ROULETTE BLOCK
Time your hit just right to get the desired item.

SAND GEYSER
Pillars of sand that sprout up. Jumping into the center pushes Mario to the top.

SANDSTORM
A strong wind that blows through the course, taking Mario with it. Coins can also be gathered in the gale.

SCREW
If you climb on top and spin them, it will activate a mechanism.

SCREW LIFT
Get on and spin it to move the lift along its track.

SILVER COIN
These coins appear when you press a P Switch. They count the same as other coins.

SKEWER
A large bludgeon with spikes attached. They pop out at constant intervals.

SPIKES
If Mario touches these, he takes damage! They're often affixed to the ceilings and the walls, too.

SPIKED BALL
A metal ball with spikes attached. Spike often throws these, too.

SPINE COASTER
A fast-moving rollercoaster made of bone.

SPINNER
They're spiked iron balls on a chain that constantly spin around.

SPOTLIGHT RAFT
Control the spotlight attached to the raft with your Wii Remote.

SQUARE CLOUD
Hit them from below and they turn into a Lakitu that throws coins.

STAR COIN
There are three on every course. You need them all to access the courses in W9.

STONE BLOCK
Gray-colored blocks. Bob-ombs can destroy them.

STRETCH BLOCK
A series of blocks that shrink into just one at regular intervals.

SUPER GUIDE BLOCK
If you lose eight times, these appear. Luigi will show you how to complete the course.

SUPER MUSHROOM
With this, Mario can power up to Super Mario.

SUPER STAR
This power-up makes Mario invincible for a short time.

SWAYING MUSHROOM
These mushroom platforms tilt to the right and left. Some move very quickly.

SWITCHBACK PLATFORM
It follows the direction of its arrow as long as it has a passenger.

SWINGING CHAIN
Chains that hang down from above, acting just like hanging vines.

SWINGING HAMMER
These swing back and forth and can be used as platforms.

SWINGING PLATFORM
These platforms vary in lengths and swing slowly right and left.

SWINGING VINE
These hang down from above. Swing hard enough to reach the next vine.

TRAMPOLINE
These portable springs can launch you high in the air.

VINE
They sprout up out of blocks. If the block is given a ground pound, they extend downward.

VOLCANIC DEBRIS
They come in two sizes, large and small, and they break nearly any kind of block.

VOLCANIC SMOKE
Billowing poisonous smoke that's lethal to the touch.

WATER BALL
These can be perfect spheres or oblong as they float in the air, and can be swum in.

WOBBLY PLATFORM
Suspended by chains, they tilt and sink downward under pressure.

WOBBLY STONE
It starts to tilt when disturbed, and eventually falls over.

YOSHI'S EGG
Yoshis hatch from these. If Yoshi lays one, an item will come from it.

AND MORE

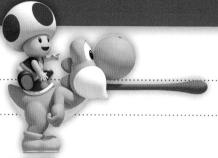

MEMORABLE MOMENTS

Here a few memorable scenes you're sure to recognize. There are all sorts of things you can do on the World Map too!

RESCUE AND REWARD

When playing solo, there are courses where a trapped Toad appears. Rescue him from the ? Block and carry him all the way to the goal. If it's a little Toad you get a 1-Up, but if it's Super Toad, you get a 3-Up!

LUIGI LEADS THE WAY

If you lose eight lives on one course, a Super Guide Block appears. Hit it, and Luigi comes out to demonstrate how to clear the course. You can either cancel the guided play in the middle or allow it to get you all the way to the end.

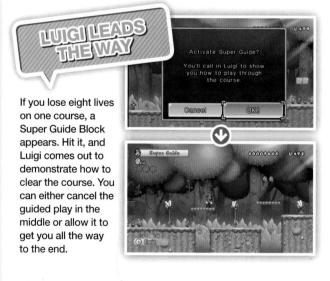

HELPFUL TOAD HOUSES

Toad Houses appear on the World Map, and they can really help Mario and his friends on their adventures. They come in three types: Red, Green, and Star. In the Red and Green Toad Houses you play minigames for items or extra lives. You can get Super Stars in the Star Toad House.

BATTLE ON THE MAP

There are enemies wandering around on the World Maps, and if they bump into you, a battle begins. Attack them and avoid their attacks while you grab all the Toad Coins placed on the screen. When you get all the coins, you've cleared the battle. Free the Toad trapped in the treasure chest and he'll give you three Super Mushrooms.

HINT MOVIES AT PEACH'S

If you go to Peach's Castle in W1, you can use the Star Coins you've collected to see hint movies. You can learn some super skills or on how to get infinite 1-Ups, among other things. There are sixty-five different movies in all that can help you on your adventure.

MAGIKOOPA PEACH

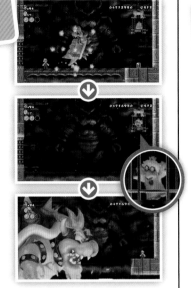

You've defeated Bowser, and now Mario can be reunited with Princess Peach . . . or so you thought! It turns out that Kamek is in that cage dressed up as Princess Peach. He then makes Bowser giant-sized, and leads you to the actual final battle.

THE SPECIAL WORLD

Once you've defeated Bowser and rescued the princess, you can access the special World 9. There are a total of eight courses on W9, but to play them you have to collect all the Star Coins on each of the courses in W1-W8. Collect all of a world's Star Coins to open its corresponding W9 course gate.

CREDITS COIN BATTLE

Mario, Luigi, and the Toads dance during the credit scroll, but you can still control them. The letters of the credits are on blocks, and if Mario hits them, some will produce coins. At the end you'll see who collected the most coins to get the highest score.

MARIO'S CAP

If you have maxed out the number of lives you can have at ninety-nine, Mario takes off his hat (if you fall below ninety-nine, the hat returns). It's only Mario who removes his cap—Luigi won't lose his lid.

HELPFUL HINTS & TECHNIQUES

Here we'll impart some tidbits that may help you on your adventure. When you've got all five stars on your save file, you've cleared the entire game.

THE HIDDEN GOAL SHORTCUT

Some of the courses have a hidden Goal Pole with a red flag (hidden goals). Most of these goals allow you to travel along a different route with a shortcut to the castle, but some of them lead to huge cannons. The cannons will warp you to different worlds. W1 and W2 lead to W5. W3 and W4 lead to W6. W5 and W6 lead to W8.

GET MORE STARS THE MORE YOU PLAY

You get stars marked on your save files depending on how much of the game you've completed. If you clear the game all the way through Bowser's Castle in W8, you get one star. If you can clear all the courses from W1 through W8 (without using Super Guide), you get two stars. Get all the Star Coins from W1 through W8, and you get three stars. Get all the Star Coins from W9, and you get four stars. If you've cleared all of the previous conditions plus opened the way to all the cannons (without using Super Guide), then you get five stars. If you've done it all without ever causing the outlined blocks to appear, all your stars will twinkle!

MAKING THE FIREWORKS HAPPEN IN MULTIPLAYER

When you play with two or more people and get to the Goal Pole when the last two digits of the time remaining are the same, you'll cause the fireworks to go off. It also makes a Toad House appear on the first circle of the world on the World Map. The time you grab the pole will determine the type of Toad House. 11 and 22 will get you a Green Toad House. 33, 44, 55, 66, 77, and 88 will get you a Red Toad House. And 99 will get you a Star Toad House.

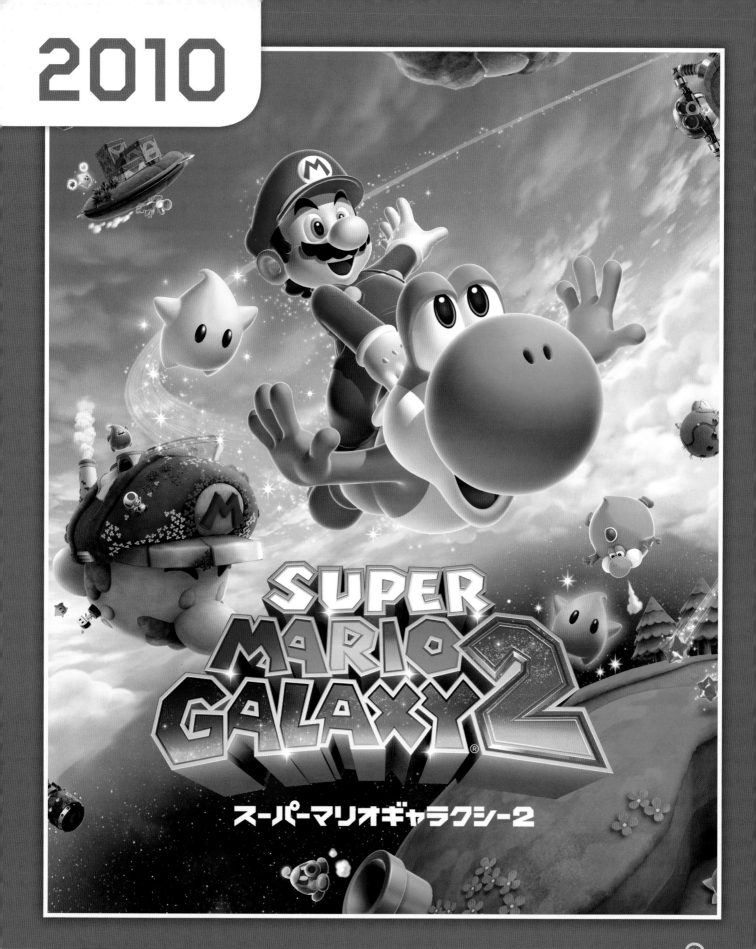

2010

SUPER MARIO GALAXY 2

スーパーマリオギャラクシー2

Package

Game Disc

Instruction Booklet

System: Wii
Release Date:
May 23, 2010
(Japan: May 27, 2010)
Player Count: 1–2

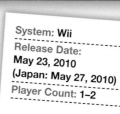

INTRODUCTION

STORY

*This text is taken directly from the instruction booklet.

Shining stardust falls on the Mushroom Kingdom once every hundred years. That time had come again . . .

Dear Mario,
Would you like to share some cake while we watch the shooting stars?
Meet me at the castle!
Peach

Mario ran through the field with stars falling around him. Suddenly, he noticed a strange light in the grass.

As he peered cautiously through the reeds, he saw a small, lost Luma.

With the baby Luma tucked safely under his cap, Mario rushed on to the castle.

But when he got there, something unexpected was waiting for him . . .

FEATURES

MARIO'S CO-STAR!

All you need is one more Wii Remote and a friend to bring in the Co-Star Luma for two to play the game together. The Co-Star Luma can defeat enemies, grab far-off items, and help Mario in his adventure.

AN ADVENTURE IN A NEW GALAXY!

They call this sequel to *Super Mario Galaxy* "another story of stardust." The basic controls are the same, but new power-ups have been added! Yoshi also joins the adventure to search for Power Stars. This time, our heroes are flying on a starship shaped like Mario's head through a brand-new world map. Some galaxies have missions where you try for a high score, and others where you grab on to a Fluzzard and glide through the world. Many different and wonderful planets await you!

INSTRUCTIONAL DVD

The Japanese and European versions of this game came with a DVD for *Super Mario Galaxy 2* beginners. It gives crystal-clear visuals of the basic actions of the game, meant especially for first-timers. It also includes a special movie collection and a section on practical techniques.

CHARACTERS

PLAYER CHARACTERS

Luigi is added to the adventure partway through, so you can choose the right attributes for each course. When two people play together (Co-Star Mode), then the second player controls the Co-Star Luma.

LUIGI

He arrives with the adventure underway. He can jump higher than Mario, but he also slides a bit more.

MARIO

Peach has been kidnapped by Bowser, so Mario leaps into a deep-space adventure to save her. He goes on adventures through space with help from Baby Luma.

CO-STAR LUMA

This character appears in Co-Star Mode. He can grab items, defeat enemies, and generally act as support for the adventure.

POWER-UPS

When you get particular items, you can power Mario up with special abilities. Depending on the situation, you lose the power-up when you take damage or when a certain amount of time elapses.

MARIO

When Mario spins, he can attack enemies or make mechanisms move. If he takes too much damage and his health meter reaches zero, you'll lose a life.

 LUIGI

CLOUD MARIO ITEM ⇨ CLOUD FLOWER

Mario can make clouds appear at his feet, which he can use as platforms. With every Cloud Flower used, Mario can make up to three clouds. It also allows Mario to jump farther.

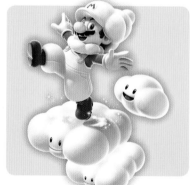

 CLOUD MARIO

 CLOUD LUIGI

ROCK MARIO ITEM ⇨ ROCK MUSHROOM

Mario becomes a rolling boulder. With it, he can crush enemies and break some traps he couldn't otherwise. Mario emerges from the boulder after rolling for a while or if he hits a wall.

 ROCK MARIO

 ROCK LUIGI

FIRE MARIO ITEM ⇨ FIRE FLOWER

This ability only lasts for a little while, then vanishes. Mario can hurl fireballs to defeat enemies, make mechanisms move, light torches, and shatter crates.

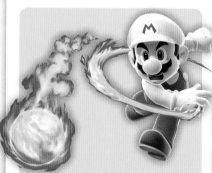

 FIRE MARIO

 FIRE LUIGI

156

BEE MARIO ITEM ➔ BEE MUSHROOM

Mario can fly for a short time. It's also possible for him to stick to and climb up honeycomb walls.

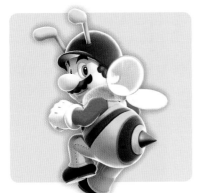

BEE MARIO

BEE LUIGI

BOO MARIO ITEM ➔ BOO MUSHROOM

You can make Mario rise by pressing the A Button repeatedly. When you shake the Wii Remote, he turns translucent and can pass through things like fences and wire mesh.

BOO MARIO

BOO LUIGI

SPRING MARIO ITEM ➔ SPRING MUSHROOM

Mario moves by bouncing along. If he times a jump just right, Mario can bounce very high.

SPRING MARIO

SPRING LUIGI

RAINBOW MARIO ITEM ➔ RAINBOW STAR

For a short time, Mario flashes with all the colors of the rainbow, and any enemies he touches are defeated. If he runs for a while, his speed increases.

RAINBOW MARIO

RAINBOW LUIGI

A POWERED-UP ITEM! SPIN DRILL ITEM ➔

Using this, Mario digs a hole straight through the ground to the other side. If he hits a hard object, he's turned back in the opposite direction.

MARIO

LUIGI

YOSHI

Yoshi hatches from an egg, and with Mario on his back, the two can jet off across the galaxy. He can use his long tongue to gobble up enemies and can also extend his jump by kicking his legs, aiding Mario with abilities found nowhere else.

YOSHI'S POWER-UPS

When Yoshi eats Dash Peppers, Blimp Fruits, or Bulb Berries, he gets some extraordinary abilities for a short time.

DASH YOSHI
ITEM ⬧ DASH PEPPER

Yoshi dashes at incredible speed, giving him the momentum to race up steep inclines and across the surface of water.

BLIMP YOSHI
ITEM ⬧ BLIMP FRUIT

Yoshi's body puffs up and he rises into the sky. He can hold his breath and stop in midair, too.

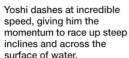

BULB YOSHI
ITEM ⬧ BULB BERRY

Yoshi's body glows and illuminates paths you wouldn't be able to see otherwise.

OTHER CHARACTERS

You'll meet many other characters on Mario's adventure.

HUNGRY LUMA

This Luma can become many things, including a planet or a new galaxy, when you feed him Star Bits or coins.

BOB-OMB BUDDY

These friendly Bob-ombs can be found in the Throwback Galaxy.

PENGUIN COACH

The coach who teaches the penguins how to swim.

GEARMO

Irate robots that ask Mario to do all kinds of tasks for them.

PENGURU

A very old penguin. He loves a place with a nice view.

GOLD GEARMO

A golden-colored Gearmo who just loves Goombas.

FLUZZARD

A shy bird who has problems getting the hang of flying, but will glide with Mario suspended below him.

GIANT LUMA

A huge Luma found in Supermassive Galaxy.

SILVER GEARMO

A silver-colored Gearmo who just loves Topmen.

PENGUINS

They can teach Mario how to swim, as well as some other underwater techniques.

GHOST LUIGI

He appears after you've cleared a certain scenario. He shows you how to do some moves.

PIANTAS

They're residents of the Starshine Beach Galaxy. Some can throw Mario high into the air.

LUMALEE

When you feed this Luma Star Bits, Lumalee transforms into an item or a pair of dice.

JIBBERJAY

These talkative, colorful birds teach Mario how to fly with Fluzzard.

WHITTLES

Wooden people that consider Tall Trunk Galaxy to be sacred ground. Their heads come in all shapes.

THE CHIMP

He challenges Mario to complete some minigames.

BABY LUMA

Mario found this lost little Luma who grants him a mysterious star power. This comes in handy as they explore the cosmos together!

TOAD

A citizen of the Mushroom Kingdom and an inhabitant of Peach's castle.

LUMAS

These star-shaped creatures live throughout the universe. They especially love eating Star Bits. There are many different types and colors.

STAR BUNNIES
Kind bunnies who teach Mario how to do things like the spin jump.

HONEYBEES
They live in the Honeyhive Town and teach Bee Mario how to fly.

LUBBA
Lubba is a spirited spaceship mechanic who travels the cosmos. After Bowser kidnapped Peach, Lubba built *Starship Mario* to help Mario chase down the spiky villain.

HONEY QUEEN

The queen of Honeyhop Galaxy. You'll recognize her by her huge body.

ROSALINA

She is in charge of the Comet Observatory. You can meet her after you've met certain conditions.

COSMIC SPIRIT

If you lose enough times on certain courses, she'll guide you to the end.

TOAD BRIGADE
A five-Toad organization, headed up by Captain Toad, that helps Mario in his search for Princess Peach. On the *Starship Mario*, they act as a bank and also deliver mail.

PRINCESS PEACH

The Princess of the Mushroom Kingdom, who has been kidnapped by Bowser.

ENEMIES

Enemies you'll find on courses. Even though some of them look like enemies from previous games, their names and methods of attack may vary.

AMP
These balls give off electricity as they move back and forth on a set path.

BANZAI BILL
Enormous Bullet Bills. Mario can defeat them using Stretch Plants.

BAT
When they see Mario they close in, let out a screech, and dive for him.

BIG AMP
They move along a specified route. If Mario touches them, he's damaged by a big shock.

BIG BOO
A huge Boo. They chase after Mario with four smaller Boos in tow.

BLOOPER
They live in the sea and undulate up and down. If they're touched or defeated, they spill some ink.

BOB-OMB
If Mario gets close, they chase him until they explode. With a spin, Mario can pick them up and carry them.

BOMB BOO
Boos that explode if Mario bumps into them. Mario can grab their tongues and swing them around.

BOMP
Pieces of bedrock that come pushing out of walls. If Mario is in front of them, they can push him off the ledge.

BOO
They try to creep up from behind Mario. A spin attack will make them translucent and they will spin around.

BOOMERANG BRO
They move by jumping and can throw two boomerangs at once.

BOOMSDAY MACHINE
A castle that also becomes a tank ridden by Bowser Jr. It can make all kinds of attacks.

BOULDERGEIST
It manipulates rocks and punches with its big, rocky hands to defend itself and attack.

BOULDERS
They're big round rocks that roll around a particular spot. Mario can destroy them with a spin attack on their red spot.

BOWSER
He's become huge due to the power of the Grand Stars. He attacks with fireballs and punches.

BOWSER JR.
Bowser's son, who tries to help his father by staging attacks on Mario.

BUGABOOM
A huge Mandibug that flies around and drops bombs.

BULLET BILL
They're fired from Bill Blasters. After flying awhile, they explode.

CHEEP CHEEP
They swim back and forth on the surface of the water but don't attack.

CHIBI CHOMP
Small Chain Chomps who roll around the same area. Defeat them by hitting them with a Stretch Plant.

CHOMP
They roll along a set course. Most normal attacks do not work on them.

CHOPPAH
They undulate along a set path in the air. Mario can't jump on them.

CLAMPY
It sits at the bottom of the sea, opening and closing. If it manages to chomp Mario, he takes damage.

CLUCKBOOM
These creatures fly around the sky dropping bombs.

COSMIC CLONE
Black, shadowlike enemies who follow Mario by imitating every move he makes.

CRABBER (CYAN)
When they see Mario, they run away. If Mario can defeat one, he gets a 1-Up Mushroom.

CRABBER (RED)
They come after Mario in a zigzag pattern. A spin jump onto their backs can defeat them.

DIGGA
They move by drilling through the surface of the ground, always along the same route.

DIGGA LEG
A huge robot. He moves across the round surface of the planet on his two huge legs.

DINO PIRANHA
When it spots Mario, it rushes after him. Its tail can be used against it.

DRY BONES
If Mario stomps on them, they shatter into pieces. After a while they form up again.

ELECTRIC PRESSURE
At given intervals, they fire electric balls of energy that chase Mario.

ELITE OCTOOMBA
Typically greener than the regular Octoomba, they shoot two projectiles at once.

FIERY DINO PIRANHA
A Dino Piranha Plant that is wreathed in flames. It shoots fireballs.

FIRE GOBBLEGUT
This Gobblegut is covered in flame that shoots off fireballs. His red bellyache bulges are his weakness.

FIRE SHOOTER
They shoot fireballs out of their nozzles at regular intervals.

FIZZLIT
They move by jumping, and when they land, they flatten and let off an electric attack.

FLAPTACK
If they see Mario they fly to get above him, then aim their spike toward him and attack.

FLIPBUG
A small bug that runs if Mario looks at it. They only attack when Mario is Bee Mario.

FLOATING MINES
These mines either float in space or are found underwater. If Mario touches one, he takes damage.

FLOMP
They're platforms that flip at regular intervals. If Mario is aboard one when they flip, he is thrown high into the air.

FUZZY

They move slowly along a specified route. Mario can defeat them with a Spin Drill.

GIANT GOOMBA

Before Mario can defeat these huge Goombas, he must do a spin attack to knock them out.

GIANT GRINGILL

Defeat these huge Gringills by hitting them with a shell, and you'll get a 1-Up.

GIANT KOOPA TROOPA

A large version of the Koopa Troopa. Normal attacks won't affect them, but Mario can defeat them with a Spin Drill.

GIANT PARAGOOMBA

A large version of the Paragoomba. They fly through the sky, and a spin jump will knock them unconscious.

GIANT PIRANHA PLANT

First a few clouds of dust appear, then the Piranha Plant shows its face by rushing up out of the ground.

GIANT THWOMP

A large version of the Thwomp. They're very wide, so timing Mario's dash under them is tricky.

GIANT WIGGLER

A large version of the Wiggler. Mario can get on and ride them, but he can't defeat them.

GLAMDOZER

She chases Mario shooting fireballs. She also can go to the underside of her platform.

GOBBLEGUT

He attacks by biting with his huge mouth. Those big red bellyache bulges are his only weak spot.

GOLD GUMMIT

They appear in particular minigames. If Mario defeats them, he gets fifty points.

GOLDEN CHOMP

A gold-colored Chain Chomp. If Mario can get him into a particular hole, a Power Star appears.

GOOMBA

When they see Mario, they charge. They can produce different kinds of items depending on how Mario defeats them.

GOOMBEETLE

Goombas wearing hardhats. Jumping on them won't defeat them.

GRINGILL

Several kinds are found swimming in the water. One type shoots out of holes in the rock and then retreats.

GROUND URCHIN

These are Urchins that live aboveground. A fireball will defeat them.

GUMMIT

They appear in special minigames. If Mario defeats one, you get ten points.

HAMMER BRO

If Mario gets close, they throw their hammers. They move by taking big jumps.

JACK O'GOOMBA

They walk along leaving blue flames behind them. A spin attack reverts them to regular Goombas.

JAMMYFISH

They swim only in certain places underwater and do not come to attack.

JELLYFISH

They're giant jellyfish that live underwater and give off electric shocks.

KING KALIENTE

He lives in the middle of the lava and attacks by sending coconuts and fireballs flying.

KING LAKITU

He rides a huge cloud, sometimes throwing Spiny Eggs and sometimes shooting lightning.

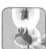

KLEPTOAD

They steal Silver Stars and coins, then run off.

KOOPA TROOPA

They walk around a particular spot. If you attack them, they turn into Koopa Shells.

LAKITU

They fly around throwing Spiny Eggs. If Mario attacks their clouds, Lakitus fall to the ground.

LAVA BUBBLE

These balls of fire come flying out of the lava at regular intervals.

LAVA BUBBLE (BLUE)

The blue variety also comes flying out of the lava, bouncing while chasing Mario. Eventually they vanish.

LI'L BRR

They give off an icy cloud. When they see Mario, they close in on him.

LI'L CINDER

Their bodies are wreathed in flames. Their fire can be put out with a spin attack.

MAGIKOOPA

They move by teleporting and attack by shooting magic that makes fireballs or enemies appear.

MAGMAARGH

They come out of the lava with their big mouths open, move through the lava for a little while, then sink beneath again.

MAGMAW

They move along the lava, sticking their heads out. They're somewhat smaller than Magmaarghs.

MAJOR BURROWS

He chases Mario by moving underground. If Mario does a ground pound close by, he comes to the surface.

MANDIBUG

They're usually waiting on paths. When they see Mario, they charge straight for him.

MANDIBUG STACK

Young Mandibugs riding on their parent as they attack. A ground pound on the back will defeat each one.

MATTERMOUTH

They move while chowing down on pathways, creating holes in the floor for a short while.

MEGAHAMMER

A giant-sized robot piloted by Bowser Jr., it attacks with its hammers and shoots out Bullet Bills.

MICRO GOOMBA

Goombas with shorter legs than normal. Mario can defeat them with a spin attack.

MINI MECHAKOOPA

They follow Mario and attack by breathing fire. Mario can knock them out with a spin attack.

 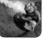

MOBILE SENTRY BEAM

When Mario gets close, they unleash a laser beam at him and just keep firing.

OCTOBOO

The ghosts of Octoombas. They follow a set route. With a spin attack, they turn translucent.

OCTOGUY

They act as if they're running from Mario, but once they get a certain distance away, they turn and shoot!

OCTOOMBA

When Mario comes close, they shoot a projectile at him. Some just run around in a small, limited area.

OCTOPUS

They switch between shooting fireballs and coconuts at Mario.

PARAGOOMBA

They fly through the air. If Mario does a spin attack on them, they lose their wings and become regular Goombas.

PEEWEE PIRANHA

It chases after Mario. Its eggshell-covered rear end is its weak spot.

PINHEAD

They're enemies in the shape of bowling pins. You can bowl them over as Rock Mario.

PIRANHA PLANT

If they see Mario, they stretch out their necks and try to bite him.

POKEY HEAD

As Mario approaches, the heads of Pokeys rise out of the ground and bounce after Mario.

PRICKLY PIRANHA PLANT

Giant Piranha Plants. When Mario gets close, they slam their heads on the ground.

PRINCE PIKANTE

He runs around in a tank that's loaded with cannons, which shoot fireballs and coconuts.

PUPDOZER

They walk along a set route. They've got spikes on their backs so their weak spot is their bellies.

RHOMP

These are stone pillars that roll down inclines. If Mario is crushed by one, you lose a life.

RING BEAM

They release an expanding circular beam at regular intervals. Mario cannot defeat them.

ROLLODILLO

He charges at high speed by rolling. His rear end is his weak spot.

SENTRY BEAM

They release a circular laser beam. If Mario gets on top, its springy head sends him high into the air.

SILVER CHOMP

They're silver-colored Chomps that roll and chase after Mario.

SKEETER

They move by skimming along the surface of the water. If they get close to Mario, they charge.

SLURPLE

If Mario gets close, they stick to him and he keeps taking damage at regular intervals.

SMEECH

They give Yoshi a big smooch, preventing him from sticking out his tongue.

SNOODLE

They live on the sea floor. If Mario gets close, they stretch their bodies and try to bash him.

SORBETTI

He is an enemy snowman who rolls around chasing after Mario. His red nose is his weak spot.

SPANGLER

They hang from a thread and swing their bodies. A spin attack will knock them unconscious.

SPIKY GUMMIT

They're found in a special minigame. If Mario touches one, it blows him away.

SPIKY TOPMAN

They spin and try to crash into Mario. If they touch him, he's sent flying.

SPINY

Mario's regular attacks don't affect them, but a spin attack will turn them upside down.

SPINY CHEEP CHEEP

It puffs up its body and chases after Mario. After some time passes, they vanish.

SPINY EGG

Lakitu throws them. If Yoshi eats one, he can spit it out as an attack.

SPINY HERMITS

They move slowly along the seafloor. Mario cannot defeat them.

SPINY PIRANHA PLANT

They attack by slamming their heads against the ground. Mario can't jump on them because of their spines.

SPINY STRETCH PLANT

They're plants with thorny heads. If Mario gets close, they stretch out to attack.

SPOING

These spider-like creatures just bounce in the same place. They don't attack.

SPRING TOPMAN

These are Topmen with springs attached to their heads. If Mario gets on, they send him flying.

SQUIZZARD

He lives in quicksand, and he shoots balls of sand to attack. His open mouth is his weak spot.

STARBAG

When they're invisible, Mario sees only their footprints. If Mario follows their footprints and does a spin attack, they become visible.

SWAPHOPPERS

There's a spike on top, but switch the gravity and their legs change orientation.

THWOMP

Heavy blocks that keep dropping and rising again. If one crushes Mario, you lose a life.

TOPMINI

A small-size Topman. A spin attack will defeat them.

TOX BOX

These cubes of rock roll along passageways. Avoid getting crushed by using the recessed part of their mouths.

TWIRLIP

They open their petals and do a high-speed spin attack. Mario can stomp on the center of their opened flower.

UNDERGRUNT

They dig routes underground. A ground pound will bring them to the surface.

UNDERGRUNT GUNNERS

Their vehicles are equipped with a cannon that fires cannonballs or Bullet Bills.

URCHIN

Their bodies are covered in spines. If they see Mario, they go rolling toward him.

VENUS FLOWER TRAPS

Mario can land on them, but they soon try to eat and damage him.

WATER SHOOTER

They fire off spheres of water in a certain rhythm. Mario can get inside the water sphere and ride along with it.

WHIMP

They're sent out by the Whomp King. They chase Mario, and after they try to fall on him, they break to pieces.

WHOMP

They come right up to Mario, stop, and try to fall on him. Their backs are their weak spots.

WHOMP KING

A huge Whomp. When he falls, the ground shakes and Mario can't move for a little while.

WIGGLER

They move along a specified route. When they get angry, their speed increases.

WORLD

C O U R S E S

Move through the World Map, choose your Galaxy to visit, and try to collect Power Stars.

WORLD 1

This is the first world Mario and team encounter once the adventure starts.

SKY STATION GALAXY

Go from small planet to small planet. There are all kinds: round ones, cylindrical ones, and more.

PEEWEE PIRANHA'S TEMPER TANTRUM

Move along with advice from the Lumas. Mario battles the baby Dino Piranha Plant, Peewee Piranha.

STORMING THE SKY FLEET

Use Stretch Plants to defeat enemies and find the locked-up Power Star.

PEEWEE PIRANHA'S SPEED RUN

Battle Peewee Piranha again, but on a time crunch! Find the Plus-10 clocks to stretch the time limit.

YOSHI STAR GALAXY

Green, hilly country with a lot of Yoshi fruits. This is where Mario joins with his brave partner, Yoshi!

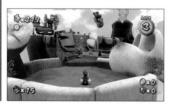

SADDLE UP WITH YOSHI

Yoshi's being held captive by a Magikoopa! Rescue him in order to move forward.

SPINY CONTROL

Team up with Yoshi to rescue a bunch of Lumas. Finally, Mario battles King Lakitu.

SPINY RAINBOW ROMP

Use the Rainbow Star to defeat all thirty Spinies within the time limit.

SPIN-DIG GALAXY

Most of the planets here are made out of dirt. The Spin Drill is a big advantage!

DIGGA-LEG'S PLANET

Use the Spin Drill to move forward. Mario does battle with Digga-Leg.

SILVER STARS DOWN DEEP

There are five Silver Stars found in underground rooms. Use the Spin Drill to find them.

DIGGA-LEG'S DAREDEVIL RUN

Mario's only got one point in his life meter in this rematch with Digga-Leg. Defeat it without taking any damage!

FLUFFY BLUFF GALAXY

A galaxy with very tall, steep, grass-topped stone mountains and clouds. This is the first appearance of the Cloud Flower.

SEARCH FOR THE TOAD BRIGADE CAPTAIN

Become Cloud Mario and hop from cloud to cloud. Near the top, Mario will find the Toad Brigade Captain.

THE CHIMP'S STOMP CHALLENGE

The Chimp challenges Mario to earn over 10,000 points by stomping on enemies. Aim for the high score!

EVERY PLANET HAS ITS PRICE

Go from the Hungry Luma to the triangular tower. To climb it, Cloud Mario will need to use every trick in his book.

FLIP-SWAP GALAXY

A planet with a lot of Flip-Swap Panels arranged in a cube shape. Electric fences and Chomps block Mario's way.

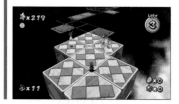

THINK BEFORE YOU SHAKE

Be sure of Mario's spin-jump timing as he crosses the Flip-Swap Panels.

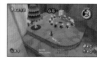

PURPLE COIN FLIP 'N' SPRINT

Gather up all the Purple Coins on the Flip-Swap Panels.

RIGHTSIDE DOWN GALAXY

Most of this is side-scrolling action as Mario moves from gravity zone to gravity zone.

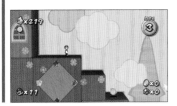

BREAKING THE LAWS OF GRAVITY

Use the different gravity areas to help Mario make his way. There's a Thwomp-filled region about halfway through.

THE GREAT CRATE INCINERATOR

Mario takes up the request of a Gearmo, and as Fire Mario, he helps with the cleanup.

BOWSER JR.'S FIERY FLOTILLA

This is a fortress with Bowser Jr. waiting at the end. There's a round planet with a lot of Fire Bars, too.

GOBBLEGUT'S ACHING BELLY

Mario enters through the fortress gates. A battle with Gobblegut awaits at the end.

FIERY FLOTILLA SPEED RUN

Mario has to defeat Gobblegut with a time limit of two minutes. There are no Plus-10 clocks here.

WORLD 2

A Grand Star flings Mario into a new world. The paths are divided into a top and a bottom route.

PUZZLE PLANK GALAXY

These are a series of planets made of wood, with circular saws that cut away Mario's platforms.

THE PUZZLING PICTURE BLOCK

Mario makes his way across the planks. Once the puzzle is solved, he battles the Mandibug Stack.

PURPLE COIN SHADOW VAULT

Gather up all the Purple Coins in the room while avoiding Mario's Cosmic Clones.

BUGABOOM'S BACK

The Hungry Luma leads Mario to a new planet with a giant tree. There, Mario battles Bugaboom.

HIGHTAIL FALLS GALAXY

These planets have impossibly steep slopes. Mario saddles up Yoshi, then powers him up to Dash Yoshi as he tries to make his way through.

HOT-STEPPING DASH PEPPER

Dash Yoshi is able to climb the steep inclines. Try not to hit the obstacles.

HIGHTAIL FALLS SPEED RUN

Ride Dash Yoshi to the end before time runs out. Mario's paths aren't as wide this time.

SILVER STARS IN HIGHTAIL FALLS

Kleptoads have stolen the Silver Stars and are running away with them. Grab them!

BOULDER BOWL GALAXY

A very rocky set of planets. Mario can roll his way through by using the Rock Mushroom.

ROCK AND ROLLODILLO

Roll along as Rock Mario, breaking obstacles to pieces. In the end, he battles Rollodillo.

ROLLING CRABBER ROMP

Use Rock Mario to take down all the Crabbers that have infested the small planet.

C'MERE, GOOMBA

Accept the Gearmo's job of luring its favorite thing, a Goomba, into its Goomba trap.

COSMIC COVE GALAXY

A quiet sandy beach cove. There are penguins busy practicing their swimming skills here.

TWIN FALLS HIDEAWAY

The two waterfalls that face each other hold a secret. If Mario can freeze the surface of the water, he can climb up.

EXPLORING THE COSMIC CAVERN

Mario needs to go through the underwater caves to rescue the captured Luma held there.

CATCH THAT STAR BUNNY

Play tag with a bunny on a small, round planet. When it's frozen, Mario can overtake the bunny by skating.

WILD GLIDE GALAXY

Mario and Fluzzard go on a walk across the sky on this tree-filled jungle planet.

⭐ FLUZZARD'S FIRST FLIGHT

Let Fluzzard take Mario on a ride through the jungle, avoiding obstacles as they go.

⭐ JUNGLE FLUZZARD RACE

Mario and Fluzzard race against the Jibberjays. Get to the goal before the Black Jibberjay can!

HONEYBLOOM GALAXY

It's a side-scrolling adventure though a heaven of flowers. Fly around as Bee Mario.

⭐ BUMBLE BEGINNINGS

Mario makes his way to the very top of the mountain. There are places only Bee Mario can go.

⭐ THE SECRET WALL JUMP

There's a secret space there, and Mario can only get to it by wall-jumping between two facing walls.

BOWSER'S LAVA LAIR

Odd traps and mechanisms are in place on this planet, where all the land is surrounded by lava.

⭐ BOWSER'S BIG LAVA POWER PARTY

Mario traverses the lava using platforms, finally challenging Bowser at the end of it.

⭐ LAVA LAIR SPEED RUN

Time is limited, so be sure to grab those Plus-10 Clocks!

WORLD 3

The key here is to transform Mario and Yoshi. Luigi arrives, too.

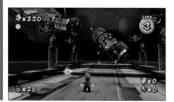

TALL TRUNK GALAXY

An enormous tree sets the stage for this planet as Mario climbs around the outside of the trunk and then inside it.

⭐ THE FLOTACIOUS BLIMP FRUIT

Turn Yoshi into Blimp Yoshi and take a midair trip up the tree. Mario must circle around the tree and go inside it.

⭐ TALL TRUNK'S BIG SLIDE

Slide down this massive trunk, the Whittles' sacred ground. If Mario is successful, he receives a Power Star.

⭐ TALL TRUNK'S PURPLE COIN SLIDE

A Gearmo dropped all his Purple Coins on the slide, and Mario has to slide to collect them all again.

CLOUDY COURT GALAXY

A garden area in the clouds. Huge musical instruments add color to the scenery.

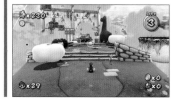

⭐ HEAD IN THE CLOUDS

Mario climbs onto clouds to go across the gardens. Here and there, he uses windmill power to move along.

⭐ THE SHADOW LINING

The Cosmic Clones are chasing Mario, so use the Space Junk to escape!

⭐ SILVER STARS IN THE PURPLE POND

Gather the stars above the purple swamp. If Mario falls in, you lose a life. Avoid the Cosmic Clones.

HAUNTY HALLS GALAXY

A creepy, dusky planet. Mario is held back by obstacles and paths that vanish and reappear.

⭐ A GLIMMER OF BULB BERRY

Become Bulb Yoshi, lighting up the otherwise unseen paths that lead deep into the mansion.

⭐ SNEAKING DOWN THE CREEPY CORRIDOR

Mario has to be careful of his footing on this long corridor. He has Boos big and small chasing him.

⭐ SPOOKY COSMIC CLONE CHASE

Cosmic Clones give chase as Mario ventures down narrow paths.

FREEZY FLAKE GALAXY

A planet covered in snow. Use the power-ups to figure out the snowy tricks.

⭐ BOWSER ON ICE

At the end of a snowy path is a Bowser sculpture surrounded by lava. Mario can use snowballs to make a path.

⭐ SORBETTI'S CHILLY RECEPTION

The snowstorm makes it hard to see the way through. A battle with Sorbetti awaits.

⭐ THE CHIMP'S SKATING CHALLENGE

The Chimp issues a challenge to take down Gummits and get a high score.

ROLLING MASTERPIECE GALAXY

A planet with brushes, rulers, palettes, and other art implements.

SILVER CHOMP GRUDGE MATCH

Get on the Star Ball and figure out the tricks and puzzles. Mario battles the Silver Chomp.

MASTERPIECE SPEED RUN

There isn't much time to roll to the goal. Watch out for the walking Bob-ombs on the greens.

BEAT BLOCK GALAXY

The Beat Blocks are all lined up and the platforms move to the beat.

STEP TO THE BEEP

Mario moves across the Beat Blocks, where he must avoid enemies to reach the pyramid.

SILVER STARS IN DOUBLE TIME

The blocks change places twice as fast, and Mario must collect the five Silver Stars when he reaches the pyramid.

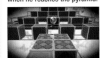

BOWSER JR.'S FEARSOME FLEET

Mario and Yoshi are constantly bombarded with Bullet Bills.

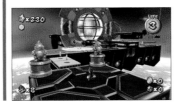

BOWSER JR.'S MIGHTY MEGAHAMMER

Mario and Yoshi try to avoid a barrage of Bullet Bills until the battle with Megahammer.

MEGAHAMMER'S DAREDEVIL BASH

Mario has a rematch with Megahammer, but this time with only one point on his life meter.

WORLD 4

This is a strange world filled with huge enemies and gravity changes.

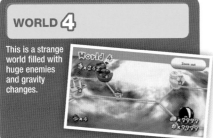

SUPERMASSIVE GALAXY

The enemies, blocks, and everything else are huge on this planet!

HUGE TROUBLE WITH BIG WIGGLERS

Avoid the Big Goombas and Big Wigglers as Mario makes his way across the huge platforms.

BIG WIGGLERS SPEED RUN

It's the same as the world's first mission, but with a time limit. There are places where Mario can take shortcuts.

IN FULL BLOOM

A plant blooms on Mario's route, taking him to a strange little world. What happens if the whole planet blooms?

FLIPSVILLE GALAXY

Using tricks and items, Mario moves from the upside to the flipside and back again to head toward the end.

FLIP-FLOPPING IN FLIPSVILLE

Rotating Fences create a path for Mario to advance. A battle with Glamdozer awaits.

FLIPSVILLE'S NEW DIGS

Use the drills to get from one side to the flipside and back. Gravity changes direction in the rooms.

PURPLE COIN SPIN SPEED RUN

Have Mario use the drill inside rooms where the gravity changes and gather up all the Purple Coins.

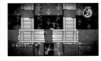

STARSHINE BEACH GALAXY

A Pianta-inhabited beach floating in space.

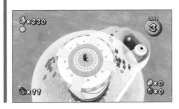

SURF, SAND, AND SILVER STARS

Silver Stars are scattered about in the sky and sea. Yoshi can help Mario collect them.

CLIMBING THE CLOUDY TOWER

First find Cloudy Tower, then become Cloud Mario and move to the top of it.

PURPLE COIN BEACH DASH

Use Dash Yoshi to collect all the Purple Coins found on the water's surface.

CHOMPWORKS GALAXY

A strange factory that churns out many types of Chomp, one after another.

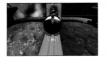
WHERE THE CHOMPS ARE MADE OF GOLD

Make sure a Chomp falls into the correct pit. Mario finds a golden Chomp at the end of it.

SPRING INTO THE CHOMPWORKS

Use Spring Mario to avoid the Chomps and advance toward the very top of the factory.

COSMIC CLONES IN THE CHOMPWORKS

Avoid the Cosmic Clones as you try to get the Golden Chomp into the correct pit.

SWEET MYSTERY GALAXY

These planets have footholds that look like sweets! Some platforms are invisible, though.

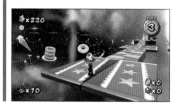

BULB BERRY'S MYSTERIOUS GLOW

Bulb Yoshi needs to light up those unseen sweets to use as platforms.

BULB BERRY'S PURPLE COIN GLOW

The Purple Coins are on those unseen platforms. Collect them and make sure the light never goes out completely!

HONEYHOP GALAXY

This is a planet of cliffs, inhabited by bees. Only Bee Mario can explore it.

THE SWEETEST SILVER STARS

Gather up the Silver Stars scattered around the Honey Queen and her village of honeybees.

THE CHIMP'S SCORE CHALLENGE

The Chimp offers Mario a challenge! Defeat the enemies and aim for the required score.

BOWSER'S GRAVITY GAUNTLET

Lava surrounds Bowser's castle. Gravity changes a lot as Mario moves along.

BREAKING INTO BOWSER'S CASTLE

Overcome the drastic changes in gravity to reach the deepest part of the castle. Bowser lurks at the end.

GRAVITY STAR SPEED RUN

Have Mario make his way to the deepest part of the castle within the time limit. You'll need those Plus-10 Clocks.

WORLD 5

A world of ordeals. After going through the pipe, you have five galaxies to choose from.

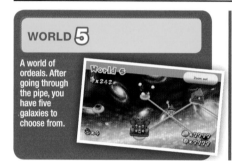

SPACE STORM GALAXY

A fortress full of electric shock hazards. Use the Pull Stars to move Mario along.

FOLLOW ME, BOB-OMB

Use jumps and Pull Stars, and then lead a Bob-omb to clear a path for Mario.

TO THE TOP OF TOPMAN'S TOWER

Use the Slow Switch to slow down both mechanisms and enemies and reach the top of the tower.

C'MERE, TOPMAN

Accept Gearmo's challenge to lure a Spiky Topman into his net.

SLIPSAND GALAXY

A set of planets where the sands keep on flowing. Every so often, Mario can use the flow to his advantage.

SQUIZZARD'S SANDY SINKHOLE

Slide down the shifting sands to do battle with Squizzard.

SAILING THE SANDY SEAS

Mario must use a Launch Star and a Sand Sailer to make his way along.

SQUIZZARD'S DAREDEVIL RUN

Mario only has one life in this rematch with Squizzard, so he will have to avoid every attack.

SHIVERBURN GALAXY

A weird galaxy where hot lava and freezing ice coexist.

PRINCE PIKANTE'S PEPPERY MOOD

Mario can change the lava to ice to skate on it. A battle with Prince Pikante awaits.

OCTO-ARMY ICY RAINBOW ROMP

Defeat all the Octoombas and Octoguys on the ice before time runs out.

THE CHIMP'S ULTIMATE SKATING CHALLENGE

The Chimp offers Mario a challenge: skate to defeat the Gummits and try for the high score!

BOO MOON GALAXY

This planet is a dusky maze filled with lots of Boos above the swamp.

SILVER STARS POP-UP

Mario reaches an area that acts like a pop-up book. There are Silver Stars just above the pop-ups.

HAUNTING THE HOWLING TOWER

Become Boo Mario to slip through the iron grills, then avoid enemies to get to the very top.

THE STAR IN THE SINKING SWAMP

Boarding the Snake Blocks will take Mario to the purple swamp, where the Power Star is hidden.

UPSIDE DIZZY GALAXY

Walk on the ceiling, walk on the walls. The gravity shifts so much, it's dizzying.

A WALK ON THE WEIRD SIDE

Use the different gravities to move upward. One section in the second half changes gravity at regular intervals.

BURNING UPSIDE DIZZY

This is another place where Mario cleans up wooden boxes with fireballs. This time there are even more boxes.

FLEET GLIDE GALAXY

Mario flies with Fluzzard. This is a galaxy of lava and fortresses.

FLUZZARD'S WILD BATTLE-FIELD GLIDE

Have Mario grab onto Fluzzard. Try to avoid the many enemies, obstacles, and traps in Mario's way.

FASTEST FEATHERS IN THE GALAXY

Mario and Fluzzard race against Black Jibberjay to see who is fastest.

BOWSER JR.'S BOOM BUNKER

Use a series of cannons to cross the moving platforms.

BOWSER JR.'S BOOMSDAY MACHINE

Mario can use cannons to go forward, where Bowser Jr. waits inside his Boomsday Machine for a final showdown.

BOOMSDAY MACHINE DAREDEVIL RUN

Mario battles the Boomsday Machine without taking a single hit. He can't lose his concentration for a second!

WORLD 6

The final world, where Bowser waits at the end. Choose between two routes.

MELTY MONSTER GALAXY

Magmaarghs and Magmaws just keep chasing after Mario on these broiling-hot planets.

THE MAGNIFICENT MAGMA SEA

Get through the lava region using Pull Stars and tornados.

A STROLL DOWN ROLLING LANE

Be careful! After becoming Rock Mario, you won't be able to stop on the narrow paths.

THE CHIMP'S BOWLING CHALLENGE

The Chimp challenges Rock Mario to a mean series of bowling games.

CLOCKWORK RUINS GALAXY

These ancient ruins with rotating platforms make for tricky running.

TIME FOR ADVENTURE

Mario must tread carefully on these millstones and mechanisms in order to make his way deep into the ruins.

THE ADVENTURE OF THE PURPLE COINS

Purple Coins are scattered over the ruins. Gather them up amid the Rotating Platforms.

THE LEDGE HAMMER TRAP

There are hammers hitting at high speed. Use a Blue Switch to move forward.

THROWBACK GALAXY

Remember the good times on this *Super Mario 64*-themed planet! Bob-omb Buddies make an appearance, too.

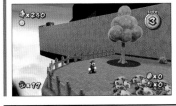

RETURN OF THE WHOMP KING

Mario climbs to the top of the castle to battle a Whomp. Once that one is defeated, the Whomp King appears.

SILVER STARS IN THE WHOMP FORTRESS

There are Silver Stars scattered all over the fortress. Only Cloud Mario can collect them all.

WHOMP SILVER STAR SPEED RUN

Gather Silver Stars, being mindful of the time limit. Cloud Mario can use some shortcuts.

BATTLE BELT GALAXY

A lava planet, ice planet, underwater planet, and many more. There are all sorts of tiny planets where your enemies await.

MINI-PLANET MEGA-RUN

Mario must defeat all enemies on every planet to move on. Each planet requires different strategies.

MINI-PLANET DAREDEVIL RUN

Mario must defeat the enemies on each of the different planets, but this time with only a single hit point.

SNACKTIME FOR GOBBLEGUT

After feeding a Hungry Luma, a new route opens up—but first, Mario must battle a Fiery Gobblegut.

FLASH BLACK GALAXY

A set of planets wreathed in darkness. At regular intervals a flash of light illuminates the floor.

JUMPING AROUND IN THE DARK

Mario saddles up Yoshi for a trip through a pitch-black maze to collect the Silver Stars.

DARK OCTO-ARMY ROMP

There are Octoombas lined up on your pitch-black path. Eliminate them all before time runs out.

SLIMY SPRING GALAXY

Mario finds himself in a long, deep, underground lake. He can use the Koopa Shell to swim through the water passages.

THE DEEP SHELL WELL

Mario can use a shell to go through the underwater passages.

THE CHIMP'S COIN CHALLENGE

The Chimp challenges Mario to beat a certain score. Collect coins and defeat enemies to gain points.

BOWSER'S GALAXY GENERATOR

Bowser's empire awaits Mario, as does the final battle that will determine the fate of the universe.

BOWSER'S FORTIFIED FORTRESS

Mario and Yoshi must use various power-ups to get through Bowser's empire and face the final battle.

BOWSER'S BIG BAD SPEED RUN

Rush to the deepest part of the empire. Mario will need those Plus-10 Clocks along the way.

WORLD S

Once you have cleared the game, Mario can go to some special galaxies. Some of these may feel familiar.

MARIO SQUARED GALAXY

This planet is composed of Flipswitch Panels that make up an 8-bit image of Mario. The opposite side looks like Luigi.

MAKE MARIO A STAR

Make sure Mario switches all those Flipswitch Panels as he avoids enemy attacks.

LUIGI'S PURPLE COIN CHAOS

Collect Purple Coins on the 8-bit image of Luigi. Be sure to run from the Cosmic Clones.

ROLLING COASTER GALAXY

Have Mario board the Star Ball and roll down the Rainbow Road.

THE RAINBOW ROAD ROLL

Roll the Star Ball down the Rainbow Road, making for the goal. Watch out for Bob-omb attacks.

PURPLE COINS ON THE RAINBOW ROAD

Roll the Star Ball again while collecting Purple Coins, all within the time limit.

TWISTY TRIALS GALAXY

This galaxy is based on a secret course found in *Super Mario Sunshine*.

SPINNING AND SPINNING AND SPINNING

Mario can navigate the rotating wooden planks with help from the Cloud Flowers.

TURNING TURNING DOUBLE TIME

The wooden planks spin faster here. Yoshi can help Mario advance.

STONE CYCLONE GALAXY

A very dangerous galaxy filled with rolling Tox Boxes. Mario must avoid being crushed.

SILVER STARS ON THE CYCLONE

Mario can use the Blue Switches to slow down the Tox Boxes while collecting Silver Stars.

TOX BOX SPEED RUN

Mario doesn't have Blue Switches this time—Plus-10 Clocks must be collected as he dashes to his goal.

BOSS BLITZ GALAXY

This is a gauntlet of boss characters from *Super Mario Galaxy*. Beat them all to move on to the next galaxy!

THROWBACK THROWDOWN

Mario must defeat five different enemies, including Dino Piranha and Bouldergeist, to make it through to the end.

THROWBACK THROWDOWN SPEED RUN

Mario must defeat all the old bosses, but this time with a time limit of only five minutes.

FLIP-OUT GALAXY

A planet with huge Reversible Walls. Retractable spike floors slow down Mario's progress.

WICKED WALL JUMPS

Red and Blue Blocks help Mario on his way. The key on this course is well-timed spins.

COSMIC CLONE WALL JUMPERS

Mario makes his way to the top of the wall while running from the Cosmic Clones.

GRANDMASTER GALAXY

This galaxy doesn't appear until all the other Power Stars have been collected.

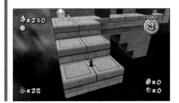

THE ULTIMATE TEST

This is the hardest course! Mario will have to use Yoshi and some power-ups to clear it.

THE PERFECT RUN

It's the ultimate test, but this time with only one hit point. Rosalina is waiting on the final planet.

ITEMS & OBSTACLES

Traps and other things you'll find in each course. It may look similar to *Super Mario Galaxy*, but this is a whole new adventure and it brings some surprises!

? BLOCK
When Mario hits one from below, coins or Star Bits appear.

? COIN
When Mario gets them, they can become Star Bits, coins, or musical notes.

1-UP MUSHROOM
Grab these to earn Mario extra lives.

BALLOON
When Mario touches one, it will burst and release Star Bits.

BEAT BLOCK
These blocks vanish and reappear to the rhythm of the background music.

BEE MUSHROOM
A power-up that turns Mario into Bee Mario.

BLACK HOLE
If Mario falls, he gets sucked into one and you lose a life.

BLIMP FRUIT
When Yoshi eats one, he becomes Blimp Yoshi.

BLOCK
Mario can hit these from below or break them with a spin to sometimes reveal coins.

BLUE SWITCH
When switched on, they slow the movements of enemies and mechanisms for a while.

BOO MUSHROOM
These power-ups change Mario into Boo Mario.

BOWSER ICE STATUE
Some hide items and others block Mario's path.

BRONZE STAR
If you get help from the Cosmic Spirit, and she finishes the course for you, you get a Bronze Star.

BUBBLE
If Mario enters the water, he's shot along inside the bubble. A spin will get him out of it.

BULB BERRY
When Yoshi eats these, he's powered up to Bulb Yoshi.

CANNON
Take aim with the Wii Remote and fire. It can even send Mario to distant planets.

CANNON TARGET
If you shoot the cannon at the bullseye, you receive a 1-Up.

CHANCE CUBE
Roll them and receive the item on the side facing up. Some may also make enemies appear.

CHECKPOINT FLAG
If you touch the flag and lose a life afterward, you will start again from it.

CLOUD
Normally Mario can't use these, but when he's Cloud Mario or Bee Mario, he can treat them as platforms.

CLOUD FLOWER
These can power up Mario into Cloud Mario.

COCONUT/ WATERMELON
Under certain conditions, coconuts become watermelons.

COIN
One coin restores one slice on Mario's health meter. Bring 100 back to the starship for a 1-Up.

COIN SPOT
These are coins embedded in the ground. They appear if you hit them with Star Bits.

COMET MEDAL
Collect Comet Medals to make special Prankster Comets appear. There is one in every galaxy.

COMET MEDAL GATE
If Mario can fly Fluzzard through all these gates, he receives a Comet Medal.

CRYSTAL
Mario can break them with spin attacks. Once broken, they reveal items or Power Stars.

CYMBAL
If Mario does a ground pound on it, it crashes and Star Bits appear.

DASH PEPPER
When Yoshi eats one, he powers up to Dash Yoshi.

DASH RING
They're found underwater. If Mario swims through them, he gets a speed boost.

DRUM TRAMPOLINE
It's a trampoline in the shape of a snare drum.

ELECTRIC FENCE
It's a trap that can move or stay, blocking Mario's path. If he touches it, he takes damage.

ELEVATOR
On these platforms Mario can go up, down, right or left. Most start moving when Mario gets on.

FIRE BAR
These bars of fireballs rotate around a block. If Mario touches one, he takes damage.

FIRE FLOWER
These power Mario up into Fire Mario for a limited time.

FLASHING LIFT
These platforms vanish and appear at regular intervals. They turn blue just before they vanish.

FLIP-SWAP PANEL
These panels flip when Mario does a spin.

FLIPSWITCH PANEL
When Mario walks on a panel, it changes color. Change all the panels and something happens.

FLOATY FLUFF
If Mario grabs on, he can float slowly downward. If he spins in the air, he can gain some altitude.

FLOWER GRAPPLE
Yoshi can grab these with his tongue and swing to someplace far away.

FLYING ? BLOCK
These ? Blocks with wings can move Mario across the sky.

GIANT YOSHI FRUIT
When Yoshi picks the fruit, it becomes a Super Launch Ring.

GLASS CAGE
These can be broken by explosions from Bullet Bills or by Yoshi spitting a Spiny Egg at them.

GRAND STAR
They appear as the last part of each world. When Mario gets one, he's cleared the galaxy.

GRATE
Metal grates that send you to the flipside when you do a ground pound.

GRAVITY SWITCH
If Mario hits the arrow with a spin attack, it changes the direction of gravity.

GREEN SHELL
Throw these to break open chests or attack enemies. Swim with one for a speed boost.

GREEN STAR
These are special stars that appear after you have collected 120 Power Stars.

GRINDER
When Mario approaches, they start to turn, cutting away a portion of Mario's wooden floor.

GROUND-POUND FLOOR
A ground pound moves the floor or platform downward.

GROUND-POUND SWITCH
Get on top of this switch, then ground-pound over it to activate it.

HANDLE
A platform appears for a limited time when Yoshi pulls it out with his tongue, using the handle.

HONEYCOMB WALL
Bee Mario can land on one to move forward.

ICE BLOCK
Blocks that can only be destroyed by fireballs.

ICE CRYSTAL
If these fall on lava, they can be used as platforms. They melt eventually.

ICE FLOOR
It's hard for Mario to put the brakes on when he's on an Ice Floor. If he spins, he can skate as he goes.

IRON GRATE
Only translucent Boo Mario can pass through these.

JUMP FRUIT
Even the slightest touch will make Mario bounce off them, making it impossible to land on them.

KEY
When Mario grabs these, a nearby door opens or a mechanism starts to move.

LAUNCH STAR
A star that allows Mario to launch to another planet by spinning.

LAVA
If Mario touches it, he's lit on fire, making him jump high into the air and take damage.

LAVA GEYSER
Pillars or balls of flame that are blown out of lava. Mario takes damage if one touches him.

LEAF RAFT
Mario can steer these rafts by walking to different ends.

LEDGE HAMMER
These huge hammers pound the walls and ground. If Mario gets crushed, you lose a life.

LEVER SWITCH
Spin near the switch to change its position and activate a mechanism.

LIFE MUSHROOM
It increases Mario's health meter to six, but the effect vanishes if the meter drops to three or lower.

METAL ROD
Mario can get a high jump out of these by grabbing on, building up momentum, then releasing.

METEOR
Balls of rock that come crashing from the sky. If Mario touches one, he takes damage.

METEORITE
These float in space and a ground pound will send them flying.

MILLSTONE
These huge rock wheels roll down an incline. If Mario gets crushed, you lose a life.

PICTURE BLOCK
Move the tiles with a ground pound. Once the picture is completed, the Mandibug Stack appears.

PIPE
When you enter a pipe, it will warp you to another location.

PLUS-10 CLOCK
Appearing on timed missions, they extend the time limit on the counter by ten seconds.

POISONED WATER
It slows Mario down, so he can't dash, and it lowers his jumps.

POLE
When Mario gets to the top, he does a handstand and can jump from there.

POWER STAR
When Mario gets one, he's cleared the mission. With enough Power Stars, he can go on to the next galaxy.

PULL STAR
Use your pointer to grab it and pull Mario toward the star.

PURPLE COIN
They're found on certain missions. If Mario collects one hundred of them, a Power Star will appear.

QUICKSAND
If Mario gets into the sand, he is carried along with the current. Sometimes he can't go against the current.

RAINBOW NOTE
When Mario gathers them all within the time limit, a 1-Up Mushroom appears.

RAINBOW STAR
This is a power-up that turns Mario into Rainbow Mario for a short time.

RAMP
A type of floor used in minigames for Rock Mario. If he tries to enter it without rolling, it turns red.

RED AND BLUE BLOCKS
One color block extends and the other retracts when Mario does a spin.

ROCK MUSHROOM
These can power up Mario into Rock Mario.

SEESAW MOON
This crescent-moon-shaped platform will tilt according to Mario's weight.

SIGN BOARD
They appear during the game to give you hints.

SILVER STAR
If Mario gathers all five, a Power Star appears.

SINKING SWAMP
If Mario falls in, he sinks, and you lose a life.

SLING STAR
Mario spins to activate them. They can send Mario up high where he can find items.

SMALL ROCKS
When Mario kicks them, a coin comes out.

SNAKE BLOCKS
If Mario gets on, they start to move, always following a specific route.

SNOWBALL
Roll these and they grow bigger. Roll them onto lava, and Mario can walk on them for a short time.

SPACE JUNK
These weird platforms fly into place when Mario gets close.

SPIKED FLOOR
The spikes in these floors extend up and retract at regular intervals.

SPIN DRILL
Shake the Wii Remote to drill through the ground —even to the other side of a planet! You can also use it to defeat enemies.

SPIN ROCK /SPIN SHELL
If Mario spins within a circle of these, they turn into Star Bits.

SPRING MUSHROOM
Use one to power up to Spring Mario.

SPRINGBOARD
If Mario gets on, he is hurled up high. Use these when you need to move up to a very high place.

SPROUTLE VINE
Shake the Wii Remote near a vine to swing up it. When you reach the end, you can jump far away.

STAR BALL
Mario moves depending on how you tilt the Wii Remote. A Power Star appears at the goal.

STAR BALL HOLE
If Mario enters one while on a Star Ball, he jumps. The blue rings are your goal.

STAR BIT
They're scattered across the courses and can be used to defeat enemies.

STAR CHIP (YELLOW)
Collect all the Yellow Star Chips to reassemble a broken Launch Star.

STEEL CRATE
These wooden boxes can only be destroyed by a fireball.

STRETCH PLANT
Do a spin attack on it, and it can use the momentum to attack an enemy or open a treasure chest.

STUMP
When Mario does a ground pound on them, they can generate coins or Star Bits.

SWING
Mario can swing them back and forth to build up momentum for a jump.

TELEPORTER
Get on and spin, and Mario will be transported to a bonus stage to receive an item.

THORNY FLOWER
They can be found on land or in the air. If Mario touches them, he takes damage.

TIP NETWORK
TVs in some galaxies show the Tip Network. Talk to it to get tips on the next part of the course.

TORNADO
If Mario touches one, he gets sucked in, but if he spins, he gets thrown out and sent gliding through the air.

TRAMPOLINE
If Mario does a ground pound on them, he is sent flying high.

TREASURE CHEST
They hold items and other things hidden inside. Use a Green Shell to open them.

TREE
Mario can grab on and climb. You can change direction by going sideways around the tree.

WINDMILL
If Cloud Mario generates a cloud platform, the windmill's breeze can move it along.

WOODEN CRATE
It's possible to break them with a spin attack. Some have items inside.

YOSHI FRUIT
When Yoshi eats these, Star Bits appear. When he eats ten, you get a 1-Up.

YOSHI'S EGG
Spin attack it to release Yoshi.

AND MORE

MEMORABLE MOMENTS

Here we present some familiar scenes that are a bit different from the previous game.

THE STARSHIP MARIO LAUNCHES!

When Mario gets sent into space, he lands on a small planetoid spaceship that seems to be falling apart. With the help of Lubba and a Power Star, it gets a makeover into the *Starship Mario*, a spacecraft that looks just like Mario's head! Mario takes the wheel and heads into the universe. As the adventure continues, *Starship Mario* takes on new crew and passengers.

YOSHI'S HOUSE

The first adventure, Sky Station Galaxy, begins with a house that looks like Yoshi's home. A signboard says, "Hello! I'm out helping some friends right now. Sorry if I missed you!" This is a reference to *Super Mario World*. As it turns out, Yoshi is captured in the galaxy next door, the Yoshi Star Galaxy.

TRADE PLACES!

You meet Luigi again during your adventures in World 3. After that, whenever you see Luigi on a course and decide to talk to him, Mario can trade places with Luigi and you can play that course as Luigi. Luigi appears in some other scenarios as well.

GHOST LUIGI

If you clear a mission with Luigi, a ghost Luigi appears. Touch him, and he'll tell you about hidden items or some super play (a run that features amazing speed or skill). If you collect 9,999 coins or more, then you don't even need to clear the mission. Ghost Luigi will already be there.

THE PRANKSTER COMET

While Mario is adventuring in World 3, the Prankster Comet comes along to add a brand-new mission to a galaxy that's already cleared. The Prankster Comet comes more often when you've gathered up more Comet Medals.

COSTUME CHANGE!

The Banktoad on the *Starship Mario* goes through six different costume changes, depending on how many Star Bits you entrust to him.

LOQUACIOUS LUBBA

As Lubba is on the *Starship Mario*, his dialog with Mario changes depending on the amount of time you've played and the number of Star Bits you've collected.

SPOOKY SHADOWS

In the very first Shiverburn Galaxy, on the tains in the background, humanoid figures seem to be staring back at you.

CHEERLEADING CO-STAR

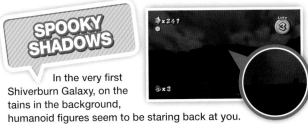

When a second player is playing the Co-Star Luma, the buttons on that player's Wii Remote can give off a range of different sounds.

PLAY DURING THE CREDITS!

Mario can still move around freely during the credit scroll section too. He isn't wearing his cap then. If you win, having collected 120 Power Stars, there's a Bee Mushroom there for you.

THE FURTHER ADVENTURES OF LUIGI

Once Mario has defeated Bowser at the end of World 6, Mario's Changing Room opens up the Starship. There, you can switch your player character to Luigi. If you're playing the game as Luigi, the title screen changes from Mario to Luigi.

BLAST FROM THE PAST

In the Throwback Galaxy in World 6, the "throwback" is a course made as an homage to Whomp's Fortress from *Super Mario 64*. The boss, King Whomp, is waiting at the end. Also, Twisty Trials Galaxy has a motif of the secret course found in Rico Harbor from *Super Mario Sunshine*. You'll also see an homage to *Super Mario Galaxy* featured in Mario Squared Galaxy and Stone Cyclone Galaxy.

THE GREEN STAR CHALLENGE!

After you've collected 120 stars and are heading toward the ending, a Green Prankster Comet passes through all the galaxies. Now you must find the Green Stars skillfully hidden within each course. Some event scenes turn their letterbox stripes green.

THE FINAL GALAXY

After you've collected all 120 Green Stars, the final galaxy in World S, Grandmaster Galaxy, appears.

THE ULTIMATE CHALLENGE!

After you've cleared the first mission in Grandmaster Galaxy (the Ultimate Test), you must collect all the Comet Medals. Plus, you must entrust Banktoad with 9,999 Star Bits before the second mission in the galaxy, the Perfect Run, appears. This is the hardest mission in the game—it's the same mission as The Ultimate Test, but now with only one hit point. The mission uses music from *Super Mario Galaxy*.

YOU'VE GOT MAIL!

Once you've cleared the second mission of the Grandmaster Galaxy (the Perfect Run), Rosalina is waiting for Mario on the final planet to express her thanks. If you have collected all 242 Power Stars in the game, Rosalina comes to visit him on *Starship Mario*.

A VISIT FROM ROSALINA

When you clear World 6 and head toward the ending, a message appears on your Wii Message Board. When you've collected all the Power Stars, you'll receive another message. Both have pictures attached and include the time you took to clear the missions.

HELPFUL HINTS & TECHNIQUES

If you clear certain special conditions, the following can also happen! Here are some suggestions to help you clear the entire game.

9,999 STAR BITS

If you collect 9,999 Star Bits, all the coconuts in the game turn into watermelons (just like the previous game). They look different but work the same way. If you've collected all those Star Bits but still haven't defeated Bowser in World 6, you will always see Luigi wanting to take over the mission.

THE CHANGING CROWN

As you complete portions of the game, the crown on your save file changes. If you've collected 120 Power Stars, it is a silver crown. With 240 Stars, it becomes gold. And with 242 Stars, it becomes platinum.

THE HISTORY OF SUPER MARIO
SERIES REMAKES

Over the years, there have been many remakes and portions of old games included for new systems. Here, we'll talk about some of them—but we're not including titles that were available for the Classic NES Series for the Game Boy Advance, on the Virtual Console for the Nintendo 3DS or Wii U, or those that are now downloadable titles.

SUPER MARIO ALL-STARS

SNES | AUGUST 1, 1993

This single SNES cartridge came packed with four remakes! The titles included *Super Mario Bros.*, *Super Mario Bros. 2*, *Super Mario Bros. 3*, and *Super Mario Bros.: The Lost Levels*. They featured prettier graphics, engaging background music, and a save-game function. The Japanese version of the game (called the *Super Mario Collection*) made a series of minor changes. For example, if you took damage as Fire Mario or Raccoon Mario, you reverted to Super Mario. These changes had already been made to the previous North American *Super Mario Bros. 3* release, and so were maintained for *Super Mario All-Stars*.

© 1993 NINTENDO

SUPER MARIO BROS. DELUXE

GAME BOY COLOR | MAY 1, 1999

This was a remake of the original *Super Mario Bros.* In Japan, this was only available for the Nintendo Power system—which was basically a flash memory cartridge—called a GB Memory Cartridge, onto which low-priced games could be downloaded. For the first time, a fan could enjoy the adventures of Mario in brilliant color on a handheld system. Aside from being able to play in original mode, other new modes were added. In Challenge Mode, a player had to race to the end while finding hidden items. In VS Mode, players raced each other using the Game Boy Color Link cable. As a bonus for fulfilling certain conditions, players were able to unlock *Super Mario Bros.: The Lost Levels* (up to W8-4).

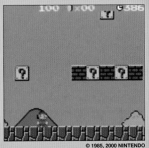

© 1985, 2000 NINTENDO

SUPER MARIO ADVANCE

GAME BOY ADVANCE | JUNE 11, 2001

This went on sale the same time as the release of the Game Boy Advance and featured a remake of *Super Mario Bros. 2*. The graphics were similar to those used in *Super Mario All-Stars*. Mario and other characters could now talk. Other new features included the ability to attain a higher score, new enemies, and easier play with a possible five lives. Plus, five "Ace Coins" were hidden in each course.

© 1983-2001 NINTENDO

SUPER MARIO WORLD: SUPER MARIO ADVANCE 2

GAME BOY ADVANCE | FEBRUARY 11, 2002

This was a remake of *Super Mario World*. Things worked quite differently if you played as Luigi instead of Mario. Luigi could jump higher, the fireballs he shot bounced differently, and he could fly higher with the cape than Mario. When he hit a 10-Coin Block, all the coins came out at once. It was easier now to meet up with different-colored Yoshis. When Luigi rode Yoshi and Yoshi ate enemies, he held the enemies in his mouth for attack, only swallowing them eventually.

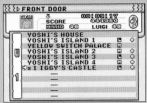

© 1983-2001 NINTENDO

SUPER MARIO ADVANCE 4: SUPER MARIO BROS. 3

GAME BOY ADVANCE | OCTOBER 21, 2003

This was a remake of *Super Mario Bros. 3*. Although some course layout elements were changed due to the screen configuration, it followed the *Super Mario All-Stars* model. If you used it in conjunction with the e-Reader (sold separately), it opened up many more game possibilities. Vegetables would appear on the course, you could become Cape Mario and fly, and enemies became stronger, among a whole host of other fun additions. If you had e-Reader cards, you could also play new original courses. The e-Reader came with two cards. Including Series 2, there were 100 different types of e-Reader cards.

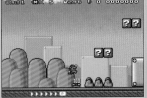

© 1983-2001 NINTENDO

SUPER MARIO 64 DS

NINTENDO DS | NOVEMBER 21, 2004

This remake of *Super Mario 64* went on sale the same time as the release of the Nintendo DS. Yoshi, Luigi, and Wario could take part in the adventure as player characters. Possible actions and power-ups differed depending on the character as they all worked together to rescue Princess Peach. New courses and missions were added, as well as a boost to the number of Power Stars, totaling 150 in this game. There was also a VS mode filled with minigames where the four try to steal each other's Power Stars, as well as a host of minigames utilizing the stylus and Touch Screen.

© 2004 NINTENDO

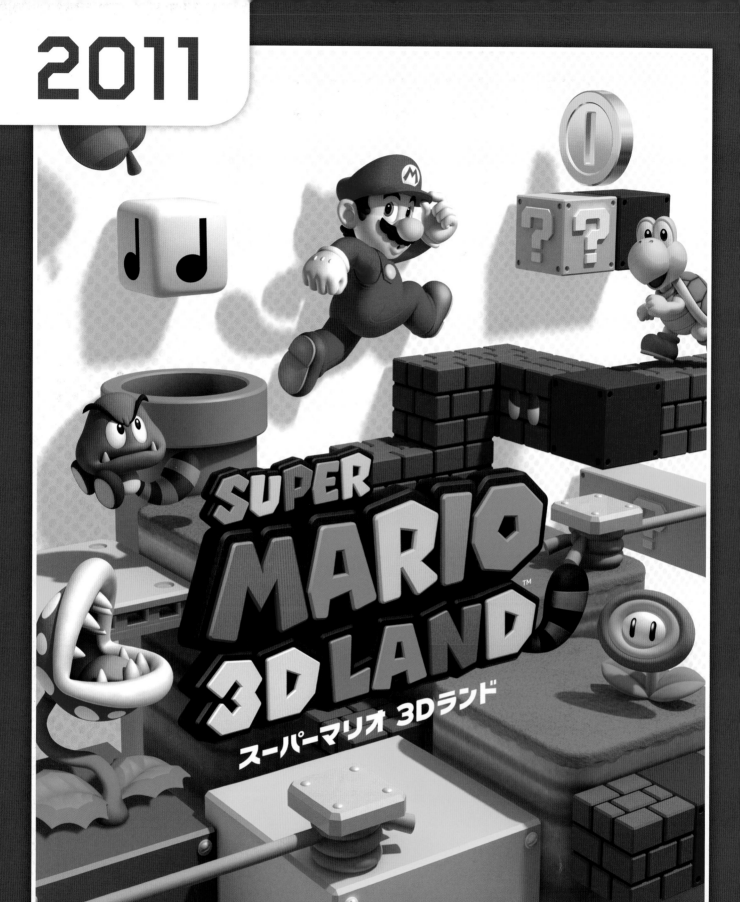

SUPER MARIO 3D LAND

スーパーマリオ 3Dランド

Package Game Card Instruction Booklet

System: Nintendo 3DS
Release Date:
November 13, 2011
(Japan: November 3, 2011)
Player Count: 1

INTRODUCTION

STORY

A great storm has blown through the Mushroom Kingdom, blowing Super Leaves all over the place!

In the chaos, the princess was kidnapped, and monsters throughout the land have taken on the powers of the Super Leaf for themselves.

Looks like another job for Mario to power up, power through, and save the day.

Here you'll meet some of the familiar and not-so-familiar new faces in this adventure.

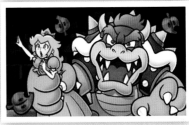

FEATURES

A NEW SYSTEM FOR 3D MARIO

This was the first Mario 3D action game for Nintendo 3DS. This return to the action-platform genre managed to reinvent the wheel by borrowing heavily from the concepts in the 2D action games (such as traversing a course to reach the Goal Pole), but it also simplified play. Even those who had a hard time playing previous 3D games could enjoy it. With the Nintendo 3DS system, the player was able to see a new level of depth within their adventures, even on a small screen.

CHARACTERS WITH TAILS!

This game and its story feature a lot of familiar characters, but this time with tails. This is, of course, the revival of the Super Leaf power-up, where Tanooki Mario can attack with his tail and float slowly to the ground, but it also sees the appearance of many enemy characters with tails. Tail Goomba, Tail Bullet Bill, Tail Boo, Tail Bowser—all familiar characters with tails and with new ways to attack Mario. Even the game logo has a tail!

ADVANTAGES WITH STREETPASS!

Using the StreetPass functionality of your Nintendo 3DS, when you pass someone who also has a Nintendo 3DS and the software, you can get Star Medals, power-ups, and other things that can help you on your adventure! And after you clear some conditions, you may even be able to swap course clear times.

CHARACTERS

PLAYER CHARACTERS

You initially play as Mario, but after fulfilling some conditions, you can play as Luigi too.

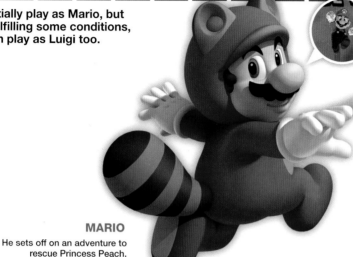

MARIO
He sets off on an adventure to rescue Princess Peach.

LUIGI
Once you've cleared S1- , he becomes a playable character. He jumps higher than Mario, but he slides more.

POWER-UPS

When you get particular items, you can power Mario up with special abilities. For the held items, if Mario's hit by an enemy he loses the item, but he doesn't power down.

SMALL MARIO

What happens when Super Mario takes damage and is powered down. If he takes further damage, you lose a life. You'll notice he does not wear a hat.

 SMALL MARIO

 SMALL LUIGI

SUPER MARIO ITEM ▶ SUPER MUSHROOM

This is what Mario looks like when you start the game. Unlike Small Mario, he can break blocks.

 SUPER MARIO

SUPER LUIGI

FIRE MARIO ITEM ▶ FIRE FLOWER

Fire Mario can throw fireballs to attack enemies. He can also activate certain mechanisms with them too.

 FIRE MARIO

 FIRE LUIGI

TANOOKI MARIO ITEM ▶ SUPER LEAF

Tanooki Mario can attack his enemies or activate mechanisms by spinning his tail around. He also floats slowly to the ground.

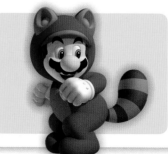

 TANOOKI MARIO

 KITSUNE LUIGI

BOOMERANG MARIO (ITEM → BOOMERANG FLOWER)

This boomerang flies level with the ground, catching items and destroying projectiles.

BOOMERANG MARIO

BOOMERANG LUIGI

STATUE MARIO (ITEM → STATUE LEAF)

This version of Tanooki Mario has a scarf around his neck. With a ground pound, Mario becomes a stone statue that can defeat enemies and smash traps.

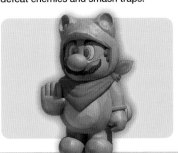

STATUE MARIO

STATUE LUIGI

INVINCIBLE MARIO (ITEM → SUPER STAR)

This makes Mario invincible for a short time, and he can defeat any enemy he touches. If he defeats five enemies in a row, you get a 1-Up.

INVINCIBLE LUIGI

WHITE TANOOKI MARIO (ITEM → INVINCIBILITY LEAF)

This allows Mario to gain both invincibility and Tanooki powers. He can get it from an Assist Block.

WHITE TANOOKI MARIO

WHITE KITSUNE LUIGI

A POWERED-UP ITEM! PROPELLER BOX (ITEM →)

If you press and hold the jump button, Mario can fly very high.

MARIO

LUIGI

A POWERED-UP ITEM! ? BOX (ITEM →)

While wearing this, Mario earns coins just by moving.

MARIO

LUIGI

OTHER CHARACTERS

These characters support Mario on his adventure.

PRINCESS PEACH
The princess of the Mushroom Kingdom who has been kidnapped by Bowser.

TANOOKI TOAD
These tailed-Toads are found in the Special Worlds.

TOAD
He appears in Toad Houses or on courses and gives Mario items.

ENEMIES

These are the enemies you'll find on courses. A lot of them now have tails, which they can use to attack in new ways.

BANZAI BILL
They may be enormous, but you can defeat them by jumping on them, just like Bullet Bills.

BIDDYBUD
These come in a variety of colors and always march in a line.

BIG BOO
A large version of the Boo that moves just like regular Boos.

BIG COSMIC CLONE
A large version of the Cosmic Clone. They can break any blocks or pillars that are in their way.

BIG TAIL GOOMBA
These huge Tail Goombas move just like regular Tail Goombas.

BLOKKABLOK
They follow a specific route. You can defeat them by breaking all the blocks on their bodies.

BLOOPER
Every now and then they spin to rise up as they swim after Mario.

BOB-OMB
If Mario gets close, their fuse catches fire and they chase him. After a while, they explode.

BOO
If Mario turns his back to them, they chase after him. If he attacks, they disappear for a moment.

BOOM BOOM
He swings his arms in a whirling circle as he approaches Mario. Eventually he falls down, dizzy.

BOOMERANG BRO
They jump around throwing boomerangs.

BOWSER
He attacks with fireballs, or he can jump, causing a damaging wave.

BULLET BILL
They fly straight, but if struck with Mario's tail, they change direction.

CHAIN CHOMP
Connected to a spike by a chain, they try to bite! Ground-pound the spike to defeat them.

CHEEP CHEEP
They follow a specific route in the water, sometimes jumping out of the surface.

COIN COFFER
They spit out coins as they run away. They are often hiding.

DRAGLET
They fly around one particular spot. If they spot Mario, they shoot a fireball.

DRY BONES
They chase Mario the instant they see him. Mario can stomp them, but they'll reform.

DRY BOWSER
He's a Special World boss. He shoots blue flame.

FAKE BLOCK
They're disguised as blocks, but if Mario comes close, they jump out at him.

FIRE PIRANHA PLANT
They shoot fireballs at Mario.

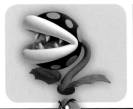

FLOPHOPPER
They shuffle around, alternating between their spiked backs and soft bellies.

FUZZY
They run along tracks, usually in groups.

GOOMBA
They'll charge at Mario, but can easily be jumped on.

GOOMBA TOWER
Goombas that are always stacked on top of each other. Mario will have to defeat them one at a time.

GRINDER
When Mario approaches, they start to turn, cutting away a portion of the floor.

HAMMER BRO
They jump around throwing hammers at Mario.

INKY PIRANHA PLANT
They spit ink onto the screen, but you can clear it by blowing into the mic.

KOOPA TROOPA
They walk around a particular spot. If Mario attacks them, they turn retreat into their shells.

LAVA BUBBLE

They come flying out of lava at regular intervals.

MAGIKOOPA

They move by teleporting and attack by shooting magic.

MAGMAARGH

They stick their heads out of the lava while moving in a straight line.

MONTY MOLE

They pop up out of the ground and start walking around.

MORTY MOLE

They wander along narrow passages. When attacked, they squash down and their speed increases.

PARA-BIDDYBUD

They fly on a particular route. They come in groups most of the time.

PARAGOOMBA

They fly around one spot in the air. This time if Mario jumps on them, they're simply defeated.

PEEPA

They move around one fixed spot. They don't stop moving even if Mario looks at them.

PIRANHA PLANT

If they see Mario, they stretch out their stems and try to bite him.

POKEY

Mario can defeat them by attacking the heads balanced atop the tall bodies.

POM POM

She jumps around throwing boomerangs at Mario.

PORCUPUFFER

They swim around one particular place. There's also a type that breaks the surface to attack.

PRONGO

They chase after Mario, then attack with flying headbutts.

ROCKY WRENCH

They pop up out of holes and throw wrenches or Bob-ombs at Mario.

SANDMAARGH

They approach Mario from within the sand, then they open their big mouths and burst out at him.

SMALL COSMIC CLONE

They chase after Mario, copying every move he makes.

SPIKE EEL

They appear underwater, peeking in and out of their holes.

SPINY

They chase Mario. Their spiky shells make them jump-proof.

STINGBY

They fly through the air. If they see Mario, they doggedly pursue him.

TAIL BOB-OMB

They wag their tails as they descend slowly to the ground. Once they hit the ground, they explode.

TAIL BOO

If Mario faces them, they stop moving, but they swing their tail around to attack.

TAIL BOWSER

They attack by spitting fireballs and swinging their tails. They show their true forms once defeated.

TAIL BULLET BILL

They're fired out of blasters and fly in a straight line. They can attack with their tails while they fly.

TAIL GOOMBA

They make big arcing jumps, and they swing their tails around to attack once they land.

TAIL THWOMP

They move by jumping. Mario can bounce on their tails.

THWOMP

When Mario comes close, they fall straight down, then slowly return to the ceiling.

WALLOP

They shuffle left and right to block Mario's way, even jumping when he jumps.

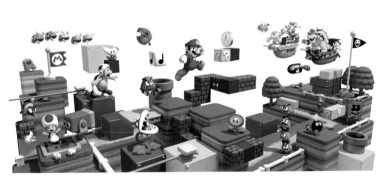

WORLD

COURSES

Once you clear Worlds 1-8, you can go on to the Special Worlds. There, you can take on the challenging courses in Special Worlds 1-8.

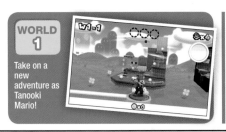

WORLD 1

Take on a new adventure as Tanooki Mario!

W1-1

A grassy area where Mario can still see Peach's Castle. Have Mario become Tanooki Mario to make his way through.

W1-2

An underground course with Spinners. The Inky Piranha Plants try to ruin your view.

W1-3

The goal is at the very bottom. Descend using the lifts and Switchboard rail carts.

W1-4

Board the Switchboard rail carts and have Mario flip the switches as he goes.

W1-🏰

A Tail Bowser is waiting at the fortress. Move along on the footholds above the lava.

WORLD 2

Boom Boom is waiting on the airship at the end of this tricky world.

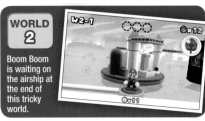

W2-1

A white castle stands above a green grassland. The Goal Pole is on top of the castle.

W2-2

Flip Panels become Mario's path above the poison bog.

W2-3

The floor is made up of the pixel-like graphics from *Super Mario Galaxy 2*'s "Mario Squared Galaxy."

W2-4

An athletic course over Red-Blue Panels. Spiked traps try to hinder Mario.

W2-🚢

An airship where a lot of Bullet Bills and Burners try to fry Mario. Boom Boom waits for a rematch.

WORLD 3

Desert sands, sky-high pathways and snow—this world has variety!

W3-1

Mario makes his way up to the very top of the ruins in the middle of the desert.

W3-2

The first underwater course in the game. Swim the narrow submerged passages where the Cheep Cheeps wait.

W3-3

An athletic course with long lines of Donut Blocks. The Stingbies block Mario's way.

W3-4

Mario must balance on the ropes to make his way across. Fuzzies travel below and Spinners swing in from the sides.

W3-5

An athletic course where cookies, chocolate, and other sweets are Mario's footholds.

W3-🚢

An airship where Skewers come crashing in from deep in the distance. Mario must be mindful of the safe regions.

WORLD 4

The compositions of these courses are complex.

W4-1

A course where Mario is surrounded by trees. In the second half, he climbs up a big one.

W4-2

Mario can use the ! Blocks and trampolines to work his way upward in this vertical underground area.

W4-3

Mario crosses the colorful rotating blocks to get through this athletic course.

W4-4

A gloomy haunted mansion. The hallways suddenly appear and lead Mario along.

W4-5

Use the Flip Panels to make paths. Think carefully about which Flip Panel to activate first.

W4-🚢

An airship where Mario has to cross Red-Blue Panels. They'll tempt Mario to jump right into an enemy attack.

WORLD 5

The first appearance of the Boomerang Flower!

W5-1

A desert course. In the middle, Mario boards a rising platform as he avoids enemy after enemy.

W5-2

This course is viewed from above. Hey, listen! You might swear you heard sound effects *linked* to a different game.

W5-3

Mario goes from lift to lift as he makes his way into the distance on this athletic course.

W5-4

A cave with passages like a maze. Monty Moles and Morty Moles are walking the narrow passages.

W5-5

Grab a Propeller Box and go from one narrow platform to the next. In the second half, Mario glides down a long way.

W5-🏰

Dash over the platforms moving over the lava and make for the fortress. There, Mario will face another Tail Bowser.

WORLD 6
This world isn't just about action, but has plenty of puzzles to figure out too.
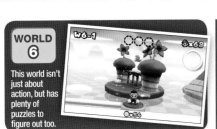

W6-1
Cheep Cheeps and Porcupuffers attack as Mario makes his way over the wooden bridges.

W6-2
Enter into the inner workings of the pyramid. Mario uses the mechanisms there to go from small room to small room.

W6-3
A haunted house separated into multiple rooms. Solve the puzzles and get to the goal.

W6-4
The block platforms vanish and reappear on the beat, so Mario needs his rhythm as he crosses.

W6-5
Mario uses the moving trampolines to make his way on this snowy mountain athletic course.

W6-🖐
Skewers are found in all sorts of places as Mario makes his way through the interior of the airship.

WORLD 7
New tricks and traps await Mario in this world!

W7-1
An extremely deep underwater course. There are big enemies blocking the very narrow waterways.

W7-2
A building with a lot of Spiked Rollers. Jump over them to get to the goal.

W7-3
Use the tightropes to climb up the huge tree. Fuzzies will try to keep Mario from proceeding.

W7-4
A course like you're inside clockworks. Mario uses the moving cogwheels to get through.

W7-5
Grinders cut through the wooden platforms and send them falling.

W7-🖐
An airship with a lot of rotating platforms. Magikoopas get in Mario's way.

WORLD 8
Bowser's turf. This world has the most courses.
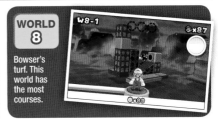

W8-1
Watch out for large numbers of Spiked Balls, both big and small.

W8-2
Mario grabs on to poles that are running on tracks to make his way through the course.

W8-3
An athletic course with a bunch of rotating platforms of many different shapes.

W8-4
Get aboard the moving floor and have Mario avoid the Boos and Peepas in his way.

W8-5
As Mario makes his way over the Red-Blue Panels, he's attacked by Rocky Wrenches and Banzai Bills.

W8-👹1
Sneak into Bowser's Castle. Mario's footholds won't be very big in the lava, and a lot of enemies await him.

W8-6
Make the platforms rotate and use them to cross the lake of lava.

W8-👹2
This is truly Bowser's home base. Get aboard the lift and avoid the many traps as Mario goes to confront Bowser.

SPECIAL 1
Clear the game to reach this Special World!

S1-1
Mario uses the series of Super Stars left along the way to make his way through.

S1-2
Mario avoids the Small Cosmic Clone to get through this underground course.

S1-3
Pixel art—and the enemies represented—make up this course.

S1-4
Face off against Boomerang Bros. on the wooden bridge, and in the second half, use the ropes to get to the goal.

S1-🖐
Mario has to battle Dry Bowser to rescue the kidnapped Luigi.

SPECIAL 2
Luigi has been rescued, and the Special Worlds continue!

S2-1
The flowing clouds may block the view of the platforms.

S2-2
Time is short! Mario can grab the + Clocks as he goes through this underwater course.

S2-3
Switchboards take Mario above the lava. Fuzzies try to block his way.

S2-4
Climb the snowy mountain with the help of a Propeller Box as Mario crosses the small platforms.

S2-5
Flip Panels twist and turn around each other. Try to find the path over them.

S2-🖐
These airships have a lot of spiked floors and Banzai Bills. In fact, there are hardly any safe spots to rest here.

SPECIAL 3
Lots of courses with high-speed mechanisms. Panic is your enemy!

S3-1
Lifts that act like pendulums and Donut Blocks line up on this athletic course.

S3-2
Get across all those colorful rotating block platforms. Long platforms make their appearance here too.

S3-3
There's very little time to finish this course. Mario has to walk along the ropes grabbing + Clocks as he goes.

S3-4
There are a lot of high-speed Spiked Rollers. Mario has to avoid them as he moves along.

S3-5

Cross the blocks that appear and disappear with the beat, but this time the rhythm is very fast.

S3-

The scrolling is faster than on previous ships as Mario has to make it through nonstop!

SPECIAL 4

Some of these courses may feel familiar, but beware!

S4-1

Get aboard the lift to proceed, but it keeps getting smaller and smaller.

S4-2

Mario's running from the Small Cosmic Clone in this haunted house.

S4-3

Bullet Bills and Banzai Bills fly above the wooden bridges.

S4-4

With hardly any time left, Mario can gain more time by defeating the Goombas.

S4-5

There's a lineup of collapsing floors. The Boos are huge, and there's hardly any place to rest.

S4-

There are enemies in lots of small rooms, and Mario has to fight both Boom Boom and Pom Pom.

SPECIAL 5

Mario's life hinges on timing in this difficult world!

S5-1

Have Mario cross the Red-Blue Panels as Spiked Balls come at him.

S5-2

Mario must escape from the Small Cosmic Clone, then make his way through the Spiked Rollers.

S5-3

Get aboard the Switchboards to get through the valley. Mario will have to use the mechanisms very well to move along.

S5-4

The platforms are cookies and sweets. About halfway through, it becomes a course with non-stop upward scrolling.

S5-5

There are a large number of Warp Boxes in this haunted house. Find the right box in each room to move forward!

S5-

Defeat the enemies to buy Mario more time. Dry Bowser awaits.

SPECIAL 6

These courses have even more poison mushrooms!

S6-1

It's a quiet night in the desert, and the Propeller Box will help Mario climb the castle.

S6-2

An athletic course over Donut Blocks. Defeat the Goombas and just dash!

S6-3

An underwater poison swamp. The Flip Panels are complicated, but they're Mario's route across.

S6-4

The many Rotating Blocks make avoiding the Small Cosmic Clone quite difficult.

S6-5

The floor moves and takes Mario along in this haunted house. There's fog, so it's hard to see very far.

S6-

Cross the Red-Blue Panels on the airship to reach Boom Boom.

SPECIAL 7

Difficult conditions lie ahead!

S7-1

There's not much time left to cross those tightropes. Defeat the Boomerang Bros. to buy more time.

S7-2

Cross the vanishing and reappearing blocks with the beat while being chased by the Small Cosmic Clone.

S7-3

Inside this huge clock, the lifts can carry Mario along partway, but the cogwheels have sped up.

S7-4

Mario avoids the Super Cosmic Clone as he skillfully makes his way across the Red-Blue Panels.

S7-5

The platforms are rotating at high speed, and Mario has to cross them on this airship course.

S7-

Mario runs from the Super Cosmic Clone and grabs the +Clocks as he makes his way through.

SPECIAL 8

The final world. Can you reach the Crown Course?

S8-1

An underground course with a lot of spikes. A Small Cosmic Clone chases Mario as he tries to grab the + Clocks.

S8-2

The many different platforms rotate sideways or front to back and at much higher speed than before.

S8-3

Mario grab the +Clocks and avoids the Super Cosmic Clone as he goes through this fortress.

S8-4

Get the + Clocks and board the moving platforms to cross the lava lake.

S8-5

The Super Cosmic Clone chases Mario across the airship's rotating platforms.

S8-

The final battle with Dry Bowser. Without +Clocks, time will run out!

S8-

Once all the conditions are fulfilled, this course appears. It's both the final and hardest course in the game.

ITEMS & OBSTACLES

Here we'll review the items, mechanisms and other things you'll find on courses. There are a lot of items that make use of the Nintendo 3DS system's 3D technology.

! BLOCK
A ! Platform Block appears each time Mario hits this.

! PLATFORM BLOCK
These appear when Mario hits a ! Block and only last a short while.

? BLOCK
They are set in place. When Mario hits them, coins or items come out of them.

? BOX
When Mario puts it on, it spouts coins for a fixed amount of time.

+ CLOCK
Increases the amount of time remaining.

1-UP MUSHROOM
They increase your remaining lives by one and can be found in hidden places.

1-UP MUSHROOM BOARD
Sometimes destroying these wooden boards make real 1-Ups appear.

10-COIN BLOCK
Coins only come out for a fixed amount of time. Sometimes it ejects coins out of it.

ASSIST BLOCK
If you keep losing lives at the same point, an Assist Block will appear. Hit it to receive a special item.

BADDIE BOX
Enemies pop out of it at regular intervals; up to three at a time.

BEEP BLOCK
These are platforms that appear and disappear according to the rhythm of the background music.

BIG GOAL POLE
A Goal Pole with a huge flag. Once Mario grabs it, he's cleared the entire world.

BIG SPIKED BALL
A huge, spiked iron ball. They can ram regular-sized ones out of their way.

BINOCULARS
Change the view by moving the Nintendo 3DS system or using the Circle Pad.

BLOCK
Some of them hold items. Small Mario can't break them.

BOLT LIFT
This platform moves up the screw when Mario goes in the indicated direction.

BOOMERANG FLOWER
These power Mario up into Boomerang Mario.

BOWSER SWITCH
These appear in battles with Bowser. It causes Bowser to fall into the lava.

BURNER
These send out bursts of flame at regular intervals. Statue Mario can break them by dropping on them.

CACTUS
These grow in some courses. Some of them produce a coin when attacked.

CANNON
Have Mario get inside, aim it carefully, and fire to send Mario flying.

CHECKPOINT FLAG
If Mario touches a Checkpoint Flag, you can try again from that point if you lose a life.

COIN
You'll get an extra life if you collect one hundred of these.

COIN RING
A golden ring. If Mario passes through it, you get five coins.

CRATE
It's possible to break them with an attack. Sometimes items are inside.

DANDELION
If Mario touches it or if you blow into the mic, they blow away. Sometimes an item comes out.

DIRECTIONAL BLOCK
When Mario hits it, it starts to move in the direction printed on it.

DONUT BLOCK
These blocks start to fall shortly after Mario gets on.

EYE SWITCH
These are found in strange rooms. When Mario gets on, you see the room from a different angle.

FALL-AWAY FLOOR
If Mario crosses these, they crack and start to fall. Eventually they reappear.

FIRE BAR
These bars of fireballs rotate around an empty block in the center.

FIRE FLOWER
These power Mario up into Fire Mario.

FLIP PANEL
They're found on certain routes, and they open to become square panels that make a path.

FLIP PANEL SWITCH
This switch creates Flip Panels.

FLYING ? BLOCK
? Blocks with wings attached. It stops where Mario hits it.

FLYING ROULETTE BLOCK
They're found after you've failed the course twice.

GOAL POLE
Grab on to the Goal Pole to clear the course. The remaining time will be converted into coins.

GOLDEN ROCK
It takes ten kicks to break, then drops five coins.

GOOMBA BOARD
This is a wooden cutout in the shape of a Goomba. When you break it, it produces a coin.

GRASS
They're found growing on courses. Some of them produce coins when Mario attacks them.

GREEN SHELL
It takes off very fast when you kick it. Some are just sitting there on certain courses.

HIDDEN BLOCK
Blocks you can't see. They appear if Mario jumps in certain places.

INVINCIBILITY LEAF
Turns Mario into White Tanooki Mario with unlimited invincibility.

LITTLE BIRD
They're found on some courses. They fly away when Mario gets close.

LAVA
A red lake where Lava Bubbles and Lava Spouts well up. If Mario falls in, you lose a life.

LAVA GEYSER
These well up from lava at regular intervals. If Mario touches one, he takes damage.

LIFT
These platforms follow a particular route. There's also a type that moves when Mario gets on.

LONG ? BLOCK
These produce coins or items in threes.

MUSHROOM TRAMPOLINE
When Mario gets on, he bounces high. There is also a type that moves.

MYSTERY BOX
Jumping in brings Mario to a special small room.

NOTE BLOCK
Mario bounces when he gets on. If Mario times the bounce right, he can bounce very high.

P SWITCH
When pressed it will produce coins, musical notes, or it could start some mechanisms.

P-WING
Allows Mario to travel instantly somewhere near the Goal Pole.

PIPE
These send Mario to a special area or odd rooms.

PIPE BOARD
Sometimes destroying these wooden boards make real pipes appear.

POISON BOG
A purple lake. If Mario falls in, you lose a life.

POISON MUSHROOM
If Mario touches these, he takes damage.

POLE
When Mario grabs on, he can climb up or down. There is also a type that moves.

PROPELLER BOX
Hold the button down to go up higher.

RAINBOW NOTE
They appear if Mario steps on a P Switch. Collect all of them within the time limit to earn an item.

RED-BLUE PANEL
These Red-Blue panels switch when Mario jumps.

RED COIN
Pass through the Red Ring to make them briefly appear. Collect all five to earn an item.

RED RING
Five Red Coins appear nearby when Mario passes through.

ROULETTE BLOCK
When Mario hits it, it stops on a picture, and that item appears.

SKEWER
They come crashing out at regular intervals. Avoid their spikes.

SMALL ROCK
These can be broken by a strong blow, like Bullet Bills or Yoshi spitting a Spiny Egg at them.

SPIKE FLOOR
The spikes extend and retract at regular intervals. Mario can pass by when they're down.

SPIKED BALL
A ball with spikes on it. They destroy any wooden boxes and enemies in their way.

SPIKED BALL CANNON
They aim their bores at Mario, then they fire Spiked Balls.

SPIKED BAR
These spiked versions of Fire Bars rotate around a block.

SPIKE BLOCK
Blocks with spikes. If Mario touches one, he takes damage.

SPIKED PENDULUM
These spiky obstacles swing back and forth like a playground swing.

SPIKED ROLLER
These long, thin pillars are always moving, while others rely on a mechanism.

SPINNER
These spiked iron balls swing over a particular area. Invincible Mario can destroy them.

STAR MEDAL
There are three on each course. They can be found in Mystery Boxes too!

STATUE LEAF
This leaf allows Tanooki Mario to turn into Statue Mario.

STUMP
When Mario does a ground pound on them, they bury further into the ground. Some produce items.

SUPER LEAF
These power Mario up into Tanooki Mario.

SUPER MUSHROOM
When Mario grabs one, he powers up to Super Mario again.

SUPER NOTE BLOCK
Bounce high on these and Mario goes to a bonus area.

SUPER STAR
This makes Mario invincible for a short time.

SWITCHBOARD
When Mario gets on board, you can choose what direction you want him to go.

TAIL WHEEL
As Mario continues to do tail attacks, the platform he is standing on rises.

THORNY FLOWERS
If Mario touches them, he takes damage. They burn when hit by a fireball.

TIGHTROPE
Mario can walk across them. When he jumps, they can send him high into the air.

TORCH
Hit them with a fireball, and they're set aflame. Doing so will often set some mechanism moving.

TREE
Mario can grab on and climb them. He can jump off the tops.

WARP BOX
Mario is instantly transported to another connected Warp Box when he touches it.

WARP PIPE
They are in hidden places and take Mario to a different world.

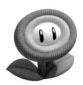

AND MORE

MEMORABLE MOMENTS

Here we look back on some memorable moments, as well as hidden scenes you'll only see if you fulfill certain conditions.

THREE-DIMENSIONAL TITLE SCREEN

If you let the title screen run for a while, you'll be able to play in some rooms where the blocks make odd patterns. And when you see them in 3D . . .?

PHOTOS FROM PEACH

When you clear a world, Mario's sent photos with Peach's present situation. They're bittersweet, making him swing between joy and worry. All of the pictures you've collected are in an album at the Toad House in World 3.

SHAKE IT!

When you shake the Nintendo 3DS system, the pictures you can see in your album move. And when you continuously shake the photo you received for clearing World 3, things appear—like a Goomba and Luigi.

FAMILIAR PIPES

There's a secret room inside a pipe where the coins are all lined up. That is a 3D version of a similar bonus area found in the original *Super Mario Bros.* game.

IS THAT A UFO?!

When you look through the binoculars on W1-3, you may be able to see a UFO fly by.

A GHOSTLY SURPRISE

Near the Goal Pole in W4-4, if you wait there a while, you see a spooky white shadow hovering around behind the fence.

COURSE CLEARING CELEBRATION

If the final number on the timer is a one, three, or six when you touch the Goal Pole, you may get a result like the photo above.

THE FLIGHT OF THE TANOOKI

During the credits, you can play as a flying Tanooki Mario using the Circle Pad or the +Control Pad. If you happen to be using Luigi at the end, the credits are slightly different than if you're using Mario.

SWEET MOVES, MARIO!

After you clear W8-2 ☺, Mario starts showing off during the title screen's scene changes. He gets faster and his moves get showier.

LEVEL UP!

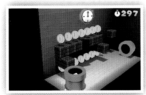

After defeating Bowser in World 8, a pipe appears in World 1. If you enter it, you're led to a special world! A whole set of them! Forty-eight more difficult courses await you!

TIME ATTACK!

In the Special World, you'll find that all the courses you've cleared now list the time you completed them in. You'll also see other players' times, and you can compete for the best time.

TWIN IN TROUBLE

Luigi has been kidnapped and is held in the castle of S1. Once Mario's defeated the Dry Bowser there, Luigi is unlocked as a playable character.

LUIGI JOINS THE PARTY

Now that Luigi is rescued, you can use him to go through the World Warp Pipe into the W worlds, and when you clear them with Luigi, you can see Luigi going through the same event screens that Mario went through. And if there's a course or two you haven't cleared yet, you can transform into White Kitsune Luigi to help finish it.

FINAL BATTLE

Once Mario's won the final battle with Dry Bowser in the Special Worlds, he'll have a rematch with Bowser. In this final battle, Bowser's movements are faster, and his attacks have been powered up. After defeating that Bowser, you get to see the true ending.

THE CROWN COURSE

After you've gotten five stars on the file select screen, a crown mark appears in world S8. This isn't a course that you can just breeze through. It's the very final course with the toughest level of difficulty of any of them. When the Crown Course appears, the background music for S8 changes.

COSTUME CHANGE

If you get a Triple Crown (obtaining 1,110 lives), Super Mario loses his hat, and Small Mario gains one. When you earn the Triple Crown, you get a fan letter in the mail.

HELPFUL HINTS & TECHNIQUES

Read on for some helpful tips and tricks, including how to decorate your save file with all five stars!

THE ★ ★ ★ ★ ★ MARK IS PROOF!

Stars appear at the top of your save file depending on how much of the game you've cleared so far. When you clear W8-☺, you get ★. When you've cleared all the courses in W1-W8, you get ★★. When you've seen the true ending, you get ★★★. When you've seen the true ending and gotten all the Star Medals from both the regular worlds and Special Worlds, you get ★★★★. If you've done all of the above and gotten a perfect clear on every course (cleared by both Mario and Luigi, and having grabbed each Goal Pole at the very top), you get ★★★★★. Avoid losing more than five lives in a single level, and those stars will really shine!

MULTIPLE JUMPS EARN 1-UPS!

This is the same technique as when you defeat enemies to get a 1-Up. In this game, if you jump on a Chain Chomp, on the tail of a Tail Thwomp, or any other undefeatable enemies, jumping on them five times gets you a 1-Up.

ENTERING THE WARP ZONE!

In W1-2 and W4-2, if you go above the ceiling near the goal post, you can find a room with a pipe that will take you to the next world. These are the same courses and approximate locations where you can find the Warp Zones in the original *Super Mario Bros.* game.

ANNIVERSARY EVENTS!
A COMPARISON...

The year 2015 marked the 30th anniversary of the original *Super Mario Bros.* game. In the past there were celebrations for the 20th anniversary (2005) and the 25th anniversary (2010), so what kind of campaign did we see during those years?

THE 20TH ANNIVERSARY (2005)

The anniversary slogan was "Happy! Mario 20th." In Japan, a mini version of the Game Boy Advance, called the Game Boy Micro, went on sale on September 13th, 2005, the same date the original *Super Mario Bros.* was released back in 1985. The look was based on a Famicom controller, and it came complete with the 20th anniversary logo for *Super Mario Bros.*

On February 14, 2004, the Famicom Mini Series version of *Super Mario Bros.* went on sale in Japan. The package came in a special version with the 20th anniversary logo and characters drawn on it. *Dr. Mario & Puzzle League* and *Mario Tennis: Power Tour* were also released. The Japanese versions featured the 20th anniversary logo.

⬆ *MARIO TENNIS: POWER TOUR*

↪ *DR. MARIO & PANEL DE PON*

⬆ *SPECIAL 20TH ANNIVERSARY EDITION GAME BOY MICRO*

THE 25TH ANNIVERSARY (2010)

For the 25th anniversary of the series, eleven games up to and including *Super Mario Galaxy 2* were included as a part of the campaign.

A huge number of products were made available as part of the Super Mario 25th Anniversary—all sporting the red-colored motif. There were red Nintendo DSi XL and Wii game consoles that featured pre-installed or bundled games like *Mario Kart DS* and *New Super Mario Bros. Wii* in America and *Super Mario Bros.* 25th Anniversary Version in Japan. *Super Mario All-Stars* Special Pack (known as *Super Mario All-Stars* Limited Edition in North America), a port of the original SNES collection, was also released for the Wii.

The official Nintendo website posted special videos including Super Plays and the "Mario Drawing Song," and held a Flipnote Studio contest.

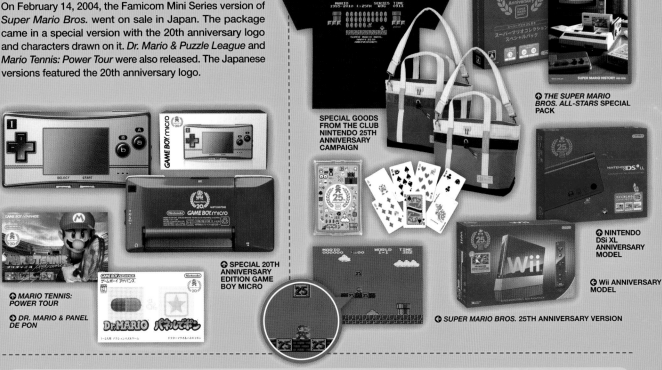

⬆ THE SUPER MARIO BROS. ALL-STARS SPECIAL PACK

SPECIAL GOODS FROM THE CLUB NINTENDO 25TH ANNIVERSARY CAMPAIGN

⬆ NINTENDO DSi XL ANNIVERSARY MODEL

↩ Wii ANNIVERSARY MODEL

↩ *SUPER MARIO BROS.* 25TH ANNIVERSARY VERSION

THE 30TH ANNIVERSARY (2015)

The 30th anniversary celebrated seventeen games and featured yellow as its thematic color. The latest in that series, *Super Mario Maker* (see page 6), allowed a player to choose styles representing four different games: the original *Super Mario Bros.*, *Super Mario Bros. 3*, *Super Mario World*, and *New Super Mario Bros. U*. They also came out with the 30th Anniversary-Mario series of amiibo figures. The Classic Color version was included in the Wii U *Super Mario Maker Super Mario Bros.* 30th Set, which went on sale that year.

On the Nintendo official website, they introduced a series of videos covering the generations. The "Let's Super Mario" campaign invited videos from fans all over the world. On September 13th, there was a festival in Japan celebrating the 30th anniversary. On September 20th and 21st, there was a Super Mario-only musical event called the *Super Mario 30th Anniversary Live*. Another event not only celebrated the 30th anniversary of *Mario*, but also celebrated the 400th anniversary of the founding of the Rinpa school of art. A golden folding screen of Mario and Luigi, styled after the Wind God and the Thunder God, was made for the occasion, and on October 23rd, 2015, it went on display at the Kyoto Art Museum "Eki" Kyoto.

The Japanese edition of this very encyclopedia was also considered a part of the *Super Mario Bros.* 30th Anniversary offerings.

⬆ MARIO AND LUIGI FOLDING SCREEN

↩ SUPER MARIO 30TH ANNIVERSARY LIVE

↪ SUPER MARIO BROS. 30TH ANNIVERSARY FESTIVAL

スーパーマリオ 30祭
SUPER MARIO BROS.
30TH ANNIVERSARY FESTIVAL
9/13(SUN) OPEN 17:00 START 18:00

New SUPER MARIO BROS. 2

ニュー・スーパーマリオブラザーズ・2

Package

Game Card

Instruction Booklet

System: Nintendo 3DS
Release Date:
August 19, 2012
(Japan: July 28, 2012)
Player Count: 1-2

INTRODUCTION

S T O R Y

After receiving an invitation to come to Peach's Castle, Mario and Luigi head there expecting a fun day and discussions with Princess Peach about the adventures they'll have.

Later, Princess Peach sees them off as they take off as Raccoon Mario and Fox Luigi to gather coins in the sky.

Eventually, the brothers take a short break and land, but a dark shadow obscures the sun above them.

With a booming sound, a Koopa Clown Car filled with Koopalings comes crashing toward the ground, aiming for Mario and Luigi!

Stunned by the sudden attack, Mario and Luigi can only watch as the Koopalings fly off with Princess Peach!

With Peach calling for their help, Mario and Luigi start a brand-new adventure!

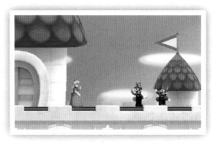

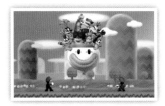

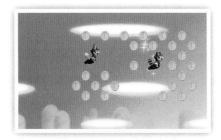

F E A T U R E S

GATHER 1,000,000 COINS!

This is a continuation of the *New Super Mario Bros.* series, built for Nintendo 3DS. This time around, not only are Mario and Luigi trying to rescue the princess, but they also need to collect as many coins as they can! To that end, they can use items such as the gold block, which spits out coins when Mario wears it, or transform into Gold Mario and throw gold fireballs that turn blocks and enemies into coins. When Mario and Luigi collect a lot of coins, certain items appear. Also, if your hero goes through a gold ring, all the enemies turn gold, and doing things like throwing a shell can produce more coins for your hero to collect. There are all sorts of ways to collect coins to reach your goal of one million!

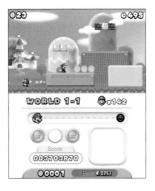

COIN RUSH MODE

In addition to the main mode, there is also the Coin Rush Mode. In this mode, three courses are chosen at random, and your heroes compete to see how many coins they can collect. Instead of the 1-Up Mushroom, there are Gold Mushrooms worth an additional fifty coins. There are also special rules here, such as a shorter time limit, plus you will need to learn new techniques that are somewhat different from the ones used in the main mode. Also, if you use StreetPass, you can compare high scores with other people and challenge their scores.

 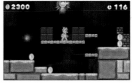

CHARACTERS

PLAYER CHARACTERS

MARIO
He sets off on an adventure to rescue the princess and collect coins.

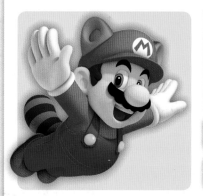
LUIGI
During Co-op Play, he adventures alongside Mario. In Solo Play, you can use him after fulfilling certain conditions.

POWER-UPS

There are nine different types of power-up transformations, plus one power-up using an item. For the transformation power-up items, you can stock one extra item and use it anywhere on the course.

SMALL MARIO

This is Mario's state when the game begins. He can't break blocks, and if he takes damage, you lose a life.

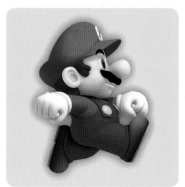

SMALL MARIO

SMALL LUIGI

SUPER MARIO ITEM ⊳ SUPER MUSHROOM

This is the form Mario takes when he gets a Super Mushroom. He can break blocks now, but if he takes damage, he becomes Small Mario again.

SUPER MARIO

SUPER LUIGI

FIRE MARIO ITEM ⊳ FIRE FLOWER

Mario can attack enemies by throwing fireballs, although there are certain enemies who are immune. You will need Mario to throw fireballs to activate the ! Pipe.

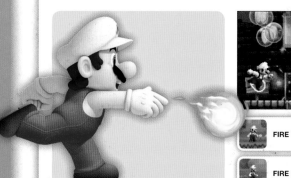

FIRE MARIO

FIRE LUIGI

RACCOON MARIO ITEM ⊳ SUPER LEAF

Build up the P-Meter while Mario dashes so he can fly. He can attack his enemies by spinning his tail around and float slowly to the ground.

RACCOON MARIO

FOX LUIGI

GOLD MARIO [ITEM → GOLD FLOWER]

When Mario throws his gold fireballs, the blocks he hits turn into coins. Also, he can get a lot of coins by defeating enemies. Once he's cleared a course, he turns into Fire Mario.

GOLD MARIO

SILVER LUIGI

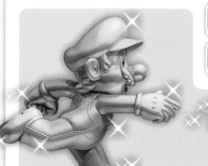

MEGA MARIO [ITEM → MEGA MUSHROOM]

For a short while, Mario becomes huge and effortlessly stomps through enemies and blocks. A ground pound will defeat all enemies on the screen. You can't keep a Mega Mushroom in stock, and this power-up is only found on certain courses.

MEGA MARIO

MEGA LUIGI

MINI MARIO [ITEM → MINI MUSHROOM]

Mario becomes much smaller than Small Mario. Because of his tiny size, he floats longer when he jumps, and he can run on the surface of the water. He can't defeat an enemy unless he does a ground pound, and if he takes damage, you lose a life.

MINI MARIO

MINI LUIGI

INVINCIBLE MARIO [ITEM → SUPER STAR]

For a short while, Mario's body starts sparkling, and he can defeat any enemy just by touching them. If Invincible Mario can defeat eight enemies in succession, you get a 1-Up.

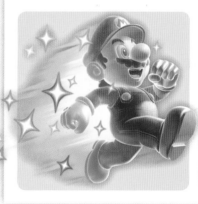

INVINCIBLE MARIO

INVINCIBLE LUIGI

WHITE RACCOON MARIO [ITEM → INVINCIBILITY LEAF]

If you lose five lives on the same course, an Assist Block appears that contains an Invincibility Leaf. With this, Mario can become White Raccoon Mario. He can fly after a shorter dash than regular Raccoon Mario, and he's also invincible. He can also dash across the water. After the course is cleared, he turns into Raccoon Mario.

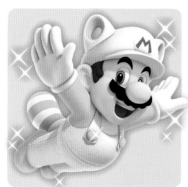

WHITE RACCOON MARIO

WHITE FOX LUIGI

[A POWERED-UP ITEM!] GOLD BLOCK [ITEM →]

When Mario puts a gold block on his head, not only does he keep whatever power-up he already has, but he generates up to one hundred coins while moving. This ability vanishes if he's hit by an enemy or after he's collected one hundred coins.

GOLD BLOCK MARIO

GOLD BLOCK LUIGI

OTHER CHARACTERS

Mario's friends who appear in the game.

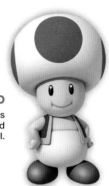

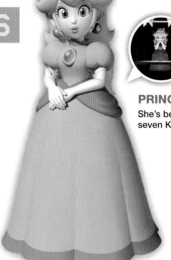

TOAD

He can give Mario items from his Toad Houses and can gift extra lives as well.

PRINCESS PEACH

She's been kidnapped by the seven Koopalings.

ENEMIES

These are the enemy characters you'll encounter. Any enemy that has "Gold" before its name has been changed to a shiny state by Mario passing through a gold ring on a course.

AMP
Their bodies are covered in electricity and they sometimes run on tracks.

BANZAI BILL
They have huge bodies but they move slowly, and can be stomped out of the air.

BIG BONE PIRANHA PLANT
Large-sized Bone Piranha Plants. They're found on the ground and they stretch out their long necks to bite Mario.

BIG BOO
Large-sized Boos. They move just like regular Boos do.

BIG CHAIN CHOMP
One of these huge Chain Chomps pulls Iggy's carriage. They can move in all directions.

BIG CHEEP CHEEP
A large-sized Cheep Cheep. Some of them have normal-sized Cheep Cheeps following them.

BIG DEEP CHEEP
These are large-sized Deep Cheeps. They move just like normal Deep Cheeps.

BIG DRY BONES
A large-sized Dry Bones. Only a ground pound will crumble them.

BIG FIRE PIRANHA PLANT
They shoot especially large fireballs at Mario.

BIG FUZZY
Huge Fuzzies. They move exactly like Fuzzies do.

BIG PIRANHA PLANT
They're larger than normal Piranha Plants. They stretch their long necks out to bite Mario.

BIG THWOMP
Huge Thwomps. They'll shatter anything below them, even blocks.

BIG WHOMP
Huge Whomps. They move just like normal Whomps.

BLOOPER
They shoot out of pipes, then zigzag their way to Mario.

BLOOPER NANNY
These are Bloopers with Blooper Babies in tow. After swimming for a while, the babies scatter.

BOB-OMB
If Mario attacks them, their fuse is lit and they explode.

BONE GOOMBA
They're found in castles and towers. They have skulls on their heads, but squash the same as regular Goombas.

BONE PIRANHA PLANT
They move just like regular Piranha Plants, but fireballs don't work on them.

BOO
They get shy when Mario looks at them, but will chase him when he turns away.

BOOHEMOTH
These massive Boos chase Mario when his back is turned—and sneak closer if Mario stands still too long!

BOOMERANG BRO
These blue-shelled enemies attack by throwing boomerangs.

BOWSER

The boss of W6. He attacks with fireballs and hammers.

BULLET BILL

They are fired out of Bill Blasters and fly straight ahead.

BUZZY BEETLE

They appear on underground courses. When Mario jumps on them, they tuck into their fireproof shells.

 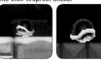

CHAIN CHOMP

They try to bite Mario, but he can free them by ground-pounding the spikes holding their chains.

CHEEP CHEEP

They swim slowly through the water, sometimes in circles.

CHEEP CHOMP

These chase Mario. They open their big mouths and try to gobble him up.

CLIMBING KOOPA (GREEN)

Koopa Troopas that climb fences. If they're on the other side of a fence from Mario, a punch will knock them off.

COIN COFFER

They appear when Mario goes through certain Red Rings. They run away dropping Red Coins as they go.

CROWBER

They swoop down to attack Mario after they crisscross the sky.

DRY BONES

They fall apart if Mario jumps on them, but eventually reform.

DRY BOWSER

The boss of W★. Instead of throwing hammers, he throws bones to attack.

DEEP CHEEP

When Mario gets somewhat close, they start to chase him.

FIRE BRO

These red-shelled enemies attack by throwing fireballs.

FIRE PIRANHA PLANT

These come out of pipes and spit fireballs at Mario.

FIRE SNAKE

Their entire bodies are made of flames. They bound after Mario.

FISH BONE

These swim in castles and similar places. When they see Mario, they charge straight at him.

FLAME CHOMP

They float around in the in the sky, closing in on Mario and shooting fireballs. Eventually they explode.

FUZZY

They move along tracks. If there's a break in the tracks, they jump across the break.

GOLD BANZAI BILL

They generate even more coins in their paths than Gold Bullet Bills do.

GOLD BIG BOO

They're really huge, but they act just like regular Gold Boos.

GOLD BOO

They run away from Mario and coins appear behind them.

GOLD BRO

Instead of hammers or boomerangs, they throw coins.

GOLD BULLET BILL

As they fly, they leave a trail of coins behind them.

GOLD CHEEP CHEEP

These swim through the water, trailing a string of coins behind them.

GOLD FIRE PIRANHA PLANT

These act just like normal Fire Piranha Plants and shoot fireballs out of their mouths.

GOLD GOOMBA

Gold-colored Goombas. Mario gets coins when he defeats them.

GOLD GOOMBA TOWER

If you can defeat them in a series, you get more and more coins for each one you defeat.

GOLD KOOPA TROOPA

If Mario kicks a Gold Koopa Troopa's shell, coins appear behind it.

GOLD KOOPA PARATROOPA

When Mario jumps on them, they lose their wings and become Gold Koopas.

GOLD LAKITU

They throw coins. If you can get aboard their clouds, they produce coins as they fly.

GOLD PARAGOOMBA

When Mario jumps on them, they lose their wings and become Gold Goombas.

GOLD PIRANHA PLANT

When these appear out of pipes, if Mario can defeat them, coins spout out of the pipe.

GOOMBA

They walk along slowly. They're blue in places like Ghost Houses.

GOOMBA TOWER

These are a whole bunch of Goombas standing on each other. Their number varies from place to place.

GRINDER

They follow a certain route, spinning their blades like a buzz saw. Watch out for the huge ones!

HAMMER BRO

These green-shelled enemies attack by throwing hammers.

IGGY KOOPA

The boss of W2. He's pulled in a carriage behind a Chain Chomp.

KOOPA PARATROOPA (GREEN)

Some of these fly through the sky, and others bounce along the ground.

KOOPA PARATROOPA (RED)

They fly through the sky. When Mario jumps on them, they lose their wings and become normal Red Koopa Troopas.

KOOPA TROOPA (GREEN)

They walk in a straight line along the ground. If Mario jumps on them, they leave behind a shell Mario can carry.

KOOPA TROOPA (RED)

They turn around to avoid cliffs, but otherwise act just like Green Koopa Troopas.

KOOPALINGS

They fly along in the Koopa Clown Car, casting flashing spells that can turn Mario to stone.

LAKITU

They throw Spiny Eggs from the sky. Some of them can fly very close to the ground.

LARRY KOOPA

The boss of W🌑. When he uses his magic, pillars extend from the floor and ceiling.

LAVA BUBBLE

These balls of fire jump straight up from the lava. They come out at regular intervals.

LEMMY KOOPA

The boss of W🌑. He uses his magic to make bouncing balls that bump Mario from the conveyor belt.

LUDWIG VON KOOPA

The boss of W5. He grabs onto chains and shoots magic from on high.

MICRO GOOMBA

They don't damage Mario if he touches them, but they can slow him down.

MORTON KOOPA JR.

The boss of W4. He magically controls Spiked Balls and his tremors can keep Mario from moving.

PARABOMB

They float down from the sky. When they are attacked or hit a surface, they become Bob-ombs.

PARAGOOMBA

They bounce along the ground heading toward Mario. If he jumps on them, they become normal Goombas.

PEEPA

They move in groups along a set route. They don't get embarrassed or stop when Mario looks at them.

PIRANHA PLANT

Some peek out of pipes, while others are planted in the ground.

POKEY

They're a big stack of cactus balls. Mario can cut them down to size by knocking away segments.

PORCUPUFFER

They swim along the surface of the water or in poison swamps, occasionally jumping to attack.

REZNOR

Tower bosses. They sit on long ? Blocks while they rotate around.

ROY KOOPA

The boss of W1. He rushes in to tackle Mario, but if he hits a wall, he gets dizzy.

SCUTTLEBUG

They appear from above and scuttle up and down their thread.

SLEDGE BRO

They throw hammers to attack. They can jump high, and cause strong tremors.

SMALL URCHIN

These are tiny Urchins. They may be small, but they move just like regular Urchins.

SPIKE TOP

They have a big spike on their shells and circle around platforms.

SPINY

They have a jump-proof spiny shell and hatch from Spiny Eggs.

SPINY CHEEP CHEEP

These are faster than normal Cheep Cheeps. They relentlessly chase Mario.

SPINY EGG

Those spiky things that Lakitus throw. They become Spinies when they hit the ground.

SWOOP

They hang from the ceiling, waiting. When Mario comes close, they dive at him.

THWOMP

They fall when Mario gets close, then slowly return to their original spot.

URCHIN

They undulate up and down in the water or roll around.

WENDY O. KOOPA

The boss of W3. Her room fills with water to prevent Mario from stomping on her.

WHOMP

They come close to Mario and fall forward, trying to smoosh him. Others shuffle side to side.

WIGGLER

They usually stroll along peacefully until jumped on. Then they sprint around, furious.

WORLD

There are eighty-five courses. You need to clear the hidden cannon courses to get to W 🍄 or W 🌟.

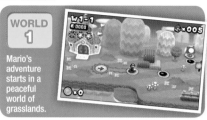

WORLD 1
Mario's adventure starts in a peaceful world of grasslands.

W1-1
This is a grassland course with many Note Blocks. There are also a lot of gold blocks.

W1-2
The place is filled with tiny enclosed rooms that have Koopa Troopas in them.

W1-3
A wooded area lined with trees. There are some items hidden at the tops of the trees.

W1-🏰
The Snake Blocks are Mario's platforms as he moves up the tower.

W1-4
An athletic course where mushrooms are Mario's footholds. Here's the first appearance of the gold ring.

W1-5
An underwater swimming course where coins and Cheep Cheeps swim in circles.

W1-A
Pipes going every which way make up this mazelike course.

W1-🏯
Mario uses the ropes to advance. Take care not to fall in the lava.

W1-🏯
Mario must avoid the Koopa Paratroopas as he dashes and jumps.

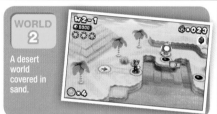

WORLD 2
A desert world covered in sand.

W2-1
A desert landscape with moving platforms. There's a gold flower hidden somewhere underground.

W2-2
A place where the platforms look like a line of totem poles. Boomerang Bros. are waiting for Mario.

W2-3
An athletic underground course. There are Pokeys on some of the lifts.

W2-🏰
Mario uses the platforms moving in various directions to make his way up the tower.

W2-🏚️
Mario is mostly trying to escape from the Boohemoth in this haunted house.

W2-4
A course set up like a pyramid. Work upward on these steplike blocks.

W2-5
A nest of Chain Chomps living in the desert. Beware their biting teeth!

W2-🏯
Have Mario get on the Switch Lifts to move over the lava. There are enemies attacking from above.

W2-A
An athletic course where Mario jumps from rail lift to rail lift.

W2-B
This is a volcanic region with Parabombs floating down. Mario can use the Bob-ombs to get a ton of coins.

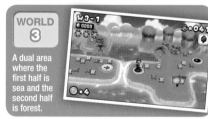

WORLD 3
A dual area where the first half is sea and the second half is forest.

W3-1
A shallows area with Cheep Cheeps jumping from the water. Use barrels to cross.

W3-2
An underwater course where Urchins and Snake Blocks try to hinder Mario.

W3-3
Mario's in the middle of the forest with a poison swamp below his feet. Use the spider webs to move along.

W3-🏰
Skewers come crashing in from the right and left as Mario swims his way through this autoscrolling course.

W3-4
Mario crosses crates floating on the poisoned water. In the second half, the level ebbs and flows.

W3-🏚️
Mario has to make his way through by getting aboard haunted lifts that move through weird rules.

W3-5
An underwater course moving diagonally upward. Huge boulders come rolling down toward Mario.

W3-🏯
When the path narrows, Mario will have to avoid Grinders to get through.

W3-A
The flowing water sends Mario sideways and upward toward the goal.

W3-B
Mario can choose between two routes in a course made just for Mini Mario.

W3-🏯
Scuttlebugs and Wigglers are waiting for Mario here. Does Mario head up or stay low?

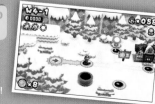

WORLD 4
A world covered in ice and snow. It's easy to slip!

W4-1
Balls of ice roll down as Mario climbs this snowy mountain. In the second half, he slides back down.

W4-🏚️
Boos within the walls try to stop Mario as he makes his way through this haunted house.

W4-2

A snowy plains course with a lot of Koopa Troopas and Piranha Plants.

W4-

A lot of boney enemies await Mario here. Get aboard the rising ice floor to move upward.

W4-3

A sloping path covered in ice. There are a lot of Piranha Plants here.

W4-4

An athletic course where Mario has to use the Waving Mushrooms and Scale Lifts to move along.

W4-5

An underwater course where the Cheep Chomps relentlessly chase Mario.

W4-

Things get dicey in this castle due to the Snake Blocks and Spiked Balls.

W4-A

Move along using the Mushroom Trampolines. Goombas are using them, too.

W4-B

An icy cavern course. Amps are running on tracks, blocking the narrow passages.

W4-C

Fuzzies large and small ride the tracks as Mario makes his way upward out of this cave.

WORLD 5

A world above the clouds, where there aren't many footholds.

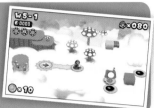

W5-1

Walk and jump along the tightropes high in the sky.

W5-2

There are lots of Piranha Plants and Lakitus, but can the gold ring get Mario a bonus?!

W5-3

Choose the route using the Pipe Cannons to shoot Mario through the course.

W5-

Climb the fences to escape from the lava rising up from below.

W5-4

An athletic course using the rising and falling mushrooms.

W5-5

Mario uses the Snake Blocks as platforms while Bullet Bills fly toward him from all sides.

W5-6

Climb down the rocky cliff, avoiding all the Piranha Plants.

W5-

Below is lava and above are hanging Piranha Plants. Mario's way across are the fences that move up and down.

W5-

Blocks make up large platforms that swing back and forth. Mario must use these to advance through the course.

W5-A

Board and move along on the golden ship. If Mario uses the gold rings, he can fill his pockets with coins.

WORLD 6

Lots of lava in this final (?) world.

W6-1

Volcanic debris falls from the sky, breaking up the only platforms Mario has.

W6-

Mario shifts back and forth between two sets of rooms that look very much alike.

W6-2

Board the Spine Coaster to cross the wide lava sea.

W6-3

An underground course with a lot of Mushroom Platforms. Fire Bros. are waiting for Mario.

W6-

Mario must make his way upward, switching off Burners as he goes.

W6-4

A creepy valley with a lot of ghosts. Get aboard the haunted lift to move forward.

W6-5

Bowser's fireballs come one after the other. The seesaw lifts make for unstable footholds.

W6-

This is the last battle with Bowser. The seven Koopalings try to block Mario all the way through.

W6-A

Mario has to run over the rocking platforms with the lava rising little by little.

W6-B

Mario gets aboard the elevator lifts while tons of Bullet Bills come shooting toward him.

**WORLD **

Mario can visit this odd world only after having cleared the Warp Cannon on W1.

W-1

Lots of colorful platforms are host to a bunch of Koopa Troopas and bouncing Koopa Paratroopas.

W-2

There are Urchins floating in the space between moving rocks in this underwater course.

W-

If Mario can use the devices cleverly, he can get a ton of coins in this underground course with unclaimed riches.

W

A haunted house with a lot of ? Switches and doors. Mario has to hit the correct switches and work through the puzzle.

W-

Mario has to run to avoid the Giant Spiked Ball rolling toward him. He must make his way over the stone blocks.

W-A

An icy cave with Spiked Balls rolling around. Mario has to make his way upward.

W-B

A nonstop scrolling course where Mario works upward. He has to move from one vine to the next.

W-

Dash through while avoiding the Crowbers who come charging at Mario.

**WORLD **

A world Mario can only get to by clearing a Warp Cannon on W3 or W.

W-1

A sunset course where Mario makes his way over pipes and Snake Blocks.

W-

A haunted house strewn with spider webs. The basement is filled with water.

W-2

The Porcupuffer swims along the surface of the poisoned water, chasing Mario through the course.

W ⬜-3
Slide down long slopes and go up again using the Pipe Cannons.

W ⬜ - 👥
Get on the conveyor belts and avoid the Bone Goombas and Bob-ombs that the belts bring.

W ⬜-A
Mario boards a moving block of ice to make his way through this icy cave.

W ⬜-B
An athletic course making use of Mushroom Trampolines. Avoid the Lakitus!

W ⬜ - 👤
Avoid the Bob-ombs on the platforms and the Amps in the air as Mario dashes.

WORLD ⭐
Collect ninety Star Coins and clear the game to access this world.

W ⭐ -1
A nighttime world with blocks blanketing the surface.

W ⭐ -2
An athletic course with a lot of moving Rail Lifts following W-shaped rails.

W ⭐ -3
There are a lot of small platforms with Whomps on them above the rushing waters.

W ⭐ -4
The water just keeps on rising as Mario works his way diagonally upward on this forced-scrolling course.

W ⭐ -5
An athletic course filled with Scale Lifts. When enemies get on them, they change the balance.

W ⭐ -6
A castle-like underwater course where Fish Bones keep watch.

W ⭐ -7
This huge pack of fire-type enemies and traps hinders Mario as he traverses the rocks above the lava lake.

W ⭐ - 👹
A difficult castle course. Dry Bowser awaits Mario at the end. The seven Koopalings show up to cause trouble, too.

ITEMS & OBSTACLES

Here's a list of things you'll find on courses. There are a lot of items here that help Mario in his quest to collect coins.

! PIPE
When you shoot fireballs into the pipe, items and coins appear.

! SWITCH
When Mario presses it, the invisible blocks become solid for a while.

? BLOCK
Items can appear when Mario hits them. They can change color depending on the screen they're found on.

? SWITCH
When Mario flips the switch, he sets off a mechanism or causes some other change.

1-UP MUSHROOM
Earns Mario an extra life. They come out of things like hidden blocks.

10 COIN
When Mario gets one of these, it's worth ten coins.

10-COIN BLOCK
Looks like a normal block, but it produces coins when hit.

100 COIN
When Mario gets one of these, he receives one hundred coins. These appear on the Rainbow Courses.

ASSIST BLOCK
Lose five lives on a course and an Assist Block will appear. It contains an Invincibility Leaf.

BALLS OF FIRE
These shoot up from the lava in succession. They fly slowly in an arching motion.

BANZAI BILL BLASTER
These cannons blast out Banzai Bills.

BARREL
These float on water. When Mario gets on, they sink.

BILL BLASTER
These cannons fire Bullet Bills. When Mario goes through a gold ring, they turn gold.

BILL BLASTER TURRET
They spin around, sending a Bullet Bill left and right in quick succession.

BLOCK
When Mario hits them, they break. Some of these can produce items.

BLUE COIN
They appear when Mario presses a P Switch. They have the same effect as normal coins.

BOO WALL
Boos control these walls and move them, forcing Mario to take a specific path.

BOULDER
These roll through underwater caves and destroy any enemies or blocks in the way.

BOUNCING BALL
These bounce along, springing away anything that touches them.

BOWSER STATUE
They fire off Bowser Fireballs. The purple ones are homing fireballs.

BOWSER'S FIREBALLS
They fly straight forward. They have the same effect regardless of size.

BURNER
These shoot out a pillar of fire vertically or horizontally. There's a type that runs on tracks as well.

CHECKPOINT FLAG
Touch this flag to start at this point if Mario loses a life.

COIN
Collect one hundred to earn an extra life.

COIN VOLCANO
If Mario can blow the top of it off with a Bob-omb, it erupts and coins come spewing out.

INTRODUCTION CHARACTERS WORLD AND MORE

CONVEYOR BELT
When Mario gets on, he is pulled along in a particular direction. There's a type that can change directions.

CONVEYOR BELT SWITCH
When Mario hits one, it changes the direction of the conveyer belt.

CRATE
These float in the poison swamp. When Mario gets on, they start to slowly sink.

CURRENT PIPE
This pipe gushes water and washes away anything caught in the stream.

DONUT BLOCK
Long or short, if Mario stands on them for a while, they fall.

DOTTED LINE BLOCK
When a ! Switch is hit, they turn into red blocks briefly.

ELEVATOR
Some run on rails. Some fall almost as soon as Mario gets on.

ELEVATOR LIFT
A jump will change the direction these platforms go.

FENCE
Grab on and climb in any direction. Punch the fence for different effects.

FIRE BAR
They are rotating chains of fireballs. They come in many different lengths.

FIRE FLOWER
This is the power-up that makes Fire Mario.

FLOWING WATER
This is a rushing current underwater that carries everything with it.

FLYING ? BLOCK
These winged ? Blocks fly through the sky. Sometimes they appear when you hit a regular ? Block.

FLYING GOLD BLOCK
This appears when your score goes over 200,000.

GHOST DOOR
These doors are Boos in disguise! When Mario tries to enter one, they vanish and produce a coin.

GIANT ! SWITCH
They show up when fighting Bowser, and deliver the coup de grâs.

GOAL POLE
Grab the Goal Pole to complete the course. The higher Mario touches it, the more points you'll earn.

GOLD BLOCK
When wearing this, Mario will earn coins just by running and jumping!

GOLD FLOWER
A power-up that allows Mario to become Gold Mario.

GOLD RING
When Mario touches this, enemies turn gold for a short time. Gold enemies produce coins in various ways.

HAND-OVER-HAND ROPE
Mario can move left or right while dangling from this rope.

HANGING ROPE
They act just like the hanging vines, but they're found in Ghost Houses and castles.

HANGING VINE
These swing right and left. If Mario grabs on, he can use them to move along.

HAUNTED LIFT
The Peepas holding it up like to play pranks. They tilt the lift to make it harder to stand on.

HAUNTED STAIRWAY
These are found on slopes in Ghost Houses. They play keep-away with the stairs.

HIDDEN BLOCK
These blocks appear when it seems like nothing is there. Some also contain coins or items.

HIDDEN COIN
Coin shapes marked by a dotted line. When Mario touches them, they turn into real coins.

HIDDEN GOAL POLE
A Goal Pole with a red flag on it. They lead to hidden routes.

ICE BOULDER
These appear on snow courses. They defeat enemies and destroy blocks as they roll.

ICE DONUT BLOCK
They have the same effect as normal Donut Blocks, except they're slippery.

INVINCIBILITY LEAF
These power Mario up into White Raccoon Mario.

KEY
These appear when Mario defeats the boss of the castle. Grab it to clear the world.

LAVA
It's lethal. On some courses it rises up from below.

LONG ? BLOCK
When Mario hits them, they can produce three coins or sometimes items.

MEGA MUSHROOM
When Mario gets one of these, he powers up to Mega Mario. They can appear from ! Pipes.

MINI MUSHROOM
A tiny mushroom that can be used to power up to Mini Mario.

MINI PIPE
Very small pipes. There is a type that only Mini Mario can enter.

MOON COIN
These appear on W ☆. There are three hidden on each course.

MOVING FENCE
The fence starts to move along the track when Mario grabs on. It shifts up or down with a punch.

MUSHROOM PLATFORM
With Mario on board, one side rises while the other descends.

MUSHROOM TRAMPOLINE
When Mario gets on, he bounces. The ones found in castles are gray.

NOTE BLOCK
When Mario gets on, he bounces. If you time it right, he can bounce very high.

ONE-WAY FLIPPER
These can be found in walls, ceilings, or floors, allowing only one way through.

P SWITCH
If you step on it, various environmental changes will occur.

PADDLE WHEEL
Lifts with a number of platforms. There are types that move on their own and types that don't.

PARABOMB CANNON
They shoot out Parabombs. There's a type that can swing its bore side-to-side.

PIPE
Sometimes enemies come out, and sometimes they can be used to move through the course. Some even spout coins.

PIPE CANNON
If Mario hops in, he'll be launched out!

POISONED WATER
The tainted waters are instantly lethal, occasionally rising and falling.

POLE
If Mario grabs on, he can climb up or down. He can use them to jump right or left.

QUICKSAND
Mario will start to sink but can escape if he keeps jumping.

RAIL LIFT
These lifts move along rails. Some only move when Mario gets on.

RED COIN

These sometimes float down on parachutes.

ROULETTE COIN BLOCK

Hit it, and coins matching the value printed on the block come out.

RED POW BOCK

Hit this to unleash a shockwave that destroys nearby blocks.

RED RING

If you touch this, eight Red Coins will appear. If you collect all of the Red Coins within the time limit, an item will appear.

RISING LIFT

They appear during the battle with Bowser. They float up from the bottom, but when Mario gets on, they start to fall.

ROTATING BLOCK

These are blocks that spin. Some rotate at fixed intervals, but others start rotating only when Mario gets close.

ROULETTE BLOCK

Mario gets the item that's showing when he hits it.

SCALE LIFTS

When anything weighs down one side the other moves up.

SEESAW LIFT

The side that Mario is on descends. This is a platform that acts like a seesaw.

SKEWER

These come crashing in from the right and left at regular intervals.

SNAKE BLOCK

They move on a particular path. Some don't move until Mario hops on.

SPIDER WEB

Mario can grab on and move, but once he jumps off, it vanishes for a short time.

SPIKE TRAP

They can be found on walls and floors. If Mario touches one, he takes damage.

SPIKED BALL

They tend to roll around a particular place, while others fall from above.

SPIKED BLOCK

These are covered in spikes, so if Mario touches one, he takes damage. They come in many different lengths.

SPINE COASTER

Mario rides this lift across lava. It has three sections that rise and fall like waves.

STAR COIN

Every course contains three of these. Once collected, they can be used to open new paths on the map screen.

STONE BLOCK

A hit won't destroy these blocks, but Mega Mario or a Bob-omb explosion can.

STRETCHING MUSHROOM

Mushroom Platforms stretch to the sides at regular intervals.

SUPER LEAF

With this, Mario can power up to Raccoon Mario.

SUPER MUSHROOM

With this, Mario can power up to Super Mario.

SUPER STAR

These make Mario invincible for a short time. His dash speed also increases.

SWITCH LIFT

When Mario is on the lift it moves, and when he leaves it stops.

SWITCH-BURNER

These send out pillars of flame. Hit the ! Block to briefly turn them off.

TRAMPOLINE

These come out of blocks and can allow Mario to jump very high.

TRAMPOLINE BLOCK

They can be disguised in the floor or are invisible.

TIGHTROPE

When Mario gets on, he can move right or left. He can also use them to jump very high.

VINE

Mario can climb up or down it. They can sometimes be found in blocks.

VOLCANIC DEBRIS

It comes falling down from the top of the screen. If it hits Mario, he takes damage.

WAVING MUSHROOM

These are Mushroom Platforms that tilt to the right and left.

WHIRLPOOL

If Mario enters one, he is pulled downward. If he's pulled all the way down, you lose a life.

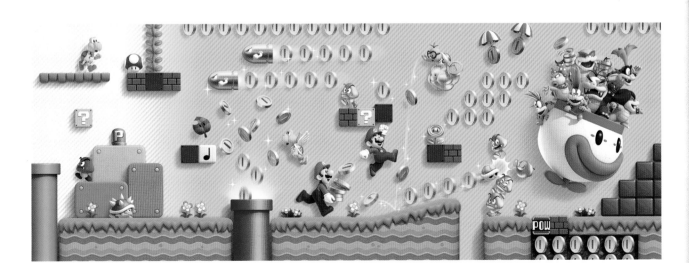

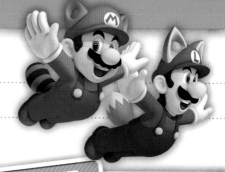

AND MORE

Here we'll go over some memorable scenes, many of which are unique to this game within the *New Super Mario* series.

DASH TO WARP

In previous *New Super Mario Bros.* games, you simply get into the cannon and warp. But in this game, the only way to warp is with a successful dash. Once Mario starts running, he doesn't stop, and you have to navigate the special course. Once you clear it, you can successfully warp.

STRIKE A POSE!

Raccoon Mario and other powered-up forms all have different poses when clearing a course.

BREAKING BARRIERS AS MEGA MARIO

In previous *New Super Mario Bros.* games, if you grab the Goal Pole as Mega Mario, it breaks. That's true of this one too, but the only world you can do it in is W5-6. Still, if you break the Goal Pole, you get a bonus of three 1-Up Mushrooms.

FROZEN IN THE HEADLIGHTS

If Mario gets caught in the flash of light shining out of the Koopa Clown Car, he gets turned to stone and can't move for a while. But petrified Mario is a rare sight that you can't see in other games.

THE HIDDEN ROAD TO W🍄 & W🌼!

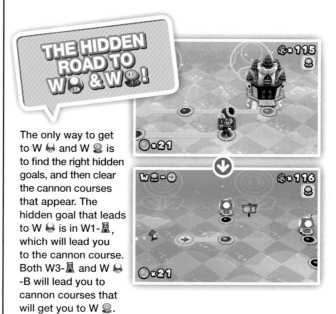

The only way to get to W🍄 and W🌼 is to find the right hidden goals, and then clear the cannon courses that appear. The hidden goal that leads to W🍄 is in W1-🏯, which will lead you to the cannon course. Both W3-🏯 and W🍄-B will lead you to cannon courses that will get you to W🌼.

LUIGI GOES ON AN ADVENTURE

After you defeat Bowser, go to the save-file screen. While holding the L and R Buttons, press the A Button and you'll unlock Luigi. He plays just the same as Mario, but where Mario would become Gold Mario, Luigi becomes Silver Luigi, among other visual differences.

THE WAY TO W ★!

After you defeat Bowser and head toward the ending, the world of W ★ opens up. But to proceed into the world, you need to have collected ninety Star Coins. The coins hidden on the W ★ courses are Moon Coins rather than Star Coins.

SHOWDOWN WITH DRY BOWSER!

In the very final castle in W ★, Dry Bowser is awaiting Mario. He throws bones and breathes blue fire to attack. Fireballs don't affect him.

HELPFUL HINTS & TECHNIQUES

Here are some tips and tricks to help you collect coins. If you gather enough coins, a golden Mario statue appears on the title screen.

THE RAINBOW COURSE: A VERITABLE COIN HEAVEN!

In any of the worlds, if the last two numbers on the timer match the course number when you grab the Goal Pole, it opens up a Rainbow Course—a bonus course with a lot of coins! With W1, you need 11. For W 🍄 you need a 77, W 🌑 requires an 88, and on W ★, you need a 99.

MARIO DOFFS HIS CAP!

When your extra lives reach triple crowns (meaning 1,110 lives), Mario adventures without his cap. Luigi is the same. Even when you turn him into Mega Mario or Fire Mario, he won't have his cap. But when the remaining lives go down again, he returns to normal.

STARRY SAVE FILE

When you fulfill all the necessary conditions, you can get five stars on your save file. Those conditions are to clear the W6-🏰 course, clear all the courses without using White Raccoon Mario, collect all possible Star Coins, collect all possible Moon Coins, and save the game with 1,110 remaining Marios. If you can go through the whole game without ever having an Assist Block appear, the stars twinkle.

THE FLYING GOLD BLOCK

If you can get a score of over 200,000, a winged flying gold block will appear on the world map. If you run the score up to the highest number (999,999,999), then the flying gold block appears on every course.

A GOLDEN MARIO STATUE

When you surpass one million coins, you'll find that a golden statue of Mario has been built on your title screen. If you can collect the maximum amount (9,999,999 coins), you'll find the statue is now a golden Raccoon Mario.

THE SECRET TOAD HOUSE

If you can collect all of the Star Coins from worlds W1-W6 plus W 🍄 and W 🌑, a special Toad House appears on W ★, where you can stock up a Super Star.

COINS IN THE CREDITS

As the credits are rolling, you can control Mario and still collect a lot of coins. The coins you collect will be added to your total.

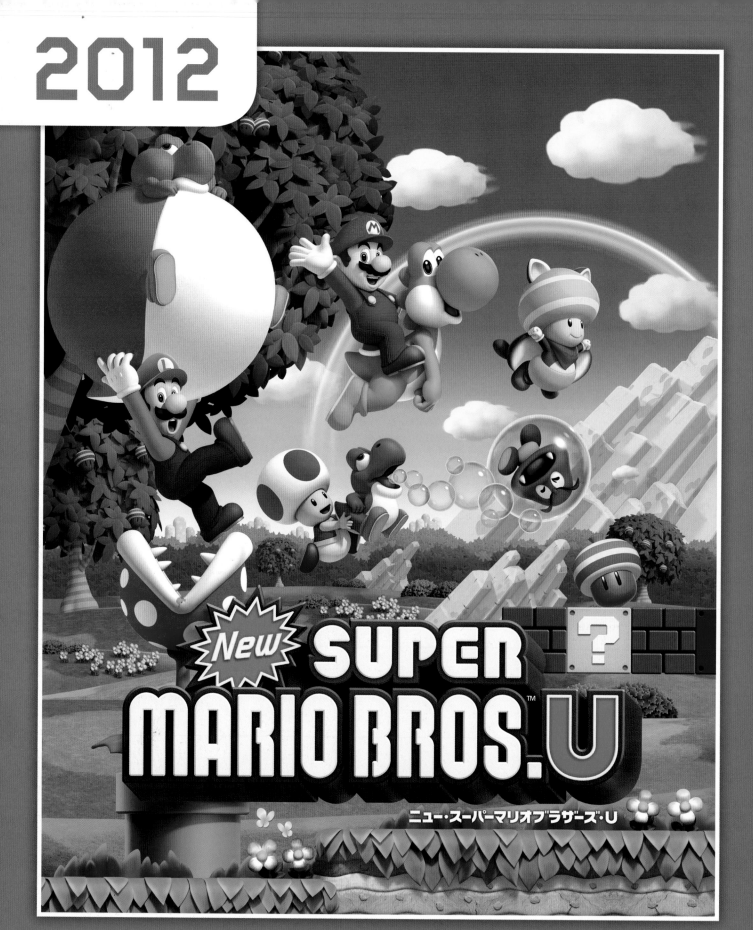

New SUPER MARIO BROS. U

ニュー・スーパーマリオブラザーズ・U

Package

Game Disc

Instruction Booklet

System: Wii U
Release Date:
November 18, 2012
(Japan:
December 8, 2012)
Player Count: 1-5

 # INTRODUCTION

S T O R Y

Princess Peach has invited Mario, Luigi, and the Toads to a tea party! But amid their fun conversation, Bowser and a fleet of Koopaling airships invade the Mushroom Kingdom!

A huge mechanical arm stretches from the biggest ship. It grabs Mario, Luigi, and the Toads and flings them toward the horizon.

They land in a place they've never seen before—right in the boughs of an Acorn Tree. From that vantage point they can see Princess Peach's Castle is still under attack from Bowser's fleet.

Mario and his friends have to make their way back again to Peach's Castle to help her!

F E A T U R E S

UP TO FIVE PEOPLE CAN PLAY!

If you add the Wii U GamePad to four other controllers, up to five people can play this 2D action side-scrolling adventure game. The player with the GamePad can use the touch screen during Boost Mode to start mechanisms moving or stop enemies in their tracks in order to help Mario and his friends get through their adventure.

A single player can also play with the Wii U GamePad alone, seeing the entire world from end to end. And with Baby Yoshi in tow, Mario can make his way to the besieged Peach's Castle.

PLAY WITH Mii!

Aside from the main story mode, you can also enjoy several different types of play. There are three different modes in the game. You can play with your Mii in each of these modes.

CHALLENGES

Go on several different challenges, including Time Attack Rush where you try to get to the goal in the fastest time.

BOOST RUSH

Amid the nonstop auto-scrolling, your hero has to make their way to the goal at top speed. The auto-scrolling speeds up when grabbing coins.

COIN BATTLE

The players compete to pick up coins and get the highest score. Switch things up by editing the courses and place coins wherever you want.

WHEN MARIO'S AWAY, LUIGI PLAYS NEW SUPER LUIGI U!

New Super Luigi U became available as a downloadable title, and was later released on disc. It's a complete remake with eighty-two courses, all starring Luigi. Aside from the special abilities you expect from Luigi—such as his higher jump but slippery footing—there are also features which differ from the main series of games. These include all courses having a countdown clock starting at one hundred. Since Mario is missing, Nabbit has joined the crew with the perk of being immune to enemies' attacks. *New Super Luigi U* was released for download on June 20th, 2013, and was also released with limited-edition packaging exclusively in the year 2013.

CHARACTERS

PLAYER CHARACTERS

There are four characters who set out on the adventure. If you're using Boost Mode, up to five people can play.

LUIGI

He appears when you're in multiplayer play or using the Super Guide.

YELLOW TOAD

He appears in multiplayer play. His abilities are the same as Mario's.

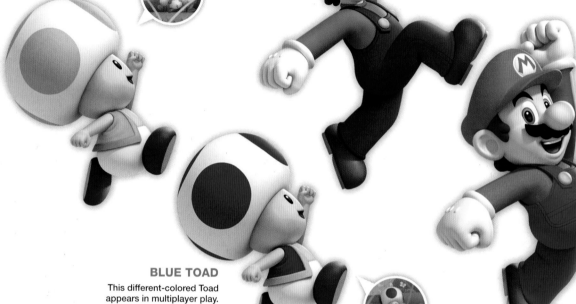

BLUE TOAD

This different-colored Toad appears in multiplayer play.

MARIO

The main character, and the only player character in solo play.

POWER -UPS

When Mario picks up different items, he powers up and has all sorts of abilities. There are some power-ups that can only be obtained on the map screen.

SMALL MARIO

This is Mario's state when the game begins. He can't break blocks, and if he's hit by an enemy, you lose a life.

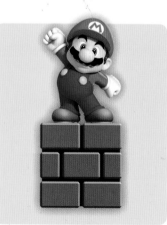

 SMALL MARIO

 SMALL LUIGI

 SMALL YELLOW TOAD

 SMALL BLUE TOAD

SUPER MARIO ITEM ⇨ SUPER MUSHROOM

He can break blocks with a punch or ground pound, but if he takes damage he becomes Small Mario again.

 SUPER MARIO

 SUPER LUIGI

 SUPER YELLOW TOAD

 SUPER BLUE TOAD

FIRE MARIO — ITEM → FIRE FLOWER

Mario can attack enemies by throwing fireballs. Two fireballs can be on-screen at a time.

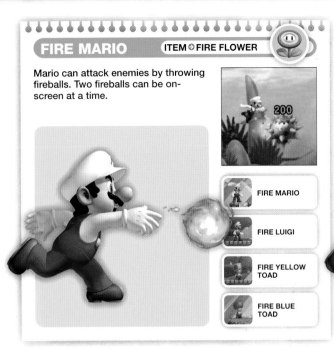

- FIRE MARIO
- FIRE LUIGI
- FIRE YELLOW TOAD
- FIRE BLUE TOAD

ICE MARIO — ITEM → ICE FLOWER

He throws ice balls that freeze enemies when they're hit. When he's attacking big enemies, they're only frozen briefly.

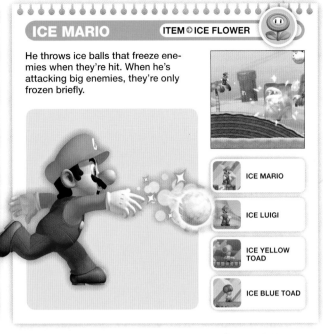

- ICE MARIO
- ICE LUIGI
- ICE YELLOW TOAD
- ICE BLUE TOAD

FLYING SQUIRREL MARIO — ITEM → SUPER ACORN

Flying Squirrel Mario can glide through the air. If Mario does a Flying Squirrel jump while gliding, he can rise higher up. He can also cling to walls for a short time.

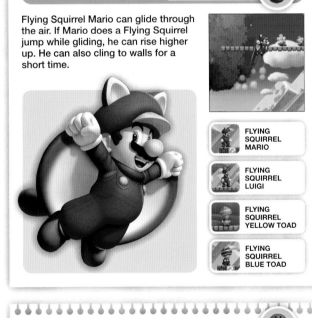

- FLYING SQUIRREL MARIO
- FLYING SQUIRREL LUIGI
- FLYING SQUIRREL YELLOW TOAD
- FLYING SQUIRREL BLUE TOAD

PROPELLER MARIO — ITEM → PROPELLER MUSHROOM

When you shake your Wii Remote, Mario flies high into the air. Like the Penguin Suits, Mario can only obtain this power up in Superstar Road Toad Houses.

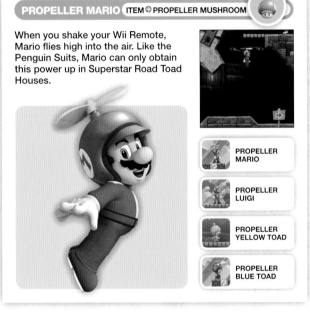

- PROPELLER MARIO
- PROPELLER LUIGI
- PROPELLER YELLOW TOAD
- PROPELLER BLUE TOAD

PENGUIN MARIO — ITEM → PENGUIN SUIT

Penguin Mario not only throws ice balls, but also swims more gracefully and won't slip on ice. He can also do a belly side with the suit.

- PENGUIN MARIO
- PENGUIN LUIGI
- PENGUIN YELLOW TOAD
- PENGUIN BLUE TOAD

MINI MARIO — ITEM → MINI MUSHROOM

Mario becomes much smaller, and he floats longer when he jumps. He can also run straight up and down walls.

- MINI MARIO
- MINI LUIGI
- MINI YELLOW TOAD
- MINI BLUE TOAD

INVINCIBLE MARIO ITEM ⇒ SUPER STAR

For a short while, Mario's body starts glowing, and he can defeat any enemy just by touching them. If Invincible Mario can defeat eight enemies in a row, you get a 1-Up.

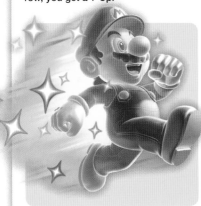

	INVINCIBLE MARIO
	INVINCIBLE LUIGI
	INVINCIBLE YELLOW TOAD
	INVINCIBLE BLUE TOAD

POWER SQUIRREL MARIO ITEM ⇒ P-ACORN

When certain conditions are fulfilled, Mario gets a P-Acorn. The basics are the same as Flying Squirrel Mario, but he can do unlimited Flying Squirrel Jumps.

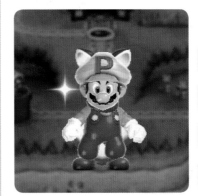

	POWER SQUIRREL MARIO
	POWER SQUIRREL LUIGI
	POWER SQUIRREL YELLOW TOAD
	POWER SQUIRREL BLUE TOAD

YOSHI'S CREW

Yoshis and Baby Yoshis appear during Mario's adventures to lend a hand (and tongue)!

YOSHI

They emerge from ? Blocks on certain courses. They can extend their long tongues to eat fruit or lengthen their airtime by kicking after jumping. Mario and Yoshi always part ways once the course is cleared.

BABY YOSHI

Mario can carry them, and they eat enemies just by touching them. By shaking the Wii Remote, you can activate several different abilities.

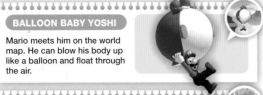

BALLOON BABY YOSHI

Mario meets him on the world map. He can blow his body up like a balloon and float through the air.

BUBBLE BABY YOSHI

Mario meets him on the world map. He can blow bubbles that encase enemies, making them items.

GLOWING BABY YOSHI

He appears on particular courses. His body glows, lighting up dark places. He can make some enemies flinch.

OTHER CHARACTERS

Characters who interact with Mario during his adventure.

NABBIT

He appears on certain courses. Mario will get an item if he can catch Nabbit.

PRINCESS PEACH

She and her entire castle are under siege by Bowser's forces.

TOAD

He helps Mario during his adventure by giving him items.

ENEMIES

These are the enemies you'll face in the game. Many of them should be familiar to Mario fans.

AMP

They spin after they give off an electric shock, but they never move from where they're placed.

BANZAI BILL

They're shot out of Banzai Bill Blasters and fly straight ahead.

BIG AMP
Large Amps. They behave like their smaller counterparts and can be frozen with a tap on the GamePad.

BIG BOO
Large Boos. They're still super shy, but they're so large it's hard to get around them.

BIG BUZZY BEETLE
A huge Buzzy Beetle. If they touch the lava, they turn into a shell and float.

BIG DRY BONES
A large-sized Dry Bones. They laugh at any attempt to jump on them, but a ground pound will shut them up.

BIG FUZZY
These are a large version of the Fuzzies. They move at high speed along the tracks.

BIG GOOMBA
Jumping on them splits them in two Hefty Goombas. A ground pound will turn them into four Goombas.

BIG KOOPA TROOPA (GREEN)
Huge Koopa Troopas that have the same marching orders as the regular ones.

BIG KOOPA TROOPA (RED)
They drop shells too heavy to carry when jumped on, but three fireballs will take them out.

BIG PIRANHA PLANT
They're larger than normal Piranha Plants, but take root in the same kinds of places.

BIG POKEY
They appear in Morton's Airship to help in his boss battle.

BIG THWOMP
Large version of Thwomps. They're so big they deserve their own postal codes.

BIG URCHIN
Large Urchins. Some ride geysers.

BIG WIGGLER
Very large Wigglers. They don't mind getting jumped on. In fact, they're super springy!

BLOOPER
They shoot out of pipes, then swim toward their prey.

BLOOPER NANNY
These are Bloopers with four Blooper Babies in tow. The babies follow their nanny.

BOB-OMB
Jump on them or hit them with a fireball to light their fuse. They'll explode shortly thereafter.

BONY BEETLE
They walk back and forth. Every now and then they stop, pushing their spikes out, before continuing on their way.

BOO
They chase the unwary when their backs are turned. Several gather in rotating rings.

BOOM BOOM
The tower boss. He swings his arms around to attack, and sometimes he flies.

BOOMERANG BRO
They attack by throwing boomerangs.

BOSS SUMO BRO
The boss of the Rock-Candy Mines tower. He stomps to cause an earthquake and sends down lightning.

BOWSER
He's besieging Peach's Castle. Once defeated, he returns in giant form along with Bowser Jr.

BOWSER JR.
The boss of the flying airships. He gets into his Junior Clown Car and sends out enemies to attack.

BRAMBALL
They walk on long, thorny legs. Their bodies turn into oranges in time with the music.

BROOZER
Broozers come out swinging! Their punches can break stone blocks.

BULBER
They light up the murky underwater areas as they swim slowly along.

BULL'S-EYE BILL
They're red, flashing Bullet Bills that home in on their targets.

BULLET BILL
They are fired out of Bill Blasters and fly straight ahead.

BUZZY BEETLE
They mostly appear underground. When jumped on, they hide in their shells, creating a usable item.

CHAIN CHOMP
They're chained to a stake, limiting their attack range. Ground-pound the spike to set them free.

CHEEP CHEEP
They swim slowly through the water, although the bigger ones swim faster.

CHEEP CHOMP
They get in close before striking. One bite is instant death.

CLAMPY
They open and close their shells at regular intervals. Some hold items.

COOLIGAN
They slide along the icy floor. Jump on them so they drop their sunglasses and speed.

DRAGONEEL
They swim toward prey with their extra-long bodies.

DRY BONES
They fall apart if Mario jumps on them, but reassemble after a bit.

EEP CHEEP
They swim slowly along and avoid confrontation.

FIRE BRO
They attack by throwing fireballs.

FIRE PIRANHA PLANT

They spit fireballs in a straight line.

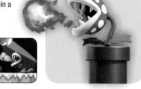

FIRE SNAKE

Their bodies are made of flames. They light up the darkness as they bounce around.

FISH BONE

When they spot prey their eyes light up before they charge in for the kill.

FLAME CHOMP

They float around in the sky, breathing out four fireballs before they explode.

FLIPRUS

They can jump very high in place and throw snowballs.

FOO

They blow obscuring fog.

FUZZY

They move along tracks or stay in one spot.

GOOMBA

They walk slowly along the ground or float on balloons.

GOOMBRAT

They're like Goombas except that they turn around when they reach a cliff.

GRRROL

These round, spiked enemies roll down an incline until they hit a wall; then they roll the other way.

HAMMER BRO

They jump around, attacking by throwing hammers.

HEAVY PARA-BEETLE

They're very large Para-Beetles that descend when ridden.

HEFTY GOOMBA

They're heftier than a regular Goomba. Jump on them to split them into two regular Goombas.

HUCKIT CRAB

They make small jumps and attack by throwing rocks.

ICE BRO

They throw ice balls in a big arching curve to freeze their victims.

ICE PIRANHA PLANT

They stick up out of pipes and shoot ice balls out of their mouths.

IGGY KOOPA

The boss of Soda Jungle. He shoots magic as he craftily navigates the pipes.

JELLYBEAM

They light up the murky water. Their movement determines their luminosity.

KAMEK

The boss of Slide Lift Tower in Meringue Clouds. He uses magic to turn blocks into enemies.

KING BILL

These are Bullet Bills so big they almost blot out the entire screen. They fly both horizontally and vertically.

KOOPA PARATROOPA (GREEN)

Some fly while others merely bounce along the ground.

KOOPA PARATROOPA (RED)

They fly in set patterns in the sky. Jump on them and they become normal Red Koopa Troopas.

KOOPA TROOPA (GREEN)

They walk off cliff edges. They also dance to the music.

KOOPA TROOPA (RED)

They're mindful of cliffs and leave their shells behind when jumped on.

LAKITU

They wander about the sky throwing Spiny Eggs. There's a type that throws Piranha Pods, too.

LARRY KOOPA

The boss of Sparkling Waters. He jumps around, shooting magic attacks.

LAVA BUBBLE

These fiery enemies jump straight up from the lava at different heights.

LEMMY KOOPA

The boss of Acorn Plains. He throws bombs.

LUDWIG VON KOOPA

The boss of Meringue Clouds. He summons magic duplicates of himself during his battle.

MAGMAARGH

These appear when Iggy's magic hits the lava. They hunger for heroes.

MAGMAW

They stick their heads out of the lava and wait for prey to come close.

MECHA CHEEP

Robotic Cheep Cheeps that are immune to fireballs.

MECHAKOOPA

They waddle around until jumped on, and then they can be carried.

MEGA GRRROL

They're larger versions of Grrrols, but are still slaves to gravity. When they hit an obstacle, they turn around.

MINI GOOMBA

They don't hurt, but they do get underfoot.

MONTY MOLE

They burst out of walls and charge straight for their victims.

MORTON KOOPA JR.

The boss of the Layer Cake Desert. He uses his hammer to send Big Pokey segments flying at Mario.

MUNCHER

They appear in groups lined up on the ground. They can't be defeated, but can be run across while invincible.

PARA-BEETLE

They can carry a whole plumber on their backs as they fly, rising while ridden.

PARABOMB

Bob-ombs that float slowly down from the sky. If they're hit with electricity, their parachutes disappear.

PARAGOOMBA

Goombas with wings that bounce along the ground. Jump on them and they become normal Goombas.

PIRANHA PLANT

They ambush victims from within pipes, but can also be found rooted to the ground.

PIRANHA POD

Lakitus throw them. They turn into Piranha Plants when they hit the ground.

POKEY

Tall cactus-like creatures with vulnerable heads. They sometimes hang from the ceiling, too.

PORCUPUFFER

They swim along the surface of the water, jumping every so often.

PRICKLY GOOMBA

They're Goombas inside a spiky shell. Use a fireball to flush them out!

RIVER PIRANHA PLANT

They float on the water's surface, blowing a thorny ball up into the air. They also appear in poison bogs.

ROCKY WRENCH

They appear on flying airships. They stick their heads up from the decks and throw wrenches.

ROY KOOPA

The boss of Rock-Candy Mines. He shoots Bullet Bills from his shoulder-mounted Bill Blaster.

SCAREDY RAT

They walk in a line in the dark. If you attack one, they all scurry off in the other direction.

SLEDGE BRO

They throw hammers to attack and occasionally jump to cause a paralyzing earthquake.

SPIKE

They produce spiked balls from their mouths and throw them at their targets.

SPIKE TOP

They walk slowly along walls and ceilings. They can't be jumped on.

SPINY

They have spiny, jump-proof shells. When a Spiny Egg hits the ground, it hatches into one of these.

SPINY CHEEP CHEEP

When they see their prey, they chase it relentlessly.

SPINY EGG

They're what Lakitus usually throw. They become Spinies when they hit the ground.

STALKING PIRANHA PLANT

They're moving Piranha Plants. They creep from side to side, then stretch their stalks upward.

STONE SPIKE

They pull spiky boulders from their mouths and throw them from above.

SUMO BRO

They shuffle along platforms, occasionally stomping to send out shockwaves.

SWOOP

They hang from the ceiling, waiting to dive and attack.

TARGETING TED

A variation on Torpedo Ted that chases its target relentlessly.

THWIMP

They're block-sized stone enemies. They move around in big, arcing jumps.

THWOMP

They rapidly drop on the unsuspecting, then slowly rise again.

TORPEDO TED

They swim straight forward through the water. Some are propelled from Launch Pads.

URCHIN

Most of them sit in the water, but some undulate up and down or side to side.

WADDLEWING

They walk up to cliff edges and glide off. Some carry Super Acorns.

WENDY O. KOOPA

The boss of Frosted Glacier. She skates over the ice, flinging magic rings.

WIGGLER

They'll mind their own business, but get deeply offended if jumped on.

WORLD

C O U R S E S

Make your way through the many regions. There are even some hidden courses that open shortcuts to Peach's Castle.

ACORN PLAINS

Flat grasslands stretching out from the Acorn Tree.

 1 ACORN PLAINS WAY

A grassland where the Waddlewings fly. Time to stock up on Super Acorns!

 2 TILTED TUNNEL

A cave course with moving platforms and pipes thrusting diagonally out of the ground.

 CRUSHING-COGS TOWER

Ascend using the cog wheels as footholds.

 3 YOSHI HILL

Monty Moles are infesting the walls. Yoshi appears to help!

 4 MUSHROOM PLATFORMS

Use the mushrooms as platforms or stroll through the sky with Balloon Baby Yoshi.

 5 RISE OF THE PIRANHA PLANTS

Big Piranha Plants are rising and descending on the enormous rocky platforms.

 LEMMY'S SWINGBACK CASTLE

Cross the swinging platforms hung on chains above the lava to reach Lemmy's Airship.

 BLOOPER'S SECRET LAIR

An underground waterway with pipes all the way through it. Bloopers shoot out of the pipes.

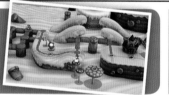

LAYER-CAKE DESERT

A region of desert with Stone-Eyes lined up in a row.

 1 STONE-EYE ZONE

The Stone-Eyes move in an odd way, but they're also footholds through this desert course.

 2 PERILOUS POKEY CAVE

There are a lot of Pokeys and Sand Geysers in this cave.

 3 FIRE SNAKE CAVERN

A dark cavern with platforms that make for unsure footing. Glowing Baby Yoshi lights the way.

 STONESLIDE TOWER

Ascend the tower by moving the crankshaft mechanisms.

 4 SPIKE'S SPOUTING SANDS

Spikes throw their ammo, but where they roll changes depending on the Sand Geysers.

 5 DRY DESERT MUSHROOMS

Use the Mushroom Platforms and watch out for the Stone Spikes.

 6 BLOOMING LAKITUS

Piranha Pods fill the rolling hills with Piranha Plants.

 MORTON'S COMPACTOR CASTLE

The huge block platforms move left and right above the lava, requiring perfect timing.

 PIRANHA PLANTS ON ICE

Fire Piranha Plants use their fireballs to melt the ice blocks—the only way across!

SPARKLING WATERS

Coral reefs spread out as far as the eye can sea—er—see.

 1 WATERSPOUT BEACH

The Water Geysers gush up and Huckit Crab rocks rain down.

 2 TROPICAL REFRESHER

An underwater course where pipes thrust diagonally from the rocks. Big Urchins block the way.

 GIANT SKEWER TOWER

Avoid the thrusting skewers as you have Mario make his way upward.

 HAUNTED SHIPWRECK

Hordes of Boos have taken up residence inside a creepy half-sunken ship.

 3 ABOVE THE CHEEP CHEEP SEAS

Cross the Scale Lifts amid a rain of jumping Cheep Cheeps.

 4 URCHIN SHOALS

The Water Geysers shoot Urchins both big and small.

5 DRAGONEEL'S UNDERSEA GROTTO

It's an intense underwater swimming marathon thanks to the relentless Dragoneel.

LARRY'S TORPEDO CASTLE

A castle of fire and water. Torpedo Teds come from all sides.

SKYWARD STALK

Use the vines and leaves of the giant beanstalk as footholds to climb upward.

FROSTED GLACIER

A snowy mountain region with steep rises and falls.

1 SPINNING-STAR SKY

Accept the challenge of the twinkling, rotating Star Lifts since they're the only footholds.

2 COOLIGAN FIELDS

An ice path where Cooligans slide along in packs.

FREEZING-RAIN TOWER

Get on the lifts and rise up. Icicles both huge and small fall from above.

3 PRICKLY GOOMBAS!

Prickly Goombas and Fire Piranha Plants await any and all challengers.

4 SCALING THE MOUNTAINSIDE

A valley where Banzai Bills, Bullet Bills, and Waddlewings fly. Use the scales to ascend.

5 ICICLE CAVERNS

Falling icicles of varying sizes both help and hinder progress here.

SWAYING GHOST HOUSE

A Ghost House where the screen scrolls. Uncover the secrets to find the exit.

WENDY'S SHIFTING CASTLE

Swinging girders and merciless Thwomps mark the way to Wendy's Airship.

FLIPRUS LAKE

The huge wooden boxes floating on the surface rise, making for unsure footing.

SODA JUNGLE

A forest stretches out over the poison bog. Figure out its mysteries or be lost forever.

THE MIGHTY CANNONSHIP

An airship that can shoot a barrage of cannonballs and Targeting Teds.

1 JUNGLE OF THE GIANTS

A jungle course where the enemies, blocks, and pipes are giant-sized.

2 BRIDGE OVER POISONED WATERS

Blocks, coins, and other things appear in this poison bog.

3 BRAMBALL WOODS

Bramballs wander over Donut Blocks in this deep-woods course.

SNAKE BLOCK TOWER

Board the huge Snake Blocks and avoid the Spinners as they proceed.

WHICH-WAY LABYRINTH

There are a lot of rooms in this murky house, but Glowing Baby Yoshi helps search for the exit.

4 PAINTED SWAMPLAND

Use the half-sunken pipes to get across the poisonous bog.

5 DEEPSEA RUINS

Although it's murky in this jungle lake, Jellybeams light things up.

6 SEESAW BRIDGE

Use the Seesaw Log Bridge to cross while avoiding the River Piranha Plant.

7 WIGGLER STAMPEDE

Big Wigglers stroll through the poison bog, so hitch a ride!

IGGY'S VOLCANIC CASTLE

Waves of lava roll past, briefly sinking the unstable platforms leading to Iggy's Airship.

FLIGHT OF THE PARA-BEETLES

Jump from one Para-Beetle to another in this stroll across the sky. King Bills fly here, too.

ROCK-CANDY MINES

The paths are narrow in this rocky area. Some roads open up using Red and Blue Switches.

1 FUZZY CLIFFTOP

Avoid the Fuzzies running on tracks. Touching them doesn't cause dizziness, just pain.

2 PORCUPUFFER FALLS

Half of this course is in the water. Use both the water and the cliffs to succeed.

GRINDING-STONE TOWER

Enemies like Grrrols and Bony Beetles own this tower.

3 WADDLEWING'S NEST

The Rocking Platform is the key in the first half, and the second half hinges on the elevator.

4 LIGHT BLOCKS, DARK TOWER

Climb the Light Blocks that switch on and off in the blackness of a cave.

5 WALKING PIRANHA PLANTS!

It's a rocky course where the Stalking Piranha Plants walk on the narrow footholds.

6 THRILLING SPINE COASTER

It's hard to see what's ahead in this dark cave, but board the Spine Coaster anyway!

SCREWTOP TOWER

Avoid the Fire Bars while turning the Screwtop Lifts and dodging the Sumo Bros.

7 SHIFTING-FLOOR CAVE

Navigate this athletic cave course with Cross Lifts moving every which way.

ROY'S CONVEYOR CASTLE

Those huge steel crates on the conveyor belts are the only way to Roy's Airship.

MERINGUE CLOUDS

An area of clouds stretching across the sky. Lifts are the best way to get around on many of the courses.

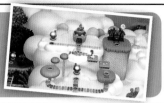

1 LAND OF FLYING BLOCKS

Board that huge cloud and take a trip through the sky. Blocks fly in from out of the blue.

2 SEESAW SHROOMS

Cross the Seesaw Shrooms in the sky while dodging Lakitus in the second half.

3 SWITCHBACK HILL

Try to make good use of the Switchback Platforms while avoiding the Bullet Bills.

SLIDE LIFT TOWER

Ascend using the revolving Slide Lifts. In the top half, Fire Bros. heat things up.

SPINNING SPIRIT HOUSE

There are several rooms that look exactly alike. Find the right doors to get to the goal.

4 BOUNCY CLOUD BOOMERANGS

Use the Bouncy Clouds to get across in this sunset course.

5 A QUICK DIP IN THE SKY

Jump from one of those Water Balls to the next to climb upward.

6 SNAKING ABOVE MIST VALLEY

Board the Snake Blocks on a trip through the Foo-infested sky.

LUDWIG'S CLOCKWORK CASTLE

Clockwork Blocks threaten to sandwich anyone trying to reach Ludwig's Airship.

BOARDING THE AIRSHIP

Attacks come from the airship above! Use the Wii Remote to board.

PEACH'S CASTLE

The area around Princess Peach's Castle, which is still under siege.

1 METEOR MOAT

Avoid the huge Meteors while keeping an eye on the platforms sinking into the lava.

2 MAGMA RIVER CRUISE

The Limited Lifts over the lava stop moving if too many enemies get on! Clear it off fast!

3 RISING TIDES OF LAVA

The tide of lava rises and falls at regular intervals.

4 FIREFALL CLIFFS

Avoid the huge Meteors while scaling what looks like the side of a volcano.

RED-HOT ELEVATOR RIDE

Ride the Wii Remote-controlled platform while trying to escape the rising lava.

THE FINAL BATTLE

The final show-down. En route, Bowser Jr. puts up his final resistance too.

SUPERSTAR ROAD

A special world. You can only play there after you've met certain conditions.

1 SPINE-TINGLING SPINE COASTER

Board the Spine Coaster and avoid the Big Fuzzies along the way.

2 RUN FOR IT

The P Switches turn the coins to blocks and become the only way forward.

3 SWIM FOR YOUR LIFE!

Frantically avoid the Cheep Chomp in pursuit!

4 HAMMERSWING CAVERNS

Between the slippery ice and swinging Hammer Platforms, there are few stable footholds here.

5 SPINNING PLATFORMS OF DOOM

Board the huge, rotating stone block platforms to pass over the poison swamp.

6 FIRE BAR CLIFFS

Enormous Fire Bars are swinging in from all directions.

7 LAKITU! LAKITU! LAKITU!

An athletic course over Slide Lifts. Little by little, more Lakitus join the party.

8 PENDULUM CASTLE

Avoid the Spinners while running over the Donut Blocks.

9 FOLLOW THAT SHELL!

Make use of the clever course design by kicking a Shell.

ITEMS & OBSTACLES

Items and other things you'll find on the courses. These include Boost Blocks and 3-Up Moons as well as other items that can only be found in Boost Mode.

! SWITCH

This appears during the battle with Bowser. Hit the switch to yank the bridge out from under him!

? BLOCK

Hit them to find items inside. After it's been hit, it becomes an empty block.

? SWITCH

Flip the switch to set off one of many different mechanisms. One type creates red blocks.

1-UP MUSHROOM

Snag one to earn an extra life. Mario can have up to ninety-nine lives.

10-COIN BLOCK

It looks just like a normal brick block but will produce up to ten coins if hit repeatedly.

3-UP MOON

They give three extra lives. They only appear in Boost Mode.

BANZAI BILL BLASTERS

They are the cannons that blast out Banzai Bills.

BARREL

These can be picked up, carried, or sometimes rolled.

BEAN PLATFORM

These grow out of the giant beanstalk. They're platforms that stretch out, then roll up again.

BIG BLOCK

They're very large, but can be broken like regular blocks.

BIG CANNON

These large-type cannons shoot out large-type cannonballs.

BIG FIRE BAR

Fire Bars made of enormous fireballs. The number of fireballs varies.

BIG PIPE

Big Piranha Plants can come out of these, but nothing else can get in.

BILL BLASTER

Cannons that fire off Bullet Bills. There's a type that will always shoot in Mario's direction.

BILL BLASTER TURRET

They spin around, sending a Bullet Bill left and right in succession.

BLUE COIN

They appear when a P Switch is pressed. They have the same value as normal coins.

BOOST BLOCK

These appear in Boost Mode. They can appear when a player touches the Wii U GamePad.

BOOST STAR

These only appear in Boost Mode and initiate Super Boost Mode for fifteen seconds.

BOSS CANNON

Hop in to be fired aboard an airship to face its resident Koopaling.

BOUNCY CLOUD

A cloud that acts like a super bouncy spring. Some of them float around.

BOWSER'S FLAMES

These fly through the castle halls before Bowser.

BOWSER JR. BATTLE BLOCK

They break apart when hit twice, and regenerate after a short time.

BOWSER STUNNER

A stone statue of Bowser that gives off electric pulses.

BRICK BLOCK

Some hold items, while others merely shatter.

BURNER

These shoot out a pillar of fire. Some turn on and off at intervals, and others burn all the time.

CANNON

They shoot out cannonballs diagonally.

CHECKPOINT FLAG

If you touch it and lose a life, you'll start the course again from that point.

CLOCKWORK BLOCK

These huge platforms move along the tracks.

CLOUD LIFT

Huge lifts made of clouds, meant for traveling across the sky. They start moving when accessed.

COIN

Grab one hundred coins to get a 1-Up. Some come down in parachutes.

CONCEALING WALL

What treasures and secrets are being hidden away?

CONVEYOR BELT

Who needs to walk when these carry things wherever they want to go?

CRATE

Smash them open with a ground pound to sometimes find items.

CROSS LIFT

These massive bars slide up and down or back and forth.

CURRENT

Anything entering the torrent gets sucked downward.

DONUT BLOCK

Standing on these makes them fall, but they'll change color to warn you first.

FENCE

Grab on and scuttle around on the fence in any direction.

FIRE BAR

Rotating chains of fireballs. They sometimes come in twos!

FIRE FLOWER

This power-up turns Mario into Fire Mario.

FLATBED FERRY

They move along a track once activated, and turn back if the track ends in a little circle.

FLOATING CRATE

Ground-pound on it to sink it pretty deep into the water. It'll then spring back high up!

FLOWER

Spin jump near one and it may produce coins.

FLYING ? BLOCK

They're ? Blocks with wings. Hit them to knock off the wings and bring them to a stop.

FOG

A spin will blow much of it away. Clearing some fog banks will reveal coins.

FRUIT

Yoshi can eat them. If he eats five, he lays an egg that contains an item.

GEAR

These are rotating platforms in the shape of cogwheels. They come in various sizes and speeds.

GHOST BLOCK

These haunted blocks attack when Mario approaches.

GHOST DOOR

Try to open it and it turns into a coin.

GIANT ? BLOCK

These are very big, but the goodies inside are regular-sized.

GLOWING BABY YOSHI EGG

Glowing Baby Yoshis hatch from these.

GOAL POLE

Grab the pole to clear the course. The higher the pole is grabbed, the greater the reward.

GREEN COIN

They come in sets of three. Collect all five sets in time to win an item.

GREEN RING

Touch it to summon Green Coins nearby.

HANGING CHAIN

Get to swinging and launch off with the right timing.

HARD BLOCK

Mario can't destroy these blocks, but some mechanisms and enemies can.

HIDDEN BLOCK

These blocks appear from thin air when hit. Some also contain coins or items.

HIDDEN COIN

Coin shapes marked by a dotted line. Touching them turns them into real coins.

HIDDEN GOAL POLE

A Goal Pole with a red flag. They lead to hidden routes on the game map.

HUGE ICICLE

After it falls and sinks into the ground, it becomes a handy platform.

HUGE SNAKE BLOCK

Each block is very big, but it moves the same way.

ICE CHUNK

A slippery ride that sometimes has coins inside.

ICE FLOWER

This item powers Mario up into Ice Mario.

ICE PLATFORM

They are large formations of ice that act as platforms. Some of them move, too.

ICICLE

Bits of ice shaped like spikes. If it's dripping water, it's about to fall!

IRON BLOCK

These float along on the lava, so Mario can use them as platforms.

JET PIPE

Pipes that spew a powerful water current. Some of these rotate.

KAMEK'S BATTLE BLOCK A

If Kamek's magic hits them, they become Donut Blocks.

KAMEK'S BATTLE BLOCK B

Blocks that fall downward at Kamek's command.

LAVA

The lethal red sea that Lava Bubbles shoot out of.

LAVA WAVE

This lava moves in large waves. Sometimes Lava Bubbles jump up from them.

LEAF PLATFORM

These grow out of the giant beanstalk. After a while they turn brown and fall off.

LIFT

These platforms move through the air in all directions and come in a variety of lengths.

LIGHT PLATFORM

These light up in intervals. There's also a type that glows when a ? Switch is thrown.

LIMITED LIFT

Check the numbers being displayed. When the count goes to zero, the lift stops.

LOG

These are dangerously slippery platforms over poison bogs.

MAGMA PILLAR

These damaging geysers of flame shoot out of the lava.

MECHA HAND

A huge hand that comes down from an airship. If it makes a fist, it's about to destroy the area under it.

METEOR

These are huge balls of flame that fall from the sky. They get smaller when hit by an ice ball.

MINI MUSHROOM

A tiny mushroom that can be used to power up to Mini Mario.

MINI PIPE

Very small pipes that only Mini Mario can enter.

MOVING PLATFORM

These platforms move up and down or right and left.

NOTE BLOCK

Hop on to be bounced. Some produce coins.

NUTS

Jump on them to move them forward and to stay balanced.

P-ACORN

When Mario gets one, he is powered up into Power Squirrel Mario.

P SWITCH

These can cause coins to switch to blocks and vice versa. Blue coins may also appear.

PADDLE PLATFORM

They have four platforms, and they can be moved along the track to which they're attached.

PALM TREE

The sturdy fronds can be used as platforms to reach varying heights.

PENGUIN SUIT

This is the power-up that makes Penguin Mario, but will only be found in Toad Houses on Superstar Road.

PIPE

They are placed throughout many of the courses; sideways, diagonally, and in other directions.

PIPE CANNON

Enter one to be fired out straight up or at an angle. They look like normal pipes.

PLATFORM

Hit it from below to raise a portion of the platform and attack whoever's above.

POISON BOG

This toxic fluid is lethal to the touch, and even worse is when it rises!

POLE

Climb up or down to leap to the next pole over.

POW BLOCK

When hit or thrown, they put out a powerful blast that defeats all enemies on the screen.

PROPELLER MUSHROOM

These power-ups are only stocked in Toad Houses on Superstar Road.

QUICKSAND

Brave the sinking sand to find hidden coins.

RED COIN

Grab all eight coins within the time limit, and each player receives an item.

RED RING

Pass through it to make eight Red Coins appear nearby.

REMOTE-CONTROLLED LIFT

The lift rises depending on how you operate your Wii Remote.

REMOTE-CONTROLLED PLATFORM

Use your Wii Remote to send this lift along the track.

ROCK WALL

Grab on tight and crawl in any direction.

ROCKING PLATFORM

A platform that swings slowly back and forth, regardless of who's on it.

ROLLING HILLS

These completely round pieces of scenery rotate. When icy, they're harder to stand on.

ROPE LADDER

It's a ladder—climb it!

ROTATING BURNER

They're always shooting a pillar of flame as they rotate 180 degrees.

ROULETTE BLOCK

The item that appears depends on when it's hit.

SAND GEYSER

They're pillars of sand that spout up at regular intervals and act as platforms.

SCALE LIFT

A set of two lifts. When one side is weighed down, the other moves up.

SCREWTOP LIFT

It spins and the lift moves along its track. Stop and it starts to slowly return to where it started.

SCREWTOP PLATFORM

Spinning it causes the platform to move along a rail.

SCREWTOP SHROOM

Spin the mushroom to move upward or downward.

SEESAW LOG BRIDGE

A bridge made of a moving log. Sometimes they rotate.

SEESAW SHROOM

These mushrooms tilt when weight is applied.

SKELEFLOOR

Bowser Jr. will ground-pound on it, sending powerful ripples throughout.

SKEWER

These come crashing in from the right and left at regular intervals.

SLIDE LIFT

These rotate around on tracks. They come in different colors and sizes.

SNAKE BLOCK

Long stretches of blocks. Once activated, they follow a predetermined route.

SPINE COASTER

A lift that moves at high speed. Ground-pound on it and the mouth lets out a rattling sound.

SPINNER

Giant-sized spiked balls on chains. The chains have spikes, so don't jump through!

STAR COIN

There are three of these coins hidden on every course.

STAR LIFT

Platforms in the shape of stars that make a twinkling sound and rotate.

STONE-EYES

Stones with faces carved in them. Some move around while others start to tip over when stepped on.

STRETCH BLOCK

A single block stretches out into a row of blocks.

STRETCH SHROOM

This Mushroom Platform grows and shrinks at regular intervals.

SUPER ACORN

With this, Mario can power up to Flying Squirrel Mario.

SUPER GUIDE BLOCK

These appear if you fail five times on the same course.

SUPER MUSHROOM

With this, Mario can power up to Super Mario.

SUPER STAR

With this, Mario can become invincible.

SWAYING MUSHROOM PLATFORM

Mushroom Platforms that tilt, sway, and bob.

SWINGING HAMMER

These swing in a wide arc, sometimes running along a track.

SWINGING PLATFORM

These platforms swing slowly left and right.

SWINGING VINE

Just like Hanging Chains, only vines.

SWITCHBACK PLATFORM

Hop on to follow the direction of the arrow. Hop off to send the lift back home.

TARGETING TED LAUNCH PAD

These red Launch Pads shoot Targeting Teds.

TORPEDO TED LAUNCH PAD

Boxes with a skull mark on them that fire Torpedo Teds.

TRACK BLOCK

These are either ? Blocks or blocks that move along rails.

TRAMPOLINE

Carry them around or use them to spring extra high.

VINE BLOCK

A block that sprouts a vine when struck. Hit it from above and the vine grows downward.

VOLCANIC SMOKE

This closes in from the left and is instantly lethal.

WATER BALL

These spheres float in the air, carrying daring swimmers.

WATER GEYSER

Pillars of water that come shooting out of the sea. Enter in the middle to shoot up to the top.

WOBBLE ROCK

It starts to tilt when disturbed. Tilt it too far and it falls over.

YOSHI'S EGG

Yoshis are found in these. If Yoshi eats five fruits, he lays one.

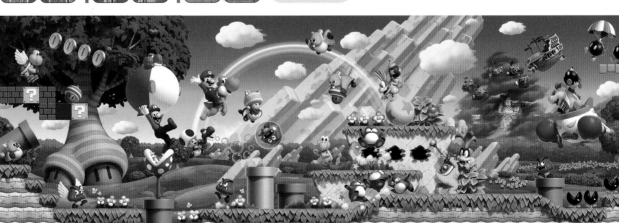

AND MORE

MEMORABLE MOMENTS

Here we look back on many of the moments that left an impression. This game featured a huge world and many different dramatic moments.

PEACH'S CREEPY CASTLE

As Bowser's forces take over Peach's Castle, the castle undergoes changes throughout the adventure, gradually taking on creepier aspects.

HERE'S LOOKIN' AT YOU!

If you stop controlling Mario for a while, he'll turn and look expectantly at you. The other player characters react the same way.

BABY YOSHI COMES ALONG FOR THE RIDE

There are two types of Baby Yoshi on the map. Speak to them and these little guys, brimming with curiosity, agree to accompany you. They've got their own unique abilities, and if you make it to the goal with them, they'll keep adventuring with you. Just remember that Glowing Baby Yoshi only appears on certain courses.

ITEMS ON THE MAP

There are items that fall on the area map screens, and if Mario reaches one, he gets to add the item to his inventory. Just know that there will also be enemies on the map screens too, and if Mario runs into them, he'll have to battle!

OF COURSE IT'S A SHORTCUT!

When you find a hidden goal in a course, a new path will appear leading to a hidden course off the beaten path. If you clear that hidden course, the rest of the path opens, making it a shortcut to Peach's Castle.

CAPTURE NABBIT

After you clear the first course in Layer-Cake Desert, a robbery occurs! A mysterious character named Nabbit steals some items and tries to run away. He appears in certain courses and Mario has to chase him down. If Mario can catch him, Toad will give Mario a P-Acorn as a reward. If Mario can catch him eight times, Nabbit will start to run faster (note: this doesn't count in areas inside Peach's Castle and Superstar Road).

A GARDEN FULL OF LAVA

The final area in this game is Peach's Castle. Normally it features pretty green gardens and white walls, but under Bowser's influence, the grounds have been covered in lava. The background music for Peach's Castle is a rearrangement of "Inside the Castle Walls" from *Super Mario 64*.

PLAY DURING THE CREDITS

During the credits, you can control how your player characters dance, to a certain extent. They can jump or lift up the other characters or even collect the coins than the Baby Yoshis spit out.

THE SECRET ISLAND

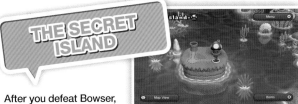

After you defeat Bowser, not only can you go to Superstar Road, but you can also reach the Secret Island. There you'll find a small Toad House. Inside you'll find a board which shows fourteen different stats compiled from your feats within the game, such as "Goombas Stomped" and "Goal Poles Reached."

SUPERSTAR ROAD—A SPECIAL WORLD!

After you've defeated Bowser and gone through the ending, a special world opens up. Superstar Road has eight courses, and each opens up after you've collected all the Star Coins from each of the other worlds. Also, if you can collect all of the Star Coins from Superstar Road, then a final ninth course opens up.

SUPER MINI BOOST BLOCKS

Boost Blocks, which can be placed in Boost Mode, become tiny when you have ninety-nine lives. It gets a lot harder to stand on them!

HELPFUL HINTS & TECHNIQUES

Here's some information that may help on your adventure: To clear the entire game, you will have to catch Nabbit every time he appears.

INCREASE THE STARS ON YOUR SAVE FILE

Star ★ symbols will be added to your save file depending on how much of the game you've completed. Defeat Bowser to get one ★. Finish every course in the first eight areas to get ★★. Collect all the Star Coins on all courses (aside from Superstar Road) to get ★★★. Unlock the final course on Superstar Road to get ★★★★. Gather all the Star Coins on Superstar Road, find every exit in every world, and catch Nabbit every time to finally get ★★★★★.

LINE UP THE NUMBERS AND GET AN ITEM!

If you grab the Goal Pole at a point where the last two digits on the clock align, Toad comes in and gives you an item. If the numbers are 11, 22, or 33, you get a Super Mushroom. With 44, you get a Fire Flower. With 55, you get an Ice Flower. With 66, you get a Mini Mushroom or a Super Mushroom. With 77, you get a Super Acorn. With 88 and 99, you get a Super Star. But if you get 00, you get nothing.

SPECIAL ITEMS AT TOAD'S HOUSE

At the Toad Houses on Superstar Road, you may be able to get Propeller Mushrooms or Penguin Suits. These items never appear on any of the courses, so these are the only places you can obtain them.

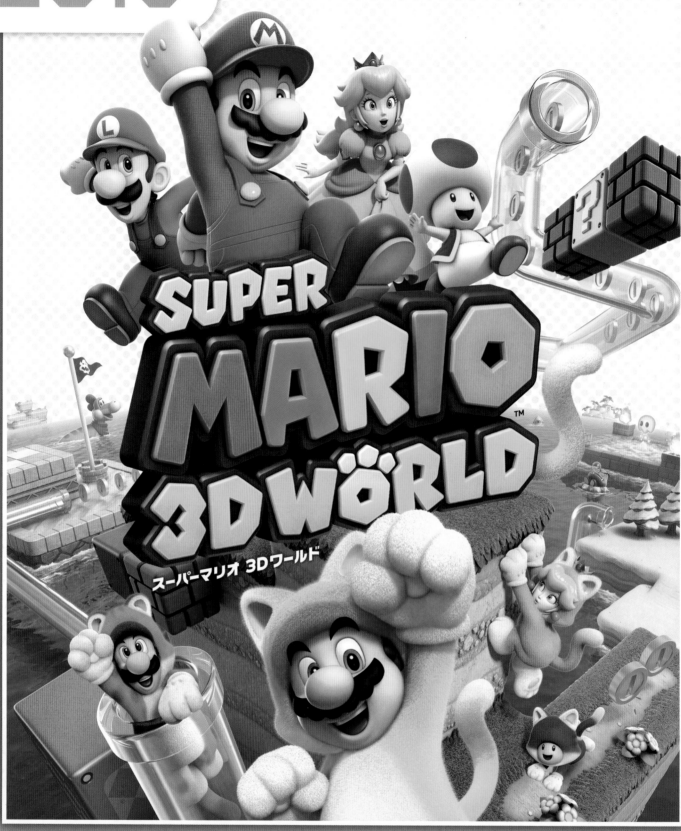

SUPER MARIO 3D WORLD

スーパーマリオ 3Dワールド

Package

Game Disc

Instruction Booklet

System: **Wii U**
Release Date:
November 22, 2013
(Japan:
November 21, 2013)
Player Count: **1-4**

 # INTRODUCTION

S T O R Y

It was a beautiful night on the evening of a festival. Mario, Peach, Luigi, and Toad discovered a clear pipe in Peach's garden. Mario and Luigi fixed up the strange pipe, unwittingly opening the way to a fairy kingdom.

Suddenly a fairylike Sprixie Princess came flying out. She told them about how Bowser's forces were wreaking havoc in the Sprixie Kingdom, and the other Sprixie Princesses had been captured.

Then Bowser himself erupted from the pipe! He grabbed the Sprixie Princess and retreated back into the Sprixie Kingdom.

Peach led Mario, Luigi, and Toad into the pipe to rescue the Sprixie Princesses—beginning a brand-new adventure for Mario and his friends!

F E A T U R E S

EVERYBODY CAN PLAY!

Made for the Wii U console, this is the first Mario 3D action game that's multi-player! Mario, Luigi, Peach, Toad, and the unlockable Rosalina each have their own distinct abilities, and up to four players can play on the same course. Many features have been added, such as Cat power-ups that allow you to climb walls, the Double Cherry that can multiply your character, and several items which, when worn, can give Mario new abilities. This game has more power-ups than any other game in the series. With all these characters and all their different abilities, as well as the plethora of power-ups, this game gives the player more choices than ever before!

VARIED COURSES

Although this follows the same basic structure as Super Mario 3D Land, where Mario makes his way through a course aiming for the Goal Pole at the end, this game enhances just about everything from the previous installment. There are some courses you can get through by using the touch screen or mic on the GamePad, and others where you play Captain Toad minigames in a tiny, blocky milieu in which you can move the camera around to plot your next move. Many more features make up all sorts of new types of courses! And with the advent of the wall-climbing Cat Mario, you can explore the courses to their fullest extent.

A MiiVERSE STAMP COLLECTION

Using the Miiverse Service, a player could leave comments on each course. There are items called Stamps that are hidden on every course, and after a player found them, they could use their Stamps to gussy up their Miiverse posts.

CHARACTERS

PLAYER CHARACTERS

Players can choose from four characters to start, each with different abilities. After completing certain conditions, Rosalina can be unlocked as a playable character, too.

PRINCESS PEACH

Press and hold the jump button down to make Peach float briefly. Her dash is slower than the others.

LUIGI

He jumps high, so it's easier for him to jump over enemies and traps, but he slides when he tries to brake.

ROSALINA

She can attack enemies with a spin, but she can't use that ability when powered up.

MARIO

With the most balanced abilities, he's good to go on any course.

TOAD

His dash speed is fast, but he's not very good at jumping.

CAPTAIN TOAD

He only appears on certain special courses. He's got a heavy backpack on, so he can't jump. If you see him on a normal course, rescue him to receive a Green Star.

POWER-UPS

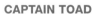

When you get particular items, you can power Mario up with special abilities. If you're hit by an enemy, you lose the power-up and revert to your previous form, even if it's a worn power-up.

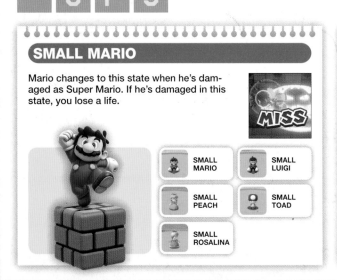

SMALL MARIO

Mario changes to this state when he's damaged as Super Mario. If he's damaged in this state, you lose a life.

SMALL MARIO	SMALL LUIGI
SMALL PEACH	SMALL TOAD
SMALL ROSALINA	

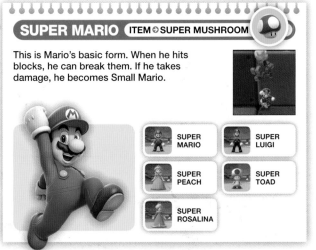

SUPER MARIO ITEM ⇨ SUPER MUSHROOM

This is Mario's basic form. When he hits blocks, he can break them. If he takes damage, he becomes Small Mario.

SUPER MARIO	SUPER LUIGI
SUPER PEACH	SUPER TOAD
SUPER ROSALINA	

FIRE MARIO — ITEM ➔ FIRE FLOWER

Mario can throw fireballs to attack enemies. When a fireball hits a torch, the fireball can light it.

 FIRE MARIO
 FIRE LUIGI
 FIRE PEACH
 FIRE TOAD
 FIRE ROSALINA

CAT MARIO — ITEM ➔ SUPER BELL

Cat Mario can scratch or pounce to attack enemies. He can also hang onto or climb most walls.

 CAT MARIO
 CAT LUIGI
 CAT PEACH
CAT TOAD
CAT ROSALINA

TANOOKI MARIO — ITEM ➔ SUPER LEAF

He can attack his enemies or hit blocks by spinning his tail around. If you hold down the jump button, he floats and extends the range of his jump.

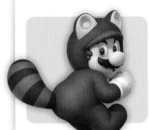

 TANOOKI MARIO
 KITSUNE LUIGI
TANOOKI PEACH
TANOOKI TOAD
TANOOKI ROSALINA

BOOMERANG MARIO — ITEM ➔ BOOMERANG FLOWER

Mario can throw boomerangs that make a U-turn and return to his hand. Not only can boomerangs pierce multiple enemies at once, but they can also retrieve far-off items.

 BOOMERANG MARIO
 BOOMERANG LUIGI
BOOMERANG PEACH
BOOMERANG TOAD
BOOMERANG ROSALINA

DOUBLE MARIO — ITEM ➔ DOUBLE CHERRY

When Mario gets a Double Cherry, he's duplicated up to a maximum of five times. Your doubles come with the same power-ups Mario has when he gets the Double Cherry. When Mario takes damage or clears the course, the effect wears off.

 DOUBLE MARIO
 DOUBLE LUIGI
 DOUBLE PEACH
DOUBLE TOAD
DOUBLE ROSALINA

LUCKY CAT MARIO — ITEM ➔ LUCKY BELL

This power-up is basically the same as Cat Mario, but when Lucky Cat Mario does a ground pound, he turns into a Lucky Cat Statue. When he drops, he generates coins and can defeat enemies that can't be beaten otherwise.

 LUCKY CAT MARIO
 LUCKY CAT LUIGI
 LUCKY CAT PEACH
LUCKY CAT TOAD
LUCKY CAT ROSALINA

MEGA MARIO — ITEM ➔ MEGA MUSHROOM

Mario grows to giant size for a short time, and he can walk straight through enemies and hazards. He doesn't swim, but rather walks along the sea floor.

 MEGA MARIO
 MEGA LUIGI
 MEGA PEACH
 MEGA ROSALINA
 MEGA TOAD

INVINCIBLE MARIO — ITEM ➔ SUPER STAR

For a short while, Mario starts to glow, and he defeats any enemy he touches. If he defeats eight enemies in a row, you get a 1-Up. Keep defeating enemies to rack up the score!

INVINCIBLE MARIO

 INVINCIBLE LUIGI
 INVINCIBLE PEACH
INVINCIBLE ROSALINA
INVINCIBLE TOAD

INTRODUCTION CHARACTERS WORLD AND MORE

WHITE TANOOKI MARIO — ITEM ☞ INVINCIBILITY LEAF

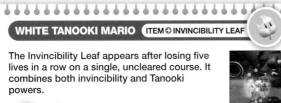

The Invincibility Leaf appears after losing five lives in a row on a single, uncleared course. It combines both invincibility and Tanooki powers.

WHITE TANOOKI MARIO	WHITE KITSUNE LUIGI
WHITE TANOOKI PEACH	WHITE TANOOKI TOAD
WHITE TANOOKI ROSALINA	

A POWERED-UP ITEM! — GREEN SHELL — ITEM ☞

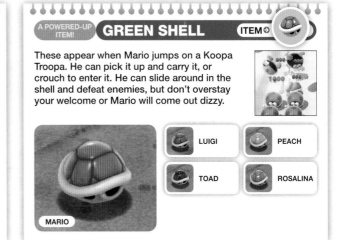

These appear when Mario jumps on a Koopa Troopa. He can pick it up and carry it, or crouch to enter it. He can slide around in the shell and defeat enemies, but don't overstay your welcome or Mario will come out dizzy.

MARIO

LUIGI	PEACH
TOAD	ROSALINA

A POWERED-UP ITEM! — ? BOX — ITEM ☞

Run around while wearing this to generate coins. The box vanishes when Mario has either hit an enemy or received one hundred coins.

MARIO

LUIGI	PEACH
TOAD	ROSALINA

A POWERED-UP ITEM! — CANNON BOX — ITEM ☞

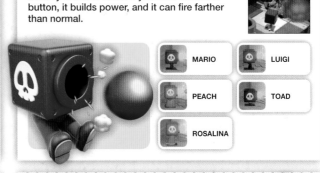

These fire cannonballs at regular intervals, which can be aimed at enemies. It can also destroy cracked walls. If you hold down the button, it builds power, and it can fire farther than normal.

MARIO	LUIGI
PEACH	TOAD
ROSALINA	

A POWERED-UP ITEM! — PROPELLER BOX — ITEM ☞

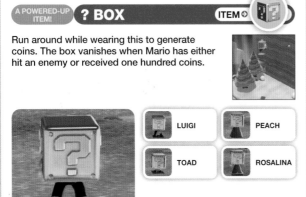

Jump while in an open-air region to fly very high. Keep holding down the jump button to drift slowly to the ground.

MARIO

LUIGI	PEACH
TOAD	ROSALINA

A POWERED-UP ITEM! — BEAM BOX — ITEM ☞

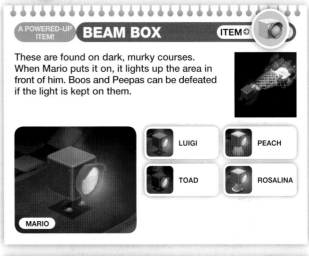

These are found on dark, murky courses. When Mario puts it on, it lights up the area in front of him. Boos and Peepas can be defeated if the light is kept on them.

MARIO

LUIGI	PEACH
TOAD	ROSALINA

A POWERED-UP ITEM! — GOOMBA MASK — ITEM ☞

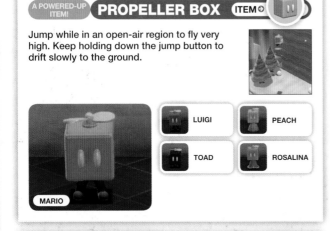

This is a Goomba-shaped mask Mario can wear. When it's on, Goombas, Micro-Goombas, and Galoombas don't notice Mario.

MARIO

LUIGI	PEACH
TOAD	ROSALINA

A POWERED-UP ITEM! — GOOMBA'S ICE SKATE — ITEM ☞

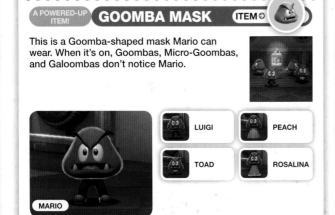

These appear after defeating a Skating Goomba. When riding in the skate, Mario can defeat enemies, slide along the ice, and skate over spikes. If Mario hits a wall, the skate vanishes.

MARIO

LUIGI	PEACH
TOAD	ROSALINA

OTHER CHARACTERS

These characters support Mario and his friends when met on the map or during courses.

SPRIXIE PRINCESSES

They rule the Sprixie Kingdom and have been captured by Bowser's forces. There are seven in all.

PLESSIE

Plessie only appears on certain selected courses. Mario and friends get on and ride down rivers or sandy hills. You can make Plessie jump or turn right or left.

SPRIXIE

They appear in Mystery Houses or on certain courses. The ones holding binoculars will allow you to see things in the distance.

LUMA

They're found on certain courses. They float along, watching over Mario.

TOAD

They appear in Toad Houses and give Mario and his friends items. The color of the Toads changes depending on the world.

RABBIT

They run around on courses, and if Mario grabs one of them, it produces an item. Keep an eye out for the big one.

ENEMIES

Enemies you'll encounter on courses. Some enemies have cat forms, too.

ANT TROOPER

They walk along the ground or on walls. They can form a line and move in groups.

BANZAI BILL
A higher caliber of Bullet Bills. They're fired straight ahead from Banzai Bill Blasters.

BIDDYBUD
They walk along a predetermined route in a line or in a circle. They come in all different colors.

BIG ANT TROOPER
They move just like regular Ant Troopers. Mario can get on their backs and use them to move along.

BIG BOO
The same as Boos, but a good deal larger.

BIG GALOOMBA
They may be bigger, but Mario can defeat them the same as their smaller kin.

BIG PIRANHA PLANT
They're huge Piranha Plants. They take two hits, or one ground pound, to take down.

BLOCKSTEPPER
They march in lines, but if Mario attacks even one, the entire line falls into confusion.

BLOOPER
They undulate through the water. If they see Mario, they turn toward him and charge.

BLURKER
They form lines, trying to block Mario's path. They vanish for a while after being attacked.

BOB-OMB
Their fuses catch fire and they chase Mario. They become a regular bomb when attacked.

BOO
They try to sneak up on the unwary, but if Mario faces them, they get shy and stop moving.

BOOM BOOM
He swings his arms in a whirling circle and becomes nearly invisible.

BOOMERANG BRO
They jump around, throwing their boomerangs.

BOSS BROLDER
He rolls at Mario. If hit with a Brolder, he spins while spewing rocks.

BOWSER

He rides along in his car. He'll drop bombs, among other things, to attack.

BROLDER

They rise up from the ground and roll at Mario. Attack them to stop them in their tracks.

BULLET BILL

They fly straight ahead, but an attack with a Tanooki tail or a Cat Mario scratch can change their direction.

BULLY

They try to ram Mario when they see him. They can be pushed off-balance with projectiles like fireballs.

CAT BANZAI BILL

These are fired out of cannons and fly directly at Mario and his friends.

CAT BULLET BILL

They get fired out of Bill Blasters and home in on Mario.

CAT GOOMBA

They attack by pouncing, and are very territorial.

CHARGIN' CHUCK

They try to tackle Mario. After Mario attacks them, they speed up.

CHARVAARGH

When Mario approaches, they come jumping out of the lava for an instakill.

CHEEP CHEEP

They swim in a particular route in the water.

COIN COFFER

These are normally invisible, but when Mario attacks them, they produce coins.

CONKDOR

They swing their long necks to peck at passersby.

FIRE BRO

They jump around, throwing fireballs at Mario.

FIRE PIRANHA PLANT

They shoot fireballs at Mario.

FIZZLET

They stick to the floor, but they also flatten themselves and discharge electricity.

FLOPTER

They rotate their wings and attack at their own pace.

FUZZLER

They roll along on tracks. Spikes cover their entire bodies.

FUZZY

They run along predetermined routes, usually in groups.

GALOOMBA

Jump on them to flip them over and knock them out. Kick them while they're down to defeat them.

GOOMBA

They normally plod along but will charge any target they see.

GOOMBA TOWER

Goombas stacked on top of each other. Sometimes they also have a different enemy or item in their stack.

HAMMER BRO

They jump around, throwing their hammers at Mario.

HISSTOCRAT

He appears with smaller snakes and attacks with large rocks.

HOP-CHOP

It bounces after Mario, but when defeated, can be used as a springboard.

HORNED ANT TROOPER

They're just like normal Ant Troopers, but their horns protect them from jumps.

INNERTUBE GOOMBA

They've fallen asleep on their spiked innertubes. If Mario gets close, they head in his direction.

KA-THUNK

These enemies are shaped like square frames. They travel along a predetermined route.

KING KA-THUNK

He attacks by face-planting. His weak point is his back.

KOOPA TROOPA

Jump on them to evict them from their shells and use them yourself!

LAVA BUBBLE

They come flying out of lava at regular intervals. Watch for the rare blue one!

MADPOLE

Aquatic enemies that doggedly chase their targets.

MAGIKOOPA

They move by teleporting and attack by shooting magic.

MEOWSER

Bowser in cat form. He attacks using his tail or by scratching.

MINI GOOMBA
Just blow into the Wii U GamePad mic to get them off of Mario.

MOTLEY BOSSBLOB
He grows huge and bounces around. After he slams into the ground, you'll see his true form.

OCTOOMBA
They shoot three projectiles at a time and can only be defeated by a ground pound.

PARA-BIDDYBUD
Biddybuds with wings. They form up into lines and fly on a particular route.

PARABONES
Aerial undead that fall apart when jumped on.

PEEPA
They move around on a fixed route, usually with several running in circles or in lines.

PIRANHA CREEPER
They move by stretching out their long, thorny vine-necks. Go for the head!

PIRANHA PLANT
They stretch out their stems and try to bite Mario, but a well-timed jump weed-whacks them.

POM POM
She makes copies of herself and attacks with shuriken. The one throwing pink shuriken is the real one.

PORCUPUFFER
These water hazards are protected from jumps and ground pounds by their spines.

PRINCE BULLY
He attacks by spitting fire. If he gets pushed through a clear pipe, he gets sucked in.

QUEEN HISSTOCRAT
A pink version of Hisstocrat. She attacks by shooting fire.

RAMMERHEAD
These wide-headed enemies always swim in a predetermined route.

RING BURNER
They shoot out expanding circular or rectangular flames.

SKATING GOOMBA
They ride inside ice skates and slide after Mario. If Mario defeats one, he can use the skate himself.

SKIPSQUEAK
They run along rotating platforms. Every now and then they jump.

SMALL RAMMERHEAD
These Rammerheads have a smaller head and a different color. Some of them jump up out of the water.

SNOW POKEY
Their bodies are made of spiked snowballs. If defeated, they leave snowballs behind.

SPIKE
They attack by throwing Spike Bars pulled from their mouths. They don't move from their spot.

SPINY
They have spiked shells, and chase Mario when they see him.

SPINY SKIPSQUEAK
They move like regular Skipsqueaks, but can't be jumped on due to their spines.

SPLORCH
They roll after Mario, leaving a trail of lava behind them.

SPLOUNDER
They peek out of the surface of water or sand. They're stunned if Plessie lands on them.

STINGBY
They fly low along the ground and chase their targets.

THWOMP
They rise and fall in a set place. Mario can walk on their tops.

TY-FOO
They blow a strong wind at regular intervals that will fling Mario away.

WALLEYE
These spiky enemies spring out of the ground and move back and forth to block Mario's way.

WORLD

COURSES

If you include the smaller courses, such as those run by Captain Toad, there are 117 courses in all.

WORLD 1

A peaceful grassland where Mario first transforms into Cat Mario.

1 SUPER BELL HILL

This is where the adventure begins. Become Cat Mario and romp through the grassland.

2 KOOPA TROOPA CAVE

This is separated into a number of different underground levels.

A CHARGIN' CHUCK BLOCKADE

Fight two Chargin' Chucks. Mario can't move on until they're defeated.

3 MOUNT BEANPOLE

Cat Goombas are wandering the mountain. Use the different devices to move upward.

4 PLESSIE'S PLUNGING FALLS

Get on Plessie's back and head downriver. There may be hidden paths in the waterfalls, too.

5 SWITCH SCRAMBLE CIRCUS

This is a series of small rooms with Switch Panels. Turn them all yellow to move along.

BOWSER'S HIGHWAY SHOWDOWN

Bowser is waiting to battle Mario. Use Kick Bombs to remove traps and enemies.

CAPTAIN TOAD GOES FORTH

Control Captain Toad and gather all the Green Stars.

WORLD 2

This world adds more mechanisms and traps. Boom Boom is waiting in the tank contingent at the end.

1 CONKDOR CANYON

Mario should avoid the Conkdors while crossing this long, expansive desert.

2 PUFFPROD PEAKS

Use the Wii U GamePad touch screen and mic to open Mario's way.

3 SHADOW-PLAY ALLEY

Spooky shadows are projected on the wall. Pick up a potted Piranha Plant for comfort.

4 REALLY ROLLING HILLS

Skipsqueaks run along on top of the rotating cylinders that dot Mario's path.

A BIG GALOOMBA BLOCKADE

Mario is in a death match with three Big Galoombas on a platform floating in lava.

5 DOUBLE CHERRY PASS

The first appearance of the Double Cherry. Make more Marios to defeat enemies and traps.

BOWSER'S BULLET BILL BRIGADE

This tank course has tricks and traps all over the place!

MYSTERY HOUSE MELEE

Mario has only ten seconds to defeat five rounds of enemies in five different rooms.

WORLD 3

A cold, icy world. It has a number of tiny isolated islands.

1 SNOWBALL PARK

A course of snow and ice. If you use Goomba's Ice Skate, you can slide across it.

2 CHAIN-LINK CHARGE

The fences move all around, so make good use of them.

3 SHIFTY BOO MANSION

A mansion where Boos live. Watch out for fake obstacles and tricky traps.

4 PRETTY PLAZA PANIC

A short course bathed in pink. Some of the platforms are shaped like a ribbon bow.

A MAGIKOOPA BLOCKADE

A fight against three Magikoopas. They teleport around and attack.

5 PIPELINE LAGOON

Swim through the narrow water passages where the Cheep Cheeps await.

6 MOUNT MUST DASH

Dash Panels are strung along in sequence for a *Mario Kart* feel.

7 SWITCHBOARD FALLS

A mountain in autumn, complete with falling leaves. Get on the Switchboards to cross the valley.

THE BULLET BILL EXPRESS

Switch between two high-speed trains to avoid the Cat Bullet Bills.

B A BANQUET WITH HISSTOCRAT

It's a showdown with the Hisstocrat. Three blows and he kneels to Mario.

CAPTAIN TOAD MAKES A SPLASH

The tide ebbs and flows via a switch. Use the underwater sections to gather up the Green Stars.

WORLD 4

A world of ruddy earth. Mountains and swamps await you here.

1 ANT TROOPER HILL

Ant Troopers, both big and small, wander over this rocky terrain.

2 PIRANHA CREEPER CREEK

A poisonous swampland with Piranha Creepers stretched out all over it.

A BROLDER BLOCKADE

Mario faces a total of four Brolders in all. Smash them or make them fall into the lava.

3 BEEP BLOCK SKYWAY

The blocks lined up through the sky turn on and off, so time your jumps well.

4 BIG BOUNCE BYWAY

Bounce along these high plains with both big and small Mushroom Trampolines.

5 SPIKE'S LOST CITY

The Spikes roll their weapons downhill amid lots of sloping paths.

LAVA ROCK LAIR

A fortress where Brolders appear. Use defeated Brolders to open paths.

B FIRE BROS. HIDEOUT #1

Do battle with three Fire Bros. in a secret underground section of the world map.

MYSTERY HOUSE MAD DASH

Make a mad dash using the mechanisms and avoid attacks to get the Green Stars.

WORLD 5

A world of widespread water. There are bonus stages hidden throughout.

1 SUNSHINE SEASIDE

Mario wanders around the white sands looking for Key Coins.

2 TRICKY TRAPEZE THEATER

Use the flying trapezes to move along on this circus-like course.

3 BACKSTREET BUSTLE

The goal is straight ahead, but side paths contain the Green Stars.

A CHARGIN' CHUCK BLOCKADE IS BACK

Battle five Chargin' Chucks in a small room. Avoid their tackles and attack them.

4 SPRAWLING SAVANNA

A beautiful grassland at sunset, with rabbits running around.

5 BOB-OMBS BELOW

A cave with a lot of Bob-ombs. Blow up the traps as Mario moves along.

6 CAKEWALK FLIP

A course with scenery made of cakes and sweets. Cross the Red and Blue Panels.

7 SEARCHLIGHT SNEAK

If searchlights find Mario, they launch Cat Bullet Bills!

KING KA-THUNK'S CASTLE

A castle where Ka-Thunks flip themselves on the narrow passageways.

B FIRE BROS. HIDEOUT #2

A showdown with a Fire Bro. at the top of the Goomba Tower.

CAPTAIN TOAD PLAYS PEEK-A-BOO

A haunted house where Captain Toad uses Touchstones to gather Green Stars.

? COIN EXPRESS

A bonus stage aboard a golden train. There are a lot of coins stacked up here.

WORLD 6

A cloudy world with a high chance of adventure.

1 CLEAR PIPE CRUISE

Use the clear pipes to move along. Enemies and items appear inside the pipes.

2 SPOOKY SEASICK WRECK

Mario has to make his way through a creepy, rocking ghost ship in the pouring rain.

3 HANDS-ON HALL

With a touch on the GamePad, you can open up doors and start hidden mechanisms.

4 DEEP JUNGLE DRIFT

Get on the wooden raft to float over the poison swamp and get past the obstacles.

A PRINCE BULLY BLOCKADE

A showdown with Prince Bully. Force him into a clear pipe, then give him a good kick!

5 TY-FOO FLURRIES

Ty-Foos try to blow Mario away as he makes his way across the snowy mountain.

6 BULLET BILL BASE

This tower is defended by Bullet Bills. Some places are only accessible to cats.

7 FUZZYTIME MINE

Avoid the mass of Fuzzies giving chase to get through this course.

BOWSER'S BOB-OMB BRIGADE

Invade the brigade of tanks manned by Bob-ombs and other explosive enemies.

B FIRE BROS. HIDEOUT #3

Step up to battle Hammer Bros., Boomerang Bros., and a Fire Bro.

C MOTLEY BOSSBLOB'S BIG BATTLE
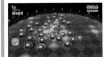
It's a face-off with Motley Bossblob. He bounces about, threatening to crush Mario.

MYSTERY HOUSE THROWDOWN

Throw balls and activate the mechanisms to get the Green Stars.

WORLD

The whole world is an enormous castle that holds the final Sprixie Princess.

1 FORT FIRE BROS.

A fortress with blue lava. Defeat the Fire Bros. to advance.

2 SWITCHBLACK RUINS

Jump on the Switch Panels to light them up in this top-down cavern course.

3 RED-HOT RUN

Run like mad over the platforms and use the Dash Panels to speed up.

4 BOILING BLUE BULLY BELT

The blue lava rises and falls as Mario runs across the sinking platforms.

A BROLDER BLOCKADE IS BACK

A rematch with Boss Brolder while Splorches get in the way.

B PRINCE BULLY BLOCKADE IS BACK

A rematch with Prince Bully. He's powered up now with a fire attack.

5 TRICK TRAP TOWER

Climb the tower and collect Key Coins. The see-through walls reveal secrets.

6 RAMMERHEAD REEF

An underground lake where Rammerheads roam. Swim carefully.

7 SIMMERING LAVA LAKE

A course where lava rises and recedes. Make sure Mario's platforms are safe.

🏰 BOWSER'S LAVA LAKE KEEP

Bowser awaits a rematch in this castle filled to the brim with lava.

C FIRE BROS. HIDEOUT #4

This time the battle is with seven Fire Bros. attacking simultaneously.

🍄 CAPTAIN TOAD GETS THWOMPED

A fortress where Bullet Bills fly. Thwomps become Captain Toad's platforms.

WORLD

A glittering world of neon lights. Bowser is waiting at the final tower.

1 SPIKY SPIKE BRIDGE

Have Mario make his way carefully over the region where spikes regularly appear.

2 PLESSIE'S DUNE DOWNHILL

Get on Plessie and ride the river of sand. There are Splounders.

3 COOKIE COGWORKS

Chocolates, cookies, and other sweets are Mario's footholds on this course.

🚂 THE BOWSER EXPRESS

A train full of enemies, with different types in each car of the train.

4 FOOTLIGHT LANE

A course with an invisible floor. Watch your footing!

5 DEEPWATER DUNGEON

Mario swims through the moving sections of water and rides Plessie, too.

6 A BEAM IN THE DARK

Mario gets aboard the floating platforms armed only with his Beam Box.

7 GRUMBLUMP INFERNO

Get aboard the Grumblumps to stay above the lava.

A MOTLEY BOSSBLOB'S ENCORE

A rematch with Motley Bossblob. The attacks come the moment Mario hits the ground.

B HISSTOCRAT RETURNS

Hisstocrat attack—again! This time, battle the fire-breathing Queen Hisstocrat.

🏰 THE GREAT TOWER OF BOWSER LAND

Mario and friends become cats and challenge Bowser for the final battle.

🎲 MYSTERY HOUSE CLAW CLIMB

Cat Mario climbs the walls to get the Green Stars.

WORLD ⭐

This world becomes accessible after the game's ending. This is where Rosalina joins the party.

1 RAINBOW RUN

Perpetually rotating rainbow platforms are Mario's way across.

2 SUPER GALAXY

The Rotating Panels are all lined up. This is where you meet Rosalina.

3 ROLLING RIDE RUN

An athletic course where all kinds of rolling platforms are Mario's footholds.

4 THE GREAT GOAL POLE

Chase the Para-Goal Pole as it runs away. Grab the Goal Pole to clear the course.

5 SUPER BLOCK LAND

Blocks cover the surface of this course. Bomb-ombs help in the search for Key Coins.

6 HONEYCOMB STARWAY

It's a top-down, vertically scrolling course.

7 GARGANTUAN GROTTO

Mega Mario pushes his way through the dark cave.

8 PEEPA'S FOG BOG

Search for Key Coins amid the platforms lost in the foggy swamp.

9 COSMIC CANNON CLUSTER

Mario puts on a Cannon Box and makes his way through the cannonball barrage.

🍄 CAPTAIN TOAD TAKES A SPIN

Every time Captain Toad hits a P Switch, the room changes direction.

WORLD 🍄

A bonus world. Some of these courses may look familiar, but the difficulty levels have gone up.

1 NIGHT FALLS ON REALLY ROLLING HILLS

Time is quickly running out on this grassland. The rotating grounds lead Mario on.

2 SPIKY MOUNT BEANPOLE

Beanpole Mountain is filled with spiky enemies.

3 DEEP BLACK JUNGLE DRIFT

Boos prowl the murky jungle, but Mario can make it through by shining a bright light.

4 TROUBLE IN SHADOW-PLAY ALLEY

If Mario can defeat all the Goombas in the Goomba Tower, the path opens up.

5 BACK TO HANDS-ON HALL

This place is filled with baseballs! Figure out the puzzles to gather the Key Coins.

6 GIGANTIC SEASICK WRECK

The Bullies are falling down, and you can fight them with Mega Mario.

7 BROKEN BLUE BULLY BELT

There are platforms and more enemies on this athletic course.

🎲 MYSTERY HOUSE BRAWL

Defeat all the enemies and get Green Stars. There are ten rooms total.

WORLD 🌼

The second half of the bonus worlds. There is no direct path to the goals here.

1 SWITCH SHOCK CIRCUS

Mario must take out the Fizzlets as he jumps on the Flipswitch Panels.

2 FLOATING FUZZY TIME MINE

Use the moving banks of water to swim away from the huge hoard of Fuzzies.

3 PIRANHA CREEPER CREEK AFTER DARK

A murky swampland. Use Fire Mario to light the torches as he moves along.

4 FASTER FORT FIRE BROS.

There's hardly any time. Fight the Fire Bros. while grabbing the +Clocks.

5 SPRAWLING SAVANNA RABBIT RUN

A wide grassland where Conkdors wander and rabbits run.

6 SHIFTIER BOO MANSION

The Boos try to trap you with many fake items in this haunted house.

7 PIPELINE BOOM LAGOON

Mario puts on the Cannon Box to take out enemies.

8 BLAST BLOCK SKYWAY

The Blast Blocks switch very fast and are arranged in a very complicated pattern.

9 TOWERING SUNSHINE SEASIDE

Take out the Fire Bros. standing on top of the Goomba Towers.

10 HONEYCOMB SKYWAY

The paths are narrower, with more enemies on this hexagonal road.

11 SPIKY SPIKE BRIDGE SNEAK

If a searchlight hits Mario and friends, the spikes come out.

12 BOSS BLITZ

Face off against six bosses, including Boss Brolder and Hisstocrat.

WORLD 👑

You can only go to this special, final world when certain conditions are met.

🎲 MYSTERY HOUSE MARATHON

The Green Stars await in the small rooms. You will need all thirty.

👷 CAPTAIN TOAD'S FIERY FINALE
Captain Toad has to make his way across unsure footing as the lava rises and falls.

👑 CHAMPION'S ROAD

The final, most complex course is the greatest test of Mario's skills.

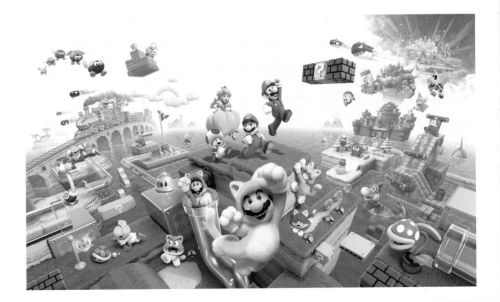

ITEMS & OBSTACLES

Items, mechanisms, and other things you'll find on the courses. Some of these respond to the Wii U GamePad's touch screen and mic.

? BLOCK
Coins or items come out when Mario hits them. Sometimes they transform into a different item.

? BOX
Coins come out when Mario puts it on and moves around.

+ CLOCK
A blue clock adds ten seconds to the countdown, and green ones add one hundred.

1-UP MUSHROOM
They supply an extra life. Most of them are found in hidden places.

10-COIN BLOCK
Coins only come out for a fixed amount of time. There's also a type that ejects coins.

ASSIST BLOCK
An Assist Block will appear if you die five times on a course.

BADDIE BOX
Enemies pop out of it at regular intervals. None will come out as long as Mario stands on it.

BASEBALL
Mario can throw them to attack. It's also possible to use them to make mechanisms move.

BEAM BOX
The area ahead is lit up when Mario wears it. A continuous beam will defeat Boos or Peepas.

BIG BLOCK
Huge blocks. Hit them five times and they break.

BIG GOAL POLE
These appear on castle courses and train courses. Grab it to clear the world.

BLAST BLOCK
These reappear at regular intervals. They come in sets of blue and red.

BLUE COIN
These appear when Mario presses a P Switch. Collect them all and get a Green Star.

BOMB
The fuse lights when Mario picks it up. It explodes on impact.

BOO'S DIRTY TRICK
These come in many shapes, such as goal poles and pipes.

BOOMERANG FLOWER
These power Mario up into Boomerang Mario.

BOWSER BOARD
Break it and Mario can receive a Green Star from Captain Toad.

BLOCK
Some of these hold items. Small Mario cannot break them.

CACTUS
When attacked, they break and leave a coin.

CANNON
These fire off cannonballs. If Mario hits one, it can become a Cannon Box.

CANNON BOX
These can come out of special ? Boxes. Put it on and it fires cannonballs.

CAT WHEEL
A nearby platform rises as Cat Mario scratches the wheel.

CHARACTER SWITCH
Only the matching character can jump on this switch.

CHECKPOINT FLAG
Restart the course from this point if you fail.

CLEAR PIPE
Mario and friends can enter these to move along. Some have enemies and items inside.

CLEAR PIPE CANNON
A clear pipe that only goes one way.

CLOUD
These are rectangular platforms. Mario can go down through them with a jump or ground pound.

CLOUD CANNON
These float in the sky. When Mario or his friends enter, they're shot up to Coin Heaven.

COIN
Get one hundred and you get a 1-Up. Some of these are stacked in piles.

COIN RING
A golden ring. Pass through to receive three coins.

COLOR PANELS
They change color when touched. A Green Star appears once all are switched.

CRATE
They break when attacked. They can produce items, coins, or even enemies.

CRYSTAL BLOCK
When anyone but Small Mario hits them, they break. They never have items inside.

DANDELION
You can make them vanish by touching them or blowing into the mic of the Wii U GamePad.

DASH PANEL
When Mario touches one, he runs very fast. The dash lasts for a limited amount of time.

DONUT BLOCK
These blocks turn red and fall shortly after Mario gets on, and reappear after a while.

DOUBLE CHERRY
These power Mario up into Double Mario. He maxes out at five copies.

EXPANDING BLOCK
A number of blocks stretch upward or sideways.

FIRE BAR
These are bars of fireballs that rotate around a block. They come with one bar or two.

232

FIRE FLOWER
These power Mario up into Fire Mario.

FLIPSWITCH PANEL
Step on them, and they turn from blue to yellow. Mechanisms start when all are yellow.

FLOATING MINE
These are found blocking clear pipes. They can be destroyed by fireballs and other attacks.

FOOTLIGHT FLOOR
A floor that normally can't be seen, but sometimes, a small section can become visible.

GIANT POW BLOCK
It blows Meowser away when hit four times.

GLOWING LIGHT
Coins or items appear when Mario does a ground pound.

GOAL POLE
Grab on to clear the course. The higher Mario grabs it, the higher the score.

GOLD P SWITCH
When stomped on, coins come out in a stream for a while.

GOLD SHELL
Coins come out when Mario carries or enters it. It breaks after one hundred coins.

GONG
Coins or enemies appear if you ring it with an attack.

GOOMBA'S ICE SKATE
Mario can use it to ram enemies once he defeats a Skating Goomba.

GOOMBA MASK
A disguise dropped by Goombas that lets you blend in with them.

GREEN COIN
A Green Star appears when you collect all eight.

GREEN STAR RING
Jump through it and eight Green Star Coins appear.

GREEN STAR
Several are found on each course. They appear when certain conditions are fulfilled.

GRUMBLUMP
Block-shaped platforms that roll above the lava.

HIDDEN BLOCK
Invisible blocks. If Mario is active nearby, they can barely be seen.

HIDDEN COIN
Coins that aren't visible. Pass through them and they appear.

INVINCIBILITY SUPER LEAF
It powers Mario up to White Tanooki Mario.

JUMP PANEL
When Mario gets on and jumps, he's sent high into the air.

KEY COIN
If you collect all five in certain areas, you can use a Warp Box.

KICK BOMB
A type of bomb that Mario can kick. It explodes if he touches it when it's red.

LAVA
Fiery liquid housing Lava Bubbles and Splorches. If Mario falls in, you lose a life.

LIFTS
These are platforms that move when Mario gets on. They come in all types.

LONG ? BLOCK
These produce coins or items in threes.

LUCKY BELL
These power Mario up into Lucky Cat Mario.

MEGA MUSHROOM
A power-up that turns Mario into Mega Mario for a limited amount of time.

MULTI P SWITCH
These come several to a set. If they are pressed down at the same time, an item appears.

MULTI-VATOR
The lift starts to move when the number of characters on it matches the displayed number.

MUSHROOM TRAMPOLINE
They bounce when Mario gets on. Try to time Mario's jumps.

MYSTERY BOX
These move Mario to an area where he can get a Green Star.

P SWITCH
Coins or Green Stars come out when it's pressed, or it could start some mechanisms going.

PARA-GOAL POLE
A Goal Pole with wings! Chase it down, grab it, and the level is cleared.

PIPE
These send Mario to a special area or some odd rooms. Gold pipes send Mario to a bonus area.

PLANTS
They're found growing on courses. Some of them produce coins when Mario passes over them.

POISON BOG
A purple lake found in jungles. It's so toxic, it's an instakill.

POTTED PIRANHA PLANT
If Mario picks it up and carries it, it will eat enemies for him.

PROPELLER BOX
Have Mario put it on, then hold down the button for a bit, and Mario flies high into the air.

PROPELLER PLATFORM
This lift moves when you blow into the mic of the Wii U GamePad.

QUICKSAND
This is a sandy area that slows Mario's movements down as he sinks.

RED COIN
Pass through the Red Ring and they appear. If you collect them all you, get an item.

RED POW BLOCK
A one-hit block that defeats all the attacking enemies.

RED RING
A red-colored ring. Eight Red Coins appear nearby when Mario passes through this.

RED-BLUE PANEL
These two platforms switch when Mario jumps.

ROCK BLOCK
These slightly larger blocks don't break when Mario hits them, but a bomb can destroy them.

ROULETTE BLOCK
When Mario hits it, it stops on a picture, and that item appears.

SAND STATUE
These statues take the form of Goombas or Bowser. When Mario breaks them, enemies and items appear.

SEARCHLIGHT
When their light falls on Mario or his friends, some trick, trap, or mechanism is started.

SEESAW
Mario's weight tilts half of it down. They come in all sorts of shapes and sizes.

SHŌJI DOOR

These won't open unless you use the touch screen on the Wii U GamePad.

SNOWBALL

They have the same effect as Baseballs. These appear when a Snow Pokey is defeated.

SPIKE TRAP

Floors with spikes in them. The spikes come out at regular intervals.

SPIKED BAR

Long poles with spikes attached. They roll along the ground.

STAMP

Stamps can be found in certain courses.

SUPER BELL

These power Mario up into Cat Mario.

SUPER LEAF

These power Mario up into Tanooki Mario.

SUPER MUSHROOM

When Mario grabs one, he powers up to Super Mario.

SUPER STAR

Makes Mario invincible for a short time.

SWITCH BLOCK

When hit, these blocks change from red to blue, changing the mechanisms around them.

SWITCHBOARD

A panel with a front and back half. The side Mario stands on is the way it goes.

TORCH

These are set aflame when hit by a fireball, sometimes starting a mechanism.

TOUCHSTONE

These move when you touch the Wii U GamePad. They return to their original position after a while.

TRAMPOLINE

When Mario gets on and jumps, he flies high into the air. He can carry them, too.

TRAPEZE

Grab on and swing! The higher Mario swings, the farther he can jump.

TREE

Mario can grab on and climb them, and sometimes coins or items come out.

WARP BOX

This takes Mario on a one-way trip to another Warp Box.

WARP PIPE

It takes Mario one world ahead when he enters.

COLLECT EIGHTY-FIVE STAMPS!

You start out with fifteen stamps, and your collection increases with each new stamp added. Collecting all 100 stamps is one of the conditions for being able to access the courses on W-👑.

Stamp Collection

AND MORE

MEMORABLE MOMENTS

Here we present some of the game's most memorable moments. You will be able to see the scene where Rosalina joins your group only once.

CAPTAIN TOAD'S INTRODUCTION

Captain Toad is also on an adventure to gather up Green Stars. Since Captain Toad is sometimes attacked by enemies, you get his Green Stars when you rescue him. You can control Captain Toad on his own adventures to gather Green Stars on certain special courses.

WIN THE JACKPOT!

As you move along on the adventure, a Lucky House will appear on the world map. There you can play slot machines for coins. The background music is an homage to the character select screen music from *Super Mario Bros. 2*.

PIXEL ART LUIGI

It was Luigi's thirtieth birthday when this game was released in 2013, and so this game was a part of the "Year of Luigi" campaign. That's the reason why there's a pixel-art Luigi hidden at nearly every turn. One may come out when a block is broken, another may be hidden in the background, and yet another may appear when certain conditions are met. There are all sorts of ways to make them appear, but they're all pretty difficult to find. There are even some hidden in the electronic instruction manual.

DANCING PLANTS

The flowers and grasses planted in the ground dance to the rhythm of the background music (their dance changes when the music changes). It's especially easy to see when Mario reaches the Goal Pole.

START YOUR ENGINES!

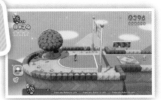

In the course W3-6, Mount Must Dash, Mario and his friends use Dash Panels to move forward. This level is based on motifs taken from *Super Mario Kart* for the SNES game system, including the start line, goal line, colorful curbstones, and many other identifiable elements. The background music is also an arrangement of the "Mario Circuit" music from that game.

FANTASTIC FIREWORKS

When the goal is reached and the final digit in your score is 1, then there is one firework. At 3, three fireworks go off, and when it's 6, then five fireworks are set off.

ALL ABOARD THE COIN EXPRESS!

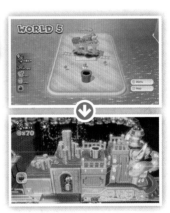

If you enter the pipe hidden on the World 5 map, Mario and his friends can find and board the Coin Express. This bonus stage has a huge load of coins piled up. The stage appears again each time you've cleared twenty-five courses.

A LONELY ENDING

If you use warp pipes to get to the next world, then the Sprixie Princesses held in the castles you skipped won't appear in the ending scene.

TIME ATTACK

After you've cleared W-, your best time on each course appears. At the same time, a fast ghost Mii appears on the courses, and they race with Mario and his friends to get the best time.

WHY DON'T YOU PLAY LUIGI BROS.!

Once you have cleared W★, a pixel-art version of Luigi appears in the lower left corner of the title screen. When you select it, you can play *Luigi Bros.* This game uses the appearance of *Mario Bros.* for the NES, but the player characters are both Luigis. By the way, if you have *New Super Luigi U* on your Wii U already, then you can play *Luigi Bros.* from the very beginning.

ROSALINA JOINS THE PARTY...

When you go to W★-2 for the first time, you will see a meeting with Rosalina. When you clear the course, Rosalina can be used as a player character. That course includes Lumas and Octoombas, and has a motif based on *Super Mario Galaxy*.

...AND THE DEMO SCREEN!

After you have cleared W★-2, go back to the title screen where the demo automatically plays. Rosalina will start appearing there. Also, after Rosalina has joined your party, she will appear with your other player characters in the credit scroll.

THE FINAL CHALLENGE: WORLD 👑!

Once you have cleared all of the courses up through W👑, collected all of the Green Stars and grabbed every Goal Pole at the very top, the final world—W👑—opens up. If you clear its three extremely difficult courses, you'll have completed the entire game. The background music for this world on the world map is the Rosalina's Comet Observatory theme that was used in *Super Mario Galaxy*.

HELPFUL HINTS & TECHNIQUES

Here we'll give some hints and tips to help in your adventure. To clear the entire game, you'll have to clear every course with every character.

THE STARS ARE YOUR MARK OF HONOR!

If you want prestige for your save file, first you have to see the ending to get the first ★. Once you get all the Green Stars up through W-8, you get ★★. Then clear all the courses of W★, W🌸, and W👑 to get ★★★. When you've collected all the Green Stars on every world aside from W👑, you get ★★★★. Finally, when you collect all the Green Stars from all courses aside from W👑, grabbed every Goal Pole at the top, and cleared every course with every character, you get ★★★★★. Avoid using an Invincibility Leaf and the stars will shine.

WHICH CHARACTERS CLEARED THE COURSE?

Once W👑 has appeared, all the courses on the world map will now show the symbols of the characters that have completed them. Additionally, when you have each character complete all the courses, you get a new stamp.

PIPES LEAD TO THE NEXT WORLD!

There are hidden warp pipes hidden in courses W2-1 and W4-2 that can take your characters to the next world. In both cases you need to discover a path running above the ceiling leading to the warp pipes.

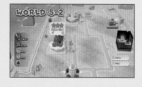

MARIO
BEFORE HE WAS SUPER

Before *Super Mario Bros.* took the world by storm, there was a period of time when it could have been in the bargain bins. Back then, Mario appeared in arcade games and the Game & Watch, among others, and we'll tell you about those humble beginnings here.

1981 — THE AGE OF DONKEY KONG

The game where Mario made his first appearance is the 1981 arcade game *Donkey Kong*.

It was an action game where the main character climbs girders and uses hammers as his weapons to rescue the kidnapped Pauline from Donkey Kong. He was often referred to as "Jumpman" at the time, and the name "Mario" first appeared in a 1981 flyer promoting *Donkey Kong* in the US. He was officially renamed in the sequel arcade game, *Donkey Kong Jr.* This is an action game where Donkey Kong Jr. uses ropes and fruits to battle enemies in his efforts to rescue his father, Donkey Kong, who has been caged for his misdeeds. In this game, Mario plays the antagonist who is controlling the enemies and attacking Donkey Kong Jr.

During this period, in games like *Donkey Kong II* and *Donkey Kong Hockey* (both for the Game & Watch), the main character was Donkey Kong. In *Donkey Kong 3*, Mario never appears, and the hero is instead Stanley the Bugman.

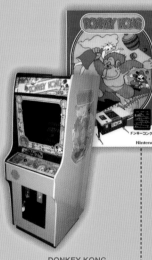

DONKEY KONG ARCADE VERSION

Released in 1981, it had a total of four stages, including the second stage (50m) and a demo that wasn't in the NES version.

DONKEY KONG GAME & WATCH VERSION

The main character climbs girders while avoiding barrels. This game used both the screens on the game machine, and this is the first time the plus-shaped + Control Pad is used to control the player characters.

1983 — THE AGE OF MARIO BROS.

The first game featuring Mario's name in the title was *Mario Bros.*, which debuted in 1983. In both the NES and arcade games, the twin brothers, Mario and Luigi, work together to vanquish monsters that appear underground. Here you can see many of the fundamental building blocks of *Super Mario Bros.*, such as coins, pipes, turtle-based enemies and POW Blocks. One of the most popular features was that two people could play at the same time, and its popularity spread Mario's name throughout the world. The *Mario Bros.* game for the Game & Watch was somewhat different, in that Mario and Luigi are placed on the right and left screens, and have to move quickly to and from conveyor belts where many packages are sent along.

Other Mario titles of the period were, among others, *Mario's Cement Factory* and *Mario's Bombs Away* (both for the Game & Watch).

MARIO BROS. ARCADE VERSION

This was released at about the same time as the Famicom version of the game—the NES version came approximately three years later—and the games were roughly the same. The graphics on the arcade version were slightly larger.

MARIO BROS. GAME & WATCH VERSION

Released in March of 1983, this came out earlier than the NES version. The player controlled Luigi on the left and Mario on the right.

1985 — THE AGE OF SUPER MARIO BROS.

This game kicked off the transition from *Mario Bros.* to *Super Mario Bros.* Set in the Mushroom Kingdom, Mario's adventure begins when Bowser kidnaps Princess Toadstool. While this game was sold along with the NES, there was also a version made for the Game & Watch. It also had an arcade version.

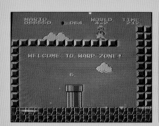

VS. SUPER MARIO BROS.

It's based on the NES game, but the course layout is slightly altered and it's a bit more difficult. When you get a Game Over, you may be placed on a Top Scores screen.

© 1986 NINTENDO

SUPER MARIO BROS. GAME & WATCH VERSION

In Japan, this was given out as a freebie at a Famicom Disk System competition event. In other regions it was sold as a part of the New Widescreen and Crystal Screen series.

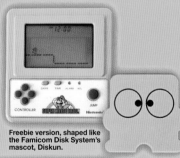

Freebie version, shaped like the Famicom Disk System's mascot, Diskun.

NEW WIDESCREEN VERSION

CRYSTAL SCREEN VERSION

SOURCE MATERIAL ASSISTANCE: ISAO YAMAZAKI

MARIO PLAYS HIS PART
IN ALL THESE GAMES

This section lists quite a few games in which Mario has played a part—dating back to the Famicom and NES age all the way up to August 2016. While this book has covered the main entries in the *Super Mario* series in great detail, there are still many other titles where Mario is the star or makes a cameo, and yet, this is not an exhaustive list. Certain games where Mario plays a minor role, his likeness is used as an item or decoration, and games that involve a member of the Mario family are included.

LEGEND

7.15.1983 NES FC → ★★★★

DATE

SYSTEM

MARIO'S INVOLVEMENT

★★★★ Main *Super Mario* series games
★★★★ Mario is a major character
★★★★ Mario plays a small part
★★★★ Mario's likeness appears
★★★★ A member of the Mario family appears

FAMILY COMPUTER/NES FC NES
Nicknamed the Famicom in Japan, it became the basis for Japan's home gaming systems. The NES was bundled with *Super Mario Bros.*, making both Nintendo and Mario household names. Released in the US on October 18, 1985 and in Japan on July 15, 1983.

FAMILY COMPUTER DISK SYSTEM FCD
This add-on hardware for the Family Computer utilized rewritable disks, which made saving the game much easier. It was released in Japan February 21, 1986, but never released in the US.

GAME BOY GB
This portable system was a huge hit that revolutionized handheld gaming. Later the Game Boy Color (GBC) went on sale. Released on July 31, 1989 in the US and April 21, 1989 in Japan.

SUPER FAMICOM/SNES SFC SNES
A huge step up from the Famicom and NES in regards to both graphics and sound. It also added the X, Y, L, and R Buttons to the controllers. Released on August 13, 1991 in the US and November 21, 1990 in Japan.

VIRTUAL BOY VB
A system that could draw the user into a 3D world through the use of separate displays for each eye. The screen featured two colors: red and black. Released on August 14, 1995 in the US and July 21, 1995 in Japan.

NINTENDO 64 N64
Play in a 3D world! The controller featured the Control Stick for easy movement. In Japan, a disk drive peripheral—the 64DD —was released and made saving games and data much easier. Released on September 29, 1996 in the US and June 23, 1996 in Japan.

GAME BOY ADVANCE GBA
Even though it was a handheld system, the GBA could provide higher performance than the SNES. Later variations had flip-screens, like the Game Boy Advance SP, or were very small, like the Game Boy Micro. Released on June 11, 2001 in the US and March 21, 2001 in Japan.

NINTENDO GAMECUBE GC
The first Nintendo console to make use of optical discs. The Game Discs were a proprietary type, measuring a little over 3 inches. Released on November 18, 2001 in the US and September 14, 2001 in Japan.

NINTENDO DS DS
This handheld system makes use of two screens, one being a touch screen. Variations on the system, such as the Nintendo DS Lite, Nintendo DSi, and Nintendo DSi XL, came later. Downloadable games were available via DSiWare . Released on November 21, 2004 in the US and December 2, 2004 in Japan.

Wii Wii
This device didn't use existing controllers, but rather an intuitive design that made for fun play. WiiWare was available via the Wii Shop Channel. Released on November 19, 2006 in the US and December 2, 2006 in Japan.

NINTENDO 3DS 3DS
This system made naked-eye 3D a reality. A number of variations on this system have been made, such as the Nintendo 3DS XL and the New Nintendo 3DS, among others. Downloadable titles in this section are labeled with 3DS-DL . Released on March 27, 2011 in the US and February 26, 2011 in Japan.

Wii U Wii U
The main controller for this system, the Wii U GamePad, features a touch screen, microphone, and camera, and can be used alongside the TV for engaging asymmetric gameplay. Downloadable titles are labeled in this section with Wii U-DL . Released on November 18, 2012 in the US and December 8, 2012 in Japan.

1984

JAPAN: 6.21.1984 FC ★★★★

FAMILY BASIC

This software allows users to create their own programs, and Mario is one of the usable characters. He appears as he does in *Donkey Kong*—he's made up of pixels.

1985

JAPAN: 2.21.1985 FC ★★★★

FAMILY BASIC V3

An upgrade to the original *Family BASIC*. Just like in the original, Mario is an available character that the user can place in their programs.

US: 10.18.1985; JAPAN: 6.18.1985 NES ★★★★

WRECKING CREW

In this game, Mario and Luigi work as a demolition crew. The goal is to destroy all the walls in each stage.

© 1985 Nintendo

US: 10.18.1985; JAPAN: 9.13.1985 NES ★★★★

SUPER MARIO BROS.

Mario's adventure to save the Mushroom Kingdom and rescue Princess Toadstool leads to a confrontation with Bowser (see page 16).

US: 10.18.1985; JAPAN: 12.12.1983 NES ★★★★

DONKEY KONG JR. MATH

Even though Mario doesn't appear in this game, the Kongs play a big part! It's an educational action game in which the player must solve math equations.

US: 10.18.1985; JAPAN: 1.14.1984 NES ★★★★

TENNIS

Mario appears as the chair umpire.

© 1984 Nintendo

PINBALL

Mario and Pauline appear in a special minigame.

1986

FAMICOM DISK SYSTEM (BOOT-UP SCREEN)

Pixel art of Mario and Luigi appears when the Disk System boots up.

DONKEY KONG JR.

Mario is the villain this time! The player controls Donkey Kong Jr. in a mission to save his father, Donkey Kong.

DONKEY KONG

The earliest console game in Japan in which Mario appears. This fixed-screen action game depicted Donkey Kong kidnapping Mario's girlfriend, Pauline, and Mario's attempts to rescue her.

DONKEY KONG 3

In this fixed-screen shooting game, the player character is a boy named Stanley.

MARIO BROS.

The earliest console game in Japan starring Mario, as well as the first appearance of his younger twin, Luigi. The two brothers must battle enemies emerging from pipes.

I AM A TEACHER: SUPER MARIO SWEATER

This program is a simulator meant to teach sewing. It provides on-screen instructions and includes patterns for characters such as Mario and Goomba.

ALL NIGHT NIPPON: SUPER MARIO BROS.

This version of *Super Mario Bros.* was a collaboration with Nippon Broadcasting System. Personalities from the popular radio show *All Night Nippon* were not only drawn on the cover; they also appeared in-game as enemies like Goombas and Piranha Plants, and even took the place of the Mushroom retainers. This was a limited-run raffle prize.

1987

FAMILY COMPUTER GOLF: JAPAN COURSE

Mario is the player character in this golf game, marking one of his earliest appearances as an athlete.

FAMILY COMPUTER GOLF: U.S. COURSE

This golf game features courses based on real ones in the States. Mario can be seen sporting red-and-white stripes.

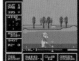

MIKE TYSON'S PUNCH-OUT!!

Mario appears as the referee in this boxing game. This version of the game was released in North America first. After its successful launch, it was given a full retail release in Japan as well.

FAMICOM GRAND PRIX: F-1 RACE

Illustrations of Mario are very prominent on the packaging.

1988

FAMICOM GRAND PRIX II: 3D HOT RALLY

Mario appears as the driver while Luigi acts as the mechanic whenever the car needs repairs.

SUPER MARIO BROS. 2

Mario, Luigi, Princess Toadstool, and Toad are all playable characters in this action game where they set out to rescue the inhabitants of Subcon, the land of dreams (see page 64).

© 1988, 1992 Nintendo

KAETTEKITA MARIO BROS.

This version of *Mario Bros.* is a collaboration with the Nagatanien tea shop chain. It includes Nagatanien commercials that play at certain points during the game.

1989

SUPER MARIO LAND

Princess Daisy makes her debut in this side-scrolling action game, which was a launch title for the Game Boy. Mario must journey to Sarasaland to rescue her from Tatanga (see page 44).

TETRIS

Mario is Player One and Luigi is Player Two, but they only appear when two players are using the Game Link Cable.

TENNIS

Just like the NES game, Mario acts as the chair umpire.

ALLEYWAY

Mario controls the paddle in this block-breaking game. Enemies such as Piranha Plants, Bloopers, and even Bowser appear in bonus rounds.

1990

SUPER MARIO BROS. 3

Mario must defeat all the Koopalings and retrieve each king's magic wand in this huge adventure in the Mushroom World (see page 32).

QIX

Depending on the final score, Mario, Luigi, and Princess Toadstool congratulate and cheer for the player.

US: 10.14.1990; JAPAN: 7.27.1990 **NES**

DR. MARIO

In this puzzle game, Mario dons a doctor's lab coat and attempts to eradicate viruses with his patented Megavitamins.

US: 12.1.1990; JAPAN: 7.27.1990 **GB**

DR. MARIO

This version plays a lot like the NES game, but the size of the pill bottle is one row shorter, among other adjustments.

1991

US: 2.3.1991; JAPAN: 11.9.1990 **GB**

F-1 RACE

When the player wins the Grand Prix, they get a special shout-out from Mario.

US: 8.13.1991; JAPAN: 4.26.1991 **SNES**

SIMCITY

A city planning simulation. If the player's city grows into a megalopolis with over 500,000 residents, they are awarded a Mario statue.

US: 8.13.1991; JAPAN: 11.21.1990 **SNES**

SUPER MARIO WORLD

Launched alongside the SNES, Mario meets Yoshi for the first time in this action-adventure game (see page 50).

US: 9.29.1991; JAPAN: 9.20.1991 **NES**

NES OPEN TOURNAMENT GOLF

Mario and Luigi are the player characters. Princesses Toadstool and Daisy act as the brothers' caddies and don matching miniskirts.

1992

US: 2.1992; JAPAN: 6.21.1993 **SNES**

SUPER SCOPE 6

These games require the Super Scope—a light gun accessory for the SNES—to play. In "LazerBlazer Type A: Intercept," Mario pilots a plane while Lemmy Koopa chases behind him on a rocket.

US: 4.13.1992; JAPAN: 11.21.1991 **SNES**

THE LEGEND OF ZELDA: A LINK TO THE PAST

A picture of Mario can be found in a house in Kakariko Village.

US: 6.1.1992; JAPAN: 12.14.1991 **NES**

YOSHI

A puzzle game where the goal is to make matches using the enemies falling from the top of the screen. If the player connects the top and bottom of an egg, it hatches into a Yoshi.

© 1991 Nintendo

US: 7.10.1992; JAPAN: 12.14.1991 **GB**

YOSHI

The gameplay is identical to the NES version of the game, but the small size of the screen forces play down to just seven rows.

US: 8.1.1992; JAPAN: 7.14.1992 **SNES**

MARIO PAINT

This game was bundled with the SNES Mouse and was the first Super Nintendo game to utilize it. The player could create drawings, animation, and music, and could even play a minigame called "Gnat Attack" that tested their hand-eye coordination.

US: 9.1.1992; JAPAN: 8.27.1992 **SNES**

SUPER MARIO KART

This game marked the debut of the *Mario Kart* series, which is still massively popular to this day. Mario and friends race against each other, using items to edge out the competition.

© 1992 Nintendo

US: 11.1.1992; JAPAN: 10.21.1992 **GB**

SUPER MARIO LAND 2: 6 GOLDEN COINS

The sequel to *Super Mario Land*. Mario must travel to six different zones to collect all six golden coins and take back his castle from his rival, Wario (see page 72).

© 1992 Nintendo

1993

US: 4.1993; JAPAN: 11.21.1992 **NES**

YOSHI'S COOKIE

The second Yoshi puzzle game. Mario, dressed as a chef, bakes cookies. The goal is to match up rows and columns of cookies.

© 1992 Nintendo

US: 4.1993; JAPAN: 11.21.1992 **GB**

YOSHI'S COOKIE

Up to four people can play in the VS. Game via the Four Player Adapter. Two new characters, Bowser and the Princess, are included.

© 1992 Nintendo

US: 6.1993; JAPAN: 7.9.1993 **SNES**

YOSHI'S COOKIE

The cookies in this version are much more colorful than in the NES version of the game. It also incorporates improved graphics, music, and a new puzzle mode.

US: 8.1.1993; JAPAN: 7.14.1993 **SNES**

SUPER MARIO ALL-STARS

This four-in-one collection includes *Super Mario Bros.*, *Super Mario Bros.: The Lost Levels*, *Super Mario Bros. 2*, and *Super Mario Bros. 3*. The original NES games were remade for this release and featured improved graphics and gameplay.

US: 8.6.1993; JAPAN: 6.6.1993 **GB**

THE LEGEND OF ZELDA: LINK'S AWAKENING

Link can win a Yoshi doll by playing a crane game. A picture of Princess Toadstool also appears. Other enemies, like Wart and Chain Chomps, appear as well.

JAPAN: 8.27.1993 **SFC**

MARIO & WARIO

A puzzle game that utilized the SNES Mouse. The player controls Wanda the fairy as she tries to reunite Mario, blinded by the bucket on his head, with his brother Luigi.

© 1993 Nintendo

YOSHI'S SAFARI

The Super Scope was required to play this game. Mario hops aboard Yoshi's back and takes aim at the Paragoombas, Koopa Troopas, and other enemies that appear.

1994

US: 3.13.1994; JAPAN: 1.21.1994 (GB)

WARIO LAND: SUPER MARIO LAND 3

An action game starring Wario, Mario's rival. Mario only appears at the end of the game.

US: 6.1994; JAPAN: 6.14.1994 (SNES)

SUPER GAME BOY

An adapter that allowed the user to play their Game Boy games on the SNES. Input a special button command and Mario appears on-screen.

US: 7.22.1994; JAPAN: 6.14.1994 (GB)

DONKEY KONG

A Game Boy title that re-creates the feel of the original *Donkey Kong* game. The first four stages are faithful remakes of the arcade version.

© 1994 Nintendo

US: 10.10.1994; JAPAN: 6.4.1994 (SNES)

STUNT RACE FX

A polygonal 3D racing game. There are Mario billboards on one course.

US: 11.21.1994; JAPAN: 11.26.1994 (SNES)

DONKEY KONG COUNTRY

Diddy Kong debuts alongside series mainstay Donkey Kong in this distinctive action-adventure game.

US: 12.10.1994; JAPAN: 2.29.1994 (NES)

WARIO'S WOODS

The last game Nintendo developed for both the Famicom and NES systems. The player controls Toad, who clears enemies from the bottom of the screen by catching bombs of the same color.

1995

US: 3.1995; JAPAN: 3.14.1995 (GB)

MARIO'S PICROSS

The player uses numerical clues to uncover the hidden picture in this puzzle game. Mario appears dressed as an archaeologist.

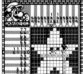
© 1995 Nintendo / APE inc. / JUPITER Co., Ltd.

US: 6.5.1995; JAPAN: 8.27.1994 (SNES)

EARTHBOUND

If the player allows the game to suggest a character name, options such as Mario and Luigi come up.

US: 6.26.1995; JAPAN: 7.27.1995 (GB)

DONKEY KONG LAND

This Game Boy game is heavily inspired by the SNES game *Donkey Kong Country*.

US: 8.14.1995; JAPAN: 7.21.1995 (VB)

MARIO'S TENNIS

A game for the Virtual Boy. Mario and his friends play tennis on a court in stereoscopic 3D.

© 1995 Nintendo

JAPAN: 9.14.1995 (SFC)

MARIO'S SUPER PICROSS

Picross for the Super Famicom. It allows two players to play at the same time and includes many more puzzles than the original. Wario appears this time, too.

© 1995 Nintendo © 1995 APE inc. © 1995 Jupiter Co, LTD.

US: 10.1.1995; JAPAN: 9.28.1995 (VB)

MARIO CLASH

Mario can pick up Koopa shells and throw them at enemies in the background. This is thanks to the special 3D graphics made possible by the Virtual Boy.

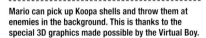
© 1995 Nintendo

US: 10.4.1995; JAPAN: 8.5.1995 (SNES)

SUPER MARIO WORLD 2: YOSHI'S ISLAND

Baby Mario's first appearance. When Baby Luigi is kidnapped by Kamek, the Yoshis take Baby Mario on an adventure across the colorful island to rescue him.

© 1995 Nintendo

US: 11.20.1995; JAPAN: 11.21.1995 (SNES)

DONKEY KONG COUNTRY 2: DIDDY'S KONG QUEST

At the end of the game, Cranky Kong counts all of the DK Coins the player collected. Depending on that number, the player ranks among other Video Game Heroes— Mario holds the top spot at thirty-nine coins.

US: 11.27.1995; JAPAN: 12.1.1995 (VB)

VIRTUAL BOY WARIO LAND

Wario stars in this action game for the Virtual Boy.

1996

US: 5.13.1996; JAPAN: 3.9.1996 (SNES)

SUPER MARIO RPG: LEGEND OF THE SEVEN STARS

The very first RPG starring Mario. If the player presses any button at just the right time during an attack, Mario deals more damage.

©1995 Nintendo / SQUARE

US: 8.1996; JAPAN: 10.26.1996 (SNES) (GB)

TETRIS ATTACK

Known as *Panel de Pon* in Japan, this often fast-paced puzzle game features Yoshi and friends on a quest to break Kamek's curse and defeat Bowser.

US: 9.20.1996; JAPAN: 3.21.1996 (SNES)

KIRBY SUPER STAR

An action game starring Kirby. When Kirby activates his Stone ability, he may turn into a statue of Mario. The Mario family are in the audience during the Megaton Punch Contest.

US: 9.23.1996; JAPAN: 11.23.1996 (GB)

DONKEY KONG LAND 2

This game is a simplified version of *Donkey Kong Country 2*, but for Game Boy.

SUPER MARIO 64

The first full 3D *Mario* game where Mario's movements are unrestricted. On July 18, 1997, a Rumble Pak version came out in Japan (see page 82).

© 1996 Nintendo

US: 9.29.1996; JAPAN: 6.23.1996 (N64) ⭐

PILOTWINGS 64

In the Little States stage, Mario's face can be seen on Mt. Rushmore. If the player shoots it, it turns into Wario's face.

JAPAN: 10.19.1996 (GB) ⭐⭐⭐

PICROSS 2

This *Picross* game is heavily expanded, including three times as many puzzles. The puzzles themselves are much larger, too.

US: 11.22.1996; JAPAN: 11.23.1996 (SNES) ⭐

DONKEY KONG COUNTRY 3: DIXIE KONG'S DOUBLE TROUBLE!

The third entry in the *Donkey Kong Country* series. Sometimes Wrinkly Kong can be seen playing a Nintendo 64, and the accompanying music is inspired by *Super Mario 64*.

1997

US: 2.10.1997; JAPAN: 12.14.1996 (N64) ⭐⭐⭐

MARIO KART 64

Eight members of the Mario family race in a 3D environment.

© 1996 Nintendo

US: 5.1997; JAPAN: 2.1.1997 (GB) ⭐⭐⭐

GAME & WATCH GALLERY

Features four of the most popular games of the pre-NES *Game & Watch* series, and several other unlockable games to boot. The Modern Version minigames feature members of the Mario family.

US: 10.1.1997; JAPAN: 1.28.2000 (GB) ⭐⭐⭐

DONKEY KONG LAND III

An action game where Dixie Kong and Kiddy Kong head off to find the legendary Lost World.

US: 11.24.1997; JAPAN: 11.21.1997 (N64) ⭐⭐

DIDDY KONG RACING

A racing game starring Diddy Kong. The player can choose from ten characters total—not all of them animals!

JAPAN: 12.1.1997 (SFC) ⭐⭐⭐

HEISEI SHIN ONIGASHIMA (PART 1)

This game was available for download using a Nintendo Power cartridge, a Japan-exclusive accessory that allowed players to download games to it at their leisure. It was originally released on Satellaview as *BS Shin Onigashima*, but on May 23, 1998, it was also released as a physical Super Famicom game. A golden Mario statue appears and related dialog translates to "A golden Mario?! No, no…it must be a golden statue of the Buddha."

JAPAN: 12.19.1997 (N64) ⭐

64 DE HAKKEN! MINNA DE TAMAGOTCHI WORLD

A party game released by Bandai. Mario and his friends appear when the Tamagotchis grow up.

1998

JAPAN: 1.1.1998 (SFC) ⭐⭐⭐

WRECKING CREW '98

This update to the original *Wrecking Crew* was a Nintendo Power downloadable title. A retail version of the game was released in Japan on May 23, 1998.

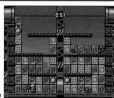

© 1998 Nintendo

US: 3.10.1998; JAPAN: 12.21.1997 (N64) ⭐⭐⭐⭐

YOSHI'S STORY

This game has a very distinct flavor! The player has their choice of which uniquely colored Yoshi they'd like to use as their player character.

JAPAN: 4.1.1998 (SFC) ⭐

FAMICOM TANTEI CLUB PART II: USHIRO NI TATSU SHŌJO

This Nintendo Power downloadable game is an update of one that was once available for the Famicom Disk System. The "Disk Reading" screen, which Mario and Luigi show up on, is a direct copy of the Famicom Disk System boot-up sequence.

JAPAN: 6.1.1998 (SFC) ⭐⭐⭐

DR. MARIO

In Japan, this version of the game was released for the Nintendo Power downloadable cartridge. It's based on the NES version of the game.

© 1990, 1994, 1998 Nintendo

US: 6.1.1998; JAPAN: 2.21.1998 (GB) ⭐⭐⭐

GAME BOY CAMERA

Using this accessory, the player could turn their Game Boy into a camera. Mario appears in some bonus pictures.

US: 9.28.1998; JAPAN: 2.27.1996 (GB) ⭐⭐⭐⭐

POKÉMON RED/BLUE

The dialog "a game with MARIO wearing a bucket on his head!" appears in the game, a reference to the Super Famicom game *Mario & Wario*.

US: 11.20.1998; JAPAN: 9.27.1997 (GB) ⭐⭐⭐⭐

GAME & WATCH GALLERY 2

This title contains six minigames, including *Donkey Kong*, from the *Game & Watch* series. It even allows a two-player mode.

US: 11.23.1998; JAPAN: 11.21.1998 (N64) ⭐

THE LEGEND OF ZELDA: OCARINA OF TIME

If the player looks through one of the windows in Hyrule Castle, they can see paintings of several Mario family members.

JAPAN: 12.2.1998 (N64) ⭐⭐

MARIO NO PHOTOPI

This game made use of the SmartMedia cartridge which allowed the user to edit and combine their own photos. Additional theme sets were available, including one for Yoshi.

US: 12.15.1998; JAPAN: 12.12.1998 (GB) (GBC) ⭐⭐⭐⭐

THE LEGEND OF ZELDA: LINK'S AWAKENING DX

This is much like the Game Boy version of the game, but in color. It features the same Princess Toadstool and Yoshi cameos as the original game.

1999

US: 2.8.1999; JAPAN: 12.18.1998 **N64**

MARIO PARTY

A collection of party minigames for the whole family (and the Mario family, too)!

© 1998 Nintendo © 1998 HUDSON SOFT

US: 2.10.1999; JAPAN: 10.21.1998 **GBC**

WARIO LAND II

In this action game, Wario isn't damaged by enemies—he just loses coins.

US: 4.26.1999; JAPAN: 1.21.1999 **N64**

SUPER SMASH BROS.

A fighting game that includes a huge trove of Nintendo characters, including Mario, Yoshi, Luigi, and many others. The player's objective is to knock their opponents off the stage.

US: 5.10.1999; JAPAN: 3.1.2000 **GBC**

SUPER MARIO BROS. DELUXE

This game is a rerelease of the original *Super Mario Bros.*, but with new modes added. If the player meets certain conditions, they may also play a modified version of *Super Mario Bros: The Lost Levels.*

JAPAN: 6.1.1999 **SFC**

PICROSS NP VOL. 2

A downloadable game for the Nintendo Power cartridge in Japan. In Character Mode, familiar faces like Yoshi and Shy Guy appear.

US: 7.26.1999; JAPAN: 6.11.1999 **N64**

MARIO GOLF

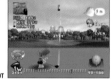

A golf game featuring the Mario family. It has tournament play as well as other modes such as "Ring Shot," which involves collecting stars by shooting golf balls through rings set on each course.

© 1999 Nintendo / CAMELOT

US: 10.5.1999; JAPAN: 8.10.1999 **GBC**

MARIO GOLF

This game is similar to the Nintendo 64 version, but had an additional RPG-style mode. In it, the player's ultimate goal is to supersede Mario as a legendary golfer.

US: 11.22.1999; JAPAN: 12.10.1999 **N64**

DONKEY KONG 64

Donkey Kong, Diddy Kong, Tiny Kong, Lanky Kong, and Chunky Kong all have their parts to play in this 3D action game. It also included *DK Arcade*, a simulation of the original *Donkey Kong* arcade game.

US: 12.1.1999; JAPAN: 8.4.1999 **GBC**

GAME & WATCH GALLERY 3

Another compilation of games from the Game & Watch; this one features *Mario Bros.* When played in Modern mode, many more characters appear in addition to Mario: Toad, Yoshi, Shy Guy, and others.

© 1980-1984,1997-1999 Nintendo

JAPAN: 12.1.1999 **64DD**

64DD (BOOT SCREEN)

The 64DD was a Japan-exclusive peripheral for the Nintendo 64. The boot screen shows Mario running circles around the Nintendo 64 logo.

© 1999 Nintendo

JAPAN: 12.1.1999 **64DD**

MARIO ARTIST: PAINT STUDIO

Much like *Mario Paint* for SNES, this software utilized the Nintendo 64 Mouse and allowed the user to create artwork.

2000

US: 1.24.2000; JAPAN: 12.17.1999 **N64**

MARIO PARTY 2

More party games featuring the Mario family. This time, the minigames are played on a stage set in an amusement park.

© 1999 Nintendo © 1999 HUDSON SOFT

JAPAN: 2.1.2000 **SFC**

PICROSS NP VOL. 6

When playing in Character Mode, the puzzles feature images of many Mario characters.

© 1995, 1999, 2000 Nintendo / Jupiter Corp

JAPAN: 2.1.2000 **64DD**

MARIO ARTIST: TALENT STUDIO

Another edition for the *Mario Artist* series, this software allowed the user to make movies on the Nintendo 64 by way of the Nintendo 64 Mouse.

JAPAN: 2.1.2000 **64DD**

SIMCITY 64

Just like the SNES game, once the player's city has 500,000 residents, they receive a Mario statue. The model is from *Super Mario 64*.

JAPAN: 4.1.2000 **SFC**

PICROSS NP VOL. 7

The seventh entry in the series, this time featuring Wario-themed puzzles.

US: 5.30.2000; JAPAN: 3.21.2000 **GBC**

WARIO LAND 3

An action game in which Wario is trapped in a mysterious music box.

JAPAN: 6.1.2000 **SFC**

PICROSS NP VOL. 8

This game includes Donkey Kong-related puzzles.

JAPAN: 6.27.2000 **64DD**

MARIO ARTIST: COMMUNICATION KIT

This software allows *Mario Artist* series users to upload their creations to the internet.

US: 8.28.2000; JAPAN: 7.21.2000 **N64**

MARIO TENNIS

This tennis game marks the first appearance of Waluigi. The easy-to-use controls assigned two buttons to differentiate a top spin shot from a slice spin shot.

© 2000 Nintendo / CAMELOT

JAPAN: 8.31.2000 **64DD**

MARIO ARTIST: POLYGON STUDIO

This software, the final installment in the *Mario Artist* series, allowed the user to create 3D graphics.

 US: 10.26.2000; JAPAN: 4.27.2000 N64

THE LEGEND OF ZELDA: MAJORA'S MASK

The Happy Mask Salesman carries many masks—one even looks suspiciously like Mario.

 US: 11.20.2000; JAPAN: 1.21.2001 GBC

DONKEY KONG COUNTRY

A port of *Donkey Kong Country* for the Game Boy Color.

2001

 US: 1.16.2001; JAPAN: 11.1.2000 GBC

MARIO TENNIS

The Game Boy version of *Mario Tennis* with an RPG-style Story Mode. Mario family characters join in some fun minigames, too.

 US: 2.5.2001; JAPAN: 8.11.2000 N64

PAPER MARIO

This RPG-style Mario game plays out amidst scrapbook-like graphics and paper-thin characters.

© 2000 Nintendo. Game by INTELLIGENT SYSTEMS

 US: 3.26.2001; JAPAN: 12.14.2000 N64

POKÉMON STADIUM 2

When the player goes to their room, the game console may have one of three *Mario* games playing on it.

 JAPAN: 4.14.2001 N64

DOUBUTSU NO MORI

This original version of *Animal Crossing* wasn't released in the US. If the player obtains a Famicom in-game, they can insert their favorite cartridges to play games such as *Donkey Kong*.

 US: 5.7.2001; JAPAN: 12.7.2000 N64

MARIO PARTY 3

The third game in the series. The story focuses on the Millennium Star, which appears only once every thousand years.

© 2000 Nintendo © 2000 HUDSON SOFT

 JAPAN: 5.11.2001 GBC

MOBILE GOLF

Foreman Spike makes his first appearance outside the *Wrecking Crew* series. Mario, Peach, and Yoshi are also unlockable characters.

 US: 6.11.2001; JAPAN: 3.21.2001 GBA

SUPER MARIO ADVANCE

Super Mario Bros. 2 updated for the Game Boy Advance. It also includes a version of the arcade game *Mario Bros.*

 US: 8.27.2001; JAPAN: 7.21.2001 GBA

MARIO KART: SUPER CIRCUIT

Eight members of the Mario family race each other, this time on the Game Boy Advance. Mario, aboard the middleweight kart, has the best balance of all abilities.

© 1992, 2001 Nintendo. Game developed by INTELLIGENT SYSTEMS.

 JAPAN: 8.27.2001 GBC

MARIO FAMILY

Using a Game Link Cable, players could connect the Game Boy Color to certain Jaguar sewing machines to create Mario embroidery patterns. It was a limited release.

 US: 11.18.2001; JAPAN: 9.14.2001 GC

LUIGI'S MANSION

The first game starring Luigi. Mario's gone missing, and Luigi has to search a haunted house to find him. Don't worry; Mario appears in the end.

 US: 11.19.2001; JAPAN: 8.21.2001 GBA

WARIO LAND 4

Wario's the main character. In this action game, Wario no longer has immunity to enemy attacks—instead, he has a set number of lives.

 US: 12.3.2001; JAPAN: 11.21.2001 GC

SUPER SMASH BROS. MELEE

Nintendo's most popular characters gathered in one huge fighting game. Peach, Bowser, and Dr. Mario make their first *Smash Bros.* appearances.

2002

 US: 2.11.2002; JAPAN: 12.14.2001 GBA

SUPER MARIO WORLD: SUPER MARIO ADVANCE 2

This game is a port of *Super Mario World* for the Game Boy Advance. It's the first version of this particular title to feature Luigi's different advantages and disadvantages.

 US: 8.26.2002; JAPAN: 7.19.2002 GC

SUPER MARIO SUNSHINE

On the tropical Isle Delfino, Mario is arrested for a crime he didn't commit; to atone, he dons the water pump F.L.U.D.D. and ends up chasing down the serial vandal responsible (see page 96).

© 2002 Nintendo

 JAPAN: 9.6.2002 GBA

DENSETSU NO STAFY

The player controls Stafy (now known in the US as Starfy) in this "marine" platformer game. One of the treasures is a Luigi hat.

 US: 9.15.2002; JAPAN: 12.14.2001 GC

ANIMAL CROSSING

This game is an updated version of *Doubutsu no Mori*, released in the US under the *Animal Crossing* moniker. If the player input codes found in magazines, they could play *Super Mario Bros.*

 US: 9.24.2002; JAPAN: 9.20.2002 GBA

YOSHI'S ISLAND: SUPER MARIO ADVANCE 3

This game bundles *Yoshi's Island* and *Mario Bros.* for the Game Boy Advance.

 US: 10.21.2002; JAPAN: 11.8.2002 GC

MARIO PARTY 4

The fourth game in the series. This is the first time the board map appears in 3D.

© 2002 Nintendo © 2002 HUDSON SOFT

US: 12.2.2002; JAPAN: 3.14.2003 GBA

THE LEGEND OF ZELDA: A LINK TO THE PAST FOUR SWORDS

In *A Link to the Past*, a picture of Mario can be found in a house in Kakariko Village.

2003

JAPAN: 2.7.2003 GC

NINTENDO PUZZLE COLLECTION

This includes three of Nintendo's most iconic puzzle games: *Dr. Mario*, *Yoshi's Cookie*, and *Panel de Pon*.

US: 5.26.2003; JAPAN: 3.21.2003 GBA

WARIOWARE, INC.: MEGA MICROGAME$!

Wario starts WarioWare, Inc., and this is the first appearance of his friends. Some of the microgames include *Donkey Kong* and *Super Mario Bros.*

US: 6.9.2003; JAPAN: 12.12.2003 GBA

DONKEY KONG COUNTRY

This port of the SNES version of *Donkey Kong Country* included some new features.

JAPAN: 6.20.2003 GBA

MOTHER 1 + 2

This title bundles two games known in the states as *EarthBound Beginnings* and *EarthBound*, respectively. This was a Japan-only port of the original games to the Game Boy Advance.

US: 6.23.2003; JAPAN: 5.27.2004 GC

WARIO WORLD

Wario punches, body slams, and of course collects all the coins he can on his way through this 3D platformer.

JAPAN: 6.27.2003 GC

DOUBUTSU NO MORI E+

This version of *Animal Crossing* was reverse-imported into Japan. There's a Mario trophy as well as Famicom- and *Super Mario*-themed household items.

US: 7.28.2003; JAPAN: 9.5.2003 GC

MARIO GOLF: TOADSTOOL TOUR

Shadow Mario, Petey Piranha, and Daisy join the tournament as player characters!

© 2003 Nintendo / CAMELOT

US: 10.21.2003; JAPAN: 7.11.2003 GBA

SUPER MARIO ADVANCE 4: SUPER MARIO BROS. 3

The Game Boy Advance version of *Super Mario Bros. 3*. It made use of the e-Reader; if the player used e-Reader Cards, they could access additional courses.

US: 11.10.2003; JAPAN: 11.28.2003 GC

MARIO PARTY 5

Toad, Boo, and Koopa Kid join the fun! The number of minigames also increases to seventy-five.

US: 11.7.2003; JAPAN: 11.11.2003 GC

MARIO KART: DOUBLE DASH!!

As of the writing of this book, this is the only *Mario Kart* game in the series where two players can ride in one kart. One player drives while the other uses items.

© 2003 Nintendo

US: 11.17.2003; JAPAN: 11.21.2003 GBA

MARIO & LUIGI: SUPERSTAR SAGA

An action-packed RPG! This story is set in Beanbean Kingdom and chronicles Mario and Luigi's journey to chase down Cackletta, who has stolen Peach's voice.

© 1983-2003 Nintendo / Developed by ALPHADREAM

US: 12.1.2003; JAPAN: 1.22.2004 GC

1080° AVALANCHE

A snowboarding game. Various Mario-themed items appear, such as a Mario ice sculpture and a Mario snowboard.

2004

US: 3.9.2004; JAPAN: 3.11.2004 GC

METAL GEAR SOLID: THE TWIN SNAKES

Figures of Mario and Yoshi can be seen.

US: 4.5.2004; JAPAN: 10.17.2003 GC

WARIOWARE, INC.: MEGA PARTY GAME$!

This game collects all of the microgames from *WarioWare, Inc: Mega Microgame$!* but has multiplayer capabilities. Mario appears in a microgame called "Ultra Machine."

JAPAN: 5.21.2004 GBA

FAMICOM MINI 11: MARIO BROS.

An entry in the *Famicom Mini* series. This is *Mario Bros.* remade for the Game Boy Advance.

US: 5.24.2004; JAPAN: 6.10.2004 GBA

MARIO VS. DONKEY KONG

Donkey Kong has stolen the Mini Mario toys, and Mario gives chase. This is a puzzle-action game, so players must use their heads and aim for the goal!

© 2004 Nintendo / Developed by Nintendo Software Technology Corporation

US: 6.2.2004; JAPAN: 2.14.2004 GBA

CLASSIC NES SERIES: SUPER MARIO BROS.

This is the first of the *Classic NES* series to commemorate the twenty-year anniversary of the Famicom. There are some differences, such as the screen dimensions.

US: 6.2.2004; JAPAN: 2.14.2004 GBA

CLASSIC NES SERIES: DONKEY KONG

A remake from the *Classic NES* series.

US: 6.22.2004; JAPAN: 4.22.2004 GBA

MARIO GOLF: ADVANCE TOUR

The player can choose from two original characters in this RPG-style story, but it's also possible to play one-on-one against members of the Mario family.

JAPAN: 5.21.2004 GBA

FAMICOM MINI 14: WRECKING CREW

Wrecking Crew remade for the Game Boy Advance as part of the *Famicom Mini* series.

JAPAN: 8.5.2004 GBA

DENSETSU NO STAFY 3

Mario appears during a stage.

FAMICOM MINI DISK SYSTEM SELECTION SCREEN

If the player presses and holds the A and B Buttons during startup, Mario and Luigi appear.

JAPAN: 8.10.2004 **GBA**

FAMICOM MINI 21: SUPER MARIO BROS. 2*

Super Mario Bros. 2 remade for the Game Boy Advance as part of the *Famicom Mini* series. *Super Mario Bros.: The Lost Levels was called Super Mario Bros. 2 in Japan.

US: 9.9.2004; JAPAN: 1.29.2004 **GBA**

POKÉMON FIRERED & LEAFGREEN

These games are an update of the original Game Boy versions, and they have the same dialog as the original.

US: 9.27.2004; JAPAN: 12.12.2003 **GC**

DONKEY KONGA

A rhythm game using barrel bongo drums that Donkey Kong and Diddy Kong found on a beach. In addition to Mario appearing on the save screen, the *Super Mario Bros.* theme music is one of the tunes available to play.

US: 10.4.2004; JAPAN: 8.26.2004 **GBA**

MARIO PINBALL LAND

Mario becomes the ball in this pinball game.

© 2004 Nintendo

US: 10.11.2004; JAPAN: 7.22.2004 **GC**

PAPER MARIO: THE THOUSAND-YEAR DOOR

Paper Mario's adventures continue in this fantastical game. Since the battles take place on a stage, the cheering of the crowd affects whether Mario wins or loses.

© 2004 Nintendo Game Developed by INTELLIGENT SYSTEMS.

US: 10.25.2004; JAPAN: 5.21.2004 **GBA**

CLASSIC NES SERIES 15: DR. MARIO

A remake from the *Classic NES* series.

US: 11.8.2004; JAPAN: 10.28.2004 **GC**

MARIO POWER TENNIS

This game adds a super-powerful Power Shot; Mario's is the Iron Hammer shot. It also includes themed courts based on other *Mario* titles, including the Delfino Plaza Court.

© 2004 Nintendo / CAMELOT

US: 11.15.2004; JAPAN: 7.1.2004 **GBA**

DONKEY KONG COUNTRY 2

A port of the SNES game to the Game Boy Advance with new features added.

US: 11.21.2004; JAPAN: 12.2.2004 **DS**

SUPER MARIO 64 DS

A remake of *Super Mario 64* and a launch title for Nintendo DS. In this version, the player can select Yoshi, Luigi, and Wario as player characters.

JAPAN: 12.2.2004 **DS**

DAIGASSO! BAND BROTHERS

Music software that allows the user to play solos or as a part of the band. It includes a medley of *Mario* themes. An expansion pack with additional songs was released on September 26, 2005.

US: 12.6.2004; JAPAN: 11.18.2004 **GC**

MARIO PARTY 6

This entry in the *Mario Party* series makes use of the Nintendo GameCube Microphone, the first one to do so.

2005

US: 2.8.2005; JAPAN: 5.26.2005 **GC**

NBA STREET V3

Mario and his friends take it to the streets in this basketball game.

US: 2.14.2005; JAPAN: 12.2.2004 **DS**

WARIOWARE: TOUCHED!

This game was the first to utilize only the touch screen and microphone as a way of control.

US: 3.14.2005; JAPAN: 12.16.2004 **GC**

DONKEY KONG JUNGLE BEAT

A *Donkey Kong* action game that utilizes the DK Bongos. Aim to become the jungle king and soothe the savage beasts!

US: 3.14.2005; JAPAN: 1.27.2005 **DS**

YOSHI TOUCH & GO

In addition to throwing eggs and gathering coins, the player uses the stylus to define a path through the sky and guide Baby Mario to safety.

JAPAN: 3.17.2005 **GC**

DONKEY KONGA 3: TABEHŌDAI! HARU MOGITATE 50 KYOKU

The third game in the *Donkey Konga* series. Like the previous games, Mario appears in the badges. The game also features a number of famous songs from the *Super Mario Bros.* series.

US: 3.28.2005; JAPAN: 1.13.2005 **GBA**

MARIO PARTY ADVANCE

Mario and crew have an adventure in Shroom City in order to gather minigames and Gaddgets. This is the first handheld entry in the *Mario Party* series.

© 2005 Nintendo © 2005 HUDSON SOFT

JAPAN: 3.31.2005 **DS**

YAKUMAN DS

A mahjong game where players play as or against Mario family characters. Mario plays like an all-around champ in both offense and defense. Luigi is smart and plays for the riichi. Each of the characters have their specialized mahjong tactics.

US: 5.9.2005; JAPAN: 7.1.2004 **GC**

DONKEY KONGA 2

The sequel to the first rhythm game. If the player can score in the top three on each song, they earn badges. Mario and Luigi badges are up for grabs.

US: 5.23.2005; JAPAN: 10.14.2004 **GBA**

WARIOWARE: TWISTED!

A *Super Mario Bros. 3* microgame can be found in the Spintendo Classics section.

YOSHI TOPSY-TURVY

Yoshi finds himself in a pop-up-book-like world. To escape, he must challenge Bowser. This action game included a gyroscopic device within the Game Pak that allowed the player to utilize tilt controls.

JAPAN: 6.16.2005 DS

DS RAKUBIKI JITEN

Several Nintendo-centric words from *Mario* and *Donkey Kong* games appear in this dictionary.

US: 8.22.2005; JAPAN: 4.21.2005 DS

NINTENDOGS

A pet simulator for raising a puppy. Some of the available toys are a Mario Kart, a Bowser Kart, a Peach Kart, and others. The player can also get a certain red hat as an accessory.

US: 8.29.2005; JAPAN: 7.21.2005 GC

MARIO SUPERSTAR BASEBALL

The Mario family heads to the baseball diamond. Mario is a triple threat: he can hit, steal, and play defense. His special pitch is a fireball.

JAPAN: 9.13.2005 GBA

FAMICOM MINI: SUPER MARIO BROS. (RERELEASE EDITION)

For the 20th anniversary of *Super Mario Bros.*, Nintendo rereleased the original game for the Game Boy Advance. This is just one of many titles celebrating the 20th anniversary.

JAPAN: 9.13.2005 DS

PLAY-YAN MICRO

A movie and music player add-on for the Game Boy Advance and Nintendo DS. There's an optional Mario-themed user interface.

US: 9.19.2005; JAPAN: 5.19.2005 GBA

DK: KING OF SWING

An action game featuring the Donkey Kong family. Use the L and R Buttons to guide the characters on this big adventure.

US: 10.11.2005; JAPAN: 11.24.2005 GC

SSX ON TOUR

Mario, Luigi, and Peach all appear in this snowboard action game.

US: 10.24.2005; JAPAN: 7.14.2005 GC

DANCE DANCE REVOLUTION: MARIO MIX

Get ready to dance to familiar *Mario* music! A dance mat controller came packaged together with the game.

US: 11.7.2005; JAPAN: 11.10.2005 GC

MARIO PARTY 7

This game allows eight players at once, arranged in teams of two for the mode called "4-Team Battle."

US: 11.7.2005; JAPAN: 12.1.2005 GBA

DONKEY KONG COUNTRY 3

This port of the SNES game includes a new world and new minigames.

US: 11.14.2005; JAPAN: 12.8.2005 DS

MARIO KART DS

This game used the Nintendo Wi-Fi Connection to allow players to race against rivals worldwide. It's the first *Mario Kart* game with Bullet Bill and Blooper items.

© 2005 Nintendo

US: 11.18.2005; JAPAN: 1.19.2006 GC

SUPER MARIO STRIKERS

A soccer game where anything goes. Mario family characters serve as team captains and perform Super Strike moves that score two points at once!

US: 11.28.2005; JAPAN: 9.13.2005 GBA

DR. MARIO & PUZZLE LEAGUE

Two great *Mario* puzzles in one package! This game was released as part of the 20th anniversary celebration.

US: 11.28.2005; JAPAN: 12.29.2005 DS

MARIO & LUIGI: PARTNERS IN TIME

Baby Mario and Baby Luigi come from the past to team up with Mario and Luigi for a four-person adventure. Adult and baby versions cooperate in this RPG that spans from past to present and back again.

© 2005 Nintendo Developed by ALPHADREAM

US: 12.5.2005; JAPAN: 9.13.2005 GBA

MARIO TENNIS: POWER TOUR

The characters in this game use the same Power Shots that they did in *Mario Power Tennis* for Nintendo GameCube. This title was part of the 20th anniversary celebration.

© 2005 Nintendo / CAMELOT

US: 12.5.2005; JAPAN: 11.23.2005 DS

ANIMAL CROSSING: WILD WORLD

Mario-themed furniture and items were made available through both the Nintendo Wi-Fi Connection and TAG Mode.

2006

US: 1.9.2006; JAPAN: 4.7.2005 DS

ELECTROPLANKTON

This media art program allows players to create music with ten different kinds of plankton.

US: 1.23.2006; JAPAN: 11.10.2005 DS

TRUE SWING GOLF

Some Mario-themed clothing items are available.

US: 2.6.2006; JAPAN: 9.22.2005 GBA

DRILL DOZER

When certain conditions are fulfilled, the main character will appear dressed like Mario, spinning on the menu screen.

US: 2.8.2006; JAPAN: 6.23.2005 GC

CHIBI-ROBO! PLUG INTO ADVENTURE!

An adventure game where players control little Chibi-Robo and try to collect Happy Points. The Eggplant Man enemy from *Wrecking Crew*, known here as Kid Eggplant, appears.

SUPER PRINCESS PEACH

US: 2.27.2006; JAPAN: 10.20.2005 (DS)

Mario and Luigi have been kidnapped, so Peach sets out to save them! She has an adventure on Vibe Island with the help of an odd umbrella named Perry.

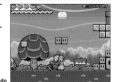

© 2005 Nintendo

TETRIS DS

US: 3.20.2006; JAPAN: 4.27.2006 (DS)

The Nintendo DS version of the classic falling-pieces puzzle game. As the Tetriminos vanish, a *Mario* game plays out on the upper screen. There's even a battle with Bowser.

KANJI SONOMAMA RAKUBIKI JITEN DS

JAPAN: 4.13.2006 (DS)

"Mario" and "Donkey Kong" are some of the words that appear in this dictionary.

DENSETSU NO STAFY 4

JAPAN: 4.13.2006 (DS)

In a collection of dolls hides a "Princess and Umbrella" pair that look suspiciously like Peach and Perry.

BRAIN AGE: TRAIN YOUR BRAIN IN MINUTES A DAY!

US: 4.16.2006; JAPAN: 5.19.2005 (DS)

At the time, adult brain training was very popular. When the player obtains the rank of "Walking Speed," a whistle from *Super Mario Bros.* sounds.

NEW SUPER MARIO BROS.

US: 5.15.2006; JAPAN: 5.25.2006 (DS)

It's both nostalgic and new, as the *Mario* series returns to its roots with side-scrolling action (see page 110).

MARIO HOOPS 3-ON-3

US: 9.11.2006; JAPAN: 7.27.2006 (DS)

Players can use the +Control Pad to move Mario and his friends, but they'll get a better handle on this basketball game with the touch screen.

© 2006 Nintendo © 2006 SQUARE ENIX

WI-FI TAIŌ YAKUMAN DS

JAPAN: 9.14.2006 (DS)

Now it's possible to use Wi-Fi to play mahjong with people all over the world. It's also possible to play with Mario and his friends.

MARIO VS. DONKEY KONG 2: MARCH OF THE MINIS

US: 9.25.2006; JAPAN: 4.12.2007 (DS)

Guide the clockwork Mini Marios to the goal using the stylus.

YOSHI'S ISLAND DS

US: 11.13.2006; JAPAN: 3.8.2007 (DS)

A huge adventure for the Yoshis, who have taken on five different babies. When Baby Mario gets a Super Star, he turns into the powerful Superstar Mario.

© 2006-2007 Nintendo

Wii SHOP CHANNEL

US: 11.19.2006; JAPAN: 12.2.2006 (Wii)

Mario and Luigi appear after a player has bought something from the Wii Shop Channel and started downloading it.

TOUCH DE TANOSHIMU HYAKUNIN ISSHU: DS SHIGUREDEN

JAPAN: 12.14.2006 (DS)

Mario appears in one of the poems featured in this ancient card game of Japanese poetry.

2007

WARIOWARE: SMOOTH MOVES

US: 1.15.2007; JAPAN: 12.2.2006 (Wii)

Fan favorite characters 9-Volt and 18-Volt feature in this new collection of microgames. Mario appears in the game . . . and so does Wario, of course.

WARIO: MASTER OF DISGUISE

US: 3.5.2007; JAPAN: 1.18.2007 (DS)

Wario can change his disguise at will with the help of the wand Goodstyle as they go searching for treasure in this action game.

SUPER PAPER MARIO

US: 4.9.2007; JAPAN: 4.19.2007 (Wii)

Paper Mario goes on an interdimensional adventure, jumping back and forth between 2D and 3D environments. In this game, Peach and Bowser join Mario's crew.

© 2007 Nintendo / INTELLIGENT SYSTEMS

MARIO PARTY 8

US: 5.29.2007; JAPAN: 7.26.2007 (Wii)

The game makes good use of the Wii Remote in the additional minigames, now totaling over seventy. The Hammer Bros. and Blooper also join the fun.

NINTENDO DS BROWSER

US: 6.4.2007; JAPAN: 7.24.2006 (DS)

This allows the player to access the internet on their Nintendo DS. The image of the Nintendo DS on the package shows Mario.

BIG BRAIN ACADEMY: Wii DEGREE

US: 6.11.2007; JAPAN: 4.26.2007 (Wii)

An illustration of Raccoon Mario appears in this game.

SIMCITY DS

US: 6.19.2007; JAPAN: 2.22.2007 (DS)

Players can unlock the landmark "Bowser's Castle" by using the password "Hanafuda."

ITADAKI STREET DS

JAPAN: 6.21.2007 (DS)

A board game where players compete to see who can collect money the quickest. *Dragon Quest* characters compete with the Mario family.

TAIKO NO TATSUJIN DS: TOUCH DE DOKODON!

JAPAN: 7.26.2007 (DS)

The theme from *Super Mario Bros.* is playable in this rhythm game.

MARIO STRIKERS CHARGED

US: 7.30.2007; JAPAN: 9.20.2007 (Wii)

Each team's captain can perform a Mega Strike to score up to six points.

248

BRAIN AGE 2: TRAIN YOUR BRAIN IN MINUTES A DAY!

US: 8.20.2007; JAPAN: 12.29.2005 (DS)

When a player reaches the "Walking Speed" rank, they hear the 1-Up chime from *Super Mario Bros.* There's also a *Dr. Mario*-style virus-matching minigame.

DK: JUNGLE CLIMBER

US: 9.10.2007; JAPAN: 8.9.2007 (DS)

Donkey Kong's left and right hands are controlled by the L and R Buttons in this action game. Diddy Kong is waiting nearby to back you up.

DONKEY KONG BARREL BLAST

US: 10.8.2007; JAPAN: 6.28.2007 (Wii)

The Donkey Kong family and the Kremlings all compete in this racing game.

MARIO & SONIC AT THE OLYMPIC GAMES™

US: 11.6.2007; JAPAN: 11.22.2007 (Wii)

With the Beijing Olympics as the stage, the Mario family and Sega's *Sonic* characters compete for medals in regular and Dream Events. There are eight different venues for twenty different competitions.

MARIO & SONIC AT THE OLYMPIC GAMES™

US: 1.22.2008; JAPAN: 1.17.2008 (DS)

Up to four people can play. The stylus provides a control method unique to the Nintendo DS.

SUPER MARIO GALAXY

US: 11.12.2007; JAPAN: 11.1.2007 (Wii U-DL) (Wii)

Bowser is set on recreating the galaxy in his own image, and Mario must stop him. This is a journey into space (see page 122).

© 2007 Nintendo

CHECK Mii OUT CHANNEL

US: 11.12.2007; JAPAN: 11.12.2007 (Wii-DL)

If a player participates in Mario's contest, they get a commemorative photo.

MARIO PARTY DS

US: 11.19.2007; JAPAN: 11.8.2007 (DS)

The Nintendo DS version of the fan-favorite series. Using Download Play, up to four people can play with only one Game Card. It even has minigames that use the Nintendo DS mic.

© 2007 Nintendo © 2007 HUDSON SOFT

2008

SUPER SMASH BROS. BRAWL

US: 3.9.2008; JAPAN: 1.31.2008 (Wii)

Wario and Diddy Kong join characters like Mario, Luigi, Peach, Bowser, Donkey Kong, and Yoshi in the battle. It's the third game in the series.

MARIO KART Wii

US: 4.27.2008; JAPAN: 4.10.2008 (Wii)

This game uses the Wii Wheel and makes use of players' Mii characters. This is the first *Mario Kart* game to include motorcycles. Players could challenge distant opponents using the Nintendo Wi-Fi Connection, and the Mario Kart Channel added more online features.

© 2008 Nintendo

Wii FIT

US: 5.21.2008; JAPAN: 12.1.2007 (Wii)

A pixel-art Mario appears on the jogging course.

DR. MARIO ONLINE Rx

US: 5.26.2008; JAPAN: 3.25.2008 (WiiWare)

This version includes a couple of puzzle games: not only *Dr. Mario*, but also "Virus Buster," the minigame from *Brain Age 2*.

© 1995, 1999, 2008. Nintendo/Jupiter Corp.

THE TOWER DS

JAPAN: 6.26.2008 (DS)

This sequel to *SimTower* features a Mario tower.

DAIGASSO! BAND BROTHERS DX

JAPAN: 6.26.2008 (DS)

Mario's theme plays in the background of the instruments dictionary.

DIGICAM PRINT CHANNEL

JAPAN: 7.23.2008 (Wii-DL)

Players could print business cards and photo albums featuring *Mario* characters.

MARIO SUPER SLUGGERS

US: 8.25.2008; JAPAN: 6.19.2008 (Wii)

The controls are easy when all you need to do is swing the Wii Remote to both bat and pitch. More than forty characters from the Mario family appear.

CAPTAIN RAINBOW

JAPAN: 8.28.2008 (Wii)

Crazy Tracy keeps pictures of the few men who accept her for who she is, and among them is a picture of Mario. Birdo also plays a large part in this game.

WARIO LAND: SHAKE IT!

US: 9.22.2008; JAPAN: 7.24.2008 (Wii)

Wario stars in this action game. Shaking the Wii Remote allows the player to traverse obstacles and advance through courses.

KIRBY SUPER STAR ULTRA

US: 9.22.2008; JAPAN: 11.6.2008 (DS)

This is a remake of the SNES game *Kirby Super Star*, but with added modes. In the audience of the Megaton Punch Contest, when Kirby activates the Stone ability, one of the forms is a gold Mario statue.

Wii MUSIC

US: 10.20.2008; JAPAN: 10.16.2008 (Wii)

This musical game includes the *Super Mario Bros.* theme, as well as Mario pixel art.

NINTENDO ZONE

US: 11.14.2008; JAPAN: 6.19.2009

Nintendo's download service. When players connect using a Nintendo DSi, a pixel-art Mario appears.

ANIMAL CROSSING: CITY FOLK

US: 11.16.2008; JAPAN: 11.20.2008 (Wii)

There's an arcade game item with Mario pictured on the screen. Also, there are quite a few Mario-themed pieces of furniture, and Mario-themed patterns appear often.

 JAPAN: 12.11.2008 (Wii)

TAIKO NO TATSUJIN Wii

One of the playable songs in this rhythm game is the theme from *Super Mario Bros.*

 US: 12.15.2008; JAPAN: 7.28.2006 (DS)

GAME & WATCH COLLECTION

This game was offered only through Club Nintendo. This collection includes the *Game & Watch* version of *Donkey Kong*.

2009

 US: 3.9.2009; JAPAN: 1.15.2009 (Wii)

NEW PLAY CONTROL! MARIO POWER TENNIS

One of the *New Play Control* series. This is a remake of the Nintendo GameCube game. And in this case, one can switch from backhand to forehand by swinging the Wii Remote.

© 2004-2009 Nintendo / CAMELOT

 US: 4.5.2009; JAPAN: 11.1.2008 (DS)

NINTENDO DSi SHOP

When downloading something onto the Nintendo DSi, Mario, Luigi, Peach, and Toad appear on the download screen.

 US: 4.5.2009; JAPAN: 11.1.2008 (DS)

NINTENDO DSi CAMERA

Players can add Mario's hat or mustache to their photos.

 US: 4.5.2009; JAPAN: 11.1.2008 (DS)

NINTENDO DSi SOUND

If players go to the Record and Edit a Sound menu, and then wait a minute, the Mario theme will start playing.

 US: 4.5.2009; JAPAN: 12.24.2008 (DSiWare)

WARIOWARE: SNAPPED!

Wario's gang advances to the Nintendo DSi. Players can have fun with microgames that use the camera.

 US: 4.20.2009; JAPAN: 12.24.2008 (DSiWare)

DR. MARIO EXPRESS

DSiWare allowed players to download this puzzle game and play without a Game Card.

© 2008 Nintendo

 US: 5.4.2009; JAPAN: 12.11.2008 (Wii)

NEW PLAY CONTROL! DONKEY KONG JUNGLE BEAT

This is a remake of the Nintendo GameCube game.

 US: 5.18.2009; JAPAN: 1.28.2009 (DSiWare)

ART STYLE: PiCTOBiTS

Make the falling pixel-like objects vanish and complete the pixel-art Mario at the top of the screen. The music is an arrangement of the *Super Mario Bros.* theme.

 US: 5.18.2009; JAPAN: 7.23.2009 (Wii)

PUNCH-OUT!!

A boxing action game. In Mac's Last Stand, Donkey Kong appears.

 US: 5.21.2009 (Wii)

TAKT OF MAGIC

On the battle mat, the "Brother's Space" is in the shape of a pixel-art version of Mario.

 US: 6.8.2009; JAPAN: 10.7.2009 (DSiWare)

MARIO VS. DONKEY KONG: MINIS MARCH AGAIN!

Players can upload stages they built themselves, and also download stages made by other players through the Nintendo Wi-Fi Connection.

 JAPAN: 6.11.2009 (Wii)

Wii DE ASOBU SELECTION CHIBI-ROBO

This is from the *Wii De Asobu Selection* series, known as *New Play Control!* in the US. The Nintendo GameCube game has been ported and updated for the Wii console.

 US: 6.15.2009; JAPAN: 2.25.2009 (DSiWare)

MARIO CALCULATOR

A utility program for the Nintendo DSi. The calculator has a design including a pixel-art version of Mario.

 US: 6.15.2009; JAPAN: 4.1.2009 (DSiWare)

MARIO CLOCK

A utility program for the Nintendo DSi. The clock has a design including a pixel-art version of Mario.

 US: 8.12.2009; JAPAN: 12.24.2008 (DSiWare)

FLIPNOTE STUDIO

Software for taking notes and for creating flipbook-style animation. Mario appears on the instruction booklet. Also between September 13, 2009 and January 10, 2011 there was a Mario Flipnote Contest.

 JAPAN: 8.26.2009 (DSiWare)

THE TOWER DS CLASSIC

The Nintendo DS version has been made a little more compact. Mario Tower is still there, though!

 US: 9.14.2009; JAPAN: 2.11.2009 (DS)

MARIO & LUIGI: BOWSER'S INSIDE STORY

Most of this takes place inside of Bowser. The upper screen shows Bowser while the lower screen shows Mario and Luigi's adventures inside his body. What one does affects the others.

© 2009 Nintendo Developed by ALPHADREAM

 US: 10.13.2009; JAPAN: 11.5.2009 (Wii)

MARIO & SONIC AT THE OLYMPIC WINTER GAMES™

Mario and Sonic take part in the Winter Olympic games, held in Vancouver in February of 2010. They compete in figure skating as well as other events.

 US: 10.13.2009; JAPAN: 11.19.2009 (DS)

MARIO & SONIC AT THE OLYMPIC WINTER GAMES™

In the Nintendo DS version, Mario and Sonic are at the Olympic games going on an adventure to rescue Snow Spirits.



 US: 11.9.2009; JAPAN: 7.8.2009 DSiWare

ELECTROPLANKTON BEATNES

Each plankton from the Nintendo DS game was sold separately through DSiWare. Just like in the original game, the Beatnes plankton makes NES sounds and plays the *Super Mario Bros.* theme.

 US: 11.15.2009; JAPAN: 12.3.2009 Wii

NEW SUPER MARIO BROS. Wii

Up to four people can play at once with the new multiplayer setup. Everyone can cooperate or be rivals (see page 140).

2010

 US: 3.22.2010; JAPAN: 8.19.2009 DSiWare

GAME & WATCH: MARIO'S CEMENT FACTORY

Another port to the Nintendo DS; this Game & Watch title was originally released in 1982.

 US: 3.28.2010; JAPAN: 4.29.2009 DS

WARIOWARE: D.I.Y.

9-Volt's microgame, "Super 9-Volt," is based on *Super Mario Bros.*

 US: 3.29.2010; JAPAN: 4.29.2009 WiiWare

WARIOWARE: D.I.Y. SHOWCASE

Mario appears in one of the sample games. One can send games made in the Nintendo DS version to the Wii and play it on the Wii.

 US: 3.29.2010; JAPAN: 9.2.2009 DSiWare

NINTENDO DSi METRONOME

This software creates sounds to the rhythm of a beat set by the player. It includes a minigame called "Donkey Kong Metronome."

 US: 4.19.2010; JAPAN: 8.19.2009 DSiWare

GAME & WATCH: DONKEY KONG JR.

The *Game & Watch* version of *Donkey Kong Jr.*, released in 1982 in the *New Wide Screen* series, is ported to the Nintendo DS.

 US: 5.23.2010; JAPAN: 5.27.2010 Wii

SUPER MARIO GALAXY 2

Mario takes on another intergalactic adventure, this time with Yoshi as a co-star. The pair's home base is *Starship Mario* (see page 154).

 US: 10.3.2010; JAPAN: 7.8.2010 Wii

Wii PARTY

The "Clover Hunt" minigame asks players to identify pictures that don't quite match . . . including a pixel-art Mario.

 JAPAN: 11.11.2010 Wii

SUPER MARIO BROS. 25TH ANNIVERSARY EDITION

This game came preinstalled on the Limited Edition 25th Anniversary *Super Mario Bros.* red Wii Console in Japan. It rearranged some of the elements of *Super Mario Bros.*; for instance, ? Blocks now show the number 25 instead.



 US: 11.14.2010; JAPAN: 12.2.2010 DS

MARIO VS. DONKEY KONG: MINI-LAND MAYHEM!

Guide the Mini Marios to the goal. Donkey Kong has kidnapped Pauline, and Mario is on their trail. Players could make their own stages and upload them for lots of people to play and enjoy.

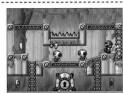
© 2010 Nintendo

 JAPAN: 11.17.2010 DSiWare

JIBUN DE TSUKURU NINTENDO DS GUIDE

Software that allows players to create travel guides, even adding photos and recorded sound. There's a Mario item in the Group Selection button icon.

 US: 11.21.2010; JAPAN: 12.9.2010 Wii

DONKEY KONG COUNTRY RETURNS

Donkey Kong has a bunch of moves up his sleeve as he tries to clear more than seventy courses. Diddy Kong rides on his back, helping him along.

 JAPAN: 12.2.2010 Wii

TAIKO NO TATSUJIN Wii: MINNA DE PARTY ★3-DAIME!

Play along to the theme from *Super Mario Bros.*

 US: 12.12.2010; JAPAN: 10.21.2010 Wii

SUPER MARIO ALL-STARS LIMITED EDITION

It contains the same early *Super Mario* games as the collection that was originally put out for the SNES (see pages 25, 175).

2011

 US: 2.7.2011; JAPAN: 11.25.2010 Wii

MARIO SPORTS MIX

This is a sports game where the Mario family, characters from the *Final Fantasy* series, characters from the *Dragon Quest* series, and others all compete in sports games. Several sports are playable, including volleyball.

 US: 3.27.2011; JAPAN: 2.26.2011 3DS

NINTENDO 3DS CAMERA

Software that came preinstalled on Nintendo 3DS. When players choose "Attention Sound," on rare occasions it will play a snippet from the *Super Mario Bros.* theme.

 US: 3.27.2011; JAPAN: 2.26.2011 3DS

AR GAMES

Software that came preinstalled on Nintendo 3DS. Players can photograph Mario. In *Fishing*, it's possible to catch Blooper and other *Mario* characters.

 US: 3.27.2011; JAPAN: 2.26.2011 3DS

NINTENDO 3DS SOUND

Software that came preinstalled on Nintendo 3DS. The percussion effects include the coin sound and Mario's jump sound. If players trigger the coin sound one hundred times, they get the 1-Up sound.

 US: 3.27.2011; JAPAN: 2.26.2011 3DS

STREETPASS Mii PLAZA

Mario appears as a picture in the minigame "Puzzle Swap," which came preloaded on Nintendo 3DS. Also, in "Find Mii," players can earn items including Mario's hat for their Mii characters to wear.

NINTENDOGS + CATS

Simultaneously released with the Nintendo 3DS. A cat and dog real-time simulation game. Players can decorate their rooms with lots of Mario-themed pieces, including *Mario Kart* toys.

US: 3.27.2011; JAPAN: 4.14.2011 (3DS) ★☆☆☆☆

PILOTWINGS RESORT

Take to the skies in 3D! *Mario* game theme songs can be heard from people's homes as the player flies past.

US: 3.27.2011; JAPAN: 5.12.2011 (3DS) ★☆☆☆☆

STEEL DIVER

A submarine action game. There is a Mario decal that increases a submarine's abilities.

US: 6.19.2011; JAPAN: 6.16.2011 (3DS) ★☆☆☆☆

THE LEGEND OF ZELDA: OCARINA OF TIME 3D

Mario's world can be seen through one of the windows in Hyrule Castle.

US: 11.13.2011; JAPAN: 11.3.2011 (3DS) ★★★★★

SUPER MARIO 3D LAND

This brand-new 3D game took Mario back to the platforming style, bringing common elements from 2D games into a new dimension (see page 176).

US: 11.15.2011; JAPAN: 12.8.2011 (Wii) ★★★☆☆

MARIO AND SONIC AT THE LONDON 2012 OLYMPIC GAMES™

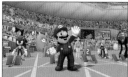

Mario and Sonic compete at the London Olympic Games. Includes the minigame "London Party."

JAPAN: 11.23.2011 (Wii) ★☆☆☆☆

TAIKO NO TATSUJIN Wii: KETTEIBAN

Players can perform the *New Super Mario Bros. Wii* theme song.

US: 12.4.2011; JAPAN: 12.1.2011 (3DS) ★★★★☆

MARIO KART 7

Fly through the air and swim through the water across the *Mario Kart* world. Players can also customize their karts.

US: 12.5.2011; JAPAN: 12.1.2011 (Wii) ★★★★☆

FORTUNE STREET

A board game where the Mario family face off against characters from *Dragon Quest*.

US: 12.8.2011; JAPAN: 10.5.2011 (3DS-DL) ★☆☆☆☆

PUSHMO

A puzzle game where players push together scaffolding to help reach a goal. Some puzzles are Mario-related.

US: 12.22.2011; JAPAN: 12.21.2011 (3DS-DL) ★☆☆☆☆

SWAPNOTE

Players can choose Mario-themed stationery.

JAPAN: 12.27.2011 (3DS-DL) ★☆☆☆☆

SUDDEN PRINT CLUB GLITTER DECORATION REVOLUTION

There are decoration sets like "Mario Basic Set" and "*Mario Kart 7* Set."

2012

JAPAN: 1.19.2012 (Wii) ★☆☆☆☆

KIKI TRICK

These minigames use auditory clues, including sounds and images from *Super Mario Bros.* and *Mario Kart*.

US: 2.14.2012; JAPAN: 3.1.2012 (3DS) ★★★☆☆

MARIO AND SONIC AT THE LONDON 2012 OLYMPIC GAMES™

Mario and Sonic compete in fifty-seven events—the most in the series!

US: 2.21.2012; JAPAN: 3.8.2012 (3DS) ★☆☆☆☆

METAL GEAR SOLID SNAKE EATER 3D

Yoshi is hiding in this game.

US: 3.11.2012; JAPAN: 4.26.2012 (Wii) ★★★★☆

MARIO PARTY 9

There are new rules for the board game this time! All four players move together and trigger minigames when they stop on special spaces.

US: 4.13.2012; JAPAN: 1.12.2012 (3DS) ★☆☆☆☆

SPIRIT CAMERA: THE CURSED MEMOIR

Players can unlock a Peach costume for the main character to wear.

US: 5.20.2012; JAPAN: 5.24.2012 (3DS) ★★★★☆

MARIO TENNIS OPEN

This game includes a number of game modes from previous *Mario Tennis* titles, such as "Super Mario Tennis," where players can advance through a *Super Mario Bros.* level by hitting a tennis ball against a wall.

US: 8.19.2012; JAPAN: 7.28.2012 (3DS) ★★★★★

NEW SUPER MARIO BROS. 2

This game includes the first appearance of Gold Mario, as well as the high-flying return of Raccoon Mario for the first time since his debut in *Super Mario Bros. 3* (see page 190).

JAPAN: 9.13.2012 (3DS) ★☆☆☆☆

CLUB NINTENDO PICROSS

Mario and other Nintendo characters appear in these puzzles.

US: 10.15.2012; JAPAN: 7.28.2012 (3DS-DL) ★★★★☆

DONKEY KONG ORIGINAL EDITION

A special reward from a summer download campaign. The arcade version of the 50m stage was added for this release.

US: 11.11.2012; JAPAN: 12.6.2012 (3DS) ★★★★☆

PAPER MARIO: STICKER STAR

A grand adventure for Paper Mario! Every battle uses stickers with important powers and effects.

US: 11.18.2012; JAPAN: 12.8.2012 (Wii U) ★★★★★

NEW SUPER MARIO BROS. U

This game was a launch title for the Wii U console. Up to four players can participate, and players can use the Wii U GamePad for Off-TV play.

NINTENDO LAND

US: 11.18.2012; JAPAN: 12.8.2012 (Wii U)

Users can play up to twelve attractions. Choose from various *Mario* series games such as "Mario Chase," "Luigi's Ghost Mansion," "Yoshi's Fruit Cart," and "Donkey Kong's Crash Course."

TEKKEN TAG TOURNAMENT 2: Wii U EDITION

US: 11.18.2012; JAPAN: 12.8.2012 (Wii U)

Unique to the Wii U, Mushroom Battle mode makes characters grow and shrink as they encounter mushroom power-ups. Various Nintendo costumes are featured as well, including Mario, Luigi, Toad, Peach, and Bowser.

CRASHMO

US: 11.22.2012; JAPAN: 10.31.2012 (3DS-DL)

This game has Piranha Plants and other character challenges.

TAIKO NO TATSUJIN Wii: CHŌGŌKABAN

JAPAN: 11.29.2012 (Wii)

Players can perform the *New Super Mario Bros. Wii* theme song.

2013

LEGO CITY UNDERCOVER

US: 3.18.2013; JAPAN: 7.25.2013 (Wii U)

? Blocks, pipes, and Cheep Cheeps appear in the vast Lego world.

LUIGI'S MANSION: DARK MOON

US: 3.24.2013; JAPAN: 3.20.2013 (3DS)

The second adventure game featuring Luigi as a protagonist. Players collect pieces of a scattered Dark Moon. Mario appears in the ending.

MARIO AND DONKEY KONG: MINIS ON THE MOVE

US: 5.9.2013; JAPAN: 7.24.2013 (3DS-DL)

This game features puzzles with connecting tiles that Mini Mario must complete within the time limit.

PHOTOS WITH MARIO

US: 5.18.2014; JAPAN: 4.23.2013 (3DS)

Using prepaid cards, this software lets people take photos with Mario characters. The first release featured Mario, Bowser, and Peach. The second release featured Luigi, Koopa Troopa, and the Koopa lineup.

DONKEY KONG COUNTRY RETURNS 3D

US: 5.24.2013; JAPAN: 6.13.2013 (3DS)

A port of the Wii game *Donkey Kong Country Returns* for Nintendo 3DS. Eight new courses were added.

ANIMAL CROSSING: NEW LEAF

US: 6.9.2013; JAPAN: 11.8.2012 (3DS)

Become the mayor of your own town! Mario-themed furniture and other items appear.

FLOWER TOWN

US: 7.12.2013; JAPAN: 6.18.2013 (3DS-DL)

A purchasable game for StreetPass Mii Plaza that allows players to raise flowers. There are *Mario*-themed decorations like Yoshi topiaries and giant mushrooms.

GAME & WARIO

US: 6.23.2013; JAPAN: 3.28.2013 (Wii U)

A party game in the *WarioWare* series, as well as Wario's debut on the Wii U. The minigame "Patchwork with Kat and Ana" features Mario-themed puzzles.

MARIO & LUIGI: DREAM TEAM

US: 8.11.2013; JAPAN: 7.18.2013 (3DS)

A grand adventure in the Dream World to rescue the kidnapped Peach. Luiginoids appear in a dream battle, as does a giant Luigi.

NEW SUPER LUIGI U

US: 8.25.2013; JAPAN: 7.13.2013 (Wii U)

A redesign of *New Super Mario Bros. U* including eighty-two new playable courses. Because Luigi is the playable character, Mario doesn't appear at all—but you might see his hat! Nabbit takes Mario's place as the fourth playable character (see page 205).

RAYMAN LEGENDS

US: 8.29.2013; JAPAN: 10.17.2013 (Wii U)

There are Mario and Luigi costumes.

MONSTER HUNTER 4 ULTIMATE

JAPAN: 9.14.2013 (3DS)

Players can get Mario- and Luigi-themed equipment, as well as Mario and Donkey Kong guild cards, through the "Mario: Oh, Brothers!" event quest.

Wii PARTY U

US: 10.25.2013; JAPAN: 10.31.2013 (Wii U)

Peach's dress appears in the Mii Fashion Plaza TV Party.

SONIC LOST WORLD

US: 10.29.2013; JAPAN: 10.24.2013 (Wii U)

"Yoshi's Island Zone" is available to download. Sonic moves eggs around the island.

DAIGASSO! BAND BROTHERS P

JAPAN: 11.14.2013 (3DS)

Various Mario-related items appear in songs, playable videos, and costumes.

MARIO AND SONIC AT THE SOCHI 2014 OLYMPIC WINTER GAMES™

US: 11.15.2013; JAPAN: 12.5.2013 (Wii U)

An update to the previous game, now set at the Sochi Olympics. In addition to the sixteen Olympic games, there are eight Dream Events incorporating Mario and Sonic's worlds.

TAIKO NO TATSUJIN: Wii U VERSION

JAPAN: 11.21.2013 (Wii U)

In this rhythm game, players can perform music from *Super Mario Bros.* and *Dr. Mario*.

SUPER MARIO 3D WORLD

US: 11.22.2013; JAPAN: 11.21.2013 (Wii U)

Choose to play as Mario, Luigi, Peach, Toad, or Rosalina for this 3D adventure. Up to four players can play at once (see page 220).

US: 11.22.2013; JAPAN: 3.20.2014 (3DS)

MARIO PARTY: ISLAND TOUR

Seven different board maps and eighty new minigames are featured in this title. The solo mode includes the minigame "Bowser's Tower."

US: 12.18.2013; JAPAN: 12.19.2013 (Wii U-DL)

NES REMIX

A remix of nostalgic NES games. Sixteen NES games, including *Super Mario Bros.* and *Mario Bros.*, were used to create new remix challenges.

US: 12.31.2013; JAPAN: 1.15.2014 (Wii U-DL)

DR. LUIGI

A puzzle game, but unlike in *Dr. Mario*, the pieces are L-shaped. It includes the "Virus Buster" mode from *Dr. Mario Online Rx*.

2014

US: 2.21.2014; JAPAN: 2.13.2014 (Wii U)

DONKEY KONG COUNTRY: TROPICAL FREEZE

Donkey Kong, Diddy Kong, Dixie Kong, and Cranky Kong have a grand adventure spanning seven islands. This game allows for two-person cooperative play.

US: 3.13.2014; JAPAN: 6.3.1986 (FCD) (Wii U-DL)

SUPER MARIO BROS.: THE LOST LEVELS

All-new, extremely challenging levels created with *Super Mario Bros.* assets, built with super players in mind (see page 24).

US: 3.14.2014; JAPAN: 7.24.2014 (3DS)

YOSHI'S NEW ISLAND

A series sequel, Yoshi goes adventuring with Baby Mario. The game includes the addition of giant eggs and new transformations.

US: 4.25.2014; JAPAN: 4.24.2014 (Wii U-DL)

NES REMIX 2

This was released simultaneously with the NES Remix Pack, which included both NES Remix and NES Remix 2. Remixes of *Super Mario Bros. 2* and *Super Mario Bros. 3* are featured in this game.

US: 5.2.2014; JAPAN: 5.1.2014 (3DS)

MARIO GOLF: WORLD TOUR

Play against people all over the world. Additional courses and player characters are available for purchase.

US: 5.30.2014; JAPAN: 5.29.2014 (Wii U)

MARIO KART 8

A new anti-gravity mechanic is featured in most of this game's racetracks. There are several new courses and a variety of playable characters, as well as the option to compete online. Compatible with amiibo.

US: 6.19.2014; JAPAN: 6.19.2014 (Wii U)

PUSHMO WORLD

These puzzles include Goombas, Cheep Cheeps, and Bowser.

US: 9.26.2014; JAPAN: 8.14.2014 (Wii U)

HYRULE WARRIORS

This game features Chain Chomps as a weapon.

US: 10.3.2014; JAPAN: 9.13.2014 (3DS)

SUPER SMASH BROS. FOR NINTENDO 3DS

Many characters from the Mario family are playable characters, including newcomers Bowser Jr. and Rosalina & Luma.

JAPAN: 10.10.2014 (3DS-DL)

CLUB NINTENDO PICROSS PLUS

A 2014 Club Nintendo Platinum benefit. Includes a number of puzzles related to *Super Mario* and other series.

US: 10.24.2014; JAPAN: 9.20.2014 (Wii U)

BAYONETTA 2

The First Print Edition and Special Edition of this game both included a bonus copy of *Bayonetta* for the Wii U. There's a Peach-themed costume available called the "Mushroom Kingdom Princess."

JAPAN: 11.13.2014 (3DS)

ONE PIECE: SUPER GRAND BATTLE! X

Using amiibo, the player can unlock character costumes for the Straw Hat Pirates, including Mario-themed ones.

US: 11.21.2014; JAPAN: 12.6.2014 (Wii U)

SUPER SMASH BROS. FOR Wii U

The same player characters as the Nintendo 3DS version, but with the addition of several unique modes such as the eight-player brawl.

US: 11.28.2014; JAPAN: 8.14.2014 (3DS-DL)

NEW SUPER MARIO BROS. 2 GOLD EDITION

This version includes all previously released downloadable content.

US: 12.5.2014; JAPAN: 11.13.2014 (Wii U)

CAPTAIN TOAD: TREASURE TRACKER

A spin-off featuring Captain Toad, who played an active role in *Super Mario 3D World*. Mario appears at the ending.

US: 12.5.2014; JAPAN: 8.27.2015 (3DS)

ULTIMATE NES REMIX

This game is made of masterpiece selections from the *NES Remix* series. It includes a minigame that is an accelerated version of *Super Mario Bros.*, called "Speed Mario Bros."

2015

US: 2.10.2015; JAPAN: 1.29.2015 (3DS)

ACE COMBAT: ASSAULT HORIZON LEGACY+

This game features Mario- and Luigi-themed aircraft, as well as ? Blocks. When used with amiibo, players can unlock different color schemes.

MARIO VS. DONKEY KONG: TIPPING STARS

Guide tiny toy versions of Mario and friends to the goal within the time limit. Since the Nintendo 3DS version contains the same content, you can play whichever version suits your style.

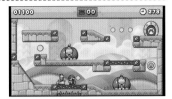

MARIO VS. DONKEY KONG: TIPPING STARS

The screen ratio is different, but this is basically the same content as in the Wii U version. By buying either one the player can play with both versions.

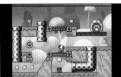

MARIO PARTY 10

Introduces the Bowser Party—where up to five people can play using the Wii U GamePad—in a Team Mario vs. Bowser mode.

STORY OF SEASONS

Special seeds yield special crops, like Super Mushrooms, Fire Flowers, and Super Stars.

ULTIMATE ANGLER

A fishing game that can be purchased at the StreetPass Mii Plaza. Players can catch Cheep Cheeps and Bloopers.

amiibo TAP: NINTENDO'S GREATEST BITS

Using amiibo, the player can experience famous three-minute scenes from NES and SNES games, including Mario and Yoshi's first encounter in *Super Mario World*.

STRETCHMO

In "Papa Blox's NES Expo," characters like Chain Chomps appear as different stages.

PUZZLE & DRAGONS Z + PUZZLE & DRAGONS: SUPER MARIO BROS. EDITION

To save Princess Peach, Mario departs on a puzzle-battle adventure.

SPLATOON

The "KOG" clothing brand includes a shirt with a Mario design on it.

DR. MARIO: MIRACLE CURE

Dr. Mario has a Miracle Cure that can be obtained for different effects. "Virus Buster" mode is also included.

DAIGASSO! BAND BROTHERS P DEBUT

A low-priced version of *Daigasso! Band Brothers P* with limited play options.

MH DIARY: POKA POKA FELYNE VILLAGE DX

Felyne characters in this game can dress to look like Mario.

SUPER MARIO MAKER

Players can build, play, and upload courses based on *Super Mario Bros.*, *Super Mario Bros. 3*, *Super Mario World*, and *New Super Mario Bros. U* (see page 6).

ANIMAL CROSSING: HAPPY HOME DESIGNER

Mario-themed furniture is featured.

YOSHI'S WOOLLY WORLD

Using amiibo figures, Yoshi can imitate other Mario family characters' appearances.

NINTENDO BADGE ARCADE

By playing this crane game, players can earn badges to decorate their Nintendo 3DS HOME Screen. Mario-themed badges are available.

2016

RHYTHM HEAVEN MEGAMIX

When certain conditions are met, characters from *WarioWare* appear.

STYLE SAVVY: FASHION FORWARD

This game features Rosalina's dress and other Mario-themed outfits.

ORIGINAL JAPANESE EDITION	ENGLISH-LANGUAGE EDITION
Publisher	**President and Publisher**
SATOSHI MATSUI	MIKE RICHARDSON
Editors	**Editors**
KAZUYA SAKAI (AMBIT)	RACHEL ROBERTS
kikai	CARDNER CLARK
AKINORI SAO	
JUNKO FUKUDA	**Assistant Editor**
KUNIO TAKAYAMA	JENNY BLENK
KO NAKAHARA (SHOGAKUKAN)	
	Designer
Assistant Editors	BRENNAN THOME
MIKA KANMURI	
NOBUO TAKAGI	**Digital Art Technicians**
	CHRISTINA McKENZIE
Design	ALLYSON HALLER
AKEMI TOBE (at)	
	Translators
Supervision and Collaboration	WILLIAM FLANAGAN
NINTENDO CO., LTD.	ZACK DAVISSON

English Localization and Fact Checking
IAN FLYNN
DAVID OXFORD

Encyclopedia Super Mario Bros. was first published by Shogakukan. First edition: October 2015.

Special thanks to Takashi Tezuka, Mary-Ann Courtenaye, Michael Gombos, Annie Gullion, Chris Thomas, and Patrick Thorpe.

NEIL HANKERSON Executive Vice President • **TOM WEDDLE** Chief Financial Officer • **RANDY STRADLEY** Vice President of Publishing • **NICK McWHORTER** Chief Business Development Officer • **MATT PARKINSON** Vice President of Marketing • **DALE LaFOUNTAIN** Vice President of Information Technology • **CARA NIECE** Vice President of Production and Scheduling • **MARK BERNARDI** Vice President of Book Trade and Digital Sales • **KEN LIZZI** General Counsel • **DAVE MARSHALL** Editor in Chief • **DAVEY ESTRADA** Editorial Director • **CHRIS WARNER** Senior Books Editor • **CARY GRAZZINI** Director of Specialty Projects • **LIA RIBACCHI** Art Director • **VANESSA TODD-HOLMES** Director of Print Purchasing • **MATT DRYER** Director of Digital Art and Prepress • **MICHAEL GOMBOS** Director of International Publishing and Licensing • **KARI YADRO** Director of Custom Programs

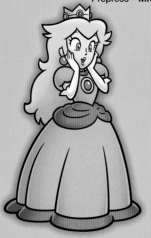

Super Mario Bros. © 1985 Nintendo
Super Mario Bros. 2 © 1986 Nintendo
Super Mario Bros. 3 © 1988 Nintendo
Super Mario Land © 1989 Nintendo
Super Mario World © 1990 Nintendo
Super Mario USA © 1992 Nintendo
Super Mario Land 2: 6 Golden Coins © 1992 Nintendo
Super Mario 64 © 1996 Nintendo
Super Mario Sunshine © 2002 Nintendo
New Super Mario Bros. © 2006 Nintendo
Super Mario Galaxy © 2007 Nintendo
New Super Mario Bros. Wii © 2009 Nintendo
Super Mario Galaxy 2 © 2010 Nintendo
Super Mario 3D Land © 2011 Nintendo
New Super Mario Bros. 2 © 2012 Nintendo
New Super Mario Bros. U © 2012 Nintendo
Super Mario 3D World © 2013 Nintendo

SUPER MARIO BROS. ENCYCLOPEDIA: THE OFFICIAL GUIDE TO THE FIRST 30 YEARS

Published by Dark Horse Books
A division of Dark Horse Comics, Inc.
10956 SE Main St.
Milwaukie, OR 97222

DarkHorse.com

First English Edition: October 2018
ISBN 978-1-50670-897-3

English Limited Edition: October 2018
ISBN 978-1-50670-807-2

10 9 8 7 6 5 4 3 2 1

Printed in China